M000105776

Saturday Nights at Lafayette Grill: True Tales and Gossips of the New York City Argentine Tango Scene

by Susan Kavaler-Adler

Foreword by Sidney B. Grant

MindMend Publishing

Published in 2016
by the MindMend Publishing Co., New York, NY

Copyright © 2016 by Susan Kavaler-Adler, PhD

All rights reserved.

For permissions to reproduce more than 500 words of this publication, email to ORIPressEditor@Gmail.com or write to ORI Academic Press Editor @ 7515 187th St, Fresh Meadows, NY 11366.

Printed in the United States of America on acid free paper.

Library of Congress Control Number: 2016963579

Cataloging Data:

Kavaler-Adler, Susan. Saturday Nights at Lafayette Grill: True Tales and Gossips of the New York City Argentine Tango Scene / Susan Kavaler-Adler

1. Argentine tango-Psychological aspects. 2. Creativity-Psychological aspects. 3. Mind-body connection-Psychological aspects. 4. Psychohistory. 5. Human psychology.

ISBN 978-1-942431-07-7 (soft cover)

mindmendmedia
piecing it together

Book design, editing, and book cover - by MindMendMedia, Inc. @ MindMendMedia.com

OTHER BOOKS
by Dr. Susan Kavaler-Adler:

The Compulsion to Create:
Women Writers and Their Demon Lovers
Foreword by Dr. Joyce McDougall
Routledge, 1993; Other Press, 2000;
ORI Academic Press, 2013

The Creative Mystique:
From Red Shoes Frenzy to Love and Creativity
Foreword by Dr. Martin S. Bergmann
Routledge, 1996; ORI Academic Press, 2014

Mourning, Spirituality and Psychic Change:
A New Object Relations View of Psychoanalysis
Foreword by Dr. Joyce McDougall
Routledge, 2003

The Anatomy of Regret: From Death Instinct to
Reparation and Symbolization in Vivid Case Studies
Foreword by Dr. Althea J. Horner
Karnac, 2013

The Klein-Winnicott Dialectic:
Transformative New Metapsychology
and Interactive Clinical Theory
Foreword by Dr. Richard M. Alperin
Karnac, 2014

To Dino, the most generous soul,
relentless supporter of arts and creative people,
and the guardian angel
of the New York Argentine tango world

To my husband Saul,
my life partner and my main tango partner

To all my tango teachers
and all my many Argentine tango partners

To all those who love tango
and dance all over the world, but especially in New York

To all who become inspired
to dance Argentine tango through this book

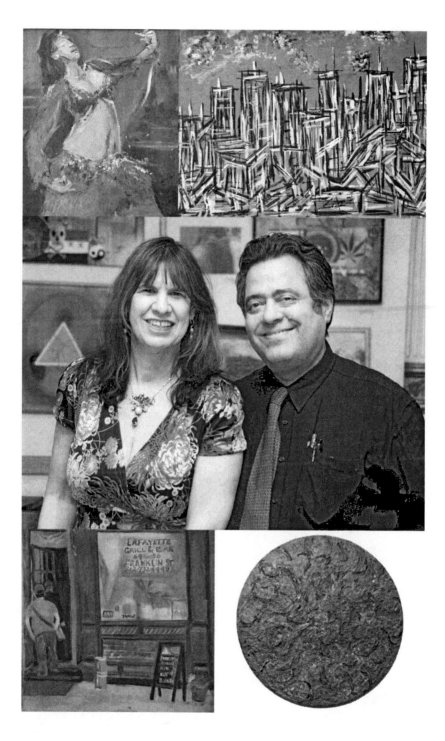

TABLE OF CONTENTS

FOREWORD

Foreword – sounds like Forward – a great word to introduce a book full of tango musings and memories. After all, if you ask any *"milonguero"* (traditional Argentine tango dancer) what the essence of this intricate dance is, he will tell you with deceptive simplicity: The "Forward" Walk! Only in Dr. Susan's case (like famous Ginger Rogers noted), she has to do what "Fred" (the leading partner) does, only backwards..., and on heels!

I should know. I've had the unique pleasure of choreographing and performing with Dr. Susan on multiple occasions and multiple venues, including the East Village Ukrainian Restaurant, the Roosevelt Hotel (with which she concludes this delightful book), and of course, our beloved Lafayette Grill. Such special memories – of a special dance, in a special place!

Memories do indeed make up the fabric of our lives. Psychoanalysts like Dr. Susan make a career out of relating those memories to their clients. As a dance professional, I make a career out of connecting clients to the nuance and passion of this extraordinary physical and emotional experience we call "tango" — especially when dancing socially at the various *"milonga*s" (tango gatherings) in New York City. And one of those former venues we miss most is indeed the Lafayette Grill, and our dearly departed Dino who managed the restaurant with such jovial attentiveness and genuine appreciation for the tango we love.

You might call my love for tango a bit cliché, as it was love at first site. I was vacationing, not in Argentina, but Amsterdam of all places and stumbled upon a sign for the closing night of "Tango Pasión" (an appropriate title if there ever was one). I followed the Dutch directions as best I could to the box office, and as luck, fate or divine providence would have it, there was a single seat available in the middle of the front row! It was a raised stage, so when the curtain opened, the dancers feet were directly at my eye level. In that moment, my life quite literally changed forever. I was transfixed by splendor, subtlety and sensuality of this masterpiece of measured movement, phrased with exquisite precision to the often haunting sounds of the "bandoneon" (a cousin of the accordion, for those unfamiliar with the instrument).

The synergy of the tango musicians and dancers elicited an unparalleled evocative quality that, well, Dr. Susan can certainly describe in greater clinical detail than I. As someone who was already a professional ballroom and Latin dancer at the time, I can simply say that I had never seen anything like it in my life. Over fifteen years later, my opinion has not changed.

xi

The same can be said of the many "*milongas*" (tango salons) that I've attended since, where dancers convene to engage in this ritualized social encounter and its time-honored "*codigos*" (codes of conduct) that have made the Argentine tango experience so unique since its birth in the brothels of Buenos Aires more than a century ago. They say that a tango is a three-and-a-half minute love affair, so these present-day settings are often pleasantly polyamorous!

Lafayette Grill was one such setting, beloved by so many in our local NYC tango community, and beyond. In fact, in a recent conversation with another well-known female doctor, Dr. Christiane Northrup, she called Lafayette Grill "sheer magic." I imagine that magic has a lot to do with what motivated Dr. Susan to put pen to paper about her special relationship with the former restaurant, and interview others in our tango family about their magical moments and memories there and elsewhere. The diversity of interviews is a testimony to the breadth and depth of our tango family: Lucille Krasne, Alex Turney, Orlando Reyes, Anton Gazenbeek, Jon Tariq, Paul Pellicoro, Jose Fluk, Tioma Maloratsky, Gayle Gibbons Madeira, Gayatri Martin, Jennifer Wesnousky, Marisa Lemche, Sondra Catarraso, Maria V. Quintanilla, Mega Flash, and of course, dear Dino.

So without further ado, enjoy moving forward into this collection of vignettes, anecdotes, philosophies and insights about tango and a handful (or is it footful?!) of reflections about Lafayette Grill and all it meant to our community. It's rather wonderful that Dr. Susan, who has authored five books on psychoanalysis, took the time out from her rigorous writing schedule to devote to this special project from the heart. No surprise there, though, since tango is danced, as that same "*milonguero*" will tell you, "corazón a corazón," heart to heart. Thank you, Susan Kavaler-Adler, for your heartfelt commitment to preserving the memory of such a cozy corner of our tango world, one which you've described it to me as both "Camelot" and a "second home" to you and your husband Saul.

May we all find our way home in this special book of yours, "Saturday Nights at Lafayette Grill"! And may all who tango continue to celebrate the special connection and special places like Lafayette Grill along the way of our dancing journeys.

Sidney Bernheim Grant
2011 USA Argentine Tango Salon Champion
Founder & Artistic Director, Ballroom Basix USA

PREFACE

Why I Wrote This Book

This book is a tribute to the difficult, complex, heavenly, and ecstatic "in the moment" experience of a dance that is more than a dance. As a psychologist and psychoanalyst (for four decades now), who has been an Argentine tango dancer for quite a bit, I find the psychological experience of Argentine tango to be as passionate an interest of mine as is the excitement of Argentine tango itself. For many of us it is a way of life, or at least it is a major part of our lives. But beyond the dance itself is the atmosphere of the characters that inhabit the Argentine tango community, and since it truly "takes two to tango," none of us is alone in this dramatic, inwardly focused, musically focused, and intersubjectively focused dance that is all about connection, and all the psychological and sociological phenomena that are manifested out of this.

Argentine tango is a dance that evolves through self and other synchronized "lead and follow" improvisations. If it is a true tango it always transcends any anticipated patterns, and any learned steps. Also, Argentine tango is done in the context of an embrace ("abrazo") that allows us to hold the heart of our partner, so we are heart-to-heart, or *"corazon a corazon."* Therefore, Argentine tango is all about relationship. It is not solely about the relationship between us and our external partners. It is not solely about us and the community of singles and partners around us. So, what is it about? The answer is that Argentine tango is about how our internal world, the land of our imagination, with dreams, fantasies, and haunting images of us and others, especially from the past, interacts with our external partners and relationships. This interaction imbues these partners and relationships with the idiosyncratic colors and character of each individual dancer.

As an object relations theorist, author, psychologist and psychoanalyst, I have written many books and articles on psychoanalysis, psychotherapy, women artists and writers, psychological development, and the interaction of the internal world of each person, within the external family and world that each inhabits and develops in. I bring all of this to my own unique romance with the improvisation that is both life and Argentine tango. Whether I am "in the arms of a stranger" (as I called one of the essays in this book) or in the arms of my husband, who has been my life partner for 32 years and my main Argentine tango partner for over 15 years now, the passion concentrated in the dance of Argentine tango is equally great! I also have been privileged to dance, and sometimes perform, with many of the professional leaders and teachers in the New York Argentine tango community. This book is also a tribute to them, and happily contains

interviews with some of these professionals, who, of course, are as in love with Argentine tango as I am. These Argentine tango teachers and performers are deeply involved in the philosophy of the dance and are some of the phenoms in the New York Argentine tango community.

In contrast to other books on Argentine tango that have been focused on the culture and history of the dance in Buenos Aires, and Argentina generally, I have chosen to write this book most particularly on the Argentine tango scene and community in New York City, which is where I live and dance tango 4 to 6 nights a week. I dance Friday and Saturday nights, but also on week nights, often going to *milonga*s (the social dance setting) later in the evening, after a day and early evening of doing psychological tangos with my psychotherapy and psychoanalysis patients. After a day and evening of dancing with patients through words, thoughts, and feelings, as they lie on my couch or sit up, I then take off to actively move out my feeling states in the improvisational dance moments of Argentine tango. Attunement to the nonverbal is as acutely important as the verbal in my psychological work. Since the nonverbal is the essence of communication in tango, the overlap of internal experiences and of tango metaphors in my psychological work, and of psychological metaphors in my tango dance, is a perpetual personal experience for me.

Dancing Argentine tango at night is a lovely contrast to the meditative stillness of being a psychoanalyst. It is a contrast to the free floating mental attention of the psychoanalyst to enter the free floating physical and emotional attention to the music and to the partner's lead. It is also after the verbal integration of self and other experience that is the art of the analyst, as I construct interpretive comments about dreams, fantasies, life narratives, and all these projected onto the therapeutic relationship (as they are intensely and emotionally, and sometimes sensually experienced by me) that I take off for the *milonga*s after 10 pm at night. At the *milonga*, I can allow myself to flow out physically in emotion and relationship, rather than sitting still with my patient's whole dynamic internal world dancing inside of me. At the *milonga*, I can flow through active body connection into the containing context of musical tone, shade, and rhythm. To me, the transition from the meditation of sitting as a psychoanalyst, to the Argentine tango meditation of dancing, is a natural transition, which I easily navigate on each evening that I do tango. Psychoanalysis and Argentine tango also have in common that they are spiritual practices that involve many technique and theories, but which must transcend these theories to be "in the moment" and to court, as closely as possible, one's own in vivo evolving authenticity. So even though I have been on two rich journeys to Buenos Aires, I am writing about the New York community in which all the parts of me come together in both the practice of psychoanalytic psychotherapy and in the dance of Argentine tango. Also as

a writer, different parts of me have come together in this book. I combine journalistic writing as an interviewer with essay writing that has personal self-expression, memoir writing, and fictive imagination.

Within and beyond all of this, is my dedication of this book as a tribute to the Lafayette Grill Restaurant and Bar, where its owner Dino Bakakos offered the Argentine tango community in New York a home away from a home for good 13 years. Dino is one of the people I interviewed for this book. Everyone I spoke with, in writing this book, has some connection with the beautiful cultural center and melting pot atmosphere of this unique restaurant, which had been a second home to me and my husband. We both attended the first *milonga* in New York, the Saturday night *milonga* at Lafayette Grill that was called the "New York Milonga" for many years. Then, three other weekday night *milonga*s began at Lafayette Grill, after the restaurant was expanded to house a big ballroom space. My husband and I joked, but also spoke with much seriousness about how Lafayette Grill was our second home. There were different hosts for each social evening, or "*milonga*," but each night brought regular guests that we befriended, along with strangers and visiting tango tourists with whom we shared our love for tango. We would often leave our table, and descend to the lower floor level, to find seats, to watch the performances. We knew the best of the best in the tango universe would appear on some rotating basis there. We have always enjoyed the heart and soul of this special Greek restaurant, where we would dance Argentine tango and enjoy Greek or other music performances, and where sometimes we would light Chanukah candles with others. Every nationality, race, religion, and occupation, and every level of tango and other education were represented at the Lafayette Grill. The thought of ever losing the place was traumatic. My husband and I were far from alone in our appreciation of the warmth and friendship we found, while we danced our beloved dance of Argentine tango, with others who equally loved it.

Although the restaurant has closed its location of 16 years, the concrete existence of the restaurant is less important than the mission I feel to extend its spirit through time, by anecdote, memory, atmospheric story, and interview with those who loved the place, and who will be glad to return to it if it is truly resurrected. So, this book is about all of New York Argentine tango and its multi-*milonga* community. However, by dedicating this book to Lafayette Grill and its owners and staff, I hope to spread the warm spirit of inclusiveness that Lafayette Grill possessed for many of us to all those who dance Argentine tango in New York City, at whatever *milonga*, and with whatever tango philosophy.

While this book mingles tales of tango life in New York with a particular loving celebration of what Lafayette Grill was, and what Lafayette Grill continues to be in spirit, the stark reality of New York tango

life must also be told. Consequently, this book extends the romance of tango into the dark corners of every day frustrations, disappointments, distracting preoccupations, and conflicts that might arise in the tango world. This allows readers to inhabit a full New York tango world experience, with all the chiaroscuro of the multi-level emotional entanglements, which we all secretly carry within our internal psychological worlds, as we interact with the internal world of others in our external world meetings, and external world tangos. The social world of tango must be part and parcel of describing the experience of the actual tango dance in the interpersonal world it exists in.

How This Book is New and Different

This book you are about to start reading is totally different than any other book written on Argentine tango and its culture. Other books have spoken about the history of tango in Buenos Aires and in Europe, the music of tango and about the technique of tango. Other books have written about the embrace and the etiquette of tango, or of the addictive nature of Argentine tango, and the tango obsession in that possesses many Argentine tango dancers. But no other books have written about the personal anecdotal experiences of those in the Argentine tango community, and particularly in the New York City community, and in the family tango community of Lafayette Grill. No other books have spelled out detailed narratives of these experiences as they transpire in the tango world, and also within the psychological mind space of the person who dances tango and socializes in the tango community. Nor have they been written by a psychoanalyst in the New York Argentine tango community. No other books have the very personal and psychoanalytic insights of a passionate advanced Argentine tango dancer, who dances tango a few evenings of the week, and who experiences NYC *milonga* goers' narratives and tales through sharing stories, and who speaks of her own tales! And no other books combines interviews with top New York Argentine tango professionals that speak of their passions in tango and their philosophies about both teaching and dancing tango, with personal anecdotal narratives that portray internal preoccupations, as well as mutually shared tango obsessions.

This book is also set apart by its specific dedication to a New York cultural center that has uniquely lived in a Greek restaurant where Argentine tango was continually danced and performed, as tourists and dyed-in-the-wool New Yorkers intermix in the passion of tango. This is truly a tribute to the rich jewel of a cultural life that can exist as a romantic dream, despite being right in the geographical range of Wall Street, and the skyscrapers and corporations of New York. This dedication is a historical

statement about what the New York Argentine tango community provides in a current sociological context that is starving for a heartfelt and "heart-to-heart" culture.

Who Is This Book For?

The unique offerings of this book will appeal to many people of New York Argentine tango community, while potentially extending beyond it, as the interest and passion for the Argentine tango are spreading throughout the world. Many have spoken of the "Argentine Tango Revolution" because of how quickly the love of the Argentine tango dance and practice has spread across continents, and existing now in every major city and state across countries. This all began when New York fell in love with "Tango Argentino" when it came to Broadway, and led to almost every dance studio in New York educating their students in the art, tradition, attitudes, and techniques of the dance, along with teaching steps and patterns. Through New York tango was revived in Buenos Aires after skipping a generation, and now Argentine tango has spread throughout the world, when in earlier eras it only reached Europe.

Both professionals and amateurs alike, who dance tango, will be interested in all the essays that provide narratives that everyone can resonate with at a deep psychological level. There are the social tango dancers who would read this book, who attend classes, workshops, and *milonga*s all over the world, and there are professional tango teachers and performers who would be most fascinated by the interviews in this book, which express different tango philosophies. All dancers of tango can identify with the authors of these tango world narrations, and also will be fascinated to learn specifically about daily happenings in the New York City tango community, and in the unique atmosphere of the Lafayette Grill restaurant cultural center.

People from all walks of life are incredibly curious about this dance, which is so sensual, romantic, sexual, and yet deep and internal as well. When they first see it or feel it, it often is an ecstatic experience, as for example described by Artem Maloratsky (Tioma) in his interview, when he remembers the first time he saw the Broadway show "Forever Tango." This interview and others, as well as the essays in this book will offer those curious but not yet in the Argentine tango community with a taste of what tango can be about, amongst those of us who live, eat, and breathe it, and experience the depths of our personal psyches within it.

True Tales and Gossips
of
NYC Argentine Tango World

ESSAY #1
ARGENTINE TANGO IN NEW YORK CITY:
HEADING TOWARDS LAFAYETTE GRILL

How many taxi cab drivers in New York City do Argentine tango? I only know of one, the one I introduced to tango quite a few years ago now. I jumped into a cab on the Upper West Side, after a day of work in an uptown office I had then. I had seen patients through the earlier evening, and was probably heading downtown at about 9 or even 10, to get to an Argentine tango *milonga* as usual. I was probably headed for Lafayette Grill, although in those days there weren't four full tango *milonga* nights at the Grill. I was ready to sit back and enjoy some rest during the ride, as I carried bags of tango shoes, and other clothes, to often stay overnight at my downtown office, so I wouldn't have to travel back and forth to my Brooklyn home the next morning. By carrying clothes, and staying over at an office, I could save time in the morning for traveling, which would allow more dance time during the week night *milongas*. The week night *milongas* ended earlier (about 1 a.m.) than weekend *milongas* in New York (which went to 2, 3, or even 5 am). I was on the way to meet my husband at a downtown *milonga*, dragging all my paraphernalia with me, when suddenly my temporary reposure was interrupted by a friendly cab driver who wanted to make small talk.

So, the anonymous male figure cheerfully intruded: "Are you coming from work?"

"Yea, a long day of seeing patients. I'm a psychoanalyst."

"Oh," he replied, "That must be hard work. You seem to be working long hours."

"Yea," I replied back, "Well that's why I need to dance at night. That's where I'm heading now. I'm going to meet my husband to dance Argentine tango. They call the place we dance a *milonga*."

Freddy, the cab driver, seemed to move from small talk mode to real interest, coming alive in his looks back to me as he drove, asking for more info on where I was going. So I obliged him, trying to size him up at the same time. He was definitely middle aged, but very alive, full of some kind of untapped hunger for life.

"There's a whole tango world out there in New York," I explained. "Although Argentine tango came from Buenos Aires in Argentina, it was reborn in New York when it almost died out in Argentina as a generation rejected tango in favor of The Beatles, etc. Now its new birthplace is in New York, where 'Tango Argentina' and 'Forever Tango' brought it back to life and spread it all over the world. They even do tango in Bali and South Korea now. In New York we're lucky enough to have all the top

3

Argentinian performers and teachers passing through town or staying to teach and perform as new residents. They teach the New York dance teachers in the Latin and ballroom dance schools, like DanceSport or Dance Manhattan... Then the people who study there branch out and frequent all the restaurants that run *milongas*. At *milongas* you can order dinner, be comfortable at a table, then dance tango to live instrumental groups or to CDs. It costs a fee to get into the *milongas*, but you don't have to eat if you don't want to. Some people just hang out at the bar, maybe have a drink.

Unfortunately, restaurants can end up resenting that we, 'tangueras, tangueros, and *milongueros*' don't drink much. We come to dance. There's nothing as intoxicating as the tango connection, when you flow as one with yourself, your partner, and the music. When the connection works and the flow is good, there is nothing like it! It's heavenly, the eternal now ecstasy! That's why we all invest thousands of dollars in tango classes- and continue training even after we become quite proficient. We're always seeking that tango high, an 'in the zone' trance that joins our unconscious through our bodies with the bodies of our partners, with all the others dancing in the ballrooms of the *milongas*, and with all the bodies dancing tango around the world."

With this whole orientation to the tango world, the cab drive flew by and I was at Lafayette Grill before I knew it. However, my cab driver wanted to know more.

"Wow," he said "There's a whole tango world right here in New York. Where can I study tango?"

I gave Freddy a tip on which dance studios he could study tango at, although they also were now teaching tango lessons before every *milonga* at Lafayette Grill itself. I mentioned all this, never thinking that I'd run into this fellow again as I ran off to meet my husband and friends at my evening *milonga*.

Many months later I went to a tango *milonga* at the Ukrainian restaurant and I saw Freddy the cab driver dancing tango with many partners, one after the other. At that time he was still mostly a "beginner" but he was certainly getting around. Actually, he noticed me before I noticed him.

"Hey doc!" he called out to me from across the room. "Look at me now! I wouldn't be here if it wasn't for you! My whole life is changed. I have a new life! Do you want to dance?"

The next thing I knew I was seeing Freddy at various Friday night *milongas*, Friday being the night he could surrender his cab driving survival schedule. If he wasn't at the Ukrainian restaurant he was at DanceSport's classes or their new Friday night *milonga* called "The Tango Lounge." Every time Freddy saw me, he'd come passionately panting over to kiss me "hello" as he was just coming down from an energetic *milonga* tango, or waltz tango. He was no longer a beginner. He was doing every form of

tango. He didn't have the finest art of those who could afford private individual lessons, but he had certainly traveled to far continents of new tango awareness with persistent and patient attendance at group classes. He certainly made the rounds to everyone, but every time Freddy would see me I knew I could expect an invitation to a *tanda* of three or four tango or waltz music pieces. He sweated in his gentlemanly suit that he wore to escort the ladies onto the dance floor and dance. Frequently my husband was given a reprieve from my wish to continuously dance on Friday nights when Freddy came around. "I don't want to intrude," he'd say. "No, my husband wants a rest." So Freddy became another *milonguero* who would give my husband a rest, for there were many men and a few women I danced with, as well as many teachers and performers, American, Argentine, Turkish, Japanese, whatever! This was the diverse multiplicity of the tango world in the melting pot of New York City, far from Buenos Aires, yet so near! And what about last Chanukah at Lafayette Grill when a whole group of us lit Chanukah candles even though only three of us were Jewish? We all crowded around a table at Lafayette Grill, and lit the candles; I said what I remembered of the Chanukah prayer, and one non-Jewish (possibly Greek) woman said: "I try to explain to people that we always gather at this Greek restaurant to do Argentine tango and do things like lighting Chanukah candles, as well as celebrating New Year's Eve here and Christmas!"

ESSAY # 2
ARGENTINE TANGO IN NEW YORK CITY:
A LITTLE HISTORY

After "Tango Argentina" and "Forever Tango" came to New York, New Yorkers who could only find a few Argentine tango classes in New York, began their pilgrim voyages to Buenos Aires to study with the great "Maestros," started to transplant the near extinct Argentine tango dance and art form to New York. All the big dance studios in New York that generally taught Latin and ballroom dancing began to hire Argentine tango teachers (whether Argentine or not) and to teach Argentine tango classes. However, as people learned and wanted full evenings of such Argentine tango dancing -- not just a dance here and there of Argentine tango, in between salsa, swing, rumba, cha-cha, foxtrot, Viennese waltz, international rumba, American or international tango, and hustle -- then it was time that full evenings of Argentine tango, in the style of the Buenos Aires *milongas*, could be invested in so as to offer the rich musical social evenings of the *milonga* to the community on a regular basis.

A full *milonga* evening included continual dancing of Argentine tango, which is distinctly different than the stylized American or International tango forms. Three modes of Argentine tango were part of the new New York milonga evening, first initiated at Lafayette Grill Argentine tango program. Tango proper, waltz tango, and the peppier form of tango, called *milonga* (same noun as used for the social evening of tango dancing) are the three modes of Argentine tango danced at a traditional *milonga*, although some *nuevo* tango music may appear, and new "alternative *milongas*" started evolving later to offer a full evening of "*nuevo* tango" faire. Argentine tango proper generally has music from many eras, going back to the 1920s, hitting the high water mark of the tango clubs and tango symphony orchestras of the 1940s and 1950s, and continuing through the modern form of tango music devised by Piazzolla in the 1980s and 1990s. Each "*milonga*," which is the Spanish word used for the evening of dancing and socializing, includes the three main forms of Argentine tango danced to many forms of music, with many forms of musical instruments, bands, and orchestras, although the traditional Argentine bandoneon is generally employed, along with piano, bass, violin, flute, etc. The traditional three or four dance *tanda* is used, where couples generally depart the dance floor after the *tanda*, and they or new ones come on for the next *tanda* during the interim music of the "Cortina." Everyone is supposed to wait and hear the music before they begin dancing. When the couples on the floor for the new beginning of a *tanda* begin to dance they will hear, through the music, whether they will be dancing Argentine tango proper--which has an infinite number of steps and figures, but which always has dancing in an open or

close embrace, and always has dancing with the lead and follow of leader and follower, who counterbalance their weights and move at the same time, in consonance with each beat chosen by the leader--or whether they will be dancing "waltz tango" or the peppier form of dance, where partners generally move quickly in step to each beat that is coincidentally also called "*milonga,*" like the name for the evening of dancing itself. *Milongas* are considered fun, with light and happy lyrics, and quick rhythms, as contrasted with what can be the more "triste" (sad) music of tango proper, with its lugubrious rhythms and its romantic tragic lyrics, where the leader could choose to wait for many stanzas of musical beats before moving and inch. In this continuous flow of movement with the partner, much more time is allowed by the leader for the follower (most often female) to talk back in interaction with her leader partner, to promote the intimate tango talk of conversation of tango. The leader must also wait for his partner to do any "adornments" she chooses in the rococo ornamentation of traditional salon tango. If she just follows his movement, and does not choose to put in any adornments between tango beats, the leader just moves on to his next steps and patterns. Increasingly, in current times, the conversational aspect of tango has been emphasized, especially in New York and the U.S, but also now in Argentina. A woman needs to express her personality in response to her male leader's lead. She does this through the passions aroused in her through the music, and through her connection with her partner, but also and primarily with herself, as she interacts with her partner and the music. In the dance of "*milonga*" the conversation is much quicker paced, but it is still a conversation, and the partners move rapidly but very much in sync.

There is also *nuevo* tango, which has its own special form of modern tango music, the new genre of modern music taking on all kinds of musical personalities since Piazzolla broke the mold with his more modern music. Often the DJ or band at a *milonga* evening will play "*nuevo* tango" along with the three big genres of traditional tango, waltz tango, and *milongas*. Today there are also more and more "alternative *milongas*" (as so often now in Santa Fe, New Mexico) where all kinds of rock, jazz, blues, and Argentine modern *nuevo* musical forms are played.

The First New York Milonga

The first "*milonga*" in New York, actually called "The New York Milonga," was started, and decades later, continues at Lafayette Grill and Bar restaurant. Before any dance studios or any other restaurants began to catch the tide of excitement and interest in Argentine tango with their own *milongas*, Lafayette Grill Restaurant, which has been supporting the arts in New York since their founding, opened the first New York City Milonga with Sondra Catarraso as hostess, later joined by Jose Fluk. What has

sustained this first *milonga* beyond the demise of many others is the heart welcoming atmosphere of those who run Lafayette Grill and their *milonga* hosts. There is no other *milonga* that I know of where the atmosphere in the restaurant is a combination of authentic Buenos Aires, Argentina, restaurants and an at home feeling. Like Buenos Aires restaurants where *milongas* are run, Lafayette Grill has paintings from current painters on the walls, and comfortable tables with cushioned booths, as well as a large ballroom space, plus a stage for instrumental and vocal performers. But even more fundamental than this is the sweet psychological atmosphere of "being at home" that is conveyed through the friendly "largesse" of the owner, Dino and his brother, Billy, along with their warm hosts and hostesses, who hug and kiss you when you come in.

Dino is himself a New York art and culture legend. Dino has been supporting the arts in New York for ages and reaches out to artists of all kinds. He has new paintings on his walls from each new artist he is supporting during the current month. His taste in the artwork on the walls is generally exquisite. He has art openings at this restaurant as well.

This support of painters is highly complementary to Dino's support of the evolving and ever developing and growing Argentine tango community, with its large rotating groups of Argentine tango teachers and performers, many of whom are coming from Buenos Aires, and others trained or now located in New York, and who regularly perform at Lafayette Grill. Dino is also the man who always reaches out to his loyal patrons with an extra free desert or a free drink. He makes those who hang out in his restaurant and its *milongas* feel like they're in their "second home" as I and my husband have felt for over ten years now.

Everything in New York Tango at Lafayette Grill

All the exciting events in New York tango are happening at Lafayette Grill restaurant, and at the same time the atmosphere is "homey" and social, full of friendships. Performers from the New York Tango Festival in July appear at Lafayette Grill, such as the world renowned Junior Cervila, who was in the original "Tango Argentina" show on Broadway, with his partner Natalia, and others who were in "Forever Tango" on Broadway, such as Claudio and Romina. As Lafayette Grill has expanded from the golden Saturday night *milonga* that launched Argentine tango *milongas* in New York, to include three other weekly *milongas*, Monday, Tuesday and Wednesday, with different hosts (all of which my husband and I attend every week), a greater variety of performances are seen.

Also, different teachers are available to teach both beginner and intermediate tango at extraordinarily low rates, compared to the regular

dance studios. Those who teach are also available for private classes. Monday nights, with the special teacher and host Tioma and his girlfriend Gayle Madeira, and the other male and female couple hosts, Jose and Savanna, has become known for the very high level of dancers who attend this *milonga*, even though this Monday *milonga* doesn't offer performances, only teaching, since the hosts aim to maximize everyone's actual dance time.

But Lafayette Grill is not only known for its fabulous music, tango lessons, performances, and dancing. Argentine Tango at Lafayette Grill also involves all kinds of social encounters, with old friends, girlfriends, boyfriends, and spouses, and with new stranger who you can connect with on the intimate level of the tango connection for the first time. I meet my husband here four nights a week and deal with all kinds of marital conversations and exchanges, in between tango conversation exchanges. However, I can also be meeting a skilled Argentine *milonguero* guy, who danced Argentine tango since the 1950s. This older *milonguero* is someone, among others, that I dance regularly with at Lafayette Grill. He and I even entered a tango competition. I like sharing this skilled *milonguero*'s intense and subtle sensitivity to the tango songs and music. We dance to the Spanish language lyrics this man thoroughly understands, and I share in his years of training in Argentina of "just walking." Male leaders in Argentina are instructed to "walk" tango for two years before they can go to *milongas* and actually dance, with figures and steps. At least this was the traditional education of *milongueros* in Buenos Aires. For many years I danced with a particular Argentinian guy, and luxuriated in his long beautiful walking steps, as well as sharing in many accompanying steps and "figures" that enhance the embrace and connection between him and I in Argentine tango. We met and danced at Lafayette Grill. We also participated in a tango competition together.

Frequently I excuse myself from my husband and follow this guy's lead. I can also be meeting a close girlfriend on a Saturday night who comes regularly to Lafayette Grill with her boyfriend. She is a professional dancer, the head of a modern dance company, who took up tango, and he is a computer guy who I knew through dancing tango, even before he met his girlfriend. Now his girlfriend and I have become close friends, so Saturday nights at Lafayette Grill offered me intimate talks and chats with a woman who I like and admire, as well as the dancing with my husband and all the men. I connect and catch up with my girlfriend in between the *tanda*s of dancing with the men, feeling conversation, intimacy, and multi-gender interaction on various levels. Then suddenly I might be dancing with a Japanese businessman from Tokyo, who drops into New York and illustrates a highly trained sensibility to all the notes in a *tanda* of three dances of waltz tango. I find myself feeling this light flow of the man with

the waltz music, and feel myself letting go of all the day's cares and stresses, in my very stressful profession as a psychologist-psychoanalyst-psychotherapist and the director of an institute that trains psychotherapists and psychoanalysts.

Another night I come to Lafayette without my husband, when my husband is tired on a weekday night, and I am greeted by a guy I've never seen before—who turns out to be a professional dancer—saying to me "Do you dance with strangers?" I say, "Yes, but I have to get my other shoes on," as I am tying my tango shoes. I begin to dance with this guy and see that he has great rhythm, although not quite the refined skill of a total convert to tango. He turns out to be a professional dancer who catches on to tango as he dances it with me, after some, whatever amount of Argentine tango experience. He says: "I see I can throw you all around. Your balance is very good!" Then he comments, after dancing "close embrace" with me, after, and in between all the fancier performance moves of "open embrace," "I don't know how anyone can let their wife dance close embrace with other men?" I and my husband obviously don't have problems with this, either me with other men, including strangers like this guy, or my husband with other women (he resisted dancing with others for a long time). This is part of what enriches our marriage, as we dance so well attuned to each other, but also need the dancing with others to spice things up and to free things up, often dancing better with each other when we "get a break" and dance with some others. This professional ballroom dance guy is not quite inside the scene yet, I think! Then I might go dance with Jose, one of the hosts on Mondays and Saturdays, who always ends his dances with me by taking my hand and kissing it, while looking deep into my eyes, proclaiming: "impeccable!," a high form of praise for my dancing and dance connection that he always seems to enjoy.

Then there was that night quite some years ago when listening to women in the ladies room at Lafayette Grill gave me a sense of another dimension of the tango world. One lady tango dancer was saying to another: "I stayed away for a while. There's just so much I can take of the tango scene! Of course I always come back. But these guys are so unable to commit to anything. Oh I don't mean they aren't committed to tango. They certainly do commit to Tango!"

I got a glimpse of the singles scene view of tango, which differed from the luxury of my marital perspective, having the fortune to actually be married to a man who loved Argentine tango as much as I did, and who loved to talk of his addiction to "it" and to the music. He had been a classical music lover, who now loved Tango and the music of Argentine tango. My husband would even listen to tango music when working on the internet, as he knew where on the internet to find it, as well as playing CDs of tango at home or in the car. The joy of sharing tango in a marriage can't

be overestimated, and our marriage has been now over 29 years old, 32 years together. Sharing such a passion as tango, going to Lafayette Grill together at least four nights a week, and to other *milongas* in New York other nights, continues to renew the fun and improvisational joy of life together in our marriage that is both "tango" oriented, and beyond. Through Argentine Tango, my husband and I can be together in the fun and letting go of the stress in life, as well as in the work and pain and problem solving of life. We have all our wedding anniversary parties at Lafayette Grill on Saturday nights, and I have all my birthday parties there. We perform together at these parties, before others cut in and dance with us in the traditional Argentine tango fiesta of birthday and anniversary celebrations. I now also have all my psychoanalytic Institute conferences at Lafayette Grill as well, full day conferences, with lots of speakers, where I give papers, and perform Argentine Tango at lunch with others in the tango world who are professionals.

ESSAY # 3
IN THE ARMS OF A STRANGER

Ironically, although happily married to a man I've been with for thirty years, I am will speak about how I enter the arms of a stranger many times a night, and many nights a week, in the same Argentine tango world that I also dance tango with my husband. I truly do enjoy the best of both worlds, inside and outside of monogamy. This is particularly true if we understand how deeply sensual, as well as musical, interpersonal, intersubjective and communal the experience of Argentine tango is.

Some compare it to actually having sex, and certainly it is an experience of love making at its best (as Jorge Torres puts it, "I see my partner with my skin, not with my eyes"), or at the very least the foreplay before love-making. It is a deep or not so deep experience of connecting. It is spiritual and loving in being "heart to heart." Yet sometimes it is merely a new adventure for me in which each new man, with each individual mode of Argentine tango technique, and with each individual way of interpreting the music of tango proper, waltz tango, and the peppier form of *milonga*, becomes akin to a new country, to experience and explore, always bringing the excitement of novelty. It is also often comforting to respond to the arms, legs, and embrace of my dearly beloved husband, as a tango partner, after these adventures, relaxing into the more familiar. But even my husband can become the tango "stranger" when he tries out new movements and new technique. Even the more familiar has its novelty in tango because every second is an unanticipated step and lead from my male partner. So even with my most familiar partner of all, my husband, I experience the novelty of his new way of putting together our patterns of movement. I experience new feelings on my husband's part too, to the music, or the new steps, new music, and my own new way of interpreting the lead and the music. There are different body connections to the music and to my partner, and always different ornaments or embellishments that I might add in-between the beats of the music, and in-between the directions of the male lead to the music and beats.

The organic fluidity and flow of Argentine tango, totally unlike the stylized movements of American tango or other ballroom dances, always can create an unexpected improvisational "eternal now" moment. This is true as long as I, as the female follower, am able to let go of conscious cognitive anticipation, just as the psychoanalyst needs to let go of any form of anticipation, allowing "free floating" attention to follow the lead of the patient's "free association." Wilfred Bion, British psychoanalyst, had cautioned the analysts to enter the analytic situation and the clinical moment "without memory and desire." In Argentine tango, I follow my partner, but do so through a connection with myself, the music, and my

13

partner. If I can't connect with myself, I can't connect with my partner. But if I can, then I can connect with hundreds of partners, as many as come along during my Argentine tango lifetime, which so far has been more than twelve years. For the last many years I have transitioned from dancing several days or nights a week with Argentine tango teachers in private lessons, or with others in group lessons, to dancing many nights a week in the social hours that are called "*milongas*," which take place in New York at either dance studios or restaurants that play Argentine tango music. I enjoy constant sets of Argentine tango music sets (called "*tanda*" in Spanish). Men and women usually join each other for one *tanda*, which includes three or four different pieces of Argentine tango music. The music is played either by a live band with the famous "bandoneon," or on CDs or iPods.

There is nothing else like it that I know of. The world and dance of Argentine tango are totally unique, and I feel so blessed to have this other world to go into, where soul – heart – body connections combine and transport you on a regular basis. Sometimes we go into the level of "the zone," where I can close my eyes and feel the containing connection with my partner. In the connection I can do all the steps and feel all the music automatically. I forget consciousness of any steps but feel my body flowing in the fully organic flow of the music. Sometimes I don't reach that trance-like level. However, I am more consciously enjoying the person I am dancing with, and the feeling of my own body, while noting the steps and patterns in the dances as I move.

Two weeks ago, I danced practically the whole night with a guy from Chile whom I may never see again. This week, I danced with two young black guys who had dramatically more charged styles than my usual partners, but as long as I could follow their lead, we connected and became acquainted in the moments of the dances. Nowhere else would I be suddenly cheek to cheek with male strangers, not to mention heart to heart, and holding each other. Black, White, Asian, South American. In New York, Buenos Aires, and now all over the world, it's still TANGO. This is a unique form of instant intimacy that requires no foreplay. We both do tango, and suddenly we're dancing to the music. But instant intimacy is not shallow intimacy. The more I dance with any one guy, the more I get to feel his personality and truly experience who he is, just as he feels my personality and gets to know me. Of course, we actually don't know anything about each other, but does the patient know anything about the analyst in fact? Yet the level, depth, and profundity of intimacy over time are very great! It is a common saying in the tango world that you can't hide anything in tango. The way you move, connect, or disrupt and disconnect, is felt in what is called the "three minute romance" of each tango song or CD. Everything about you is in your movement, without a word being

14

spoken. After all, we all begin the expressions of our human personalities in the nonverbal experience of our mother's arms! We start to become who we are before our own spoken words ever enter the picture. When in psychoanalysis, we either surrender or we experience all our resistances to surrender; so too in Argentine tango.

Marcia Rock (who filmed and directed the documentary "Surrender Tango" and who is the Director of Broadcast Journalism at NYU) and I were in agreement that mutual surrender is today's experience of Argentine tango as a social dance, even more than as an art form, despite the fact that Argentine tango began in a highly macho chauvinistic culture, in which sadomasochism often drove the technique rather than the organic flow contained in the embrace that we know today. It is common knowledge that Argentine tango started in the brothels of Buenos Aires where Italian, Spanish, and German male immigrants first created steps together. Tango then evolved in the local "barrios," or neighborhoods, where in the 40s and early 50s, at the height of the great Argentine tango orchestras in Buenos Aires, each neighborhood had its own dance club. Men danced with men to practice, since they had to be accomplished leaders in tango to win the few female partners around then. Argentine tango was frowned on by the wider Argentine society until Argentinian artists and musicians living in Europe, as well as rich aristocratic European males brought the dance to the high society drawing rooms and ballrooms in Paris, where the dance enflamed the hearts, minds, and bodies of Parisian society. Then tango traveled back to Buenos Aires, where it became popular, and in the 1940s and early 1950s great orchestras developed around the dance, and neighborhood social clubs had whole families socialize through dancing tango. But there were also the *milongas* that have thrived to today where singles and couples danced all night, and the legendary singer, Carlos Gardel made the lyrics of tango songs into a new genre of tragic romance. Towards the end and following the Peron era, along with a military dictatorship and decreased interest, tango went underground. Thus began the tradition of the dance hours for the *milonga* tango party being very late at night, taking place in public buildings and churches that were converted into *milonga* dance halls.

Traditional *milongueros* (tango dancers) feared tango would be lost forever. But when Tango Argentina came to New York in 1985, and took New York by storm, it led to New Yorkers reviving tango in Buenos Aires, Argentina, where this opened up more and more dance halls and restaurants for tango dance nights. Through the revival in New York tango jettisoned back to Buenos Aires, producing more and more teachers and performers, resulting in tango being the chief economic commodity, along with grain, as tourists flocked to Buenos Aires to learn tango and to view the big tango shows.

As a result, we now have the latest of all the tango teachers in Buenos Aires teaching and performing at our nightly *milongas* in New York. Meanwhile tango reached across the continents. I have danced Argentine tango in Seoul in South Korea, when I was invited to speak for three days at a conference on my theoretical work, called *developmental mourning* vs. the *demon lover complex*. My husband and I were in South Korea for 11 days through the generous all-expense paid treat of the Director of the Object Relations Psychotherapy Institute in Seoul. During the days of my lectures, speaking to an audience of 150 people with translators, I surprised some of the attending psychology students by showing up and dancing with my husband at a Seoul Argentine tango *milonga*. Of course, I danced with some South Korean strangers, as well as with my husband, at this *milonga* in Seoul. The world community of Argentine tango dancers provides a melting pot of intermixing cultures, enriching the life of tango dancers in all continents. When I danced with a man from Chile a few weeks ago I quickly learned he was a fabulous Argentine tango dancer. He was young, spirited, and incredibly dynamic. We matched each other well, and he kept asking me to dance that evening so we almost spent the whole evening together. If it weren't for tango and my quick adaptation to his personality and dance style, we never would have met. In between dances I learned from him that he was a businessman who worked for a company that dealt with mining. What did I know of that? We might not have anything in common if we didn't both surrender our hearts and souls to the dance of Argentine tango, sharing each other's moves and rhythms for an evening. I'd love to dance with him again. I hope he stops in again on his next business connection in New York. Nevertheless, we may never meet again. And that's OK. That's tango. I went home later that night to my husband. Another night, I was dancing with a businessman from Tokyo who did a fabulous waltz tango with an exacting technique that made the flow of the music and all its subtle shades and overtones, come alive for me!

In the Arms of the Stranger, a Professional Tango Dancer

One of the great excitements of being in the Argentine tango world is that of dancing in the arms of a stranger, who you have seen perform at *milongas* as a consummate Argentine tango professional. There's a particular thrill if they are actually from the mecca of Argentine tango, from Buenos Aires. One tall dark Argentine tango professional stranger was Omar. He and his wife and partner, Veronica, came to New York last spring. They dazzled the whole New York Argentine tango community with their brilliant tango, *milonga*, and folkloric Argentine dance perfor-

16

mances. During their stay, I saw them at several different *milongas*. Several of their performances were at Lafayette Grill. I watched Omar with his long gliding tango movements, so elegant in the best evolution of the Argentine tango male. I saw his subtle but firm embrace with Veronica as he gallantly walked and then swirled into his turns and pivots. He led Veronica into high and low *boleos* (leg motions) and into *ganchos* (hook-like motions under partner's legs), while he performed *ganchos* under her legs. I watched Veronicas feet stepping vividly on the balls of her high tango heels, in the most technically and emotionally gorgeous expression of the tango music on CDs from the great tango orchestras of the 1940s and 1950s—Pugliese, D'Arienzo, etc. Veronica's feet entranced me as she executed each miraculous step with a grace that I always aspired to, and was always in awe of, when watching her. I watched how Veronica interspersed eloquent ornaments in between the steps that Omar led to the exact flow and sweep or in *milonga* to the exact beat, of the music. I was mesmerized by her legs and feet as they drew their images on the floor and swept up above her head and above his head as well, in long fabulous *boleos*. Her upper and lower body areas were appropriately dissociated. Her upper body was always in the embrace with Omar, while her lower body and legs flowed all around, and in opposition, to that above. Yet, Veronica was always contained in Omar's embrace, and always guided by Omar's lead. They were a marvel to watch! And the sensual engagement of his masculine energy and her feminine energy response—although the two had mixtures of the masculine and feminine energies as well—invoked in me the most sensual and erotic of flows through my own body as I watched them. This was then to organically enrich the love making experience I would share with my husband a day after.

Being so transfixed, as well as feeling so much a part of them through vicarious pleasure, as they performed their elegance before me, it was quite the exquisite treat to be asked to dance by Omar at a *milonga*, right after their performance. The first time I danced with Omar his gracious invitation to join him in several tango numbers followed his warm interlude with his charming and beautiful partner, Veronica. I had met Veronica on this personal basis at a Thursday night *milonga* in town, after already having seen her and Omar perform on a Tuesday night at Lafayette Grill and then at a *milonga* at another restaurant on a Friday night. Omar and Veronica hadn't yet performed together when I found Veronica coming over to compliment me as we sat near one another in the *milonga* space. She said to me, "Your dress is so *milonguera*!" This was a great complement coming from an Argentinean. I was wearing a red dress with big white polka dots that tightly shaped my breasts, waist, and then opened to a little flair over my upper legs, leaving my legs showing in their suntan color stockings and their red and gold tango heels up to a place a bit above

my knees. I thanked Veronica for her compliment. Veronica then added that she loved my bag and my shoes as well.

Veronica was full of warmth and affection, and loving life at every moment. The decades in age between us didn't matter a bit. At that moment we were both women who loved Argentine tango. We both also loved dancing with the men in the Argentine tango world. Veronica and I were both married, and as I danced with my husband in New York *milongas*, Veronica was performing tango all over the world with her tall Argentine professional tango husband, with whom, I later learned and saw, she had a one and half year old baby. She was at the prime of her life, and seemed to be enjoying every minute of it. I was part of it all by dancing Argentine tango, and by dancing in the same space at these New York *milongas*. When Veronica then joined Omar on the dance floor to perform I saw those gorgeous sculpted feet of hers again sculpting their designs in the tango floor. When she and Omar performed the more peppy tango dance form of *milonga* I saw her almost fly as she would do this flourish of boleo kicks with her body and legs, I was again entranced and mesmerized. One leg went over and around the other in a second to second thrill *milonga* rhythm velocity. Her agile body technique and her organic body flow seemed woven together effortlessly and magnetically. I was a fan, but the wonderful thing about being her and Omar's fan, was that just after their performance I would no longer be a spectator.

A moment of tranquility and exclusion from the dance floor after the performance was then going to lead into a moment of ecstatic surprise and entrancement. My husband was not with me that evening, and although I had danced with some men earlier in the evening, I was left languishing in a chair as the performance ended and everyone else seemed to be joined in couples on the dance floor. I sat and watched. And then suddenly, the masculine god of the evening, Omar, approached me and invited me to dance. I made a mental note in my mind that it sure didn't hurt to make friends with Omar's partner earlier on, and to have welcomed Veronica's admiration of my dress. This all went on in an instant as I got up to accept Omar's gracious invitation to dance. Then I was in the large, comfortable, and containing embrace of the tall dark man with the long black hair and slight beard. He was so tall that the top of my head barely touched his chin as I leaned forward in my tango heels to fit into his embrace and to embrace him with my arms. We glided across the ballroom floor in the most musically acute walk, with pivots and turns, and with my own embellishments, and perhaps some high or low boleo kicks and some under the leg *ganchos*. I was in heaven, but I was a little too concerned with following his steps, I thought, rather than just closing my eyes and losing myself in the tango connection. I was half in and half out of the tango "zone," because I had some self-consciousness in dancing with him for the

first time, after having just seen him perform at the height of his performance time in the Argentine tango world. I inwardly thanked Veronica as Omar and I moved sinuously across the floor. Omar and I then did a second dance in which I felt myself surrender more to the connection with Omar and the music, and to my own deep interior body-self-connection. I didn't know if Veronica had actually asked Omar to ask me to dance, but her good graces were with me. That I could be sure of! And when the dances were done and Veronica was sitting for an interlude I went over to join her. I said that her *milonga* was absolutely transporting and scintillating. Unlike Omar, she understood English and I didn't have to switch to Italian (that I usually do with someone speaking only Spanish). At first she didn't understand me, but then she did. She looked up at me from her seated position and glowed with a radiant smile as she exclaimed, "Dancing *milonga* is sheer joy!" I felt the joy! I felt her love for life, and her life of love for her art form, for her husband, for her sister, who I was also to meet at a tango workshop where she was giving instruction. I also felt Veronica's love for me, a perfect stranger, but a woman who loved the life of the Argentine tango community, where the art form and social dance of Argentine tango could be mutually enjoyed and shared. Seeing the love she had for her baby and for her sister later, and her sister for her, only added to this impression.

After having surrendered to Omar, although with some self-consciousness, when Omar walked languidly across the room at that *milonga* dance night to ask me to dance, I felt confident to ask Omar to dance when we encountered each other again at other *milongas*. Soon the New York engagement would be over for the special couple. They would then travel to Europe with the sister and the baby. However, I danced several sets of dances with Omar at other *milongas*. Then one Sunday, I and my husband attended a 5-hour workshop with Omar, Veronica, and Luna.

At this workshop I would dance with Omar again, taking instruction from him this time. Since Omar would always recognize me and kiss me when I saw him at *milongas*, it was easy to say, "Can we dance?" Each time that Omar graciously accepted, this tall dark Argentinean male stranger became slightly more familiar, allowing me to surrender a bit more each time to our mutual connection in the dance, with its embrace and steps that followed from his lead and from our connection. Certainly, we were strangers. Omar hardly spoke English. We spoke some words in Italian since I didn't speak Spanish, and had studied in Italy. But mostly we just danced. We flowed. This time, I closed my eyes. This time, I felt the languid movements of his body with mine, and relaxed more fully into them, while also staying in my axis and doing some embellishments in between the beats of the lead and music. His lead was so subtle in the social dance, much more so than in his performance. I followed the subtleties, and

small tiny movements of my feet happened, along with the movement of my abdominal muscles and waist in the dissociation of the tango dance. I even felt some kinship with the feet of Veronica in these subtle and elegant movements. I was also aware of others watching me dance with Omar, who was so proficient at synchronizing every movement to the music. I tried not to be aware of the others, but there was always some part of me that gloated a bit internally, and glowed a bit externally with pride, as I enjoyed seeing others watch me partner with a guy who gave me a distinct legitimacy in the tango world. I wasn't just any *tanguera* or *milonguera*. I was a serious Argentine tango dancer who had taste, and also was dancing in a simpatico organic flow with a top level dancer. I didn't want such thoughts to invade the psychological space of just being in the moment with my partner. I knew that I could lose the magic of the "eternal now" moment that lent me some immortality, through the tango connection, if I got too concerned with my image to myself or to others. I had written books about "the creative mystique" as opposed to the pure lived in experience of being fully eternally alive in the creative moment and the creative process, which included the social dance creative process. So the music could help me be swept into the tide of the second by second organic flow of Argentine tango as I joined my partner in the embrace and the movement and rhythm.

Then linear time could be suspended and I could be released from the persecution of time with all its reminders of my dead line mortality. I could just be so fully alive in the moment, which was the richest when enjoyed in the couple, and for me enjoyed through being a woman with a man. Whether I danced with a stranger who I really didn't know at all, and hadn't seen before, or with this god like professional male tango star, or with my husband, or with male tango friends, I could suspend the haunting impingement of linear time and all its deadlines by joining these men in the full immortality of the rich and alive tango moment. In Argentine tango, a dance of improvisation, you never "anticipate" as the follower, if you want to fully enjoy the dance. You surrender to the lack of agendas in the spontaneity of play in the Argentine tango dance, and so does mortality temporarily transform to the psychological and spiritual experience of immortality. As Argentine tango dancers, we dance heart to heart, "*corazon a corazon*," so we melt into the fluidity of spirituality even as our instrument is the very concrete body. This experience may at times be most available with a stranger, one who we meet and live with only in the precious moments of the tango dance. In the Argentine tango world we speak of the "three minute romance" as each tango song is prolonged and suspended for only three minutes, although we generally dance three or four of these tangos in a row during the "*tanda*," between the sets of the music. The *tanda* ends when the *cortina* (curtain) plays, which is a very short piece of music between *tanda*s, but which can be sometimes felt as a

dissonant chord interrupting the tango connection. We go back to our seats, to our spouses, as we leave the stranger partner behind. But in the Argentine tango world we can always look forward to another piece of immortality in the "eternal now" quality of the dance later in the evening, or the next evening, or the next week when we dance. It is a life apart from our other life, and yet it mirrors life as a whole.

One Argentine Tango Stranger who became a Friend Tango Partner

His name is Jorge, a popular Argentine name for men. He dances social tango in a highly rhythmic and nuanced *milonguero* style. In tango he is fluid, and in *milonga* he is very sharp and syncopated. When I dance with Jorge, I feel my hips moving sinuously as I turn and pivot around him in close embrace *molinete* (grapevine), in which I circle him in small languid movements in tango, and much quicker and more rhythmic movements in the peppier dance of *milonga*. I sense his lead, with all its subtleties, through the close embrace of our upper bodies and through my feeling of his weight changes on the floor. I also sense him through the rhythm and flow of the music.

We speak very little. Yet whenever I see Jorge at a *milonga*, and usually at Lafayette Grill, which to me is the center of New York tango, we kiss each other on each cheek, in the manner of the Argentines. I might run up to him and kiss him, or he might see me across a room and nod, although he is very contained and reserved when not in the dance. "Hello Suzanne. Of course we'll dance. Just give me a few minutes." Or, "I promised this set to so and so,—a little later." "Hello Jorge. When can we dance?" Or he sees me at a table at Lafayette Grill with my husband and waits till I dance with my husband before approaching me. Or I see him dancing with several fabulous women tango dancers, while I'm dancing nearby in the embrace with my husband. He never turns his head to nod hello when dancing with another woman, as some American men might. He wouldn't do this when with another woman, even in between dances, even though people talk on the ballroom floor. But after the dance set (*tanda*), when he parts from his present partner, I might approach him, and say, "My husband wants to take a break. Can we dance?" He graciously takes my hand and leads me to the floor. Then he drops my hand and holds his left hand out for the formal tango embrace, while he puts his right arm around my waist. I put my left arm around his back and neck.

When the music begins he begins to move within its flow in dynamic harmony and aerobic flow. Sometimes he sighs or breathes deeply to get to a deeper level of inward connection with the music, and this allows me to surrender more fully as well, to his embrace and to the music,

and to the inward connection inside of myself. My upper body moves first, and the circulation of movement travels down to my feet that carry out rhythmic and melodic messages, but my lower body, from the waist down, often flows in the opposite direction from my upper body that is encased in Jorge's embrace.

I am most with him, myself, and the music, when I am not aware of any steps, but just let the steps flow from following Jorge's body in its state of directing leadership. Of course, if I hadn't danced tango for years and known a million tango steps, letting go of thinking about the steps would not be so possible. When we enter the true tango "zone," a semi trance of merger with the music, the movement that allows me to forget the steps is most natural and effortless, like "nothing" they say, or the "no thing" of W. Bion, and D. W. Winnicott's true self play and spontaneity.

I never fully forget the steps though. I am at least subliminally aware of how my legs and feet select three step motions, back and forth, around Jorge in the tango *molinete* or more quickly in the tango *milonga*, which also has different kinds of ocho steps that flow from the waist down without the Latin hip motions of Salsa. I know how much I am in the zone by sensing the fluidity of my upper body, then waist, then down through the hip and leg motions. When I feel the flow sensually travel through my own body, and am particularly reminded that I am a female, I know I have let my head control go enough; just as the Buddhists speak of losing your "self" and becoming empty, meaning surrendering to ultimate receptivity. So too they speak of losing the steps and becoming the flow in Argentine tango. We unite in this way, and refuel our psycho-physical beings in each such connection, while music of many tango eras leads the way. I continue with Jorge and sense not only the three rhythmic steps to the beat or in syncopations between the beats. Then he motions to the side, where my lower body and legs go out to the left without my feet changing weight on the floor. They call this the *ocho cortado*, but now it is just a natural extension to the left, because thinking of its name in my head would disturb the movement. "I feel her through my skin" says the famous "Forever Tango" show performer and teacher, Jorge Torres, in the documentary film "Surrender Tango." Just like in making love, Torres explicates, you don't need to see with the eyes. You can shut your eyes and flow.

Of course, on a crowded *milonga* floor, with other couples all around, the Leader of the Argentine tango couple, whether male or female, must keep his/her eyes open to see that there are no collisions with other couples. The follower, however, who is usually, but not always female, has the richly textured luxury of closing her eyes, and thus of fully experiencing the body flow without the cognitive consciousness that we are used to indulging in through our eyes and visual perceptions. Yet, with my stranger-friend Jorge, I sense him closing his eyes quite a bit, to focus

deeply on the music connection and the musicality of each differentiated step. We are both joined in a meditation. Many in New York tango have spoken of the "Zen" of tango, because it is a state of deep concentrated meditation in which all stress from internal and external pressures is relinquished, so that one might be so fully present in the moment that we breathe in sync with our partners, as well as in sync with our own bodies and with the music that is guiding it all. In this Zen meditation, Jorge's sigh is a sure sign for me that Jorge is entering a deeper realm of body and mind concentration. This letting go in the entire body, heart, and soul accompanies the letting go of the breath, and the entering of a domain of deeper breathing. I often refer to this domain when I lead my group guided psychic visualizations, which start with breathing.

When the three or four dances of the dance set are finished, we part. Whether we danced tango proper, classical or *nuevo*, tango waltz, or the happy-and-peppy *milonga* (that removes us from the sorrow and grief of failed or tragic romance in tango song lyrics), when the music stops we stop. In tango dance competitions you are penalized for one extra dance or foot movement after the music ends. The Argentineans are extremely exacting about this format. Even though the Argentines seem to lack discipline in their outside lives, they seemed to have gained this discipline in the *milonga* rituals or in the club dances they had in the 40s and 50s. Although in Argentina divorce may be even more common than in America, romantic etiquette that grows in the *milonga* dance halls, and in the experience of the dance itself, helps all who dance tango learn how to live better as well. So those of us who dance tango with all its traditions and rituals – and with the underlying discipline of wedding ourselves to music for the immediate and also sustained connection – seem to gain more discipline in our outward lives, as well as gaining more sensitivity to others. This dance of intersubjectivity of couples can translate to our coupling and marrying in the outside life. I do believe that those of us who do tango together in marriage often find it easier to stay together, despite how many actual tango professional partnerships may break up. When I see a vision of the perfect tango marriage, like that of Veronica and Omar, with baby and all (and even with the sister as a support for their marriage), the true romantic in me emerges. I then imagine Omar and Veronica dancing together into eternity. The fact that they, like I, can continuously have the exquisite sensuality of dancing with a stranger, while committed and bonded to their tango mate, only reinforces the marriage or couple bond.

So now returning to Jorge, the dance set has come to an end. He kisses my hand and says regularly as he departs from me, "Always a pleasure Susan." I reply "A pleasure for me too, Jorge. Thank you. See you next time..." The next time may be tomorrow night at another Lafayette Grill *milonga*. But since he periodically returns to Argentina, it might be six

weeks or six months until we dance again. Objectively speaking, what do I know of this man? Very little. He has aged somewhat since I've known him. But his dancing always inspires me, with the virtues of the subtleties of aging. He now may make a point of saying, "I am low energy tonight." Or just "I am tired after dancing at another *milonga* for a few hours." Yet I find he still dances like a dream. I do not know his occupation, or whether he is retired. I know less of him than of many tango male friends I have, who, in the course of dancing with them, have gone from the status of stranger to friend. Yet Jorge and I know each other in an authentic form of intimacy in the meditation, dance, heart-to-heart, psycho-physical connection of Argentine tango. We dance as one, which is tango. We meet as strangers and have several three minute romances in each tango dance set, all of which is TANGO.

ESSAY #4
ABERRATIONS IN THE LINE OF DANCE

The traditional Argentine tango *milonga* has very specific rules, related to the overall *coda*, for how each couple in a *milonga* is to move around the dance floor. Each couple is supposed to follow the music and dance all their Argentine tango walking, steps, and "figures (special combinations of steps)" in a circular counterclockwise direction, which is called "the line of dance." In Buenos Aires the fluid and smooth movement of this line of dance is so vivid, as the discipline of the *coda* is strictly followed by all couples on the dance floor. Everyone moves forward in sync with each other as each couple follows the tempo and flow of the music. Anyone who doesn't move forward, despite whatever steps are being performed, is not tolerated. Anyone who moves backwards rather than forward in their overall figures of movement also would definitely not be tolerated, as this would rupture the overall flow of the elegant Buenos Aires Argentine tango line of dance. Such intrusions on the flow would be terribly "gauche" in Argentina, and much of this might result in a group of male *milongueros* forming a circle around the intruding party and forcing the male lead of the trespassing couple to all the way out of the door of the *milonga* venue, a traditional form of excommunication and sanction cultivated by the Argentine tango community in Buenos Aires to keep the *coda* discipline of the *milonga* intact, enforcing its premises so that the civilized and communal repartee of the *milonga* can be promoted and continued. The enforced elegance of the Buenos Aires traditional *milonga* (as opposed to some *nuevo* tango forums) is known internationally. Tourists, who join in, from whatever land or nation, are expected to fit in with this elegant and contoured genre of dance respectability. Anyone who does not fit in is in jeopardy of being seen as an intruder, and in the worst case scenario, being forced out the door. In milder cases, however, where mere sloppy intention is seen on the part of any male leader, resulting in slightly wayward or disruptive direction on the part of the leader of each couple, some degree of tolerance might be seen, but dirty and contemptuous looks will probably be evoked, along with arrogant slights and whispered critiques during the first part of a new tango in a *tanda*, when couples can stand and talk with one another before engaging with the music fully and beginning to dance.

In fact, it is a great source of pride for those of us who come to Buenos Aires to do Argentine tango as tourists to not be guilty of any disruptive dancing. It is a great source of pride to "fit in" with barely a ripple or ruffle of disruption. It is a great source of pride to us to be told by our tour guides or group leaders in tango tours that we flowed with the

milonga energy in a smooth and harmonious way, not "god forbid!" looking like New Yorkers!

But how does this all translate to the *milongas* back home in our more "gauche" as well as more prosperous New York? How does this translate to the oldest *milonga* in town in New York City, the "New York *Milonga*" at Lafayette Grill and Bar restaurant? In the dance studios in New York there is great variety, and so one guy studying at DanceSport remarked, "At Dance Manhattan, the tango students are taught the line of dance in classes. Here, it seems to be each man for himself. We seem to take our life in our hands as we advance on the tango floor *milonga* where the line of dance is considered incidental and not explicitly taught. If the male leader isn't vigilant in the non-*coda* atmosphere, his female follower may be suddenly kicked or bruised by another *tanguera's* tango shoe heel!"

But what about Lafayette Grill's *milongas* where no expectation is ever arrived at that the decorum of the *milonga coda* should be taught as it might be at a professional dance school? Is it "every man for himself" or worse on the ballroom floor at the Grill?

Yes and No, and yes, chaos can reign but New Yorkers at the Grill can also experience that chaos can be creative, a truly American *coda* of thought! We don't only bump into each other here (despite some mild reminders from the hosts with the microphones that "Argentine Tango is danced in a counterclockwise direction.) We also witness and experience the oddest of semi circus performances right in the middle of the dance floor as all the serious *tangueras* and *milongueros* attempt to keep their high level of concentration on each step, walk, and "move" within the dance terrain. One male *milonguero* who frequents the joint several nights a week, and most particularly on Saturday night, is famous for his athletic displays of his own form of tango, combined with his inspired energy, sometimes to try to win applause. Fascinated by how much the female body can bend, this congenial but not too young gentleman, will pick a willing female, no matter how young and flexible or old and flexible due to tango, and will proceed to use his inspired and idiosyncratic tango technique, to twist the lady into a pretzel and then unwind her, or to lift her up at her center with her head hanging down towards the ground and her feet lifted to a height of no return if he were to slip on a banana peel, or by some other mishap of his failed omnipotence, to drop her. Those who are first time comers to the restaurant are the most likely to give such a circus feat applause. Some are actively wild with enthusiasm. It has been said at one time by an experienced tanguera who ran her own *milonga*, and who seemed at that time to greatly appreciate this acrobatic man's patronage that "Mr. X. really knows what he's doing ladies! You don't need an insurance policy to 'dance' with him!" Really? But does the "Lady Protest Too Much?"

Perhaps this is all part of the creative chaos of Saturday night at Lafayette Grill. Let's see what else might be part of the creative chaos on the same Saturday night.

We see another spectacle after the elegant three planned tango dance performance of the evening, a performance more sedate and expressive of high level subtlety than many other performances (like a performance by last year's second place winner of the New York Tango Festival), along with an advanced female teacher who's dropping in, right off the plane, from Argentina. Although one might think that such a performance would set the mood for an elegant dance floor that had couples obeying the *coda* of counterclockwise movement, something impulsively but also spontaneously emerged that seemed quite to the contrary. The amazing thing is that what might have started (and remained a rather bizarre act of circus dimensions) actually arose as a creative and compassionately humane act in the midst of the usual serious tango dancers. Before any warning could be launched, some first time male gentleman, who seemed to know a few tango steps and who came accompanied by a table of non- tango dancing onlookers, was wheeling a handicapped female friend of his in a wheel chair onto the dance floor, and was beginning to dance with her as if she was standing on her feet and dancing.

At first, I of course, resented the intrusion and the obstruction of the path of my partner and myself, as we attempted the profound inward and outward connection that is tango, connecting with oneself, one's partner and the music. How could we go into the concentrated, sometimes closed eyes, "zone" of tango heaven and in sync coordination with this guy placing a woman in a wheelchair in the middle of the floor, while he proceeded to dance in, and around her path? Was nobody policing the tango dance floor? Didn't anyone care if we had room to dance?

But as I danced and began to simultaneously watch this man's rather careful performance with the wheelchair lady, until another gentleman joined him and took up even more room on the dance floor, I started to become mesmerized by the nature of what was actually taking place before me. My mind suddenly flipped over in its own attitude from annoyance and contempt for the untrained people on the floor who vied for attention at any cost, to an attitude of bedazzled wonderment. This guy really seemed to be involved in an act of making love as he stayed glued to the eyes of his wheelchair lady partner, and wooed her with the moves and gestures of tango as if she could truly follow his lead. His belief in his connection with her, and with the music to entice and seduce her into a moment of pure pleasure and amazed joy and enjoyment, could be seen as nothing less than an act of love! This guy is totally committed, in the length and time of this tango three minute romance song, to embracing this

handicapped female in a wheelchair who he isn't touching, but is certainly avidly wooing! He wants her to truly know what it feels like to dance, and to dance the dance of all levels and depths of connection, not any dance. As I watched him, still catching every step my partner led me in with my body, and feet, and legs, I was taken into a private moment of total human compassion. I could feel the authentic generosity in this man, the genuine reach across the great divide of those physically fit and those physically handicapped.

ESSAY # 5

PARTNERSHIPS IN THE WORLD OF NEW YORK ARGENTINE TANGO

Brilliant, beautiful, sensual partnerships in the world of Argentine tango dance before the eyes of us New Yorkers, the professional ones standing out as billboard spectacles, the amateur colleague ones being a mere curiosity. As one of my former Argentine tango teachers declared, "Argentine tango is meant to give expression to the voluptuousness of the female body."

Stars from "Forever Tango" perform for us, with such elegant precision between the two partners, and between the partners and the music, that it is hard to believe it's possible. We watch in awe, admiration, and envy! We look to see what we can copy in technique, attitude, embrace, and steps, and take away with us. Sometimes we are immediately inspired after a performance to feel the flow of the voluptuousness in our own tango flow. Many pull out their cameras to take the performance of the tango "maestros" and stars home with them. We may see the same top tango couple perform at the Ukrainian restaurant, and then at the "All Night Milonga," then again at various *milongas* at Lafayette Grill.

Sometimes the man in the partnered couple is older than the woman. Then the younger woman stands out for her lithe agility and her extremely skimpy tango stage dress, that leaves very little unseen and for her tantalizing allure in the eyes of her older male partner. This certainly is the case when Romina Levín and Claudio Villagra perform. The young female body articulates each note of the music in the tango cd with such defined and etched elegance, with her foot and leg speaking so clearly while her upper body folds in with her man in the passion of the tango embrace. As she twists and turns with the musical accents and musical voice in her body Romina's barely pasted on shell of a long tango dress, with a total split up the center to reveal her dynamic and shaped legs, ending its long line of assent at the core of her crotch, which is shielded by a heavy dancer underwear, tights material around her thighs, buttocks and waist. She becomes a combination of refined but sexy elegance, with the professional skill of a prima ballerina. Some women comment: "I think that dress was a little too much!" "She didn't need it to make her statement!" This contrasts with other comments, usually from men, like my friend from Santa Fe, New Mexico, who comments, "What did you think of that dress?" I say, "She always wears those kinds of dresses on stage. She has a beautiful body and she wants you to see it!" "I like the dress!" I add. "So do I," my male friend from Santa Fe comments with undulating emphasis.

Those of us in the New York tango community are used to the spectacles of the female body semi-exposed, semi-mysterious (unlike the

29

raw stripper) and so refined and elegant in the flow of her meeting the connection with the partner and the music that she seems like some rarified spiritual angel, combined with her mermaid like other half as a stripper. The exhibitionism is contained and sublimated in skilled technique and refined articulation of that technique. That is what makes our world so unique and special: Our exhibitionism and voyeurism can both be gratified in sublimated forms. Men don't openly masturbate in front of the female tango dancer. They take graphic photo prints with their cameras and watch in silent admiration, until they can grab a female tanguera, or their very own partner, and imitate the ecstasy dramatically acted in dance by the couple on the stage.

Also, unlike the go-go dance stripper (who interacts with men by coming down to them at their tables or bar seats, to ask if they want to talk and buy them drinks), and unlike the old time "Gypsy Rose Lee" stripper (who takes each piece of clothing off at a gradual pace to the rhythm of gyrating music, which inevitably leads to her fleeing off the stage and disappearing from view, and declining any interaction with voyeuristic and masturbating men), the Argentine tango performer is visibly appealing, while being contained and protected in the tango partnership with her man. Who the man is who shows her off by connecting with her to the music then becomes of great importance and the tales of professional tango partnerships enduring or disintegrating start to strike us as legends then in our current tango world. How many actually lead to marriage, and how many have other boundaries that are respected by both members of the partnership? How many couples dissolve into angry conflicts and distractions with other male and female artists alluring them to remake their creative identity? How do we in the Argentine Tango world in New York interpret all this? What can I add to this interpretation as a psychoanalyst?

When Partnership Boundaries Fail

This reminds me of one Argentine tango professional partnership, which for years had been contained in an offstage partnership, although later I was told (although it is the ordinary grapevine rumor) that the legal marriage certificate was never signed, a common macho male happenstance, I am told, in the Buenos Aires immigrant tradition. This was after all a dance that was born in the barrios, in the streets, and in the brothels of Buenos Aires, where the local poor and the immigrant Italian and other workers mixed. Later it moved from the brothels to the gymnasiums and schools, where formal tango clubs were formed in the 1950s when the big tango symphony orchestras began to play, followed by the singing of the legendary Carlos Gardel, a poor immigrant boy, whose mother loved him, and instilled the faith in him to rise to stardom. He

30

hardly danced a tango step, except for the petite *Il Gardellino* movement he made up himself. But he sang like the messiah of the Argentine poor who were seeking both an angel and a dramatic hero. This hero began to sing songs of desperate despair contrasted with the pathos of undulating longing for love, or contrasted with the wailing grief of just barely losing a horse race, after rising from poverty through singing to buy the horse.

When Carlos Gardel ended up in Hollywood movies, his tragic death in a plane crash (when planes were only available to the elite) came about as perhaps most fitting ending to the tale of a populace saint rising out of the barrios, to bring poetry, lyric, and Spanish rhyme to the people that danced in the streets (or in the brothels), before they could enter the tango clubs and dance. Only the best dancers could make it in the clubs where all the "kosher" girls of the provinces and of the Argentine capitol city, were lined up by number to challenge them. They had to practice for days, nights, weeks, months, and years with other males before being allowed to dance with the precious few women who danced tango. They had to dance with girl #1 to girl #100 before the arrogant self-selected *milonguero* men, displaying their leading technique for the elder *milongueros*, who were the self-appointed professionals (see Virginia Gift's book *Tango: A History of Obsession* for this history).

Only with approval by the elder *milongueros* could any new young Argentine male succeed in entering the tango clubs on a regular basis in the "golden era" of tango, when the great orchestras played. The arrogance of the older *milongueros* was part of the atmosphere and part of what was learned along with the new creation of tango dance technique. That which we call "Macho" became the crowning jewel of Argentine male attitude, which encased the male ego whenever a rejection for a dance might threaten. To protect the male ego even more against its internal fragile core, a "coda" of rules was set up that included the law that a man would make eye contact with any woman he decided to dance with, and would need to get some nod or facial gesture of acceptance before he would take the plunge of actually approaching the lady to escort her to the tango dance. So sensitive to rejection was the average Argentinian male that if he did not follow this prophylactic ritual of getting an "assent" from his chosen damsel before he approached her, and if then the lady should dare to refuse him, the Argentine male *milongueros* would be forced to flee the whole terrain of the tango *milonga* in the gymnasium club or alternate venue. He would flee in shame according to the macho male tradition of "success or death" in the false bravado of the aura of narcissistic perfectionism. So to save his "face" he would have to get the advance consent by the wink of an eye, or the availing smile, in order to know he could take the risk of asking for the hand of the woman in a dance. With such terror of rejection in this macho culture, is it any wonder that the risk of asking a woman for her

hand in marriage would be even more of a challenge to the male, and by not asking he supposedly kept his lady around without any commitment, so that he could have other women around to guard his fragile ego against the devastation of any female rejection?

So given this background, it is interesting to observe Argentine tango partnerships, on and off of the dance floor. We can see how tango partnerships based on men in other than this macho nationality might differ and offer differing options to women in the Argentine tango world, both those in the professional and amateur realms. But first a tale of the alliance between one Argentine male and his professional tango partner: what happened after 20 years? I will refer to this well-known Argentinian Tango couple by fictitious names. The man I will call Carlos, since there are a million named Carlos, and the female mate I will name Juliana (so we have an appropriate reference to Romeo and Juliette).

When this professional team hit the New York tango scene they appeared as a totally committed and married couple. They always performed together. They taught tango classes together. They spoke together of their passion for tango and for each other. They performed in all the well-known spots where there were tango *milongas* in New York. So of course, they performed and taught at the oldest *milonga* in town, the "New York Milonga" at Lafayette Grill and Bar restaurant. They performed choreographed pieces, as well as improvisational tango, so it was clear they spent many hours a day and week together working on these routines. Carlos liked to show off Juliana, and Juliana spoke with pride of how generous Carlos was in his designing tango figures and steps to show off the feminine elegance of his partner, who performed her sedate "embellishments" in between the steps of Carolos's skilled and matured lead. Carlos would walk with such grace and assurance that New York tango dancing women, tangueras, would swoon like 1960s Beatles' fans. "Look how the man walks," one or another *milonga* host would cry out as the room erupted with applause after he and Juliana would parade their art in front of all the tanguera and *milonguero* eyes that watched with worshipful anticipation to see "the real thing," straight from decades of development in Buenos Aires, as well as abroad in Europe. Of course, what made it all the more magnetic and magical was the fairytale romance that we could each paint in our minds, the romance we believed lay behind the fantastic tango connection of a macho and his mate, as they illustrated such shared and harmonious "musicality," moving to every musical note together with the air of easy agility and "heart- to heart" or "*corazon a corazon*" connectedness! We watched them. We listened to them speak in classes about how they shared the passion of tango, and how it continued to bring them together for two decades now! Then one evening at Lafayette Grill they announced that after all their years of having fun dancing, teaching,

and performing tango together, they wanted to settle down a bit while still continuing their craft. They wanted to have children. Juliana was pregnant.

During this period they danced as Juliana became increasingly pregnant, and then rather rapidly, right before the eyes of their fans and students in New York, they appeared with a new baby boy. Juliana now revealed an entirely different part of herself as she became fully engrossed in her "maternal preoccupation," demonstrating the deepest symbiotic joys of motherhood and of breast feeding. Their new baby boy grew up in the atmosphere of the world of New York *milongas*, growing quickly to the fast paced age of two, romping around as many female tangueras tried to catch him to contain and quiet him down. He seemed fairly wild. But wherever or under whatever chair their little boy might be, or in whatever state he was in after bursting balloons that hung from tango festival celebrations, whenever his parents would perform together, little "Carlos" would run out onto the center of the dance floor where his parents would stand together, glowing, as they mutually received the tremendous applause that greeted them after each tango, waltz, or *milonga* performed. Their choreography was seen as flawless, and was so impeccably timed for each of the two members of the tango couple to resonate with the other! Little "Carlito" would run out and rush up into senior Carlos's arms, clapping his hands and bowing to the audience before he relinquished himself into the secure hold of his father's arms. Carlito would be swept up in his father's arms with the resounding applause commemorating the triumphant moment—the three archetypical souls standing their together in the midst of the adoring crowd—like a triptych—father, mother, and child—the Madonna's motherhood belied by the sharp sexuality behind the exposure of her tango body and legs.

So the New York tango community had its mythic tango family. Yes, they seemed to say with their skilled bravado, bathed in what seemed to be a display of perfect love, "It can be done! Love, art, and creativity can co-exist!" The only further culmination of this spectacle of human and artistic triumph was yet to come, and as so often happens in life (particularly in a life that must traverse the stage and land on the cement of the city), the culmination brought the whispering echoes of a shadow that was about to emerge.

It was again one Saturday night at Lafayette Grill when Carlos and Juliana appeared, but this time the second pregnancy brought a new triptych, one that would bring shock in the home of harmony. And it all came about with so much practiced grace and graciousness! Carlos stood on stage, pointing with pride at Juliana, his now second time ripe pregnant wife. "With Juliana's permission," he smoothly declared, like singing a song, "I will be performing tonight with a guest performer who will be my female follower and partner for this show," and he gestured to a young,

33

slim, dark haired woman, whose eyebrows slanted mysteriously downward upon the upper visage of her face. She was dressed in a black but short tango gown. Then again he turned to his declared beloved, Juliana, who responded with warmth and enthusiasm to their shared credo of "the show must go on!" "Yes," Juliana declared to the audience, "I am definitely out of it for some months now." She was "very" pregnant, possibly five months or so, and of course, she could hardly perform tango at this point. Again, all was grace and graciousness, as Carlos, having received public permission from Juliana, now turned to the habitual male tango partner of the new lady in black, and exclaimed towards this other gentleman dressed in handsome splendor for the occasion, "And of course with your permission, Sir, the young lady and I will now perform to a musical piece of shared interest, Pugliese's "Recuerdo." or something of that nature.

All was proper and innocent as it should be. Little Carlito was not running around that night, so the public at Lafayette Grill could relax and watch the show. Juliana watched too, with admiration for her husband in his versatility to adjust so quickly to a new partner, to accommodate her and their mutual plan for a full family in the critical months of her pregnancy. After two tango performances the audience cried "autre, autre," the Spanish cry for encores, for more, for a *milonga* added to the carefully contrived tangos. So we watched as Carlos and the young thin lady in black did now an improvisation together. Since it was no longer contrived tango choreography, this was the real test of whether the partnership would survive the stage. Carlos and his new lady partner seemed perfectly in sync as the peppy *milonga* rhythms demanded their utmost concentration. Again, Juliana seemed to watch in harmonious rapture with the new couple, as she seemed so securely ensconced in the fruition of her relationship with Carlos, the relationship that extended beyond the stage to the bedroom and living room and to the bank. They were in it all together. Why, therefore, should Juliana mind a brief "understudy" interlude of her man, and another woman performing in the most public conditions on the *milonga* stage at Lafayette Grill? For us in the audience it was all part of the continuing saga of a happy tango couple who had made it for many years and two decades, who were now at the height of their affection, through having a second child in what we naturally thought to be a certified marriage.

We all heard there was a new baby boy. Before we knew it, Juliana appeared at another New York *milonga* with a bundle of baby pride, again breast feeding a bit in public. But then she seemed to disappear. We heard, through tango emails and grapevines, that living in the suburbs of New York was becoming much too expensive. Juliana was said to have returned to Buenos Aires with both her children, to join her family, while Carlos stayed in New York to earn money for the family as much as possible.

But somehow the economic explanation for Juliana's departure began to wear thin as I entered Lafayette Grill on a week night, and saw Carols sitting rather very close to the young lady in black who he had taken on as a new tango stage partner. My husband commented to me, "Don't you think it's a little inappropriate for them to be holding hands?" "I know the Argentinians are into kissing and hugging everyone at *milongas*," he said, "but this seems a little past that." I had noticed them too, several times now, and never saw the young lady in black's original male partner to be in the vicinity anymore. He seemed to have vanished. Both Carlos and his new partner smiled at me as I entered Lafayette Grill one night. But they very quickly returned to looking deep into each other's' eyes, not even dancing much that night, as they held hands, and each gazed into the eyes of the other at a table on the balcony of Lafayette Grill. At one point I asked Carlos to dance with me on the pretext that it had been my birthday that week, and I had just had a big party at Lafayette Grill on Saturday night. Carlos did oblige me, and I danced a waltz with him, too preoccupied then with feeling his skilled lead, and showing him I could follow his lead to now question what was going on with him. Yet the appearance of Carlos and his partner at Lafayette Grill, almost every night now, for their weekly *milongas*, started to raise suspicions in more than myself and my husband. No third parties appeared, no children appeared. Every night now it was just the two of them, and I overheard Carlos say to a friend one night, "We are still in the honeymoon phase!" But what about his family and what we had all assumed to be his happily married, long term wife? What was going on? Everyone was oh so polite to Carlos to his face. Once night it was his birthday and the whole room of females at a big New York *milonga* lined up to dance with Carlos. The hostess of that *milonga*, Argentine herself, seemed to have nothing but praise for Carlos. "Oh can that man walk," she exclaimed to the group of drooling women, "only in Buenos Aires do they learn to walk like that!, but nobody walks like Carlos. He moves like the suede on the bottom of our tango shoes, so smooth, lithe, and fine in every nuance! His new female partner graciously stepped aside for Carlos to dance for a minute or two with each female tanguera who lined up to celebrate him in his birthday dance! And then he performed with his new partner, and he praised how she had picked up so much of tango in only a few months living in Buenos Aires. "I have been dancing tango for twenty years, so don't watch me. Watch her! She's amazing after just a few years of tango and only a few months of *milonguero* style tango in Buenos Aires!"

Had he just been to Buenos Aires too? What had happened to his new family? Could he have gone there without visiting them? Had Juliana thrown him out? The rumors multiplied. Then suddenly Juliana appeared on the New York scene again, alone, without her children, who stayed with her parents in Buenos Aires. She seemed to have lost 20 or 30 pounds

although she had been thin to begin with, but had put on weight with her pregnancies. Now she was ram rod thin, much thinner than the young new lady in black partner. She appeared one night at a big *milonga* with Carlos, and temporarily all seemed to be right again. She had told a well know hostess in the tango *milonga* world that she hoped that she and Carlos would be able to go into couples therapy. She didn't really know I was a psychoanalyst and could have referred her to an experienced professional. What did she or he know about psychotherapy of any variety, although there are more psychoanalysts in Buenos Aires, I am told, than anywhere else in the world? That night, when I saw her dancing and performing again with Carlos (the man that all naïve New Yorkers like me had assumed to be her legitimate husband), she excelled, but she also could not help reveal a slightly manic edge to all her movements, and to all her conversational phrases. She spoke of wanting to be able to do something "new" again in her performances with Carlos. She spoke as if this would just be the exciting icing on the cake after all else continued with its usual grace of implied commitment and implied marital longevity. Then she added, "But for now I just want to be with my baby all the time. He wants to be with me all the time. And I want to be with him all the time, so new tangos will have to wait."

Oh, I was wrong, she had not left both her children in Buenos Aires, only the obstreperous older boy. Her second son, who could already walk, was fresh in sight, and she was so busy being a mother at the end of the evening that she seemed to be saying that that was all that really mattered.

We in New York, who had seen the whole family saga, were left on the edge of wondering what was really up. Carlos seemed to be sedately at Juliana's side that evening, but his recent behavior belied this somewhat forced tranquil exterior. The next thing I knew, Juliana was back in Argentina with her family. Apparently Juliana's hope for couple's therapy never happened. The next thing I heard from one of the hosts at Saturday night Lafayette Grill was that Carlos had followed Juliana back to Argentina to remorsefully confess to her: "We just couldn't resist!," obviously revealing his romantic behavior with his new female *tanguera* partner, the lady in black. Up till then, Juliana may have only suspected this. So, despite the proclamation of therapeutic reconciliation, and according to the Lafayette Grill informant, Carlos's confession brought immediate high intensity retaliation from Juliana, who threw him out of the house and declared that their children were hers, not his. She was doubly betrayed because Carlos's commitment to her and their two sons had only been based on the supposed trust of a twenty year tango relationship, which lasted as long as Juliana could keep up with the program, of tours, traveling, performances and heavy teaching. As we heard, not knowing if it

were true, Carlos had actually never married Juliana We learned that like the actual majority of Argentinian men, trained in the macho tradition, despite the tango grace, and politeness--actual legal marriage was not considered necessary or at all practical. Why close all the doors when other opportunities might arise?

Some of us in New York were indignant, and swore not to come to any more of Carlos's tango performances and classes. But Carlos was everywhere now in New York with his new Argentinian gal, despite interludes touring in Europe. It was difficult to avoid him, when our favorite spots continued to hail him as one of the great contemporary princes of tango. He and his new partner were handing out leaflets for their workshops every night, and they performed at all the big spots.

And although some of us were indignant, and started to blame the untrustworthy nature of all Latin men with their macho bravado, others looked at Carlos's departure from his own children as a mere creative turn of events in a true artist who needs freedom of all kinds to reach his full artistic potential. One of my dance teachers, ironically one who was quite committed to his own wife and child, despite a passionate tango partnership with another woman on stage, declared that "Sometimes you had to switch partners to create a new dimension of yourself in the dance, to continue to evolve." Yet a close female tanguera friend of his seemed to differ as she spoke of how she would never trust Argentinian men.

But what about his children? Many different opinions continued to emerge about a man who seemed to cut out on his children when he fell in love with a new woman. One rumor I heard was that Carlos and his new partner were performing one night at a club in Buenos Aires, and his two young sons were there into the late Argentinian tango hours. "Suddenly," I was told, "a woman flew in like a dark witch on a broomstick, so enraged was she, and swooped up the two young male dudes of 4 and 6 at that time." Perhaps Juliana was raging about Carlos having kept their children way beyond their bedtimes. She didn't say a word to Carlos, apparently. She just took her two sons back! Who knew what happened after that? But later, several years later, it seemed that some peace had come to Carlos and Juliana. But in the meantime we were all left in the dark, and needed to guess what was going on in the break-up of one tango partnership that spawned children, and in the creating of another that would become a formal marriage.

However, before the later family reparation, I was wondering, how Carlos could have abandoned his children in his passion for tango and his impatience with having a disconnection from his 16 year tango partner, Juliana? The last story indicates he made some attempt to have contact. Nevertheless, the New York tango scene revealed more, and it was revealed to me again at Lafayette Grill, on a Sunday afternoon, when I was having a

37

psychoanalytic conference, with a tango performance at Lafayette Grill. Apparently, the restaurant owners had double booked, and when I went off stage to go to the ladies room, I saw that Carlos and his new partner were holding a workshop in the coffee shop adjoining the Grill.

Right after I performed tango with a male professional, after also giving a psychoanalytic paper, I brushed past a baby carriage on the way to the ladies room. Yes, indeed, Carlos was serious about being a father. So now with his new woman, he had had another baby. It seemed like it might be a girl, but the baby was too small to be sure. She/he was amazingly cute of course! I didn't know what to say, so I congratulated Carlos.

Life goes on but somehow at least part of the New York tango scene seemed to feel betrayed by the image of marital bliss, family life and fatherhood, breaking down. The image represented an eternal myth of marriage and stage partnerships being fulfilled, as symbolized by the fecundity of offering the whole tango community, not only a view, but a full engagement with the children. People wanted the current maestros to incarnate this mythic image of fulfillment, and Carlos was a current legend in the Argentine tango world. I can't help but feel that the betrayal of Juliana was shared by the whole tango community. At least many of us regress to the most primal movie star state of fans wanting mythic icons, icons that are hoped to survive in a romantic partnership, both on and off stage.

One last scene of this episodic saga took place again at Lafayette Grill when Juliana came back to town to teach and perform. She was said to be staying with a friend in the suburbs, and she and her friend came one night. We talked and she was energized by coming back to the tango world in a professional way. She said she was teaching and performing a bit again, traveling, from New York to Boston to do so. That night she performed with an Argentinian tango teacher who taught and performed regularly in New York. I could see how thrilled her male partner was to dance and perform with her. So I was content to see that tango never dies in those who live in the contours of its passion. But Juliana also had her children. She whispered intimately to her female friend, perhaps so that I could overhear, "I'm just such a mommy!" Carlos's children were obviously safe with her, but I still couldn't help but wonder about the older son's anger, particularly the older one that had known Carlos well, and had jumped in his arms to clap after each performance of his two parents. What did he remember now of the two alluring tango parents who had made a prominent part of his early life "being on stage with mommy and daddy"?

ESSAY #6
SCARS UNDER the OFFICE CARPET:
SIGNS OF AN EX-STRIPPER'S EXISTENCE, or
WAS SHE the SHADOW SELF of an ARGENTINE
TANGO DANCER?

Scars under the office carpet, in the office that I owned in the middle of Manhattan... That's what it felt like they were – scars, deep white scars in the plush green fuzz of the carpet as it stretched to line the narrow hallway from the bathroom to the waiting room. If these white marks had been embedded deep in my skin, they wouldn't have seemed so vivid as lying there in the middle of the green carpet. I knew they were there, even though I had covered them with a second short floral patterned rug with fringes to hide them from the view of my patients, and perhaps from my own view. But I knew they were there! They were really bleach stains, accidentally flung in a chaos of disorganized disregard by my former non-paying four nights a week tenant in the office I owned. She had lived there free three, four, sometimes five nights a week, when I had been renting an office uptown to see my patients in. She had lived there free because she did some work for me, to help her through college, which included cleaning this coop office of mine.

Alicia was an ex-stripper, an ex-go-go dancer/strip club stripper, who had entreated me to give her work while she waited tables and tried to get back to finish up her courses in college. In her forties at the time, she had gotten too cold stone sober to do the hustle anymore at the clubs. Now, she was trying to surrender her stripper life ways, such as when she fell back on soliciting cash from former strip club patrons on the side by offering sexual favors. This kind of freelance lucrative dating wore thin when she became squeamish about being touched in all her private places by strangers after she quit the booze and the narcotics.

When Alicia and I first encountered one another in a coffee shop (me with my usual, heavy on the skim milk, café latte), we were both looking for some kind of asymmetrical companionship. At least this is what I surmise now. Because otherwise, what got either of us into this strange almost-living together liaison, just because she cleaned my office and printed a few bills for me, and other odds and ends? I vividly remember taking comfort from seeing some of her belongings carelessly left in corners of my office at that earlier time, ten years ago or more, probably, because they made me feel less alone in this private, one person office, where I listened to a multitude of others as an experienced "shrink," only to be left with all of my own personal thoughts and feelings for extensive periods of time, despite the close relationship I had with my husband. When my accountant of the time had asked me, "Why in hell are you

39

offering your office free to this person to live in so many nights a week, when you could rent it out part time for more?" I had replied that it was nice to be able to have a companion I could go out to breakfast or lunch with, in between working, when we were both around. Now I felt my female accountant looking skeptically down on me, decidedly from above, finding my explanation a little bizarre. But this female accountant, with a gabble of children, as well as a husband, and possibly a much better internalized childhood inside of her than I had, didn't seem to get what to me seemed obvious! She thought my "charity cases," as she called them, were just one of my many idiosyncrasies, along with being an Argentine tango dancer at night, and a serious psychoanalyst by day—actually the name of a workshop I had done.

Perhaps I was better understood by a male patient of mine who, without the benefit of knowing anything in actual fact about me, surmised through the osmosis of our unconscious connection (as he lay on my consulting room couch) that I "had a deep existential loneliness inside of me," which he said he thought had nothing to do with my present life. He thought I carried this state of loneliness at my core, from whatever ancient history I carried within me from my childhood," or possibly from past lives, I added in my own mind. He somewhat apologetically added, "Of course it could be a projection." I knew it wasn't, or definitely not totally. How does my male patient's perception of my inner core place of existential loneliness relate to the tale of my entanglement with Alicia, and all that she came to represent? And how were we linked by our two very different forms of dancing?

Alicia had spent most of her life up on a strip club stage, dancing in a g string and heels. She could ecstatically describe her sense of "total freedom" as she danced seminude or naked, feeling like "a newborn baby" she said, free in her own mind to dance to every impulse at the second she felt it, and simultaneously to luxuriate in the golden glow of all the men's' eyes focused totally on her. She experienced herself as mesmerizing, easily able to disregard the gyrating off stage, as the men whose eyes got so deeply into her as she danced with a certain arrogant pride, to every distinct beat of the music, masturbated to the point of rushing off to the men's' room to come.

I, on the other hand, who had also danced all my life, was currently dancing in short cocktail dresses and tall red or black tango shoe heels almost every single night at Lafayette Grill restaurant. This was after a long day and evening of sitting quite still while I listened with the proverbial "third ear" to my patients. Even when I was teaching student psycho-analysts I sat, usually in my office, as I lectured on readings and led discussions. Then I sped down by cab to Lafayette Grill and Bar, where the music, the men, the fruit salads and lattes, both mirrored and contrasted the

alcohol dens of strip club mania that Alicia, as a young Polish immigrant girl, had inhabited.

Occasionally there were parties that both Alicia and I created, particularly the big Argentine tango birthday parties where I would perform Argentine tango improvisation and choreography with my husband and other male partners, and male tango teachers. When Alicia was in a loving mood towards me she could appear quite festive and warm at these parties. Once she celebrated me after my birthday performance by handing me a red rose that I could easily imagine nestled between her teeth as she danced in a G-string with castanets.

This was during a time when she was inspired by my life, which seemed to represent to her the straight world success that she had always dreamed of, especially when she became mired in the walls that she herself had built around her in the underground world of the strip clubs. She had become imprisoned by her lack of education and skills for use in the straight world. For decades she languished in an underground world that began to feel like her prison, even as she tried to continue to dance frenetically on stage, as her choreographic skills waned and she was losing energy through aging. She was also losing interest in finding her men through the clubs, after the culminating "true love" of her life broke her heart, a man who was married and had half lived with her. The clubs she had then inhabited were slammed shut with Health Department stickers on the doors, and the doors to her heart were blocked up as well, as she lost her favorite man to a professional woman, besides his having a wife.

Alicia had attempted to reach beyond her psychic and actual imprisonment as she reached her 30s and 40s, by merging in her mind with any of the "intellectual male professionals" she hand selected at the strip clubs to seduce. This feat was often accomplished with a mere lap dance as she breathed in the man's intellect through her senses, or merely through a conversation at a man's table after her appearance on stage, when she would throw out a political or news related question in an attempt at instant and eroticized education.

Back in those early days with me, as she inhabited the rather small dimensions of my psychoanalytic office, with its books reminding her of my actual lengthy education, Alicia was similarly inspired by thoughts of housing in the land of my intellect and my intellectual accomplishments, symbols of the straight world success that she herself had always dreamed of. So celebrating me at one of my Argentine tango birthday parties seemed a natural sharing in me and my life that could come out of this and the whole terrain of fantasies that Alicia harbored in her mind as she struggled to master undergraduate courses in English grammar. When she brought out a rose to applaud me, she confided that I was more relaxed in my dancing than she had remembered, comparing myself to her, her own

41

glamor temporarily resting in the background of her mind. However, the expressions of admiration and sharing in my life as an inspiration were quite suddenly subject to the other side of her admiration where unconscious resentments and envious hostilities lay. Although she had shared in my world of Argentine tango at one party, the one where she produced the congratulatory rose, she also began to make critical comments about how she could never tolerate the discipline of Argentine tango. She had always shunned any dance instruction, preferring to be wild in her personal interpretations and steps. She found Salsa somewhat more tolerable, and at one dance studio Christmas party she tried to feel me through dancing salsa with me.

Everything that I loved in the sublimated grace, elegance, sedate walking and well skilled body dissociation and expression of the languid tango music through the main medium of the male/female or lead/follow connection of Argentine tango she began to disdain and depreciate. The next time she attended one of my Argentine tango birthday parties she turned my request to greet guests at the door into an unconsciously (it seemed) well timed act of rejection towards my friends. Instead of being the smiling hostess I was hoping for, Alicia face turned into a pouting and indifferent coldness, irritable with impatience at the incoming guests as they entered my party at Lafayette Grill. She seemed to become a blimp of submerged hostilities!

The baby, the child, the sister

But what had motivated my involvement and enmeshment with Alicia? How had this middle aging Polish woman, ex-stripper, woven herself into my life, so that now when I walked past a certain hotel in my office neighborhood I was compelled to think of Alicia. I was compelled to remember how she had first met a male lover there, in the midst of the formerly seedy prostitute scene at that hotel, the one she called the "love of her life," the most professional and intellectual of the boyfriends she had hooked up with through the strip clubs. She had told me every blow by blow scene of their first blooming illicit romance, first unleashed in the backroom of the midtown strip club that had long since been wiped off the face of the earth by Giuliani's Manhattan clean-up.

I was struck by how many memories I had of Alicia. After all it was even Alicia who had greeted me in my lobby on that tragic day of sunlight and beautiful weather, which became 9/11. My husband was ushered home through the streets of Brooklyn, by the cops. I was still lodged at my office. It was Alicia who had come to get me, sharing news of what was happening beyond what I had heard on the radio. It was Alicia who took me by the arm to a local outdoor restaurant, where the brilliant

golden weather of the day seemed to turn surreal as more was heard about the destruction of the World Trade Towers and of the people jumping off the top levels of them just right across town. It was also Alicia who then became enraged at our waitress and got the owner of the restaurant to ask us to leave, when she complained to him how our waitress failed at all the well hone skills and grace that she had learned as a waitress. The dark clouds of Alicia's ever-ready to explode anger still symbolize for me the dark ominous clouds of national despair that lay behind the superficial visage of tranquility in the spring weather that day.

But who was Alicia to me? What deep existential void of loneliness in me was my psyche trying to fill with her all around presence of the time?

Dreams began to emerge to haunt me when I first began to unconsciously ask this question. Dreams of babies began to emerge, when they never had before, reminding me of my earlier womanhood and earlier days of my marriage, but also bringing a distinct symbolic message of their own. Was my unconscious seeking in Alicia the baby, the child I never had? Was she the substitute for some part of me that needed to be born? As far as I knew the babies I had never had in biological concrete fact were expressed through my creative productions.

For years I had published books and papers about psychoanalysis, about theories with cases, about the creative process, the mourning process, and about the lives of brilliant women artists and writers. I had also occasionally created Argentine tango dance performances, with my husband, and with others. I had danced to the famous "Recuerdo," a musical piece by Pugliese, a celebrated Argentine tango composer and conductor from the great tango eras in the 1940s and 1950s. My male partner, for that performance, was a very creative improvisational tango dancer, had decided to try choreography at my request. He learned all the choreography with me, dancing to each phrase and shape in the music, as he was taught by a male tango dance teacher, who had once performed this choreography, his choreography, with me at a local dance studio.

But what happened in between dance performances, giving psychological workshops on both tango and psychoanalysis—in between writing books and journal articles and writing short stories or commencement speeches for graduating student psychoanalysts? In between my unconscious mind began to bring up the old pre-menopausal yearnings for having the thing itself, the original concrete performance of a woman's biological nature, the real concrete chubby baby, before its symbolic representations took over. The real baby was of another era.

I thought I had forgotten it when Argentine tango became the new "baby" of me and my husband, and me and my dance teachers, after my "book babies" had been delivered into the world, after each book's

pregnancy and incubation. I thought I had forgotten, but inevitably my unconscious mind remembered.

So now the "baby dreams" start emerging. One showed me tenderly kissing the delicate ear and skin and neck of a full blown gorgeous baby, reminding me of the intimate tenderness I share with my husband, when we make love through either actual sex or through the sensual expressions and connections of our dance of Argentine tango.

Then there was the baby dream where I had somehow managed to deposit the beautiful golden looking baby in a top dresser draw, where it was mixed in with all kinds of unsorted out clothing that was overflowing. In this dream I seemed to be trying to put the baby away for a while, being too overwhelmed to care for it, although I was careful not to close the draw and suffocate it.

How come, I had to ask myself, these dreams started to prevail in the voyage from my unconscious to my conscious mind at the very same moment as I was becoming overwhelmed by my haunting awareness of the bleach stains made by Alicia on my green office carpet? The scars of these stains were like the scars of my remembrances of Alicia, which forced me to wonder what she had indeed been to me, during our era of togetherness, when she had lived so much in my office. Now seeing or imagining the stains of bleach like scars under the rug and on top of the green carpet, erupted in my mind as the baby dreams emerged. Consequently, I was forced to think back to my 20s and 30s, years when I did expect to become the mother of a real "baby." I had put off the actuality for years, but then in my early 40s I was faced with the powerfully ambivalent prospect of an actual pregnancy. The miracle that had provoked both ecstasy and terror in me had lasted just 10 short weeks. Then suddenly, it was over, as the Obstetrician announced that he had lost the baby's heart beat on the natal sonogram screen monitor. What had all those extra vitamins been for? Suddenly I was to go to the hospital to have a D&C for a miscarriage, and I was running down the block until my husband caught me and held me tight, so I could begin to cry it all out in his arms. "Do not blame yourself," he kept repeating as I stammered out that I probably shouldn't have been lifting things for a move from one apartment to another when I was pregnant. The doctor just reassured that I had gotten pregnant so quickly, so I was sure to get pregnant again. But it never happened, and I drew the line at fertility drugs and IVF. I had books to write anyway! They were the babies I knew how to produce.

So the baby idea was put away in a mental drawer in my unconscious mind. However, drawers can be re-opened, and now it seems the unconscious drawer was opening and presenting the potential baby of the past to me at the same time as memories of Alicia, and a potential book she had promised to offer me material for, which was aborted by another

44

miscarriage, Alicia's refusal to release all the information she had promised me in discussions and interviews.

What was this all about? Was Alicia some substitute for the actual biological baby I never had, the one that precipitously said "good-bye" and aborted me, and my connection with it, through its miscarrying in my body? Oh how I had forgotten all those fantasies I had had early in my relationship with her of bringing her, like a special daughter, on vacation with me! I had forgotten fantasies before trips to Florida, when I imagined bringing her with me, and watching her play like a child on the beach. She also was the one I gave used clothes to, which I thought would match her personality. What was this need in me to give her presents, even on Christmas, when I was Jewish?

Sister?

And what else was she to me? Could she also have been some symbolic substitute for a sister, when my actual sister and I had only the most superficial connection and bond? Was my emotional connection with her, which appeared torrential at times, but had also, been creative and humorous and rich in emotional sharing have been an avenue to seeking sisterhood? One day after she had sent me a very hostile email, accusing me of many things, I responded that I had seen a movie called, "Under the Same Moon!" It was about a mother and her young son, who had been separated when the mother came as an immigrant to the U.S. The whole movie was about the yearning on both the sides of the mother and her young son for being re-united, in the face of violent arrests and interrogations of Mexican immigrants. I cried in that movie, thinking of the warmth that had turned to coldness between me and Alicia, and I told her about it in an email in response to her accusatory attacks. Although she had just totally trashed me, the next thing I knew she had immediately flown to see the movie. Before I knew it, she was writing to me that the acting in that movie was "so natural!" She had loved it, and again there was a bond of shared imagination between us as we both felt the pain of separation, and the longings for re-connection in that movie!

Then one day, after she had stopped living in my office, and had successfully finished college and gotten her degree, Alicia calls me and asks that we see a movie together. It is a movie about former "Burlesque Queens," a documentary. This is the only movie we ever went to together. This was a movie about elder Burlesque Queens, and their memories of being on Vaudeville stages, following the comedian acts. They recalled their competition to come up with some unique gimmick to draw the audiences in and to just keep their jobs, with the glamor of the stage, although some recounted reaching the edge of madness as they perceived

the gyrations of the masturbating men off stage. One seems to have gone to Creedmoor and never come back, being placed on anti-psychotic medication.

After watching the movie together, Alicia recalled the maturing lady with the still red flaming teased hair, who recounted her naïve presumption that somehow this Vaudeville life would continue endlessly, continuing to bring in the bread. She remarked on how she had never thought of saving any cash, and the cash was hardly great, much less than Alicia and her fellow strippers earned at the later strip clubs, and they never bothered to file for taxes. Alicia seemed struck more by the naïve presumption of some infinite eternal youth than by any financial illusion in particular. She had certainly shared in this presumption in her early go-go dance days, when she was first moving from New Jersey clubs where she wore bikini bathing suit tops and bottoms, to topless clubs in the heart of Manhattan. Unlike her friend in New Jersey who saved money through go-go dancing, which she found to much more lucrative in the '70s and '80s than the former Wall Street job she had had, and who managed to save her ten dollars an hour payments, even without tips, to later build and buy houses in the real estate market, Alicia had lived much like the Burlesque Queens in the movie who seemed to have believed that their youthful bodies would endure and bring in the cash forever. As Alicia spoke of this, I recalled the tragic life of Zelda Fitzgerald, who when first living with her husband Scott, after the gold mine explosion of his *Great Gatsby*, imagined herself as the omnipotent and immortal American flapper, who would live on forever basking in wealth and fame and the feminine American dream— young and nubile forever. Later she navigated back and forth between insanity and fundamentalist religion, and ended her life abortively in the flames of a fatal fire that overcame the mental hospital institution in which she came to reside, when Scott tried to convert his intuitive skills at novels into Hollywood's movie screenwriting mode, which he could never master.

Alicia related to the aging Burlesque Queens recall of youthful financial naiveté. She too, when feeling like a queen on the strip club stage, had believed that her body would be forever tantalizing enough to bring guys towards her who would finance her. She too had never thought of saving a cent! In fact she had given away tons of cash to whatever man she had dated, after meeting them in the strip clubs. She gave one guy, who was hooked on cocaine, nightly infusions of cash when he couldn't extract any more from his father's business and bank accounts.

This left Alicia bereft, short of funds later on. So she came to often rely on me to pay her rent when her Landlord was suddenly breathing down her neck, trying to evict her. Sometimes Alicia couldn't pay me back. So she offered me vivid tales of her stripper club days in lieu of cash or check. I was supposedly going to be able to cash in on her tales by writing a book

chapter or even a book. But this was an offer she later reneged on—even after I gave her several thousand dollars in addition to the times I had paid her rent.

What kind of a sister was this? Ultimately, Alicia became as "not there" for me as my real sister. I had also become "not there" for her.

But each night at Lafayette Grill, I danced out all these frustrations, extending my evenings there from Saturday to Monday, Tuesday, and Wednesday. I studied tango, and socialized in the tango world. My husband and I would dance there each night after I finished my many day and evening hours of seeing patients. We would also dance with others, as we continued to build our technique and repertoire in tango. We absorbed the tango world and the tango world community, the whole atmosphere. We dined in that world, mostly at Lafayette Grill.

Last night was a Saturday night at the Grill. It was Halloween night, after a Halloween party the night before. There was a costume contest. I wore my red witch's hat, and made up for the lack of a full costume by dressing in a black velvet dress, and adding a dance walk with a swagger that I think any ex-stripper would have been proud of.

Later in the evening, as the music continued and I danced salsa, I was able to let down from the incredible stresses of that day. I breathed in the Saturday night Lafayette Grill atmosphere. Just hours before, I had felt imploded with the internal upset that because of critical and urgent emails about mishaps in the psychoanalytic institute that I founded. I thought one faculty member, now writing back to me from out of the country, had failed to be there for a class, and had left the students waiting on his office doorstep. Then there was the phone call from one of the main discussants at our next institute conference, who seemed to think that a conference program in February of next year was happening this year, a week after Halloween. My body absorbed the tensions and shocks of each email or phone call, as I clinched at the little blackberry phone, on which I carried on a world of business, to text out mildly alarmed, and hardly contained responses to my colleagues, hoping to save the day for the institute and for the students.

Due to these urgent SOS alarms that I psychically ingested from our modern technology, it was almost 11 pm when my husband and I reached Lafayette this Saturday night. Yet the moment we entered the door the tension that gripped me from within to the top of my throat and neck, nearing the level of stifling asphyxiation, began to ebb a little, and I could feel the evening's transformation begin. The minute we entered the door, I felt the hugs, kisses, and acknowledgments of all the other witches and goblins dressed for the Halloween evening. Then I began to dance. Then I began to breathe. I heard and felt and heard the music, as I felt the familiar containing, sensual warmth of the tango embrace. Then we ate and watched

a tango performance by a top tango couple just up from Buenos Aires—people I'd met and danced with many times before in lessons and *milongas* at Lafayette Grill. As the evening unfolded many familiar faces and bodies greeted me. The regulars, of whom we were one special couple, had their places at their tables and on the dance floor. One of these couples, George and Betty, had just won the Halloween costume competition, George as a clown, and Betty as a sexy Rocket. Others came in and the floor filled, but as the evening continued more space opened on the floor for us to experiment as we danced. My young tango doctor friend, who came with the young tango attorney wife he had just married, greeted me after he took a woman new to tango onto the floor to show her what it was all about. He had said he wanted to dance with me later. He danced with another experienced tango dancer, but now he was dancing with this other woman, graciously introducing her to our shared world of Argentine tango. Eventually, after I danced salsa and several more tangos and *milongas*, the young doctor did ask me to dance a *tanda* (set) of four dances. I closed my eyes, totally relaxing now as I felt the familiar well-balanced tango embrace of this man. With my eyes closed, I could sense the clear, vivid, lead of this man's body, and I could breathe in the tango music, further relaxing the soul that lay inside of my overtaxed body, relaxing my mind as well. In between dances we might talk, but I also looked around and felt the warmth and happy gaiety of this crowd that I knew so well, along with some strangers eager to view us in this special world.

I saw the guy who twisted Lois into a pretzel doing his usual show on the floor, while we others strained to follow the line of dance. I saw others who knew me, who I often danced with, and the women I often shared conversation with. I felt mildly enveloped and didn't ever want to leave as early as my husband might want to. This was our typical Saturday night, for years now. This was the place I unburdened myself, especially with the peppy *milongas*. I could always feel renewed here. This was a strange but familiar family that had become more of a family for me and my husband than any other we had known. This was the place where I could detoxify myself from the painful and poignant memories of Alicia and her parallel universe in the world of modern day strip clubs, even as she now was entering graduate school training after I had helped her to get through the undergrad struggle that had taken for her many years. Here at Lafayette Grill I could renew my sense of creative inspiration, hoping that the miscarriage of any baby or book would soon be replaced by a new creative venture that could reach fulfillment, just as I could feel fulfilled as my body flowed with the tango connection. My marriage connection was here. My social connections were here. My birthday connections were here as we all had our birthday dances in this restaurant's environment. And now even my psychoanalytic institute's conferences took place here, as I

integrated Argentine tango connection and dance with the mind's integration through psychoanalysis within this world of tango. The scars under and on the carpet could begin to fade as I felt the flow of life that reached its ebb and flow each night, and particularly Saturday night, at this location of celebration, at Lafayette Grill.

ESSAY # 7
MARRIAGES, PARTNERS, and BOUNDARIES

Sometimes partnerships in the Argentine tango world really work! When I first started taking Argentine tango lessons with a man who had a passion for Argentine tango and for his Argentinian Argentine tango partner, I began to witness an amazing example of how a tango relationship can reach the heights of creative and interpersonal ecstasy, while still remaining within professional boundaries, just as a psychoanalyst and her/his analysand patient experience the heights and depths of emotional intensity while still maintaining very vivid boundaries. Of course in psychoanalysis we don't touch each other, and in tango we do! But in tango just like in psychoanalysis, there is a frame around two individuals. In psychoanalysis the frame comes from the session time being specific and consistently kept, and from the physical space kept between the analyst and patient, either with the analyst patient in two chairs spaced apart, or more frequently with the patient lying on the proverbial couch, with the analyst sitting behind.

In Argentine tango, we touch, but we hold each other in a frame with our arms, and upper parts of our bodies, while we do all kinds of things with our legs underneath, as we dissociate upper and lower parts of the body at the waist. We are both contained and coordinated with each other. Each person in the partnership, which may last for a three minute dance, a *tanda*, or for an ongoing working relationship with dancing, performances, teaching, or just learning together, is in the frame of dance, and in the outward line of dance, when in a social setting. In this way each tango dancer maintains a steady spatial relatedness with the partner, which contains all kinds of emotions as they emerge in the moment through the improvisational – and always surprising – constellation of the dance that gives vivid personality to the music that creates it.

But there is more! As my tango teacher told me, Argentine tango is a celebration of the voluptuousness of the female body. He saw his role as both interactive with his partner, and as facilitating the lithe and sensual tango movements and embellishments of his female tango partner. But he also saw himself and his partner becoming like one, sometimes breathing together as they navigated through the powerful emotional and physical connection that they formed through the lead of the music. The intimacy in Argentine tango can be quite profound. I both shared in it from the inside, with my partners, and also viewed it from the outside as I watched my teacher and his Argentine female partner.

I also watched the lives of these two people develop in their own spheres and in their discourses with the "outside" life partners, as they lived together in the inner sphere of the tango dance and the tango world com-

munity. Unlike the couple I described in an earlier chapter whose boundaries broke apart when the tango partnership of the husband changed during his wife's pregnancies, the partnership of my tango teacher remained intact as long as their internal tango world romance served a mutually beneficial professional function. Whatever grief, anxiety, or despair they suffered during the course of their professional relationship they were able to continue their partnership as a supportive friendship, speaking to each other about their individual problems both outside and inside the tango world. They were also able to top it all with a shared sense of humor and playfulness that kept them engaged with each other in a safe and boundary circumscribed way. My teacher and his female partner navigated through the terrain of all their outside social and marital commitments to preserve the brilliant tango passion that could take place in the improvisational moment of Argentine tango.

One photographed moment stands out when I think about my Israel tango teacher and his partner. It seemed to be in the middle of an instinctively chartered *molinete* pattern, where the woman dances around the man, at a steady measured distance from him, keeping the embrace above, but dancing forward, side, and back, over and over until he stops the *molinete* pattern with his lead. My teacher's lady, who I will call Liliana, was enveloped with the flood of hot and passionate tango energy as she looked straight at her male partner in this picture. He in turn seemed to gaze passionately into her eyes as well as they synchronized all of their body motions with each other through the creative flow of the music. Her skirt came up high, showing the outline of her voluptuous legs, and her dress swirled around her. My tango teacher seemed to be experiencing the height of masculine virile power as he led his partner around in the *molinete* circles with such precision and such incision inside of the music. This is a picture of the perfect moment of tango couple passion that I will never forget! It certainly felt like watching a love affair when I looked on at this moment in this picture, but it was a love affair with clear boundaries that invigorated the passion itself, as the boundaries acted as the necessary constraints to play out the most erotic and yet sublimated of male-female relations.

Marriages

My tango teacher was married all this time to another professional dancer, but not one who specialized in tango or lived in the world of tango. She was mainly a swing dancer and teacher, with some salsa thrown in as well. She performed, taught, and worked in dance studios just as her husband did. Throughout the course of my teacher's relationship with his partner Liliana, who had taught him most of his technique in Argentine

tango, as well as dancing and performing with him—his wife, who I will call Linda, was extremely supportive of his tango relationship with Liliana. My husband often remarked on the degree of her support of Larry and Lillian's relationship. She would come to their performances and applaud widely, telling everyone around her about how great they were! Her support and enthusiasm were consistent to the end. The end came when she and her husband had a baby, who was growing to two years old in New York. Then Linda wanted to return to their home abroad, where all her relatives, her husband's relatives, and now her little girl's relatives were.

While this was developing in Larry's life, his partner Liliana was going through her own life transformations. She had been in and out of major Broadway tango shows, and was performing whenever she could. She was always teaching, but would much rather be performing all the time. Having been a single woman when she first taught Larry and then became his professional tango dance partner, Liliana was also dating. Liliana had left one boyfriend, even after living with him, perhaps because he was suggesting marriage and children when she was still dreaming of more performances and traveling all around the world. But then, the next dating relationship reached serious dimensions. This new guy wasn't in the theatre or performance world at all. He was an attorney who could support her and a gaggle of children if she should choose to have children. Suddenly she was pregnant, a rather challenging condition for a dancer and performer.

One day she looked ill at the dance studio where she danced, and was running into the bathroom to throw up, it seemed. Nobody knew what was going on yet. Nobody knew anything about her outside of the studio personal relationship. Certainly nobody knew she was pregnant. But as the pounds Liliana put on became visible the story of her life outside the dance studio, and outside her fantasy marriage to her tango partner within the Argentine tango dance and performance world became visible. We now were forced to see her belly as an intrusive sign saying to all of us: "No. She, and her dance partner Larry were not a couple in the outside world." They existed only in our imaginations as a fantasy dance marriage. Without knowing anything of the facts or specifics of who made her pregnant (and I imagined she was staying single with her baby), we all began to see Liliana's life become a fact before us. She was going to be a mother, and her students could no longer imagine themselves her children, and her male partner had to see the evidence of her relationship with another man outside every day as they continued to dance. Liliana danced and taught until the tail end of her pregnancy, when she was quite expanded around her middle. She later thanked Larry, at his "Going Away" party as he, his wife, and daughter left for their native country, for "putting up with her when she had become so heavy, both emotionally and physically during this period.

The baby shower for Liliana

The whole dance studio circulated that day around the two male dance students' preparations for a special baby shower, a party for Liliana. Everyone was excited and during the party extremely moved as Liliana opened presents, one after another, with baby toys, but also with gorgeous slinky short negligees. Up until this time nobody knew who the father of the baby actually was. Streamers coming down from the ceiling, balloons, and all kinds of cakes and cookies surrounded us, as we watched the star "princess" of the day, or rather the "queen," who the men were all the more willing to bow down to on this day, open her presents. When she opened the negligees everyone giggled, and guffawed and applauded. But most prominent in the audience was Liliana's partner, my male dance teacher, Larry, who was in awe and rapture and filled with voyeuristic humor as he demonstrated his tantalization for the guest of honor for all to see.

He cried out with other men for Liliana to put on the negligee right there and then, obviously delighted at the fantasy of seeing her seminude, after having sharing all the emotional passions in their very intimate tango connection. His open jokes and voyeuristic indulgences, as he worshipped her, along with many others, was certainly proof enough to the rest of us that he and Liliana had never actually seen each other naked. Obviously, they had never succumbed to relinquishing their boundaries.

ESSAY #8
MY LEGS

I took my legs for granted until graduate school. Even as a dancer and then exploring dance therapy, I wasn't particularly aware of being noticed for my legs, as opposed to for my breasts or whole well-proportioned feminine body, and sometimes even for my brain. Then one day in what was supposed to be a class in a doctoral program in graduate school, the atmosphere was suddenly turned into that of a then very faddish 1970s encounter group. The transformation was led by the professor of the class who also was known for having his own practice in psychoanalysis. But in those days all psychoanalysts and therapists were including groups in their work. Therapeutic groups had become more than a fad as the 1960s revolutionary spirit hung over the 1970s, and the "encounter group" zeitgeist hung over all of them. Enactment, particularly of aggression, became the norm as encounter groups flourished. No boundaries, limits, manners, or diplomacy was allowed in these groups. You were supposed to "tell it like it is." "Shooting straight from the hip" was considered "hip!" The hippie era was still with us, and the flower children had turned the corner from peace and love to starving vagrants on the street who had no patience for anything but the most immediate jargon and jive! In the encounter group everyone was supposed to express the most uncivilized thoughts as quickly and immediately as possible towards whom ever in the group happened to be the subject of those thoughts. There was no thought of using such reactions to understand transference projections or psychological dynamics of any kind. The linguistic currency of impulse was to exist in its most raw form, being then taken to be the absolute unadulterated "truth." Typically the most gut wrenching levels of hatred were freely expressed and promptly applauded within the group. Why this zeitgeist should emerge so dramatically in the Ivy covered walls of academia was still a mystery to me, as I was so at my comfort level when only academic papers, dissertations, essays on tests, and class discussions were required. Contrary to this supposed academic contract was the encounter group atmosphere in a group class that had suddenly took a turn towards me one day. Before I knew it some blond female classmate of mine was screaming at me: "You think there's nothing sexual about how you act!" The other voices of attack and accusation remain only in volume in my mind without any verbal distinctions or differentiated lyrics.

I just felt the general assaultive impact that made me internally cringe, and later ran in the bathroom to cry! The teacher of the class, who was the designated group leader, had nothing to say in my defense. On the contrary, he warned me that if I didn't get angry at the class mob that had

arisen with me as the "it," I would create guilt in my classmates and make everyone uncomfortable!

But even that group assault was not actually led by the professor who was the teacher of the class. Today I was in another class with another professor who like the former group leader, was supposed to have his own part time clinical practice on the side. I had no sense of where the class was headed on this day. We had been talking about a new crisis clinic that had been established with students in several graduate programs manning it, including myself. Then before I could make out what the nature of the class format was that day, or for that matter, what the nature of this class was altogether, the professor began going around the room with his "shooting from the hip" comments about the students in the class. I don't remember what he said to anyone else, but when his intent and penetrating stare landed on me he volunteered an observation that he apparently thought was an encapsulation of my entire character and personality: "I wonder if you know that they call you "the legs!" I didn't say anything, but I assumed by "They" he meant the entire graduate school faculty. Then to add some more insult to what to me was injury, but what to him seemed to be the most benevolent gift of honesty and straightforward communication, he continued: "By wearing dark, rather than flesh colored, stockings you keep the mystery of your legs hidden, rather than coming out in the open. You make everyone feel teased."

He seemed to be declaring to the entire graduate school class that I was a "tease!" I didn't say anything. I was in shock. Nevertheless, I was simultaneously contemplating that I actually wore black tights, which went along with the world of dance therapy I lived in outside the academic Ivy walls. There I wore tights with leotards and skirts over the leotards to participate in experiential dance therapy classes with one of the pioneers in the world of dance therapy. I wore the tights with leotards and skirts to be free to move fully when given psychological themes for improvisational movement that could express the deepest feelings and emotions, the deepest desires, fears, and longings, and conflicts. In group dance therapy classes we each did our personal improvisations, without the intrusion of music, since we were supposed to move totally from the music inside of us. We each moved in our own improvisations on the large wooden studio floor until the time was up. Then we came together to share what we each individually experienced in our improvisations. In private dance therapy sessions I did the improvisations to my own concerns about myself and my life as they came up. The aging dance therapist, with a life time of experience, would then listen to me speak about what I experienced in each improvisation. She would often make interpretations, but when my improvisations began to include her as the subject, she would evade the transference (which she declared she didn't work with) by saying, "Do an

improvisation on your mother!" Eventually I had to leave her to go to a psychoanalyst who would work with my transference. Naturally, I had t leave this psychoanalyst, and go to another, who could sustain his objectivity.

My Legs in My Analyst's Countertransference

Many years into long term intensive (3 times a week) psycho-analysis, a sudden countertransference enactment from my male analyst made me all too aware of my legs again. This came after many of my patients had remarked with awe or admiration on my legs, or in some cases had remarked with disapproval about my short skirts that allowed my legs to be clearly featured and viewed. More often the comments were from women than men. Sometimes there were Lesbian attractions or bi-sexual ones involved. Sometimes there was envy or identification involved. One woman spoke of my "gorgeous gams!" Another spoke of the sense of pride she took in identifying with my body and dress as she compared me to the other "dreary and drab" therapists who dressed in suited uniforms. She said, "You dress in really bright colors (unlike most New Yorker) and you're not afraid to show your legs!"

So my legs were often the topic of conversation in the clinical consulting room, but this did not prepare me for what was to come next with my own psychoanalyst. One day when I was at a point of alienation with my husband, and felt like he wasn't giving me the attention he had, I said that I tried to challenge his attraction by demanding he comment on my legs. Obviously being somewhat detached due to an anger that was yet to be expressed, he said only half-heartedly in response that my demand that my legs were "nice!"

I became quite insulted and went into my next analytic session and reported this to my analyst. Unlike my husband at that point, my male analyst was giving me plenty of attention! Suddenly, any lingering note of objectivity or neutrality went out the window as my analyst practically leapt across the room as he passionately declared, and angrily towards my husband, "Your legs aren't nice Cindy, they're GORGEOUS!" (I Felt the "g" in gorgeous at this moment as a monstrous capitol "G.") Before I knew it, and this is really hard to believe for any reader I am sure, my analyst was declaring that he felt like kissing my feet! Although I think he was sitting in a chair I remember this moment as if he was actually crouching down on the ground next to my legs and feet, as if he were about to actually kiss my feet! I said that my husband didn't like the idea of kissing my feet. My analyst responded that that was tough on him that he couldn't enjoy the rapture of such a wish and inspiration.

However, as my analyst's passion cooled and turned into a rejecting hatred, I made some self-deprecating comments about my legs that seemed to capture my own sense of being spoiled, used, or unwanted goods. I told my analyst that I sometimes wished I could substitute my legs for my face, since I didn't like my face anymore. I also told him, in the course of telling him that I believed in past and future lives, that I feared that in my next life I might not have such great looking legs! He said I was seeing my next life as a punishment. Perhaps true, but it was a fantasy of a very particular type of punishment.

My Legs in the Argentine Tango World and at Lafayette Grill

In the last 12 years of dancing Argentine Tango my legs have often become the subject of both male and female attention. Despite the rather hostile associations I have just written about in relation to those commenting on my legs, I have sustained and continue to sustain a favorable view of my legs, and a pleasurable enjoyment of admiring comments about my legs.

However, in the case of Max my pleasurable response became somewhat contaminated by the "over the top" attraction. Max was admiring in every way as he became more proficient in Argentine tango and began to dance with me at Lafayette Grill. He admired my looks in general and also my mind, as he bought all my books, and actually attempted to read them. He wanted to buy dinner for me at Lafayette Grill while we danced and offered to drive me home or to my office when my husband wasn't there. I enjoyed the shrimp cocktails along with my latte's that I accepted for a while, but if I allowed Max to drive me home he had the unpleasant habit of trying to actually touch my legs! I found this annoying. I felt like he was an annoying pest, as I said "Stop touching me! You can look but not touch!" He would say, "But your legs are so beautiful! Nobody has legs like you! Sometimes he'd say "Nobody has those "things" like you," pointing at my legs. And then he'd try to touch my head, saying "And your mind! What an imagination! How do you think up all that stuff?"

I decided to stop accepting Max's dinner invitations or rides home anymore, although I occasionally still danced with him. He had a very good sense of rhythm for *milongas* in particular. But when his admiration became extreme adulation for my legs I'd just walk away.

Other men were a little more polite if not subtle. After a performance I did with a male Argentine tango teacher at a professional conference, one male professional colleague came up to me and said, "I hope you're not offended Cindy, but you really have fantastic legs!" He had earlier complimented me on a professional paper, but I must say the earlier

commentary didn't reach this level of enthusiasm! The funny thing is that I got much more of a thrill from his comments on my legs than from those on my theoretical and clinical paper.

The male tango teacher I had performed with also had made a few "leg" comments in the rehearsal private lessons I took with him before the performance. He said that he wanted to teach me embellishment steps that would accentuate my legs, and that I should really extend and develop the height of these embellishments because not all his female students had the kind of legs I had.

The Women

Although a multitude of men might comment on my legs, it really has been the women making such compliments that most stand out in my mind, and perhaps they have even outnumbered the men. First, there are the women who don't do Argentine Tango that have commented on my legs at parties. If they see me perform tango they often comment to each other, "She really has the legs for tango!," or directly to me, "You really have the legs for tango!," sometimes perhaps implying that they don't think they do, which can feel a little uncomfortable. During one anniversary party performance I did with my husband one woman looked over at me afterwards, saying "You really have the legs for tango," and I whispered to our mutual female friend, "I thought she was going to comment on the connection I had in the dance with my husband, but she's speaking about my legs!"

But then there are the women who are Argentine Tango dancers themselves who have commented, and their comments stand out because they are often skilled Argentine tango dancers and performers. One top female Argentine tango performer (who is Argentinian and who danced with the great Carlos Copes for a while, as well as generally performing all over the world and in New York) had comments that have left their etchings in my mind.

In the past she had complimented my actual dancing, which meant a lot to me coming from her. She also always thanked me for supporting her culture by dancing Argentine tango so well and so often. She saw me constantly at Lafayette Grill whenever she came there to dance or perform. She said that I danced like a real Argentinian, and she asked me to tell her by email whenever I did a performance, so she could come. I replied that I'm not a professional dancer and only performed at my parties and annual conferences that I had at Lafayette Grill. But then one day, after she was sitting at a table at Lafayette Grill and apparently was watching me as I danced, probably with my husband, but perhaps with others as well, she said to me, "Cindy, you have such a great body! And legs!" When I showed

her some pictures of a performance I did at a conference with my male professional tango teacher friend, she said, after viewing one picture in which my legs came way up, in parallel with my male partner's, as he led me in a step that brought both of our legs up high in front of us, she exclaimed with great vehemence, "Cindy, your legs should be in Reportango Magazine! You should send the pictures to the editor!"

There were also many comments from female amateur Argentine tango dancers that I knew well, who might happen to notice me dancing on any particular night at Lafayette Grill, sometimes wearing designer dresses that might stand out that night. As I was leaving and saying "good-bye" two such women said how great I looked dancing in that dress, and "your legs really looked great!" But then there was the ultimate compliment from a young 25 year old Argentine tango dancer, who I envied for her age and early skill in Argentine tango, and for her frequent dancing with a young male tango teacher who I had so enjoyed dancing with. She was also a performer of Argentine tango music songs, singing in a band with this male tango teacher. One day, she told me that she would like to design and make a dress for me, a dress that featured my legs and my jewelry. She said, "I was just standing there looking at them," meaning my legs! She continued, "You have the best set of legs in the whole Argentine tango world."

What more is there to say?

ESSAY # 9
BEING PRESENT or NOT:
the PHENOMENA of CONNECTION
or INTERNAL DEMON LOVER INTRUSION

Wednesday nights at Lafayette Grill interact with Mondays, Tuesdays, and of course Saturdays in my mind, as each of these nights has a Lafayette Grill milling, expanding out of the original Saturday night format. When I walk into this week's Wednesday night *milonga*, I listen as the DJ plays CD tango music with Yiddish *cortinas* evolving in between. This will lead into Chanukah latkes celebrations and performances with a guy and a woman dressed as two Hasidic Jewish men as they spring into swing steps following a rendition of Jewish orthodox praying (davening). The two performers kiss their little prayer books, pocket them, and then join together and do all kinds of varying swing movements to Yiddish Chanukah music. Then we participate in singing the Chanukah blessings and lighting the Chanukah candles. I have some potato lotus and join several Argentinian men in partnership in Argentine tango, *milonga*, and waltz tango. There's a brief intervening dance of the boss nova.

I am struck by the happy feeling flowing through me even as I lack a steady partner tonight, because my husband is home, sick with the flu. Feeling the melting pot in our Lafayette Millings makes me happy, but it is much more than this as I find a way of celebrating Chanukah and dancing Argentine tango at the same time in a New York tango community that embraces so many of such various and intermingling backgrounds and varying genre orientations as well.

As I dance I am experiencing various images of men go through my mind, and I wonder how I can do this while I also follow every unanticipated step merely by feeling the embrace and the angle and balance of the man on the floor next to me, leading me. There are always an infinite variety of steps and styles among men and musical variations from a multitude of historic tango music eras. Yet I follow the flow instinctively as an experienced tanguera. I wonder how this has become so easy and effortless. I feel that flow, the merger, that loving connection with the whole flow on the dance floor, as well as with the music and with each man that I join in the tango embrace with my upper body, while I swirl around and through his legs as he guides me with his upper body, and my legs fall where they improvisationally fall. I am struck how this can happen with almost any kind of man, amateur or professional, as long as I feel he knows Argentine tango and can feel the music and create a lead for me, where the connection dominates and the steps flow with it. I blend in with the alternating patterns of *milonga* with a professional tango "maestro" from Argentina. It is thrilling to see how quickly I can grasp the direction and

61

nonverbal cues for varying steps, those which I may certainly have never done before, but which I can feel in the overall attitude of *milonga* and its peppy music. I have done *milonga* long enough over the years to adopt to whatever leads I get, even if I need to let my left foot fly up as my hip turns diagonally up from the floor, and my other foot and leg navigates within the gravity of the floor. I spring off from the floor and also use it to paint designs onto it with my feet when back in the tango music, after *milonga*.

My feelings lead to my own embellishments in between tango music beats, and my interpretation of the music and its sonorous Spanish lyrics (when I know only English) still feel each word from a musical and emotional vantage point, feeling my own passion intermingle with the music.

Today my mind as well as my body embellish my attitude and flow in the dance. My mind can be thinking of another man I am attracted to while I dance with a man who seems more attractive to me tonight than other times. I can do this while still moving with each beat, never missing a beat of the music, and adding my own undulating ornaments in between beats. Occasionally, I might find the lead slightly cryptic, miss a beat, and say "I'm sorry" to my partner, while he responds: "No it was my fault, my lead was off."

But overall the evolution of the dance within the floor of all the dancers at the *milonga* is smooth and fluid, giving life to the music, whether live or with CDs, and giving life to the feeling of being part of a community as all of us tango dancers follow or sustain each beat, follow the lyric or the back rhythm. We do all this while keeping connected through the leadership of the music, which suspends our motion for each three minute tango within a *tanda* and then gives us a clear intermission, both in between dances in a *tanda*, and in between *tanda*s, when we usually separate and go back to our tables or to other partners. Sometimes the end of the CD recording of any one tango is abrupt or slightly unclear and all partners have a slight confusion as they are poised to stop as soon as the music does. When there is a false ending and then an abrupt one, the conversation between us tango couples is often about this confused ending. Then we go on to the next tango or back to our separate tables or spaces at the end of the *tanda*, saying "Thank you" or "Thank you. I enjoyed it." The communal tango flow continues, giving us a sense of family that we all crave, and that recreates itself every night with the new gathering of tango dancers, but which is sustained by our overall sharing of tango passion and our continuing to appear at different *milonga* parties to dance.

It Wasn't Always So: On Not Being Present

It wasn't always so. There was a time when any intrusions in my mind disrupted the tango flow. There was a time when the intrusions could also be great, like obsessions with a demon lover within me that would take over. Now I can even contain such intrusions and continue an accurate flow of the dance, but a sensitive partner will notice when I am not fully present with him in the moment.

There was one Argentine tango teacher I could never fool. He created his own intrusions too, but if I should have any distracting internal thoughts in my mind he could immediately sense it. He would say, "Where are you? You're not here, Cindy!"

There was a time when his words would shake me down and make me painfully conscious that some parasitic other was living as a preoccupation in my mind. It was a former professional partner of mine, a partner in my profession. His provocations and double messages haunted me, and eventually I realized he was provoking guilt and enraging me over his attempts to provoke and control me, just as my mother had throughout my childhood and adolescence, and later years as well.

What could have been in my mind then when my Argentine tango teacher demanded my total presence, attention, and emotional availability? This man lived inside my mind, representing many others. Why wasn't I present with my tango teacher? Unlike many other congenial Argentine tango teachers this man enraged me. He could be snide, snarky, contemptuous and critical just like the mother that lived inside of me. But then there was the other man too that was living inside of my internal world like a parasite haunting me, like a demon lover who had once attracted me, but now only taunted me from within with my own resentments, resentments that could never be resolved and relinquished, as long as this man had a title that gave him power as the partner in the educational institute I ran, an institute which I had founded, but with his help. There seemed to always be some haunting rage in me towards him that was only relieved when I could express it to him, but then his behavior would trigger the same rage again. It could never end as long as he had a title that supposedly gave him equal power with me, when I was doing all the work, and donating all the money now, unlike when we began together. Also there were the double messages that went along with his sexual attraction to me. When he wasn't being hostile and accusatory towards me he was giving out messages that said I was so special, and yet he was actually exploiting me to do all his work for him by maintaining that I was so special, and by telling me how he was offering me so much emotional and well as practical support. If he was really supporting me why did I so continuously feel undermined? Why was he always accusing me of taking

63

away something he felt entitled to? Was he somehow represented in the following dream?

The Dream:

Three young people came to see a male analyst for a therapy appointment. However, they were also coming to see me in my office. Rather than coming for an individual appointment for therapy, they came as a group, or as a family. There were two young women and one man, but the man was totally in shadow, undifferentiated as an individual, and maybe representing many men, with my male partner on the surface, but going back to my first husband when I knew him during my teenage years, and maybe back further to my father, who died when I was ten, because the two women could also have been me and my sister from my original family. But they were also two parts of me, one representing the sensual part of me, and wearing a white coat I had once worn when being courted by my first husband when he was my boyfriend and fiancé. I looked sweet, sensual, young, and virginal. The other women, who could also go back to being a teenage girl, was dressed in black and seemed to represent the angry and aggressive part of me. She was the spokesperson for the group. She was angry that I, or the male analyst, was five minutes late for the appointment. The analyst said that he would give them the five minutes at the end of the session, but even before we left the waiting room to enter his office he was saying that there were only 29 minutes left. The girl dressed in black, who was the angry party of me, or my older sister, got enraged at this, and said we were being cheated. The guy in the shadows didn't say anything, but he was letting the women do all the work for him, communicating for him, while he kind of came along for the ride. Of course, he could have also been ill or incapacitated in some way, but on the surface he was just placing himself in a position to have the two girls or women take care of him, and do all the dirty work for him, all the communicating, especially around anger, rage, and desires. In the version of the dream in which I am the analyst I feel guilty about being strict about the boundaries by saying there are only 29 minutes left. To show some indulgence, and following someone in the Argentine tango world having said I was the coolest psychoanalyst around (in real life), I manage to let my blouse open, a loose blouse, and a bare breast is exposed, probably my left breast. There seems to be a double message here.

As I think about this dream a memory comes back to me. I am ten years old. My father has been ill and dying from kidney cancer in a Veteran's hospital, where he has been staying for an entire year. I am being sneaked into the hospital because children under 13 are not allowed in. I'm sitting in the back seat with my mother and one or two aunts, my father's sisters, and another aunt and her husband are in the front seat. I have to get off my seat and duck down and hide between the back seat and the front ones so the security guards do not see me as our car enters the hospital gates. The next thing I know I'm standing in a hallway in the hospital and someone is wheeling this man who looks like a skeleton towards me in a wheel chair. He smiles at me and wants to speak to me and I am numb, in total shock. I don't remember anything more except that in retrospect I think I must have gone numb, as if fainting, when my expectation of seeing my formerly tall, handsome, dark haired, and solidly built father turns into this nightmare of a skeleton with a thin layer of skin gazing at me and wanting me to respond and speak to him. His eyes seem like two fragile beads glistening like lone spirits, barely in their eye sockets, waiting for their departure to some other light filled place where bodies don't exist. His wanting me to respond is killing me. Years later I wake up half between sleep and waking, and my whole body feels paralyzed.

I am trying to cry for help, trying to scream, but the word for help is stifled in my mouth and jaw as it cannot come out into the outside world. I am screaming and screaming inside of me, but nothing is coming out to the outside world. My jaw is locked, like Sylvia Plath's tongue trapped in her jaw, stuck in the snare of a barbed wire snare, as she said "ich ich ich," and couldn't speak, in her "Daddy" poem in her *Ariel* book of poems that she wrote before her suicide. I am screaming, screeching, crying for help, but all is stifled by my body paralysis and my mouth and jaw being locked, so the words on my tongue cannot come out. Half between waking and sleeping I am in a purgatory of a moment that seems like an infinite time of endless torture and torment. The chief torment is having self-expression totally denied to me, and even my body, which I have tried to dance out my feelings with, when I couldn't speak and never was allowed to speak my feelings to anyone who could hear them, is paralyzed and blocked from any self-expression. I was only supposed to be loved as the cute little girl without a substantial voice, all words that might come out of me having been threatening to others, particularly to my mother and sister, who also could be the two women/girls in this dream.

I remember two times in my twenties when this body paralysis took place half between waking and sleeping, when the words inside of me, formed on my lips, crying for help, could not escape the snare of the paralyzed body trap. One memory is linked with a man, an Indian man from Trinidad who had been my boyfriend and lover for two years, after we

had met dancing in the Calypso Carnival in Trinidad; after dancing in the streets with all the carnival floats, crowds, costumes and steel drums, at the point, after a week of socializing, when we both suddenly ignited with the feeling of being in love. He now called himself my fiancé, but I was terrified of the ending, which both of us unconsciously, if not consciously, knew was coming. It was in New York, where he stayed with me at my apartment, when there were strikes in Trinidad and he closed down the law practice he had as a British educated Solicitor, for a few months. We had traveled to Italy, Greece, Crete, and England together. We had danced in the streets just like in all my fantasies, because this guy had grown up with Trinidad calypso dancing, as well as the other social dancing stuff like merengue, and was a lithe, sensual and fabulous dancer. I had been dancing more than ever in my life then, training to be a dance therapist, but also just dancing as much as possible so that Trinidad with its carnivals had become a great magnet for me to have a romance based on dancing.

But Italy had also been my dream, and this young Indian British attorney, 8 years older than I, had joined me in revisiting some of the most erotically aesthetic places in Italy, including Florence, or Firenze, where I had lived and studied when I had been just eighteen. We had danced in the streets of Venice, with the famous canals and gondoliers all around. We had spent an evening kissing inside a gondolier when the moon was so gorgeously full against a black Venetian night time sky. We had dined in the finest of restaurants and danced once more. One American woman who befriended me in Venice exclaimed about how my Indian boyfriend ran across some piazza in Venice—possibly the main vast one near the Venetian Gothic Cathedral that was merged with middle eastern Byzantine, Constantinople-like designs on its mosaic murals—to find me and had opened up to such ecstatic excitement in viewing me begin to come towards him. Then in Crete and in London we had made such passionate love, but I began to feel the demise of hope for enduring passion in London as we headed back to the states. It was absolutely for sure that my boyfriend or fiancé could not practice law in New York or the U.S., having been trained only in British law. In London, where he could practice, and where he had hoped to return, if he could entrust his "gold mine" of a practice in Trinidad to a brother of his, we shared some fragile gossamer of a fantasy that we would go to live there together. We had already contemplated living in Florence, which was always my dream, although my Italian was far from fluent. During the daytime in Florence, when Indal had on his business-like attorney air, he had begun to look at the Italian stucco dwellings and villas, even like the one I had taken classes in through Syracuse University, as real estate, real estate that he might invest in so we could live in Italy together.

He said to me, "I've been thinking about buying a building here so we could try living here for a while." I immediately wanted to share in the

66

fantasy, totally ignoring who I was in reality as a professional person in New York. The fact that I could be in Europe at all with him was due to my working in a hospital as a dance therapist, and not yet having any practice of my own to cultivate. But by the time we got to London, Indal was thinking more about returning there in England to live, and I was more desperately fantasizing now of living in London with him. I remember one night of several periods of love making when I tried to enter the belief that I could just pick up and move to London with him, as if I could assume by some miracle things would work out between us. I had even imagined living with him in Trinidad, thinking of totally surrendering any hopes of being a professional woman, neither in New York, nor in London. I tried to imagine totally inhabiting the feminine side of myself and having babies in a tropical atmosphere. But the terror of any kind of actuality made reality crash down on me like a not so Byzantine, Venetian, Florentine, or gothic, ton of American bricks.

Why, I had to ask myself, was I always trying to live in some far out fantasy that I could never imagine existing in the world of reality? That night in London that I remember, after the daytime world of museums and the Egyptian Tutankhamun exhibit at the British museum, I was gaining momentum for sexual and erotic passion from a powerful sense of gut wrenching desperation and perennial longing.

Then back in New York, after making love again, but then feeling like the bottom was dropping out of everything between us, I woke with Indal beside me, in that half-awake psychic situation where my body felt paralyzed from top to toe, and the cries for "help" could not penetrate the barrier of my psychically rigid paralyzed jaw to emerge outside into the world of outside reality where others existed. I felt sealed off from all the others outside of me, and Indal, next to me, seemed like some figure of Carnival costume fantasy that I had totally contrived to give me companionship, while I felt so alienated from others in the world whom I was totally unable to speak to and communicate to. Then at that moment, the memory of my father being wheeled towards me in the hospital sprung up into vivid Technicolor film imagery before me! I began to connect in my mind that memory of the threatening ghost-like apparition of my father, far more feeble and vulnerable than Hamlet's ghost, coming towards me with the immediate and inarticulate sense of terror that was gripping me in its teeth at the moment. I began to relate the terror in my seemingly paralyzed muscles and jaw, with the inarticulate internal part of me crying for birth into articulation with the memory of the ghastly and otherworldly vision of my father, as he smiled at me through a skeletal frame thinly veiled with skin, crying out though his eyes to me for a response that I was totally incapable of giving him. I began to connect the realization of muscle knots I had found in my upper thighs in dance therapy classes, and which I

had worked out there, with that memory of terror that clutched me now in its Technicolor glory! The Technicolor was actually a vivid gray in the dark and white institutional hospital wall emptiness. But then miraculously there was only some thin golden light that seemed like it was trying to emanate from behind my father's eyes and come towards me.

I felt like extinguishing all consciousness in a faint as I thought of this but suddenly other memories were erupting. I thought back to an outdoors sparkling and breezy summer's day. It was after my visit to see my father in the hospital, my father who had been so demonically or angelically transformed—it was hard to tell which—when my mother suddenly appeared before me at my sleep away camp, where I had gone for eight weeks for three summers now—up in the Adirondacks. She was telling me, or about to tell me something of great import, but I beat her to it, burst out crying and burst into words through my tears, saying "Daddy died!" She said "Yes. He has died." I just kept crying and then she showed me all these packages of gifts that friends had sent me when they heard the news. The next day I was outside the confines of the camp, outside the camp in which my father had been there all along to see me in a camp musical comedy show one night, where I danced and was in the chorus. I had not known he would show up, because he had come to tell me that other summer, while I was eating in the dining room with my bunk mates that he might not be able to come to the show the following night. Just like when hearing of his death yesterday, this summer, I had cried and cried that other summer afternoon when my father had said he might not be able to be there for my show. I had cried and cried nonstop, even after he left, and the counselors were at a loss as to what to do with me. I had no idea that my grandfather had just died and my father had to go to the funeral the next day. Maybe he had told me, but I hadn't heard if he had told me this fact, which was the culprit of why he might not appear at my show that next evening.

All I remember hearing was that my father might not be at my show, after all the rehearsals and preparations. But the show must go on, so I danced and sang accordingly. It was only after the show, when everyone was applauding that I my eyes found my father among the others seated in the audience applauding. I don't remember if I cried or screamed, but I know I ran up to him afterwards and hugged him fiercely. I was not, however, yet aware of any premonition that he could ever be gone for good. That maybe the next summer he might not come, and instead my mother would come like a messenger conveying the naked news of his irreversible departure from me. How could I have cried so much when he told me he might not come to my show, and only have cried for ten minutes when my mother told me my dad was dead? Where had all the feeling gone, so quickly, so immediately that the next day when I was outside the camp at a

beach by the resort where my mother was staying near camp, playing on the beach and swimming in the lake water, with my mother by my side, I seemed actually happy and content. Where had all the anguish gone? Of course, I didn't know the word "repression" back then, nor had I ever heard of Freud or psychology or psychologists or psychoanalysis or psychotherapy. Like my father's former remission from cancer, so tragically prolonged with the deception of ongoing life before his yearlong tortuous journey into the bowels of death, I was in a temporary emotional remission from all the anguish and pain that would finally emerge through a ghastly like rupture in my twenties, after I left my first husband.

But much prior to that, there were the days of me and my mother, those few years after my father's death, and before I wanted to be outside on the streets with the young guy who I felt enthralled by, who would become eventually my boyfriend and then my first husband. These were the few years after my father's death when my six and a half year old older sister was already away at her Ivy League college, leaving me uniquely alone in a new and larger apartment with my mother. These were the few years when I experienced the warmer side of my mother, which I had felt off and on in my childhood, but which I would lose as soon as I threatened our tight little post tragic death symbiosis by wanting to leave my mother for periods of time to be with the first guy I fell in love with as an early and late teenager. This warmer side of my mother gave me some safety at a time when I ran into my mother's bedroom, from mine, when struck with absolute terror that I would die, or she would die, after my father's death.

All I could see was a black hole at ten years old. Later the black hole would threaten me again when in high school at fourteen, and I feared that my powerful amorous longings for my male crush would not be requited because at that time he was still supposedly still in love with my best girlfriend and I was only then allowed to be a friend. By fifteen this was to change, and by sixteen we were both madly in love and practically engaged, even though I planned to go off to a faraway university and would eventually go to study in Italy and Europe, all places of which he followed me to. But somewhere between fourteen and fifteen my fear of unrequited love brought that same middle of the night black hole terror to me, and at that point I no longer ran into my mother's room for comfort and holding. Instead, I read chemistry books to score well on SAT exams, being also attracted to my handsome male chemistry teacher. By that time, whatever warmth was left in my mother was tempered by her coolness towards my desires to be outside with my teenage crowd that was headed by the guy I longed for.

The temporary symbiosis between my mother and me after my father's death when I was ten had only lasted two years. I had the best of my mother back then. She would make meatballs and spaghetti especially

for me at least once a week for dinner. She would sit down and teach me my junior high homework assignments on memorizing how a car is built with pistons and other mechanical contraptions I can't now remember. She actually had been educated to be a teacher, although her forte was in math, or math and physics, and she could give me the best of herself in that intellectual mode of nurturing, which is probably why I like teaching others now.

But even then, after my mother's rages at me had turned to calling me a "good girl" when my father was first in the hospital dying and she took the time to make homemade blintzes with me tranquilly and quietly helping, and after his death when she held me in the middle of the night in her bed when I saw the endless black hole in my mind coming towards me to vanquish me – even then, there was a darker side to the warm side of my mother. In my twenty-five year old poetry it became a "dark malicious stream" that I believed inhabited me under the persona of a girlish, attractive appearance. By then I had already left one husband, maybe to protect him from me, because I couldn't hide the "dark malicious stream" in me forever, even though we had both preferred to blame all malice on the witch-like image of my mother that we then both shared.

But what was this dark, shadowy side of my mother, the only parent I had left after my father died? How did it crawl around me like a slithering snake with a hidden agenda, or like the actual poisonous Portuguese Man-of-War monster fish that had literally wrapped its tentacles around me during the second year of my romance with my British educated, native Trinidadian boyfriend? All this happened when I returned to Trinidad for another carnival, and promptly got stung by a poisonous fish on a beach. Everyone else had scattered and ran from the beach, somehow aware of the Portuguese Man of War fish heading towards the beach. How had I not seen that pink bubble of the fish above the water that clued others in to the poisonous demon below the water's surface, thinking it was some kind of children's toy? Similarly, how had I not fully comprehended the slithering snake side of my emotionally starved mother that lurked behind her maternal exterior when it revealed itself through her double messages? But I didn't see it all coming. So on that day when my mother suddenly pushed me away from being held by her, and dramatically exclaimed, "What is wrong with you? Why are you talking like that?" I was totally unprepared. It was only she and I then, even before my teenage years with my male crush and our crowd of friends on the street. I was about 10, not long after that summer when she had come to camp to tell me of my father's death. It was just the two of us at home, and probably it was before we had moved to a larger apartment. For months we had been holding each other and hugging a lot. I had responded by trying to become as little as possible to maintain some regressive position in her arms. Perhaps I

thought I would endear myself to her with baby talk. I don't know how many times we had been in this state together, but suddenly she pushed me away, stood up from the chair she had been sitting on, and hysterically screamed at me, "Why are you talking like that? What's wrong with you?" Suddenly the unexpressed, nonverbal rules were being changed on me. Again I was in some kind of shock that couldn't be articulated. I didn't say anything. But I never forgot that moment. Was it some kind of slithering snake in my mother that had transformed her maternal offer to hold me (when I was terrified), or just scared, or just wanting affection, into some kind of enactment of her own in which I became her mother, holding her? I became the mother giving her the affection she had longed for from the mother of her childhood, the one who had turned from symbiotic bliss into the witch of manic depressive reactions to her children's separations, turning from warm to frigid cold as the underlying depression and rage surfaced with each child's departure from her symbiotic arms? What double messages did my mother give me when she seduced me into this constant state of craving for physical holding, just because I had ran to her in the middle of the night when terrified after my father's death? She had craved this comfort of physical holding just as much as me after my father's death, and also because she was not actively mourning, although she claims she had done it all already. She wasn't mourning and she wasn't dating, and would choose not to date or remarry. So wasn't she inadvertently using me to be her maternal other half now, and hadn't she seduced me in the course of her seeking comfort from me as I looked to her for comfort. Who was who here anyway? But it sure became clear: we were not one—and without the gradual ending of the Argentine tango symbiosis when the two partners in tango moving as one separate at the end of each tango lyric—when my mother's hysterical scream and accusation pierced right through me: "What's wrong with you?" Again I had been bamboozled and entangled by my mother's many artful forms of double messages. Supposedly, she had been being a mother to me, naturally comforting me because of my need to be comforted.

Yet, suddenly the tables were turned and I learned without being able to conceptualize it at the time that she was feeding her own need for mothering through me. So when she became aware of my regressed reaction, when she became aware of my accommodating her need to feed herself through me by me acting out the part of a small child speaking baby talk, she was faced with the embarrassing consequence of her unconscious machinations to get her own childhood needs met. So she promptly freaked out and accused me of the terrible wrong doing that was causing her to suffer embarrassment and consciousness, when she would have probably much rather have remained unconscious. I would learn as I grew up and became more conscious of my mother, and who she was, just

how much she operated out of unconscious double messages. So by the time she was aging, and I was an experienced professional woman in the world, I would be quite suspicious when my mother would show me the healthy side of her that claimed to be a sane and rational mother. By that time I knew that her healthy side had only momentary validity and that in any next moment (or moments) things would flip around. My mother's message to me at that time when she was showing me her healthy mother side would need to be re-interpreted by me as a mere seduction into her more slithering snake side, demon lover side, desires to seduce and then exclude, blame, and accuse me.

So in my later adulthood, when she told me that she wanted to get to know me for who I really was, my suspicious antennae started to go up. When she told me she knew my sister for who she was, and would genuinely like to get to know me, my suspicious antenna went up. I could remember then that she had offered me an heirloom lavaliere from her mother as a present, at one time to comfort me, when I was crying from the pain of being divorced after I left my first husband, who had also been my first boyfriend. Afterwards, she had then turned against me by telling me how my sister had a fit when she gave me the gift. My response was to lose the gift by keeping it out in a hotel room when room service came, and someone from room service stole it. My mother could then accuse me in an enraged tone, without any explicit words to make clear what the actual nature of the accusation was, of somehow having betrayed her by letting the gift of the jeweled heirloom lavaliere be stolen! I could again become the source of blame (as always) to accommodate my mother's pathological need to externalize all blame for her loneliness and for whatever miseries her life had brought. So when she told me she really wanted to get to know me by me meeting with her and with her and my sister more often, I was no longer the totally unaware fool. I had certainly learned through a lifetime of double messages from my mother to definitely look a gift horse in the mouth, and to look again and again before responding.

So how did I then repeat being the subject of all the seductions and betrayals with certain unconsciously manipulative others, such as my business partner, who like my mother, offered seductive double messages on a regular basis? Becoming enraged by the constant promises of these double messages and their following betrayals, with my doing seduction and betrayal on my own side, perhaps, as well at times—became a way of life over 15 years of working with this man. So no wonder thoughts of the most current insult or false promise from him should preoccupy me, even during that most intimate encounter of dancing Argentine tango with a male teacher. How could I be present with all of this going on in my mind? How could I be present, when this man kept claiming all he wanted to do is help and support me, and yet any time he had to take on any real responsibilities,

which come with his title of co-director, he had threatened to resign his post..., until one year I really wanted him to resign and leave me free to move things forward without having to deal with all his covert and overt demands for nurturance, love, money, and even sex. As soon as I began to feel that I really wanted this man to leave the titled post that he presumed to keep when usually I was doing all or most of the work, this man, who had continually threatened to resign whenever problems came up with our business, would then turn around, and accuse me of victimizing him by wanting all the power and glory for myself. Despite the fact that the power and glory included me being willing to surrender any salary and to in fact continually contribute money to our nonprofit venture, while my male partner went off with whatever income he had gotten, and kept making my life impossible by demanding more, my partner's final agreement to resign his post came with a huge load of self-righteous and vindictive accusations towards me, that were for the most part said behind my back.

Until the day he resigned I could never be completely present in my Argentine tango lessons. I was always inwardly obsessing in my mind over my so-called partner's latest machination. I felt threatened by having any power I actually had undermined, while my partner constantly claimed to be supporting me. I must have been continuously ensnared by the guilt of being provoked into believing I was victimizing my business partner, and I was also tormented by self-doubt because I must have been, for so long, buying into his pointed message that I couldn't actually operate our business without him. All this was part and parcel of the same victimized double message game of seduction, exploitation, and betrayal that my mother had played. How interesting that my Argentine tango presence, in the moment, improved so radically when my male business partner finally resigned. I also then could move on to a better male tango teacher, and to a much better lifetime of dancing and enjoying the intimacy and celebration of Argentine tango with my husband, which radically improved my marriage over time!

So in that one moment of being discovered by my tango teacher to not be fully present in the tango connection, which always demands full presence to achieve the coordinated harmony with the music, myself, and my Argentine tango partner, I found many levels of conscious and unconscious associations and memories that told the story of a lifetime. In between my Argentine tango teacher partner and myself was a body and mind compromised by an unconscious reliving of the traumas and daily betrayals in my early and late life. Not many people who do Argentine tango may be aware of how a fraction of loss of focus and attention may be symptomatic of a whole internal world of experience, an internal world that is drawing them into an obsessive preoccupation, which can greatly interfere with their tango presence, as it must interfere with their presence

in other endeavors, moments, and relationship connections in their lives, and with connections within themselves to pursue their own artistic and creative purposes in this life on this earth.

ESSAY # 10
NEW YEAR'S EVE and MARRIAGE

The New York City Argentine tango scene has always included big New Year's Eve parties. Up until 2009, going into 2010, these New Year's Eve tango parties had taken place in big dance studios, and each party organizer competed with the others to get as many tango people at their party as possible, announcing their event months in advance. Starting in 2009, Lafayette Grill started to organize their own New Year's Eve parties, which allowed for full dinners for those of us who attended, as opposed to not enough food that was the norm in the dance studios. But it was much more than the food that appealed to those of us who signed up for the pre-registration dinner and party at Lafayette Grill. Part of it was that so many of us knew each other from dancing together at the Grill and in the tango world in general, so that when midnight came and the ball dropped, we felt a real genuine affection in going around kissing each other and saying "Happy New Year!" But that wasn't all of it. Both regulars and *milongueras* that occasionally frequented Lafayette Grill mixed, kissed, and hugged, and blew confetti in each other's faces, along with horn blowing and the whole bit, while also including all the new faces and new feet that had never been in the Grill before in our merry making. However, this was then heightened by trading off tango partners, and dancing Argentine tango proper, the peppier form of *milonga* tango, and waltz tango. Then salsa and swing could be mixed in. As the after midnight celebration escalated, the entertainment also escalated. A professional young female belly dancer entranced us with her long blond curls flying as she harnessed the beat of the music to every motion of her belly and breasts, while using her arms to reach out to us all with undulating motions of scarves and scarves attached to big fans. Even her shoulders did their own isolated movements to accent the beat and symbolic meaning in the music. Her sheer pleasure wrapped around all of us as if the scarves, fans, and arms were actually embracing us, and gathering us all together in one huge Mediterranean hug right in the middle of New York City. As her repertoire continued and expanded, many clapped and moved in unison with each other and the music. Also several men and women were drawn in to dance with the belly dancing lady of the evening, either by direct invitation as she reached out her literal arms to them and brought them from where they stood or sat onto the dance stage, or by sheer ebullient inspiration that emerged within them as they watched her. Several familiar men from the New York tango scene got up to dance and sometimes gyrate along with her. One did salsa like movements to accompany her large and swirling motions, and another did some mixture of tango moves and semi Greek dance moves. The ecstatic screams and hoots followed from their friends and partners. People used their cell

phones as cameras, along with the professional photos being taken, to capture the rapture and ecstasy of the moment.

Then many of us flocked again to the dance floor to dance tangos and *milongas* as more live music by a band of well-known musicians followed. We danced, as the rare bandoneon player spoke to the soul and heart as the bandoneon is known to do. The marvelous lyrical skill of the pianist also vanquished us into the Argentine tango surrender, as the bass player accented the back beat and gave us a sense of time within the midst of the passionate, mournful, and romantic tango lyric. Syncopated rhythms pervaded within us. I danced many *tanda*s with my husband, but he was tired, having worked all that day, and so I was free to also dance with many other men in the tango world that I knew. I kissed some women, as well as men, in between dancers, who I knew, and who wished to celebrate the "Happy New Year" feeling with affection, as well as with our joint champagne toasts at midnight. Suddenly, while with one male partner, I was next to a dear female friend of mine, who was dancing to the live music, the only music she liked to dance to, with her boyfriend. I would dance later with her boyfriend in the warm soup of the tango family mix, but I also felt very close to this female friend, his girlfriend, who had been emailing back and forth with me. When she saw me standing right next to her in between the tango dances within a *tanda*, she exuberantly threw her arms around me, and I reciprocated. Her boyfriend then came and kissed me and said, "Happy New Year!" and I echoed this.

Then we were all treated to the many songs, in sets of threes, by a professional tango singer, who had been visiting and performing in New York. Since I attended Lafayette Grill regularly I had heard her sing many sets of songs in her recent stay, on Wednesday and Saturday nights, and last week at a private tango Christmas party. She had started to feel like a sisterly friend. Whenever she saw me she would come over and kiss and hug me, and declare, "You and I are the real *milongueras* here!" By that I knew she meant she had been seeing me dance tango with many men at many nights of tango, and knew I half lived in the tango world. Tonight she was dressed in particularly elegant long satin tango dresses, changing from one dress to another with each set of songs. This was Friday night New Year's Eve.

The performance wasn't just a performance; it was full with audience participation. This was especially true with the glamorous singer because she always invited us all to dance to the melodic muse offerings of her singing. We brought food from the buffet in the other room back to our tables in between our dances and enjoying the performances. My husband brought me cakes for desert, after the midnight champagne, and he woke up more fully up when the belly dancing female appeared. Yet he was fading as I was growing in engagement with the whole tango scene around me.

Here was potential conflict in our tango marriage, even though we were both so continually enriched by enjoying the tango social world together, along with enjoying the tango dancing and music together.

The "behind the scenes" flame of the conflict began to invade my equilibrium, but not my tango balance when actually dancing. The tension of my husband's angry silence as he got more tired, and as his foot started hurting, began to create a toxic "bad taste" in my mouth. The heat of dancing with so many men, and dancing in so many in the rooms, began to reach a new height as the silent heat of the marital conflict arouse within my body. I always had more energy and wanted to stay longer than my husband. I always wanted to dance more and to engage in the social festivities more. Images of Princess Diana and Prince Charles during the strained years of their marriage began to enter my mind. Princess Diana always wanted to dance all night, while her substantially older, more staid and jaded husband always wanted to cut the evening short. The pumpkin always arrived too soon for this princess, and the pumpkin was threatening to cut my evening short on this special New Year's Eve night.

I was all too much aware of my husband's refusal to dance again, and although for most of the evening he graciously suggested I dance with other men, and I certainly did, his growing silent rage invaded my being as the after midnight portion of the New Year's Eve celebration emerged more fully. I unsuccessfully tried to engage him by pointing out how one guy I had just danced tango with was now dancing with two women at a time during a salsa dance number. My husband snapped back at me that he didn't care, and I then realized that he was in pain, not just tired. As we went from 2 am to 3am I was threatened all the time with deflation and disappointment about not being able to stay since my husband was not enjoying the party any more, and at the same time I was threatened with the guilt of my continual pleading with him to just stay a little longer, just until 3am when they serve continental breakfast. As the threats on both sides of me intensified, and as my husband became more fixed in his idea of leaving, I felt the heat of the conflict that later that night I would feel in my sleep, waking up sweating like hell! I felt for his frustration, and certainly for his pain, and told him to remove his shoe to relax his foot, and so that I could massage it. He complied with the first suggestion, but declined my massage offer. I felt definitely set up to be the "bitch!" and became angry at his now assumed victimized status.

Why couldn't I just enjoy New Year's Eve without having to be placed in the position of being the "bitch" that didn't care about my husband! Suddenly he seemed so old, and I resented having my full of energy body be opposed by a stifling opposition. However with every such thought, the guilt would knock me over my head and persecute me with the same message he was now giving me, which I could only think of myself.

Why did I have to suffer this on New Year's Eve? I looked around me, and a young couple I knew from regular attendance at Saturday night Lafayette Grill *milongas* seemed so alive and happy, sharing the evening as it turned into 3am the next morning. This guy had gotten up to dance with the belly dancer, and his steady girlfriend had hooted and celebrated his exhibitionism with the joy of her hooting and laughing.

Suddenly I felt envious! It wasn't fair. If it wasn't for my husband I would feel just as young as this couple, even if my biological age defied that! I was full of energy and also desire, desire to have the full fling of a tango New Year's night, morning, and maybe dawn! I fought against the feeling of alienation and guilt in relation to my silent and withdrawn husband by getting up and dancing with another man. But even now, while dancing, I couldn't help saying to my partner that my husband was tired, that he had worked the whole day, when I had been able to be off that day and rest and relax before the party. My partner understood. Some of my partners may have been getting tired too. But I was still full of energy, and so many in my presence were at the height of partying. Even though the tango band had retired for the evening, the second DJ of the evening-morning had taken over, and many were still going strong at 3am. Only a few had left! Why should I have to capitulate to my husband's demands? Why of all nights was he encroaching on my celebration with his fatigue? But of course, another part of me felt for him, and did genuinely feel like a bitch for prolonging his agony by staying. So, at 3am, after one look at the pastries that were being served as continental breakfast, I changed from my tango shoes to my boots, and prepared to leave with my husband. I didn't believe it would be right to leave our mutual family restaurant on New Year's Eve night separately, with him leaving first and me after. My conscience was stifling my fun now as much as my husband's angry silence. So we left and the heat of the conflict invaded my sleep. The tango world had been a shared world of fun and social engagement for me and my husband. It had transformed and enriched our marriage, since both of us could share a whole life through dancing. But this conflict of my energy versus his, this was real too, and I felt threatened by an escalation of this conflict as we got older. Still, my love for him won out.

ESSAY # 11
THE CLOSING OUT OF OPPORTUNITIES:
A DREAM (JANUARY 9, 2011)

I was in a huge, large conference rooms with all open seats. Somehow I managed to end up closed out of all the conference room seats by the time the conference was to begin. I associated to last night at Lafayette Grill when Mega got angry at me and said "Why do you think men don't want to dance with you? Everyone knows you're a fantastic dancer." He implied that it was my "rudeness," or my hostile and castrating personality that made men not want to dance with me. I associated to the woman in my therapy group that day who had said: "You're half a man!" to her ex-fiancé who then pulled back from the wedding plans. I associated to my aggressive manner at NIP when I was so enraged in my competitive comments with the "self psychologists" who had taken over the place. Although Mega admitted that there was no actual fact about any man not dancing with me because of my personality, and admitted he just was saying that back to me in anger when he felt I was being rude, I had felt stung, and genuinely became concerned about my own castrating tendencies. My husband said that I had embarrassed Mega by my snapping, raised voice, that which he frequently calls "screaming." Screaming to me would involve much more volume, like my mother's loud screeching screaming demands and criticisms throughout my childhood.

I wanted to play a bit of the prima donna, the 'diva" as someone had called me at Lafayette Grill: "You are the Diva in the couple. Your husband has such a quiet manner." After all I felt entitled, since I had supported Lafayette Grill as a restaurant more than any other. Jokes were made about whether I slept there, or whether they had a plaque on the walls for me, since I attended every Argentine tango *milonga* there, four nights a week, and had all my birthday and anniversary parties there, plus my institute's conferences and holiday luncheons, and maybe now faculty meetings. I was writing essays on "Saturday Nights at Lafayette Grill," partly to help the restaurant continue their former success, since it was the most home-like place for the New York Tango scene. So why shouldn't I have the right to sound a little like a prima donna, when they had promised to accommodate my request for the Argentine tango performer and teacher of my Saturday night birthday party to be a professional guy who I had danced tango with-- a guy who really seemed to enjoy my tango dancing, and who knew I was a top amateur dancer? Was it so unreasonable for me to get a little loud on Wednesday night, and a little irate, when Mega told me that the tango teacher they had said they would get for that night couldn't make it? Was it so unreasonable of me to get loud when the teachers scheduled for the night of my birthday was a guy who never

danced with me at tango *milonga*s? The one time I had danced with the scheduled tango teacher he didn't seem to know at all that, as the host of the *milonga* had said, I was a "fabulous tango dancer." He seemed totally oblivious, as if he could have been dancing with a beginner, the one time I had danced with him. So why shouldn't I object in somewhat vociferous terms, "No! Definitely, not so and so!" And after the male host had promised to hire alternative other tango teachers for that night, at my request, hadn't I the right to be angry when he then said that the schedule was set and "so and so" was on whether I liked it or not, using as an excuse that the teacher and his class, and the tango performance, would be totally separate from my birthday party? How could the guy's teaching and performing be totally separate from my tango birthday dances with all the tango dancing men? How would I feel if the teacher of the evening didn't join in my birthday dance, when others, such as the teacher on the night of my birthday party the year before had, actually been a big part of my birthday dances, and had wanted me to be shown off, and had wanted to dance with me after the birthday dances? There was another year when the tango teacher, who didn't even know me back then, had joined in my birthday dance, and had actually led me into lifts that threw me up in the air as we danced. That was an exciting birthday dance! Why shouldn't I look forward to something like that again? Why should I settle for a tango teacher who did his thing, and then was oblivious to all the goings on for my birthday party, rather than joining in and showing me off? Why should I settle for having been promised one thing, and then being told that my request had been unreasonable in the first place, because the schedule had been set? Why should I capitulate to the explanation that despite the appreciation of my patronage at Lafayette Grill, I had to respect the schedule of dates already set for teachers and their performances on Saturday nights?

Had I been a bitch (as my husband said), in relation to how I interrupted Mega and tried to speak or shout over him, while telling my husband to keep quiet when he tried to stifle me? Had I been a bitch like the woman in my therapy group who had told her fiancé he was only half a man – right in front of his whole family? Or was I falsely being accused of being a bitch just because men were overly sensitive to women raising their voices when they wanted to express themselves with a lot of feeling? Was this just another occasion for people to badmouth me by whispering about my hostile attitude and behavior, when I was just trying to get a point across? I was brought back in my memories to a time when I challenged the clinical work of so-called "self-psychologists," and was treated (behind my back) to a chorus of gossip spreaders who said that my comments to the speaker were presented with a hostile attitude. It didn't matter that my comments were clinically correct, and the speaker was naïve in his clinical

presentation. All this was reported to me by a former supervisee of mine who commented on the gossip hostility by saying: "if you were a man it would have been different. People can't stand aggression in women. If a man made those same clinical and theoretical comments you did at the conference, they would have been listened to. Instead, when you, a woman, came out strong in your beliefs, no one listened. They just said that you were too aggressive, while they fail to own their own aggression, of course, in shutting you down."

All this came back to me when my husband and Mega acted like they were the male victims of me as the female bitch being too aggressive, claiming I was rude, and implying "castrating." Was I no different than my therapy group member who had called her fiancé "half a man" in front of his family, and did so in a dissociated state so she didn't have to take responsibility for it?

So what does a dream I had then have to say about all this, since it seems to reflect my worst unconscious fears about how I will be punished for my attempts to speak, particularly at conferences? I seem to fear that all my vast opportunities for "seats" in the conference room and at the conference table will be denied me, despite all the intelligence and clinical acumen I have to offer. All the seats are going to be taken by others, and my voice will be extinct as if never heard at all because I won't even have a space to sit, let alone to speak at the conference. First all the seats will be taken even though they were all open when I entered the room. Then I'll find that the one obscure seat I managed to squeeze into in the back of the room was now behind a wall of glass, so no one could ever hear me. Then in my constant frustrated attempt to find a seat I would finally be reluctantly placed at a long table of people, like the long table at a recent luncheon where I had the microphone, and where I was a center of attention as I honored each of the guests. In my dream I lost my special status completely, and I was squeezed in on the side of the table with 50 others going down both sides of the long table. Nobody was listening to me. I was back in the little girl situation of my original family, where I was the cute kid never heard as a person. Nobody talked to me like I had anything to say. I could do a dance, but my more adult voice was not acknowledged. In the case of the adult conference I might be too threatening to be acknowledged. I was back in the child position.

ESSAY #12
MARRIAGE and NEW YORK ARGENTINE TANGO

My husband and I re-discovered each other through the dance of Argentine tango as well as through the social dance world of Argentine tango. After many years of marriage our relationship was re-born through it. Brief studies in Latin and ballroom dances in the dance studios gave us a form of shared creativity that we craved, but it was not until we both discovered Argentine tango that our souls joined in fluid sensual oneness. Suddenly, within the dance, we could truly sense the music together, breathing together as we moved as one. When asked by a stranger what had allowed our thirty- year marriage to stay rich and alive, my husband replied, "Passion and Tolerance!"

Argentine tango became our shared passion along with our passion for each other. In fact our passion for each other, which had to weather much anger, annoyance, and rage over the years—would be renewed by intimate conversations about our fears, longings, and desires. But this renewal was always celebrated though a new and deeper level of passion in dancing Argentine tango together.

Our social life became more and more the evening *milonga* party life at restaurants and dance studios in New York, where tango proper, vals tango, peppy *milonga*s, and sometimes tango *nuevo* were the vehicle for social intercourse. There was also the social discourse of table conversation in between tangos. Many of our friendships with others, and usually shared others, blossomed under these conditions. Our sense of family was gained in the tango world, but particularly at Lafayette Grill.

How much can a marriage really crystallize and re-shape itself through Argentine tango? My husband and I found that even our annoyance with each other could be dealt with by each of us dancing with other tango partners, and then we came back together, re-joining each other in the music and sensual full body embrace of tango. The versatility to do this was hard won. Many, many years of private individual and couples tango lessons went into being at a level to hone these options.

Of course tango is not enough to make a marriage. Many couples have been formed through single people meeting at the *milonga*s, only to flounder on the shores of extra tango life. Re-joining each other in tango, after an argument between my husband and I, did not resolve the hurt feelings and interpersonal misunderstandings that my husband and I endured and experienced. We still had to talk, empathize with each other, and reach out to the hidden vulnerable places in each other that were resonating with the hurts and assaults of the past. We still had to confess our own hurtful meanness. We still had to sort it all out. But we could be eased into all this through the tango connection on the Lafayette Grill dance

floor, before we left for an evening. The story of our souls' passionate embrace on the Argentine tango dance floor, along with the Argentine tango music, could blossom into a renewed willingness on each of our parts to extend tolerance to each other. Passion on the dance floor led, not only to tolerance, but to a psychological embrace. Tango connection could open the avenue to caring between us, so that we could give up defensive forms of anger and tune into the vulnerabilities of each other that we had tread upon.

One night my husband walked out of the restaurant without me. He was angry. He had thought of doing this other times, times when I was still full of energy and wanted to dance, while he was feeling tired. Sometimes he could wake up from the tiredness through the energizing music, movement, and connection of tango. Other times he could not, and he resented my even suggesting that he relax and enjoy the music, letting it energize him. From his perspective I was just doing everything on my terms by wanting to stay and dance. This perception of me made him angrier and thus more tired. I could not intervene in his mode of exhaustion without being blamed for my insensitivity to his needs, so I often just kept dancing with others, and hoped he would dance with someone else to revive himself. Other times I capitulated since he did seem quite tired, and we left together.

But one night my husband became enraged, walking out on me with accusations about my lack of concern for him. I danced a few dances that felt less alive than usual because I was feeling the heartache of my husband's leaving, feeling it in that deep heart-soul place where we were joined. In my head I was also preoccupied with him, so I felt like I was going through the motions with my partner. When the dances of the *tanda* were done I went into the bathroom and called my husband on my cell phone. My husband answered and started screaming at me, at quite a volume, so that I responded back softly to cover the sound when another woman entered the bathroom. I was saying in a condoling voice, "Yes you have been very loving. I'm sorry you feel hurt." I said, "You have been very loving" several times while he continued to scream. He screamed that if it were up to him he would only go dancing two or three times a week, not four or five or six. I was shocked! I was threatened! What would happen to the tango life style that I thought we mutually shared? However, his main point was that he was doing it all for me, because I wanted it so frequently, and that I had dared to criticize his dancing on the dance floor and made him feel like shit. The other lady was still in the bathroom so I continued to say in a mollifying way: "Yes, you have done so much for me lately, and have been so loving!" My husband then stopped screaming and seemed to be calmed by having gotten his explosion out. I told him how much I loved him and loved dancing with him, even though I could dance

on my own with others. He told me to go and enjoy some more dances at Lafayette and that he would get some sleep and see me later.

Interestingly, my husband never actually pulled back from our multiple nights of dancing at Lafayette grill, although I did make it possible for us to spend more time together at home then without dancing. It was pretty clear from his behavior that he wanted to be doing tango as much as me, but he had been injured by my commenting on his dance technique while we were dancing. We had a very close week together, after he got out his rage on the phone. Before I knew it, my husband was dancing tango with me as much as ever. But I had learned that even if he was pulling me off my dance axis, with problems in his posture and thus balance, I needed to cut him slack and only discuss it in private dance classes where he felt less defensive, because he was being given feedback from a paid professional. Holding myself back from criticizing my husband while dancing with him was sometimes difficult, but I had learned in our tango marriage how important this was. He might be tired and off center, but he would regain himself when the music and spirit of tango, and my own relaxation into his lead and embrace soothed him. When we had more space on the dance floor he would "get his mojo back," as I would say to him.

"Yes, you were very loving!" I would say to him in the Lafayette Grill ladies room, "I really appreciated it," as he screamed at the top of his lungs at me. How ironic, since, at least from my husband's perspective, I was the "screamer" in the marriage! But marriage is about seeing each other's point of view, and I was so relieved that even if he left me at Lafayette in a way he never did before, after all those years there, he was able to scream at me when I gave him the chance, and to really communicate the depth of his anguish about feeling that I was not tuning in to his level of fatigue and discomfort enough. He also got through to me about how he felt our whole marriage was on my terms. This allowed me to relinquish control and let him stay home even when I wanted to go out dancing, or to stay at home with him more for our extra tango world intimacy.

ESSAY #13
The BIRTHDAY PARTIES and
the BIRTHDAY DANCES

All the men line up to dance with me. Each one leads me in a different flow of Argentine tango steps, embrace, motion, and connection. How did I ever have birthdays before entering the Argentine tango world? The tradition of the birthday dance meets my most primal needs to be special, front stage center, and appealing to men on the yearly occasion of my birthday. I can be center stage with my husband, and center stage with all the other men, some of whom are consummate professionals who can really show me off, with drags, lifts, *boleos*, *volcadas*, and *ganchos*, or waltz steps in the waltz tango where we flow and turn in large *molinete* patterns with the music. Then there are my male tango dancing friends who attend my party. They come especially for me and join in my yearly birthday dances at Lafayette Grill. I hate having to end with each of them to go on to the next man, but each man is a different country to discover, and here, each man leads me with his own unique style and embrace. Each wishes me "happy birthday" as we dance, and then each is confronted with another man standing before us, waiting to dance with me, "the birthday girl," and I am twirled around under the arm of my "in the moment" partner and passed on to the next guy waiting. This is the beautiful dance celebration and ritual of the Argentine tango party and *milonga*. I enjoy birthday dances on each birthday in several venues, such as the delightful Sunday night *milonga* at Session 73 with the famous Argentine tango *milonga* organizer, Lucille Krasne, but it is at Lafayette Grill that I always have my big birthday parties, and it is Saturday night when the whole restaurant becomes alive with a balcony full of my friends who I treat to dinner and to a vision of the magic of the Argentine tango world. It is very special to have my friends from outside the Argentine tango world come to share in my party, where they are sometimes filmed and interviewed, but are always guests at my improvisational tango performance with my husband and to my performances within the birthday dance with many professionals and tango friends.

I swirl from one man to the other in the birthday dance, and I enjoy watching other women and men do the same on their birthdays. Jon Tariq buys me a birthday cake and does special tango moves with me on the dance floor during my birthday dance. He lifts me on to his lap as I cross my legs over him, and he drags me across the floor in a lean while we then turn and pose for the audience. But the special connection in tango can be seen with my husband as well. And then there is the surprise entrance of the guest professional of the evening, Aldo, in my birthday dance, just before

he performs tango with the maestro female teacher and performer, the Argentinian Alicia Cruzado.

As I get one year older each year and do more and more birthday parties at Lafayette Grill I thrill at the celebration of my full bodied energy at my new age, while I have friends and colleagues who become depressed on their birthdays, or who wish to forget that they are advancing another year as we all move forward in years. Jon introduces me as "turning 21" and some clamor to him to hear the truth of my age. He proclaims I am maybe turning 44 or 46. Who cares about an extra decade and a half more? My energy is at a level that all those who know me envy. I agree. I am always so energized by dancing Argentine tango, and on the night of my birthday dance I am sufficiently flattered when I am told that rather than my advanced age I am really a "twenty year old." Flattery will get one anywhere for a while, as long as there is also substance underneath.

All my life I have insisted on a special night for my birthday. But having friends over at home or having them join me to celebrate in an ordinary restaurant could never give me the height of joy and the feeling of specialness that I have found in the Argentine tango world.

I know that not everyone likes parties on their birthday. But having had a party each year to celebrate when I was young, I feel a certain right to continue the tradition no matter how old I get. When I reached 50 I had my first really big dance blast on my birthday, but it was in a large fifth avenue cathedral, where I had to worry about catering and hiring the DJ, dance teachers and dance performers myself. Since people often fail to RSVP I would have to pay big fees for dinners when people didn't tell me enough in advance that they couldn't come. I performed in this terrain and we had all kinds of dancing, not just tango back then. My husband and I had taken our first tango steps and did our first performances for my friends at my birthday parties. I had three big parties in this St. Bart's Cathedral space, with huge high ceilings and an amazingly large dance floor. Everyone got a tango lesson with the very special teacher I hired. People who hadn't the faintest idea about what it was like, to lead and follow in partner dancing, let alone in the special connection of Argentine tango, tried out an eight pattern basic step with my tango teacher. How many actually sensed what the connection was about – I will never know. They may have ended up just thinking that tango was a bunch of steps, until they saw me and my husband dance, or until they watched the professional tango couples perform.

But all this was changed when I brought my birthday parties to Lafayette Grill. Not only could I plan my party at a vastly less expensive level, and not have to worry about paying for those who didn't show for the occasion, but I could relax and let the restaurant be responsible for providing tango lessons, and for providing tango performances, and live or

CD tango music, full of waltz tangos, *milonga*s, and traditional and *nuevo* tango. As soon as I switched my tango birthday parties to Lafayette Grill I felt at home on my birthday, and brought my friends into the "home" me and my husband shared at this very unique restaurant. They came into the embrace of an evening where I felt special friendship throughout the year. Here all my friends were invited to take a free beginners tango lesson with Jose, one of the Saturday night hosts who knew how to teach tango right from the start through a lead-follow feeling of connection, rather than teaching it through steps. This gave newcomers a feeling of how unique Argentine tango was as a dance, embracing you with the organic flow of life, two beings whose legs and arms moved as one being, holding each other in the hug of the tango embrace. My friends or other newcomers of the evening would get the message. Steps are secondary. The connection with one's oneself, and through that with one's partner and with the music is primary. We don't talk. We only move and breathe with one another as we dance. Those who wished to continue could then watch or try to engage in the intermediate class that followed the beginners' lesson for only $5. I warned all my friends that the performances and birthday dances would be after 11 pm, so those who, unlike me, were not night people, would have to extend their usual hours to join in the celebration of the night.

I have always been a night person. My parties would extend to 2 or 2:30 am, when Lafayette Grill closes, but here the dividing line between tango and non-tango people would be seen. My non- tango friends would try to keep awake until 11:30pm to see my performances and birthday dances, and to see the professional performance of the evening as well, and my tango friends would stay and dance with me and my husband until 2am. Tango gave me the night life that was so fitted to my nature. I was always a tanguera at heart, one who danced many nights of the week, but particularly on Saturday night into the wee hours of the morning

Still the birthday night was and remains unique. I bring my outside world friends into the tango life to see my very unique world at Lafayette Grill. This last birthday I wore a dress especially designed for me by a young 25 year old tanguera, named Zoe. Although Zoe had to work and couldn't make my party, she designed a Wonder Woman-esque dress for me. In this dress I had all gold on top, with gold sequins, and red here and there, while the dress was a flowing fabric of turquoise color that was matched with turquoise jewelry from Bali and from Santa Fe New Mexico. Zoe had observed my jewelry and legs at Lafayette Grill *milonga*s, and she decided she would love to make me a special dress. Lucille Krasne also came up with the idea for me to have one of Zoe's asymmetrical specialties. After I had danced in tango competition, Lucille proclaimed that next time I had to have one of Zoe's asymmetrical specialties that was "so tango!" So I joined in the spirit of this idea and invited Zoe to design a dress for my

next birthday party. The gold top had two different toga top designs for my shoulders that brought in the asymmetrical quality, with one side fanning over my shoulder and down my arm and the other more straight. The combination of blue turquoise, red, and gold, did bring comments about me appearing like Wonder Woman. I also had a jacket that was reversible with gold or red on alternate sides.

When Zoe was first fitting me for the dress I was a little scared. What if it didn't help me look slim? What if it was too much? What if it wasn't me? I had already committed myself to the dress and to Zoe's special arts without having seen anything of hers before. I was trusting in my tango sister, Lucille, for the idea and inspiration. Zoe assured me that when she worked out all the measurements, and draped things properly all would be perfect for my figure. So I put my trust in her. Voila! My dress was fully formed and draped upon me one night at a Middle Eastern restaurant, where Zoe worked. After slipping into the elaborate creation in the ladies room, I came out into the restaurant. People began to spontaneously applaud. Before I knew it, the female belly dancer who was standing on the side while a man played a Middle Eastern instrument, reached out her arm to me to join her in her dancing. I accepted the invitation graciously. Before I knew it I was dancing like a belly dancer in my new gold, turquoise and red creation. I moved in an undulating fashion to the music along with the professional belly dancer as we danced around and passed each other. I let my arms flow and my body undulate to the rhythms, holding the flowing skirt of my dress at times and using it in my improvisational dancing. I was reminded of a party in England where I had imitated belly dancing for the guests. But even more I was reminded of when I imitated Balinese dancing in the Royal Court in Bali. The King of Bali, entertaining my conference group as he generally entertained tourists, asked me to join him in the dancing. Later my dancing with the King of Bali would be captured in a picture by one of the conference participants' husband, who had the picture blown up and presented it to me at my next Lafayette Grill birthday party. Till today that blown up picture of me dancing with the King of Bali, is hung, having been framed by me, across from the men's room at Lafayette Grill. There I am doing improvisational Balinese dancing with the King of Bali in the Royal Court. The King is dressed in traditional royal golden garb, and so are his attendants who can be seen in the background. The court atmosphere is quite unique, with Balinese fabrics and tents and with the people from my conference appearing here and there in the background. At the actual time of the dance with the King, he asked me to do several kinds of dances with me. My whole conference group watched while he then tried Argentine tango, with me trying to show him tango even though I was in the following position. Then the King invited me to do a cha-cha, which came off as the most

partnered interaction since the "King and I." Much applause followed from my conference friends, and I felt swept up in the flow of it all. One of my conference group friends exclaimed about me, "She's up for anything!" This came back to me as I danced in Zoe's new creation for me at a Middle Eastern restaurant, accompanied by a young twentieth something belly dancer. There was again applause and someone proclaimed, "Where is she from?," referring to me as I danced like I knew what I was doing. "Where is she from?," as if I was from some exotic place and climate. I said I'm from New York, and someone said, "No, really?"

But then back before this time was a birthday party year when I actually danced a choreographed dance at Lafayette Grill. I had first performed the dance at a well-known New York dance studio, DanceSport, with a teacher there who liked doing choreography. Teachers would prepare dances for their students to perform for those at the dance studio and for guests at the studio. So, one of my private Argentine tango dance teachers was inspired one day to create a choreographed dance for me to perform with him. We danced to each phrase of the music in a famous tango by Pugliese's 1940s famous orchestra, the particular piece called "Recuerdo." I spent fortunes on extra tango private classes to practice all the parts of this dance. There were quite advanced steps, and some needed quite a bit of practice to master. I got them all, and my teacher did a lot of fancy maneuvering around, under, and with me as Pugliese's music flowed. We got much applause and I was told that our dance was at a professional level. But my tango teacher reprimanded me for going a bit too fast when he was doing kicks under me as I went around him. This stung a bit, after everyone else had been so enthusiastic who saw us perform. Nevertheless, I was up for another go at the choreographed creation since it had been created just with me in mind. So I found a male tango guy who I often danced with, who I thought could master the male partner's steps and patterns. He said he would be willing to join me in tango lessons I would pay for with the tango teacher who had created the dance. He learned the man's part, and we tried to do each bit with the music. Our tango teacher warned us to go slow to stay with the music. We were going to perform the dance at Lafayette Grill at my next birthday party.

So it happened! Lafayette Grill didn't yet have its bigger ballroom space, so we performed our dance to Pugliese's "Recuerdo" in the narrower space, with all my friends and Lafayette Grill participants watching. My husband also watched us, planning to join with me in an improvisational number afterwards. The whole *milonga* group watched as my friend Joe and I did all the patterns that my tango teacher had taught us. But the music began to get ahead of us. We were not as perfect as the professionals. Joe was used to feeling the dance through the music in an improvisational flow, and here he was called on to match planned steps to each musical phrase.

Still it came off, and a photographer appeared who got some great shots of us in our dance moves and poses. Some of these pictures were framed and hung at Lafayette Grill. Having these pictures on the walls, as well as the one of me with the King of Bali, reminds me of past fun times that I have had at the Lafayette Grill and Bar restaurant. These pictures bring me back to happy times there, and help to make the place a second home for me, along with having my friends there.

Birthdays are a continuing joy because I can perform for my friends with my husband and do birthday dances with my friends, both professionals and social dance amateurs, all of whom I care so much for. I feel sorry for anyone who doesn't feel like celebrating themselves on their birthdays, and as I and my friends get older I feel even more that celebrating birthdays is a precious and privileged experienced that must be cherished! I am glad that I was celebrated by my father in my childhood and always given birthday parties. I look back sadly at years in which my birthdays weren't able to be celebrated as they were in my childhood, and as they are now, perhaps even more so, in the Saturday night *milonga*s at Lafayette Grill On each birthday I celebrate at Lafayette Grill I am able to share the passion and love that I and my husband feel for Argentine tango with many special friends, both those in my outside tango world life, some of whom join me from my professional life, and with those who share in the Saturday night magic spell at Lafayette Grill on a regular basis. Each year brings a unique experience of birthday dances and performances, and of friends and colleagues.

Also, there are the anniversary parties my husband and I have at Lafayette Grill, where we express the bond of our triple decade marriage in our anniversary dance for friends and Lafayette Grill regulars. On the Anniversary dance nights, my husband and I begin the dance, whether it be a waltz tango or a traditional tango, or *poema*, which is a particularly romantic tango, and men cut in to dance with me, and a line of women cut in to dance with my husband, in another Argentine tango world tradition- that of the wedding anniversary celebration.

ESSAY #14
JON and JUDY COME to TOWN
from BUENOS AIRES

In some ways it was a typical Saturday night at Lafayette Grill. There seemed to be a lot of commotion in the earlier part of the evening as I entered the restaurant. I kissed and greeted the hosts and the staff as I entered. There was a class going on that had quite a number of couples on the dance floor participating. There were some regulars already seated at the tables eating or talking. Up on the balcony was a long table of birthday party guests gathered for someone's birthday. Several tables were marked "reserved," waiting for the occupants to arrive later as the classes ended and the evening of *milonga* dancing began.

I came in from a cold winter's night knowing and expecting to feel warmed as soon as I entered the walls of the restaurant that was my second home. I also came from an afternoon of frustration in overseeing an advertising campaign for a conference I was to conduct, speak at, and dance at the following Saturday at Lafayette Grill. I had felt emptied out and drained by finding errors in the advertising for a conference that was just one week away. I almost felt on the verge of despair, having worked so hard to plan and organize the conference, thinking that day of how all my efforts might fail if the word didn't get out this last week. But in the middle of feeling all my usually abundant energy wiped out as an empty pit feeling entered my stomach, and pessimistic thoughts entered my mind and began to depress me, I knew I would be all right the minute I entered the walls of Lafayette Grill for the evening. I knew that all the festivities of the evening would transform my feeling state totally, and that energy and even joy would return to my psyche. I emphatically knew this. This was my faith, my belief, and this is exactly what happened on this fairly typical but also special Saturday night, on a cold winter's eve.

First I ran into one of the bathrooms to change from the slacks, sweater, boots, and jacket I wore for the weather, into the dress I had chosen to dance in that evening. It was a dress that fitted and flowed, and reminded me of the recent celebration luncheon I had held on an afternoon at Lafayette Grill. It had flowers on it, and had the fit of a 1940s dress on top, retro and flowing and fitted at once. But it was the jacket I threw on above it that got the first of my complements of the evening, all of which was part of the ambience at this special restaurant. The evenings were usually filled with many complements about both what I would wear and about my dancing. This is all part of what made me feel at home, even if my husband and I would get temporarily critical with one another, disrupting the harmony at times.

93

I recognized the couple "from Buenos Aires" who were the invited teachers and performers of the evening. I watched their class from afar as I sat down at a table to order dinner. I was starving after spending the entire day worrying about advertising. I knew the teachers of the evening from *milonga*s of the past, both at the Grill and elsewhere. They were an American, probably Jewish, couple, who had taken up living in Buenos Aires when they fell in love with the passion of the tango as well as the passion for each other. They would come back to the states, as well as go to Europe, to teach and perform and to earn a living, although they were some of the many who left the states for Buenos Aires, who really loved to make Buenos Aires their home. I knew they were "Jon and Judy." I thought of joining the class, but being late for it, and not yet having my husband as a partner to arrive yet, I decided to nurture my appetite before dancing, promising myself that I would "make nice" to myself after agonizing and suffering the tortures of the damned all afternoon, related to the flawed advertising that raised my anxiety about the outcome of a conference I had worked on since the summer, when I had been inspired to write the main paper of presentation for the conference. So I sat down and ordered one of the restaurants' specialties, the Greek restaurant's "moussaka," as I watched the Argentine ambience of the evening.

As I waited for my food I began to engage in talk with a familiar female who also had found a home in the Argentine tango world through finding Lafayette Grill. I had seen her hundreds of times and had even had her as a guest at my recent birthday party at Lafayette Grill, yet I realized how little I actually knew about her as she began to reveal much more than ever before. In response to my asking her if she wanted to attend the conference the next week, she began to tell me of how she had abandoned her practice as a psychotherapist for a spiritual journey in which she was finding a calling as the one to help her grown children to open up however slightly from their rigid belief systems that had taken the form of religious tenets used to defend them from any form of self-observation. She began to tell me how she was visiting Buddhist ashrams and writing "love notes" to an extremely rejecting and hating daughter, as well as to nieces, nephews, grandchildren, and other relatives. She seemed much centered in her convictions of the new direction that her life had taken. She made it quite clear that as brilliant as my papers and conferences might be she had to give the whole thing much quiet deliberation, since she was "going in a different direction" now. All this had apparently been going on in the background while my female friend and I shared continuously in the dancing, and sometimes classes, of the Lafayette Grill *milonga*. Last week I had talked to a couple that I had known through Lafayette Grill for ages, who had both come to my birthday party there for the first time this year, and I began to hear about their lives in a way I never had before. Once the dancing began

94

this couple embraced me, both the man and woman kissing and hugging me. The woman then complemented one of my necklaces, and I said that I had gotten it in Santa Fe, New Mexico, where people learned I went in the summer and got all my jewelry, while I danced tango there as well. I also pointed out to her my other necklace, a beautiful heart with diamond chips that my husband had bought me for my birthday after my birthday party. She responded warmly to my saying that my husband had given me this present, and I felt that an important part of my married life was being validated by my fellow dancers, especially by other couples and singles that attended regularly and became part of the Lafayette Grill family. The complement meant all the more from this woman since I had just recently learned some personal things about her, such as that she actually loves doing laundry, and considers it a form of Zen meditation, and that she also loves to cook, something I always left to my very creative chef husband, when we weren't eating out at *milonga*s as we usually were.

Then I ate my moussaka and saw my husband show up. I pressed him as usual to get his tango shoes on, so we could dance as the *milonga* dancing began after the tango class with Judy and Jon ended. I noticed Judy and Jon go to their table, but they still hadn't seen and recognized me. I felt an impatience to flow into the music and the dancers on the dance floor as tango waltzes were played. My husband had to finish his soup so I waited, not too patiently, and observed the familiar couples on the floor as well as the new ones that dropped in for the evening. I went to kiss and hug one of the male hosts, who was the DJ of the evening. He told me that he had heard I was to perform tango the next week at the conference with his fellow host at the Monday night *milonga*, and he said that he had asked his friend to "make me look like a princess" in the performance. I kissed him and thanked him. This was all part of the warmth of this special restaurant—the familiar and intimate in the middle of the strangers that congregated in the usual restaurants in New York City with its vast array of variety.

My husband was ready to dance and as we danced our first dances the end of a *tanda* of dances allowed me the opportunity to say "hello" to the guest teachers, Jon and Judy. When I said "hello" to Judy first she immediately recognized me. She greeted me warmly. Then I tapped Jon on the shoulder and he opened up a big smile as he saw me. He playfully said to my husband "look over there" and kissed me a bunch of kisses on my cheek, very sweet and tender, as if he had to steal his time with me from my husband who might be jealous like an Argentine man might be. Then he said to me "You're looking great! You're also looking happy!" Little did he know how burdened and distraught I had felt just a few hours ago. Then he turned gallantly to my husband and exclaimed: "She's looking really

happy! You must be keeping her happy! That's great!" My husband smiled as we began to dance again.

This was to be a very special evening, like every evening at Lafayette Grill, especially on Saturday night. Tonight would be made special by the social engagement, which of course involved dancing, with this couple that had absorbed the tango *milonga* scene in Argentina, in Buenos Aires. As the evening continued we would become increasingly engaged with Jon and Judy.

But first I would have the frustrating experience of watching my husband literally fall asleep while he sat at the table after eating. He put his jacket on him, and said he was both cold and tired. I wondered how I would negotiate his discomfort and complaints with my need to enjoy the evening and to feel the "magic" of Lafayette Grill envelope and hold me. I moved away to see if Jon wanted to dance. He was at that moment fully engaged in conversation with an Asian tango dancing gentleman, so absorbed he didn't see me trying to get his attention. Instead I sat at the table and hugged and greeted a Russian woman who was with him and Judy, Judy was now off dancing with someone, or preparing in the bathroom for her upcoming performance with John. The Russian woman reminded me of her name and I reminded her of mine, since names were often forgotten even when those at the *milonga*s greeted each other so warmly and felt such a sense of finding one another again after a period of time.

I returned to my table. My husband was literally sleeping. I felt bad for him and annoyed at him. I decided to let him sleep, hoping he would return to an energetic state later. He hadn't been happy with his dancing so far that evening, so I thought he was actually feeling depressed in his sleepiness. But I knew he could easily come out of that state with one good tango, or with some friendly conversation, or with just gaining some space on the dance floor as the evening wore on.

Then it was time for the performance, and Judy and Jon performed three tangos, two traditional tangos and a waltz tango. I cheered and applauded, and welcomed more by crying, "Autre, autre," as others did. They demonstrated a very precise and intimate form of salon tango that was typical of Buenos Aires dancers, and of the profound partner connection that was essential to salon tango. I watched both of them in their lead and follow roles, with a "close embrace" that demanded exquisite coordination of movement between them. I watched Jon feel each step by feeling each phrase of the music. I watched Judy, in gold pants and high heeled gold tango shoes move with lithe elegance to each innuendo, and shift, and turn ("*giro*") executed by John. They imbibed the music as they moved as four legs with one body, an exquisite team.

As soon as they ended their performance John said he had to dance with me, so I came over to prompt him. He took my hand and led me to the dance floor. Then he made me feel so elegant and sensitive to every step as I pivoted oh so slowly in this direction, and that, with his lead. He said in between dances, "How have you been?" I said that I was dancing a lot, usually at least five nights a week. He then said that it showed. He said "You're dancing really well!" I was particularly pleased with a complement coming from him. We then continued to dance. I would smile at him after each dance. At one point he laughed because he had steered me nearly into a large massive column on the dance floor. We barely missed it and both laughed. In the middle of such subtlety and grace in his dancing with me, there was also laughter and fun. When we finished the four dances in the *tanda* of dances, John made a point of formerly accompanying me off the dance floor, arm in arm, as was the Buenos Aires etiquette, taking me back to "sua casa" as he said, back to my table with my husband and to my seat.

After I returned to my table my husband seemed still asleep so I did a *tanda* of tangos with one of the male hosts of the evening. He exclaimed that I had become one of his favorite women to dance with. He said that he was enjoying dancing with me like never before. Here were more complements to revive me. He said that my dancing had become better and better, and that he could try out all kinds of fancy tango moves with me, and I could always follow and interact in the dynamic of his lead. I had fun, but wondered about the difference between this "modern tango" dancing and the dancing I had just seen in the performance by John with the traditional salon tango style. The salon style was lithe and sensual and slower than what Mega, the host, liked John could do all kinds of steps but he chose to mix in few figures with the lovely walking and pivoting of the *milonguero* style tango dancer, who was always practiced in the style of the salon.

So as I wondered about this contrast as I observed it, I decided to approach Judy for a conversation, while I brought her a calendar with pictures of me and my books and articles, and my social activities, which I had given out at my recent birthday party. I also brought pictures from a performance with a professional guy I had done at a conference a year ago. We sat and talked and she told me about her DVD with famous tango couples, some of whom had died. The DVD also had John dancing and teaching. I said I'd be glad to buy it. Then John came back to the table and started to engage in jokes and fun conversation with me. I showed him the calendar with my recent activities, and he seemed fascinated. He said he couldn't stop smiling with me because I was so charming. Then I realized that my husband had woken. He joined us at John and Judy's table. Suddenly he was waking up and enjoying himself, which was quite a relief to me, but not a surprise. John invited him to tell jokes and to speak about

tango. I asked about John and Judy's itinerary and was sorry they would only be in to New York City for a week, and not at Lafayette Grill. Then they would be on to Europe. But they invited us to come down to Buenos Aires and be shown around by them. My husband and I had been in Buenos Aires twice, and had frequented most of the most well-known *milonga*s with a group tour. They said they would show us Buenos Aires as we never experienced before, just as a couple in all the hidden *milonga* places, with their guidance. They made it sound very inviting.

Then there was the major surprise of the evening. John asked me to dance a whole other *tanda* of dances, even though he was the central male figure of the evening as the guest teacher and performer. Such attention to me and my companionship in dancing felt quite flattering. We danced again, without any close calls with the columns on the dance floor this time. Again I was moved and mesmerized by the slow elegant and graceful way I was led to pivot and turn with John. He made each step feel like a work of art. I had to be intensely alert, and yet could close my eyes and be "in the zone" at the same time. My intention must be clear as his lead was clear, and I never knew which way he would twist and turn next. But I did know that I was dancing without the kicks, *boleos* and *ganchos* I often did, just straight and subtle salon tango with its softness and slow elegant and artful style and embrace. It felt wonderful in my body, and my mind cleared and rested as it hadn't all day.

Then I was ready to dance more patiently and harmoniously with my husband, surrendering to him, so that he could surrender to the relaxation and energizing effect of the dance. He had woken up from the social conversation with John and Judy, and from dancing with me and then another "regular" tanguera female at the *milonga*.

I felt so relieved and invigorated by seeing my husband become alive with the magic of the evening, the very special Saturday evening at Lafayette Grill. As I danced with John I had thought of the cosmopolitan life I led by just being at Lafayette Grill four nights a week, while others came to this special New York *milonga* from places all over the world. As I danced with John and heard of his itinerary, which made me cherish the eight dances I had with him even more, I also remembered dancing waltzes on a Monday evening at the Grill with a Japanese businessman from Tokyo. I never saw him again, but dancing with him was fabulous novel dances experience in a world of familiar strangers, as well as of friendships, with the steady others who inhabited Lafayette Grill.

The evening ended with more jokes and stories, as John became increasingly animated while we all did our last dances at the Lafayette Grill evening at 2:15 am. Jose, the host and DJ, who hosted along with Mega, always had to disappoint those who wished to continue dancing when he said this was the "last *tanda*" or these are the last three dances. The last

dances felt special in their own way just because "parting is such sweet sorrow." Even though my husband and I went home together, and didn't part, we were saying good-bye to a fabulous evening, which was "triste" like all the mournful and romantic songs of tango itself. Even though I felt sad to go home, I also felt fulfilled, and always preferred ending at this time at Lafayette Grill to going to the "All Night Milonga" at a local dance studio, although sometimes the "All Night Milonga" could be an exciting event to intersperse with the regular evenings at Lafayette Grill. Mostly, we just wanted to experience the uniqueness of each Saturday evening at Lafayette Grill, no matter how crowded or "slow" it was on any particular Saturday night. This night had been one of the crowded ones, but people had kept the line of dance well enough to make dancing a pleasure. And having a special partner like John for the evening allowed me to enjoy the dancing with my husband even more at the end of the evening.

My husband told John a Jewish joke that really made him laugh and he shared it with Judy. Then he exclaimed: "This has been a great night!" He invited us to join them and a few others to go to an all-night restaurant, now at 2:30 going towards 3 am in the early morning of Sunday approaching. My husband definitely declined, but I said that it was probably John's way of continuing the Buenos Aires life in New York, since *milongas* and dinners there always proceeded to 5 am. John agreed and seemed wide awake and rare on to go.

And so we returned home at 3:30 am and I was in bed by 4 am, figuring out that I needed to sleep till noon on Sunday. Before we were out the door, Mega, the male host who had told me how ecstatic he was becoming about my dancing told me so again, and he also complemented my husband by declaring that the jacket I wore over my dress was the most gorgeous piece of clothing he had seen for a long time. He said this to my husband because I had told Mega that my husband had picked out the jacket. My husband smiled and was pleased. As I had predicted, once he woke up he was able to dance with great ease and a simpatico connection and coordination with me. We danced till the end, and he seemed wide awake now. Again the magic of Lafayette Grill had worked.

ESSAY #15
FINDING a HEALING FAMILY FEELING
at LAFAYETTE GRILL

I was in pain. I was preoccupied with an intense journey into the dark side of my unconscious where disturbing visions of my childhood family sent out their haunting vibrations. Yet it was Saturday night, and I entered Lafayette Grill, as usual dressed for tango, having just thrown on a red dress with large white polka dots, after throwing off a brown dress that I had spent the day in while running a professional group. I was hoping for a change of mood in the changing of the dress, for the brown dress now echoed the darkness of the painful dark place inside of me, where an internal family lived. I was carrying the encounters with the family... members within that had been evoked by the professional meeting I had led. Each figure was filled with rage towards me that had been vibrantly expressed, filled with judgments that now were echoed in my own internal attacking judgments towards myself. Most of all there were the hostile words of the sister figure, which saw me as a transferential vision of her mother, unable to let her go or to see her successes without a possessive envy that held her back. In her own words, I was the narcissistic mother for her.

In the meeting that vibrated back to me through visions of the dark family within, the sister figure dramatically declared that I couldn't see her, but only saw her as an extension of myself. When I asked her what this meant she evaded me. The group said I was interrogating her so I had stopped. But we got up to the point where she said I never let anyone go. Why couldn't I validate her incredible growth in the group over the years? Why did I hold that back from her? Why wasn't I proud and happy for her when she planned to leave the group? Eventually she conjured up a memory of a poem she had written in which she wished to stay in the dark waters of her mother's womb, but was kept there too long by the mother who couldn't let her go. I told her she saw me as the mother who liked having her in my uterus and didn't want her to leave. Could I let go? She saw me now in the cynical view of her own narcissistic parents, and couldn't imagine me freely letting her go. My questioning her view of me as non-responsive, when I had consistently responded to her over a 5 year period became an aversive interrogation in her mind, which others declared I should stop as she kept declaring she felt "attacked." I was silenced. I felt guilty. My anger escaped, and embarrassed me. I couldn't put my curiosity to rest I asked her again: "Why would I need to make her into an extension of myself?" She couldn't answer distinctly. She was reaching. She stammered, "Maybe you're not separate." I persisted. She claimed I was attacking. She was on the spot. Others said I was aggressive and "grilling

101

her." I said that she may have felt then that I was retaliatory with vengeance and venom behind it. She shook her head "yes" to this interpretation. It suited her current view of me. I was in my internal family in a helpless place. The professional meeting had just that afternoon evoked this internal family place, a place where I was the one helplessly speechless in the face of so many judges. I experienced so much rage behind the sober but cold stares of the judges in my dream, a dream that brought this internal family alive.

When I entered Lafayette Grill that Saturday evening all this was haunting me in my mind. Inside of my body was the accompanying pain in the form of anger and a wounded injury felt in my heart area. I was preoccupied with the meeting, and with the internal images of the family within myself that mirrored this family experience at the meeting. I was afraid of losing everyone and everything. My anger had showed. I had been told I was being too angry. I listened, but I found it difficult to bare the projection of me as a cold, nonresponsive father-mother, the demon lover figure for this woman who I saw in the role of my sister. I tried to question it. It was hopeless. She was too "in it" to listen. I felt the pain of anticipating her parting from me and the group. I began to see all too clearly the generalized "agoraphobic symptom" that this lady had come to me and the group for help with being played out in her fear of how I would attack, judge or be indifferent to her. Her internal demons were all focused in her image of me now. Yet she wouldn't face it or explore it. She was too in it. And as my frustration turned to anger, I just confirmed her view of me as a rejecting father and as a possessive mother. I wouldn't see her growth. I wouldn't see her ability to now engage in the world that she had formerly withdrawn from. I was too hidden from her behind her resentment. My own anger only reinforced her view that I could not see her and validate her growth. I was the black uterus of hell that would not yield and let her go.

What a relief to throw off the brown dress that now had become like a shroud! What a relief to grab my tango shoes and head for a cab to enter the hoped for sanctuary of Lafayette Grill on a Saturday night! As soon as I got out of the cab and entered the music filled restaurant, with crowds at the bar, a tango lesson going on on the dance floor, and tables already filled with people starting and having dinner, I felt better. I felt still better when my entrance brought immediate recognition from so many quarters. First the Major D said "hello" to me by name, and then the host of the evening came to kiss and hug me. I saw that my date was not there yet. I was glad to have some time. I was pent up and wounded on the inside, plus stuffed up in my throat and nasal passages from a cold. Yet the warmth of Lafayette Grill began to pervade me, soothing somewhat the psychological invasions of the earlier hours that day at the meeting, which had conjured up the internal images of the dark family within—all the

judges. The pain of the dark penetration of the wound, the preoccupation, and the searing agony began to slightly fade as I was immediate greeted with full recognition by so many.

Of course there was the waiter who knew what I wanted before I knew I wanted it. However, tonight he anticipated my usual request for a café latte, and was surprised to hear me as for a green tea with lemon and honey. Yet immediately he got it. He said I guess you're not feeling well. I said "You got it," and added on an order of onion soup. I was looking for soothing broths, but the pain within and the obsessions about the damage of my own anger continued to haunt and pervade my consciousness every other moment. Yet these moments had punctuated reprieves as others greeted me. Warmth entered my being! Several men I had danced with, and a male tango teacher, came by and kissed me on the cheek or hugged me. A woman I had known at a dance studio, where we had both taken private tango lessons, came up to me, and gave me a big hug. I said I was glad she had joined us all at Lafayette Grill. As I went down to the dance floor to dance with a male friend I received several complements on my dress. "I love your clothes," one woman said, or maybe a man. Such soothing words did not totally quell the pain within but the subtle salving quality of the words did help. And the minute I began to dance the dancing helped so much more. I felt the music, the warmth of my partner, now my date, my husband, my friend, who held me in the tango embrace!

Just before I had come I had tried to open to the anguish and release some of the pent up feeling in grief stricken tears. I was only successful at such release, when I allowed my mind to formulate the tormented words spoken to me by another about "some deep existential loneliness" at my core. The words echoed in me, "existential loneliness" and a few tears graciously flowed forth, to take the edge off. But the well of injury inside hardly relented. Still my psychological paralysis was somewhat less after this, and I was able to begin to move, to gather my things together to make the trip to Lafayette Grill. For a few hours before I was transfixed in internal obsession, repeating the dialogues of the meeting of the day in my mind.

Also, as I entered Lafayette Grill the intermingling of the couples who were our close friends by now was extremely comforting. We danced and watched the dance, as the dance floor flowed with an early evening fullness. Later that evening my husband and I would exchange partners with another couple. The man was dressed in a fabulous lavender color shirt tonight and as he passed by to kiss me earlier in the evening I commented on his great colors and its blend with his dark distinguished suit. He seemed pleased. Later I saw his wife was wearing a matching lavender dress, and as she came up to hug me, as she went down onto the dance floor, I commented on their matching colors, as many had com-

mented when I and my husband serendipitously wore the same colors. These comments were seemingly on the surface of things, and I noted this in my mind as I took what pleasure I could from this level of friendship. But I also realized that there was a terrain beneath this surface pleasure based on mirroring admiration purely on the basis of clothing and looks. The couple we exchanged these comments with could be considered part of a New York tango family that centered itself at Lafayette Grill, particularly on a Saturday nights. We had seen and encountered them over much time. Recently, they had attended my Lafayette Grill birthday party and the male of the couple had joined in my birthday dance as well as dancing later this evening with me. The female of the couple was a pretty Asian lady who now would join my husband in the tango embrace and partnership, letting her mind flow with the music as her feet moved to it. She had become more aware of me as a personality, beyond the tango evening itself, when she was given a calendar with pictures of me at my birthday party. She saw the books I had written there. She began to ask me about this scholarly work in my life. She also commented that she appreciated the taste with which the whole calendar was put together, because she at first was slightly repulsed by the thought of a whole calendar focused on me. She prided herself on not displaying herself so. Yet she would get down and dirty on the dance floor with the guy who loved to twist the bodies of women into interesting pretzel shapes, as he literally floored them in the course of supposedly leading them in tango. She seemed quite the exhibitionist at this time herself. Perhaps she had been taught in her culture, however, to not display herself consciously, even if unconscious displays seemed to become acceptable in the tango world.

So could this be like a real family, this gathering place for every Saturday evening, as well as other evenings, at Lafayette Grill? Could it substitute for the injured yearning for family in the professional meeting I had attended? Throughout the evening, I danced with so many other men besides my husband. Some were tango friend regulars at the Grill. Some were those dropping by occasionally. Some were foreigners from out of town. Some were hosts of the *milonga*s and professional tango teachers. At the end of the evening I danced with one gentleman who had his *milonga* at Lafayette Grill on Tuesday night. I often danced with him. Sometimes I took lessons from him and greatly benefited from his instructions in weight shifts and other advice on tango technique. When he came in this evening he said he and I would dance later. So I felt free to ask him to dance later on.

Also as a reprieve from the internal pain, there was the performance of the night, from an Argentine couple from Buenos Aires who did choreographed show tango from a current pageant called "Tango Passion." Focusing on the dynamic thrills of the couple, even if outside the sphere of

104

social tango, allowed my mind to feel a part of a world much greater than I or I and my husband-partner. It allowed me to take with me the frequently experienced feeling of being part of a shared passion that had the flow of sensual desire and intimate connection. How intimate could it really be if rehearsed for a show? But later I could see the man and the woman of the night's performance dance the intimate improvisational moves of the social tango and its tango embrace.

The last dance of the evening I reserved for my husband, and urged him to take advantage of it before changing his shoes back from tango shoes to street shoes. I had danced the two proceeding dances with my professional tango teacher from Tuesday nights. I got to feel the full expanse of my legs and body with him, which gradually relaxed the injured wounded emotional area inside of me. It's not that it wouldn't come up again during the night, but the outer tango family at Lafayette Grill gave me a temporary haven four nights a week in which I could rebuild my strength to process the pain through my body and mind in the next few days to come. Yes, I would conclude, the tango world can provide a kind of family. Being recognized and greeted with a special appreciation of my dress, dancing, and personality gave me a place in my heart for many who also shared me in their hearts as well. They became the extended family for me and my husband.

ESSAY # 16
NEW YORK TANGO: RUMORS and HEARSAY

"Oh," I recalled her image when I saw her dancing with grace but also with her usual air of arrogance, in the relaxed atmosphere of Lafayette Grill. Isabella stood out for the sharp lines of tension and contention in her demeanor, which so much contrasted with the relaxed home-like restaurant at Lafayette. She seemed to be harboring many secrets behind her seemingly contrived nonchalance—also mixed in with genuine enjoyment. She was quite a mixture, as her technique cut edges in a dance that was all about flow and intimate connection. She came in close against the men but she seemed very much apart from them, as she paraded and performed, while in the welcoming tango embrace of her partner.

"I remember her," I thought, as I languished in a weekday *milonga* at Lafayette Grill, taking up with my own "strange men," but hopefully more for fun than performance, when I was engaging in social dancing at a *milonga*, not scheduled for a performance on a stage. "I remember her," I thought. She was the one who I had heard such colorful tales told about from an evening at a dance studio nearby the Grill. I was at Lafayette Grill with my husband that night as usual when the high drama episode had apparently taken place, the one that radiated across the on line Facebook frontiers after its climax, going on for weeks, with commentary on both sides of the mélange and psychological mutilation. A few brief insults cut quite deep, apparently, for all the crowds of observers, both amateur and professional, who attended the "All Night Milonga" that particular night. It was someone who attended Lafayette Grill regularly on Saturday nights who had told me the story. As extremely articulate tanguera, of a literary as well as a dance background, she told the story well.

This dame, who we all knew by her first name, Isabella, as we are all known by our first names in this social dance world, had fearlessly and defiantly parked herself in front of the famous Argentine tango performer, and had declared: "Give me a tango lesson!" as he sat with a full long table of fellow professional teachers and performers at this "All Night Milonga" in New York, when they were all mostly Argentinian. As my narrator at Lafayette Grill then related, the maestro at first politely declined by saying he was too tired to dance after a brutally long day of nonstop teaching. But the Russian *tanguera* took this as a challenge and proclaimed: "Aren't you the famous Miguel? I want a tango lesson." Now feeling irritated by the lady's demanding and almost screaming manner, the maestros attempted to put the dame in her place, along the lines of the Argentine machismo tradition and "*coda*" that declared all women followers must wait to be invited to dance by male leaders, who look at them in the eye and see if the woman will accept or refuse. The woman's position was to be a receptive

107

one, but not the initiator. This did not fly in the world of American, and particularly New York, women. This international gender controversy reached its crystallized apex as the Argentinian Miguel declared to the New York *tanguera*, "You're not supposed to ask a man to dance. You must wait till we are ready to ask you!" Now really screaming right in front of his face—"That's over there! We are over here!" Before anyone at the maestro's table or at the *milonga* knew what was up, the maestro had slapped the New York lady across her face, and she landed on the floor near his feet. In speaking of what next transpired, my narrator made the editorial point, that this flattened lady could not have been much hurt, because when a well-known New York tango teacher came to break things up by asking the feisty female to dance a few tangos, she was up and moving in no time. But she was obviously seething in the interim of dance, because ten minutes later she was back to slash the male maestro across his face with the surging fluids of an unleashed glass of red wine—at least as this tale was reported to me. It was sure that the wine was red not white, because everyone at the table then wrote in the Facebook dueling commentary that followed about how they had been splashed and stained with the wine. One well known Argentine tango female teacher, who lived and ran a *milonga* in New York, having been at Miguel's table that night hissed out her resentment: "And then she came back and threw wine in his face, and it got all over my dress, and I couldn't get the stains out!"

When I asked someone else about this night's events, someone who had her own weekly *milonga*, she said that she had offered to use her email list to send the lady's apology to the New York Tango community, for having caused that night's uproar. Unfortunately, the lady was highly offended that anyone should think she had been at fault. In fact, she was downright incensed that anyone would think she should offer an apology when she clearly continued to see herself as the victim of the machismo man's Argentine arrogance, perhaps not having any self-observation of her own air of royal contempt. Consequently, she snubbed that lady with the *milonga* who was kind enough to think she would help this gal repair her relationship with the New York tango community. All that resulted was that the offended lady removed her patronage from the "friend" who offered her the email list for an apology. Then on the other side, the side of the macho male, there appeared a carefully worded and thought out apology that everyone thought was from the horse's mouth, from maestro himself, through a diplomatic publicist, in this formal statement that joined all the Facebook commentary. In this supposed statement of apology, Miguel had supposedly stated that he regretted the whole incident, knowing it was wrong to hit a woman. However, he defended himself by proclaiming that he had been exhausted after a marathon of teaching during his brief New York stay, and by explaining that he was unable to control his reaction after

ten minutes of having this woman coming up so close that she was screaming her demand for him to dance with her in his face! This would have seemed like the macho man had come out now in a more humble and human way in this heated gender climax of controversy, if the apology had actually been authentic. A little while later it came out, according to my narrator, that this statement was actually a fake. The maestro had had nothing to do with it. Apparently, it was some fan of his that wanted to make him look good, rather than to leave him with the mud on his face. In a world where tango reveals the deepest truths of who anyone is, a tango world in which dance teachers wear t shirts proclaiming, "You can't hide in tango!," because the authenticity of the soul is revealed through every motion of Argentine tango, as the connection to oneself, one's partner, and the music, demands an ultimate coordination of the mind, body, and heart, and its breathing flow, two arrogant personalities can trump the odds of authenticity in the negative direction with their behavior off the dance floor, and in the social milieu of the sacred tango *milonga*.

The next time I saw Isabella dancing, with her usual air of confident condescension, I couldn't help think of this tale of her drama queen victimization, carried out as if speaking for females everywhere against the royal contempt of machismo male pride. Her demeanor seemed to match the tale, when I showed her and some others pictures of myself performing with a male professional I danced with, her only comment was that the photography was good, and who did it? Obviously, even such a casual exchange was stamped with her superior attitude and her indifference to me and my pride in my performance, as she only perused the pictures to see if she could get the photographer to take some winning shots of her. She was always center stage. She seemed to have a strange resemblance to my sister, but who am I not to own my own narcissistic self-absorption, while I comment on hers. Still, I think I feel the tango connection in a more intimate and less detached, and self preoccupied way than she appears to me. A little psychoanalysis goes a long way in my case, and being a psychoanalyst demands I undergo the self-examination of psychoanalysis that Isabella can so very astutely fend off. Perhaps Isabella, who became the center of this colorful tale, can perpetually keep up the walls of her contemptuous attitude, which complements the walls of male macho narcissistic attitude, up so high!

ESSAY #17:
CAT FIGHTS at the BLACK-AND-WHITE BALL, and MISSING LAFAYETTE GRILL

The following essay was written when the New York Tango Festival's Black and White Ball was held at the Stepping Out Studios, where chairs were scarce for all the those who attended the Ball and watched the brilliant tango performances. The anonymous author wanted to share her experience to show some of her frustrations in the tango community, in a satirical and personal way. The Black and White Ball was held for many years at the Stepping Out Studios, but in 2013 the Tango Festival's Black and White Ball was moved to the grand dining and ballroom space above the Ukrainian restaurant on 9th Street and 2nd avenues in Manhattan.

Since Gayatri Martin found this new space the chair conflicts are no more. Everyone has chairs at tables, where they can now comfortably view the international Argentine tango performers at the Black and White Ball. However, the inclusion of this essay on the "Cat Fights at the Black and White Ball" captures some of the dark side of the New York Tango community's ambience that happened in the background for several years.

Prologue

The New York Tango Festival has always been an exciting time for all the *milongueras* (tangueras) and *milongueros* (tangueros) in this town, and for those who wish to come from out of town to dance here. Top stars in tango from Argentina, Europe, and New York City, come to teach and perform during the July week of the summer festival. There are special group classes, with the additional offer of private classes for those who wish it. The Film Festival, and other events through the week, plus the now renowned championship competitions, all contribute to the festivities. The whole annual tango festival culminates in the elegance of the Black and White formal ball on Saturday night, which used to be on Friday nights.

When Lucille Krasne began the Festival, back in the 1990s, she brought together the best and the brightest of tango teachers with special events, like dancing Argentine tango on the Staten Island Ferry, dancing outdoors in Central Park, and the culminating *milonga* in the Black and White ball on Friday night. Saturday night for all in town and out of town festival people was a night where they were invited to the New York *Milonga* at Lafayette Grill for discounted dinner prices. The Saturday night entertainment was also at Lafayette Grill.

Gayatri Martin, who took over the festival from Lucille Krasne, brought in the championship competitions that mirror those done in Buenos

Aires. She re-organized and worked on bringing in top stars like Junior Cervila, Jorge Torres, Anton Gazenbeek, Guillermina Quiroga, and many others, over the years, into the entertainment at the Black and White ball. In the process of re-organizing and making room for two championship competition nights, Lafayette Grill's central role on Saturday night got eliminated, as the Black and White Ball, which generally takes place at Stepping Out Studios was moved to Saturday night. (The ball was moved to DanceSport in 2012). So consequently, the Black and White Ball became competition for the dancing and *milonga* entertainment on the Saturday night at Lafayette Grill.

All this is the prologue to set the scene for the current drama I wish to describe.

The Real Beginning

I have never had fights in the Argentine tango world other than the battles over chairs that take place at the Stepping Out Studios during the Black and White Ball. Sometimes I feel rejected if I'm not asked to dance, or not asked to dance by someone I would like to dance with. Sometimes I've accidentally kicked someone on the dance floor or have been kicked, when our partners are not guiding us adequately through the crowded dance floor, in the New York *milonga*s, where the line of dance is vague or extinguished all together. This kind of thing happens occasionally and seems to be part of the norm. But I personally have never had the intensity of conflictual encounters (to the point of metaphorical challenges to duels) that have become a new norm at the Black and White Ball. Rivalries to possess a chair for the very full program of performances hits the wall of the grave paucity of chairs to be had, and this happens after each woman has been standing and dancing on high tango shoe heels all evening.

This year followed a back log of preceding and foreboding events with other women at the Black and White Ball in the battle of the chairs. When another lady threw down the glove of challenging me to a duel, I was already reeling from several other years of female hostilities at this same event. I was already remembering how the last time I lost the fight and had to sit on the floor, after the preceding year having stood with my feet aching in my tango heels through the whole lot of brilliant performances. I still had the hostile face and tone of the lady who defeated me three years ago vividly in my mind. She declared that she and her husband had come early to the ball (at its early inception when a group class was taught) when I told her that my husband and I had been sitting in certain seats and had placed our belongings on two chairs. She said that she had been there at this earlier time, and with an arrogant increase in her volume, and a distinct tone of self-righteous disdain, exclaimed that she was not moving an inch

from her chair even if I had sat there earlier and placed my belongings there. She was obviously not only someone who had to be right, but when faced with the challenge of me placing my derriere in what she was considering to be "her" territorial chair, she managed to reach such a range of combined contempt and nauseous disdain – supposedly for my impotent intrusion – that she peaked as if in orgasmic heights when she thought she had succeeded in humiliating me by her declaration. As usual there were no other chairs open to be had at the Black and White Ball, which could result this way in black eyes on white faces. Consequently, I was relegated to a lowly posture on the floor, albeit along with many others. I then felt further humiliation as I spied out of the corner of my eye this same female dominatrix laughing mockingly with her girlfriend about my plight, while her husband slinked away to stand calmly on the sidelines during the professional tango performances, obviously avoiding being involved in this female brawl.

I attempted to speak to Gayatri about the chair situation after this. However, the stress of her organizational task did draw itself out clearly before me as I tried to describe my personal predicament, which I proposed might not just be my personal predicament, because a large majority of the Black and White ball crowd every year went without chairs. She of course was subject to the setup of the studio, which normally didn't have so many sitting on the side lines for so many performances at once. And further, it was obvious that even by some miracle they could transport chairs, or beam them in from outer space as on "Star Track," just at the very moment when the *milonga* transformed into a stage set for entertainment, the extra chairs would obstruct the large ballroom space that was provided, not only for each individual performance, but for all the performance couples dancing on stage at once during the grand finale. So I had to concede to Gayatri, at least for the moment, and accept my fate in the mélange of the Black and White Ball failed ambiance. However, I managed to salvage a note of hope, lodged in the sadomasochistic scene I had just participated in that year at the Ball. Although the misanthropic dance, which was really a fight, between the lady and I that year had left me burned, and although I had to grovel a bit to Gayatri, when I made my complaint, I managed to salvage some comprehension of the content of my opponent's message, despite the lady's arrogant bravado. The lady who defeated me had declared that the rational for her claim to the chair was founded on her entitled position related to her having arrived at the earliest inception of the Ball. The self-righteous lady founded her claim for precedence on her own report that she had arrived before the beginner's class began, even though she was an advanced dancer. Consequently, I decided that if I did return to the Ball in future years I was determined to get there at the outset of the evening.

The next year I was left with enough of a bad taste from the chair encounter to not buy tickets for the Ball. My husband and I went as we usually did to the Saturday night *milonga* at Lafayette Grill instead. But because the hostess expected very few people on that particular Saturday, and since the tango festival was no longer stopping at Lafayette Grill on Saturday nights as it once had, no entertainment had been planned. This in turn resulted in the very small attendance that was actually predicted in the mind of the hostess, since nothing to compete with the Ball was advertised. The expectation became a self-fulfilling prophesy. So I naturally wondered, what was going on "over there" at the old Black and White phenomenon.

So the next year, with Gayatri's usual enticement to buy tickets for the Ball, I decided to try again. But this time I prodded my husband to get to the Ball at practically the moment of its inception. There was only a beginner's class being taught that we didn't want to participate in, but the Argentine tango shoe peddlers were there with their elegant essences, and although there was no food yet, and we couldn't dance, I did emphatically see to it that we sat with some propriety and proprietorship in two then vacant chairs at the edges of the ballroom terrain. I also decidedly deposited belongings of mine and my husband's, both on and below the two chairs that we occupied, anticipating the perils of getting up to dance, when other tango dancers who were either resting or not asked to dance would swoop in like vultures to make their competitive claims to "our" seats.

Ultimately the dirty deed did come to pass. Without a steal case with padded locks to put our chairs in, some women sat innocently in our chairs while my husband and I, or I and other men joined others on the ballroom floor to dance.

However, this time when I came to re-claim my own chair I conjured up my chosen rights and phrases, declaring to a lady I actually knew that I and my husband had been in those chairs from the earliest time of the evening, and hoped therefore to return to the chairs to rest again. I didn't even provoke the situation by mentioning the impending performances. Perhaps not wanting to fight, since she knew me and my husband, this lady said that even though she didn't believe that it was right to reserve chairs, since I obviously did think reserving chairs was my right, she would agree to disagree, and would surrender her chair. She even conceded that I might have a point.

I gratefully smiled, and said I did appreciate it, since my husband and I had made so much effort to get to the studio for the Ball extremely early, requiring much inconvenience and effort on our parts, and given that my husband was tired. So this lady was skeptical but agreed to disagree, and relinquish her chair. I felt this was quite a civil encounter compared to my last experience at the Ball.

However, civilization was not to survive another year and another challenge. More aggression would be required of me in this next year when I made the very difficult choice to deprive myself of a full program of performances and dancing at Lafayette Grill (the place where I would dance with all my friends, and with the hosts that were my friends), to once more invest in tickets for the Black and White Ball. I had less time this year to attend other events at the Festival, so I thought I'd be part of things by at least attending the Ball. My husband agreed, although he had had a physical stress problem that weakened him, and the weather made even a well air conditioned inside event into a rapidly escalating steam bath, which further weakened my husband, and didn't delight me.

When I learned that some very special friends of mine were going to be the performers at Lafayette Grill on the Saturday night of the Ball, which I wished had been on Friday night as in the past, I had some regret and doubts about whether I had made the right choice for that evening. Yet, I knew there would be exciting performances at the Ball, and I enjoyed getting ready for it, wearing a very short black cocktail dress, that was low cut, and had feathers, along with my black and gold custom made tango shoes.

Again I insisted to my husband that we get to the Ball extra early to claim our seats for the later performance time. So we got there before the food, and before the majority of the guests, seeing only an assorted few dancers sitting on the few chairs on the side lines, while my husband and I, and maybe one or two, or three couples at a time danced. At one point we were the only ones dancing. I again placed my bags, my shoes, and my husband's vest, and my husbands' shoes, on the seats whenever we got up to dance. For insurance, I even left some items on the chairs when we sat down. I was staking out our territory, and this already was interfering with the pleasure quotient of the evening for me. As male friends of mine came into the ballroom space I thought I would like to dance with various guys. As the heat escalated, I suggested to my husband that we go into the slightly cooler room where *nuevo* tango music was being played. I danced with someone there. Then I left my husband there, since he didn't want to budge from the slightly cooler space, and anxiously returned to see what the chair situation was, since I was determined not to be on my feet or on the floor if possible for an hour or more of show time.

Since show time did not come too soon, I realized I would have to sit quite still, for quite some time, to keep the chair that I had to reclaim from someone who had sat in it. I may have danced once more, so I had put my bag and my husbands' shoes again on both our chairs. When I returned this time, the lady who agreed to disagree with me last year was in my chair talking to a friend of hers that was planted in my husband's chair. Extremely lightly, I tapped the lady I did know on the shoulder, and said

"This was my seat." This lady obliged me and stood up without looking at me, and proceeded to converse with her friend from a standing position.

I was relieved and sat in my chair. She was then gone off to dance or eat, and I observed that her friend was sitting on my husband's chair with the paraphernalia I had placed there remained behind her on the chair. I decided to sit still, despite how much I longed to get up and find a friend to dance with. Earlier I had gotten up to dance with a gentleman I knew who came to ask me to dance. However, now the clock was ticking towards the time of the planned performances, along with the sultry weather heating up, keeping my husband off in the *nuevo* tango room.

It did occur to me that I would like my husband to have the opportunity to sit and watch the performances with me. I didn't want him to miss the performances, and I didn't want him to have the stress of standing through over an hour of performances, especially given his recent pains and strains. I then observed the lady next to me, on what I clearly considered to be my husband's chair, tell someone I knew not to sit down on the chair on the other side of her since she was reserving that chair for her female friend, who had recently danced off. I watched the lady, who she had just cautioned to not sit there, oblige her by not sitting down.

It was at this point that I took the plunge. I declared that my husband was sitting in the chair she was currently in. This grand dame then glared at me and put all the gravity of her weight in her speech as she re-articulated the word "was" with a trenchant challenge. I felt and saw the glove being thrown down in a challenge to a duel as she proclaimed, "I'm glad he *was* sitting there." Whether a gauntlet or a glove was thrown down before me, I instinctively threw my weight behind my words in a counter-point and declared, "And *will be*!" All my emphasis was on the word "will!" to clearly state the case that my husband would indeed return to the chair he vacated merely to cool off.

I also thought what a hypocrite this woman was, as she just had asked my other friend to decline to sit to accommodate her friend who might or might not be coming back. Then the games began. I said I had placed my husband's things there since we had come quite early and he had sat there. She said: "These things shouldn't be here!" for the first time noticing she was sitting in front of a shoe and a bag and a vest. She proceeded to indignantly place my carefully placed items on the floor that had been on her chair. I looked directly at her, and then picked each item up, including the shoe, and placed it back behind her on the chair. She then proceeded to take the things and again place them on the floor. I then proceeded to place them back on the chair. And once more, she placed them on the ground, and I precipitously followed by placing them emphatically back on the chair! Finally exasperated, the lady who had challenged me to this duel exclaimed, as I felt the intensity of my own

116

blood and bile surging through my veins, "I'm going to tell Gayatri that you are doing this!" Primed now for an immediate retort, I countered, "I have already spoken to Gayatri about this!" And indeed I had. I had already spoken to Gayatri about the chair challenges three years ago, so I felt quite trigger ready to reiterate the point, and have the last counterpoint word.

Then I asked the lady who had stood up to oblige my opponent who hypocritically claimed my husband's reserved chair, "Why don't you sit down?" She said she didn't mind standing, because my opponent had said she wished to save the chair for a friend. Just at that point, my opponent got up to join a gentleman in a dance, and I said to the female friend who had obliged her, "She's not saving it anymore. So my friend sat down in that lady's friend's chair, and I had my husband's chair back, with all the appropriate paraphernalia on it. All this time, I was thinking, I'd been sitting in my chair, on the side lines of the room, feeling like a wall flower, not dancing, or getting up to find someone to dance with, just so I could reserve these damn chairs for the upcoming yearly Black and White Ball performances! Was it really worth it? I certainly hoped my husband appreciated it. I did remember the years in the past when my feet ached terribly as a stood through all the performances, in my tango heels, reducing any pleasure I could derive from the performances. After all, I had now done the work of coming early and of sitting like a wall flower for what seemed liked ages to stake out my territory, so I could enjoy the performances, and so that my husband could at least sit after being wiped out by the heat.

Would I receive any husbandly gratitude? I contemplated this question, as a young and obviously healthy blond girl comes by and plead, seeing the chair next to me packed with paraphernalia, "Could I please sit here? It's so hard to find a chair in this place. All the other chairs in the room are taken." I reply that she can certainly sit in that chair, and I remove some things from the seat of the chair, but I add, "This is my husband's chair and he will be returning." She seems to assent to this at the moment when I relieve her by offering the chair.

Just moments before the performances, my husband reappears. I say to the young lady who has now occupied his throne, "My husband is back and needs the chair." She reluctantly stands up, but then sputters out as my husband sits down as if nothing has happened, "I don't think one should be able to reserve chairs!" I just ignore the ungrateful 20-something creature and she walks away.

As the show begins, I lean over and whisper to my husband, "Aren't you going to thank me for saving a chair for you? I was challenged to a duel to safeguard your territory. I had to fight for your chair." So what does my husband say? He comments with the same apprehension that the lady's husband showed three years ago, whose wife had defeated me in the

battle of the chairs: "I would have stood up. I don't want to be involved in any fights." Then he denies any current aches or pains, until the following evening, despite his earlier complaints. Couldn't my husband see that I saw the challenge of a duel, with the glove thrown down, inciting me to defend the honor of my husband's rights? I had responded as any fine French Aristocrat of the 18th century would have done, except that it would have been a gentleman Aristocrat and not a lady.

Is this comic or tragic? Again, I end up enjoying the Black and White Ball less than other festival events, particularly as I wistfully recall my friends at Lafayette Grill, and miss having been there on Saturday evening. Fortunately, in spite of this, I am reassured about the New York Tango Festival itself when I take a great "Advanced class" on turns and rotations with the renowned "Forever Tango" star Jorge Torres, and also enjoy a film offered at the festival the next day, Sunday afternoon. And although I saw the lady who became my opponent whispering to her friend about her encounter with me, I didn't see any mockery or ridicule in her friend's face. After all, this time I had won the battle, and both of them were sitting on the floor.

I felt justified that I had earned this victory by coming early and sitting like a wall flower for some time. I then did get to enjoy seeing all the performances without physical discomfort. Nevertheless, I yearn to return to Lafayette Grill where I feel such a homey family like atmosphere, and where I always have a table and chairs to return to, to have privacy and relaxation in between dances. And wasn't it just last Monday at a Lafayette Grill *milonga* that the combined pleasure of the Lafayette Grill atmosphere and of dancing with a really good and developing male tango dancer, who is also a visual artist and painter, resulted in an in between dance spontaneous conversation. My male partner looked at me and exclaimed suddenly, while we waited for the next round of music, "Your smile is like lantern lighting up this whole room!" I said, "Since you're a painter you notice these things." He said, "Yes, but I'm also a human being!" Then we began to dance again. Two days before, at the long standing Saturday night Lafayette Grill *milonga*, another male partner had made me giggle at 2 am in the morning, when we had lots of floor space in the ballroom, so that he could lead me in high kicking *boleos* that wrapped themselves around my body. The child in the woman could emerge freely in this special Lafayette Grill ballroom play space.

ESSAY # 18
The TANGO BIRTHDAY PARTY
within the GREEK FESTIVAL

I wanted to perform for my Argentine tango birthday party. Lafayette Grill was the place that allowed me to perform either with my husband and or professional or amateur tango friends. I also would do the traditional birthday dances, in which all the guys line up to dance with me. Within the Argentine tango community one can always feel special on one's birthday, because of the traditional birthday dance in which all your friends at the *milonga* would line up to dance with you, but also because others at the *milonga* that night would line up to dance with you as well. Those lining up weren't always the best dancers that lined up, but by having my own birthday party dinners at Lafayette Grill, I made sure that I had both professional and advanced tango dancers who would want to line up and dance with me, during the traditional birthday dance. In addition, I would get permission to perform a separate dance with my husband or with a professional guy. Since they cut back on me doing two such performances, I hoped to integrate a dance with my husband and with Jon Tariq, a professional teacher I was currently taking lessons with. I also usually had a professional photographer and videographer filming my performance and birthday dances.

Practicing some choreography along with improvisation, I was anticipating a very special evening for my birthday party this year. I was inspired by Jon Tariq's lessons to aspire to *molinetes* with back *sacadas*, and with special *planeos*, with embellishments (also called "ornaments") both in the air and on the ground. It was always fun to practice with the image of performing before an audience. Also, as an amateur with rare opportunities to perform, my Lafayette Grill birthdays, where I invited friends and colleagues who would be in the audience along with other tango friends and strangers who were at Lafayette Grill that night, gave me the kind of excitement that the professional tango performers had, yet without the stress of having to perform to impress, so as to make a living through tango. I considered it the best experience as an amateur in the tango world, who had a totally different profession than tango teaching or performance. Lafayette Grill had given me this opportunity every year, and I was very grateful!

So what a shock it was for me when several weeks before my party, which I had scheduled with Dino, the owner of Lafayette Grill, a year in advance; and after all the email birthday invitations had gone out to my friends, I was confronted with a potentially disrupting reality-- a gross and enraging intrusion, as I experienced it. It was during a Saturday night *milonga*, in the middle of dancing with my husband and others, that

someone told me that there was going to be this big Greek festival at Lafayette Grill on the very same Saturday evening as my tango birthday party was scheduled (where I had reserved the whole upper balcony area, with its tables, for my friends)! I couldn't believe it. At first, when someone just mentioned this event to me, I didn't believe it! I was told that there was a flyer being given out announcing the Greek Festival event: a whole Greek troupe of performers, with two top Greek Festival World Champions were on their way. I said it must be happening at another place or on another night. I said that was the night of my birthday party, and I was going to perform and do my birthday dances! I felt my performance threatened, as well as the whole ambience of my friends celebrating my birthday with me up on the balcony and then being in the audience for my performance. I went over to one of the managers at Lafayette Grill and asked what was happening, telling her that was the night I was performing for my birthday party, clearly asserting that I had scheduled my party a year before.

The female manager showed me the big postcard flyers, and I grabbed them to take up to my balcony on the table to read. I grabbed a whole bunch of them. She called after me, and said "We need those! We paid a lot for them!" I ignored her for the moment, ran to my table and read the text of the flyer. Yes, damn it! There was a whole Greek Festival weekend planned at Lafayette Grill on the weekend of my birthday party. I was enraged and scared, angry and despairing. My big night might be in jeopardy. I felt like tearing up the whole bunch of flyers, but had some rationality left for restraint, realizing they were not my property, realizing I was acting out like a child wanting to throw a tantrum. I brought the flyers back to the female manager, and said I wanted to speak to Dino because he had put my birthday party down in his schedule a year ago, and I had confirmed it six months ago, and three months ago, etc. I wanted to make sure my guests could be on the balcony and I could do my performance and birthday dances. I protested again to the manager: "All the invitations have gone out! People RSVP, and they are coming. Everything is set! I must be assured by Dino that this Greek Festival will not interfere with my party!" I was told that Dino was not coming to Lafayette Grill that night because a dear older woman friend of his, who he had frequently brought to the Grill to eat and spend time as his guest, and who he had brought out to breakfast and to other outings from the residence she lived in, was quite ill. Dino was there by her side. "Oh, I'm so sorry!" I said. I was contrite. Dear Dino was being a wonderful "mench" again, for an older Jewish woman. He was a Greek "mench," I thought. I couldn't say anything else, except that I hoped to speak to him as soon as he comes in to the Grill, or I said I would try to call him. I emailed, but got no reply. I did have his cell phone, but I thought I should wait, since he was his brother, Billy, said this dear friend was serious ill, and that Dino was exhausted, but constantly visiting her. I

felt ashamed of my self- important birthday agonies in the midst of what might be a terrible and tragic loss for Dino—Dino, who had been so compassionate to all, as he was being compassionate to his dear female friend. I would have to wait.

Dino's Special Arrangement for My Birthday Party and Performance on the Night of the Greek Festival

When Dino returned to Lafayette Grill he offered to talk to me about my plans for my birthday party, even though he looked tired from all that he had been through. I told him I was very sorry to hear about his dear friend's death. Then we spoke about how I had planned with him to have my birthday party on the last Saturday night of the month of January as I always had. He said the Greek Festival had been booked for that weekend for months. I said I had told him of my birthday party date way before that. He said that he would see what he could do, but that the Greek Festival Directors were in charge of the whole weekend at the Grill and they would have to agree. At the moment they were still in Greece, where the Greek Acropolis champions had won the competition. I reiterated that my invitations had been sent two weeks before and people were planning to come. I said I would have approximately 30 to 40 guests, perhaps more. We confirmed that my friends would all sit up on the balcony.

Dino kept his word to work things out with the Greeks. When the Greek Festival company arrived in town, and the Directors of the company came to speak with Dino on the Saturday night a week before the festival and my party, Dino made a special point of introducing me to the Greek Festival Director and his wife. The male director was Argentinian. He spoke English, and was married to a Greek woman for many years, who did not speak much English. When they came in and sat at a table on the ground level, coming to discuss all arrangements with Dino, I and my husband were at a table on the balcony. After they conferred a while, Dino asked me to come down and be introduced to the Greek Festival directors, who also sat with friends. He introduced me, and said to the male Director, who could understand more fully, "This lady is a very special patron of Lafayette Grill. She and her husband come four nights a week here to all our *milongas*, and they have dinner and dance tango. This is Dr. Susan Kavaler-Adler. She would like to meet you. She is going to be having her birthday party here next Saturday night, during your festival. She would like to perform for her birthday and have birthday dances, before your champions perform. I hope this is all right with you. She is a very special person here at the restaurant." The Argentinian man, who was the director of the Greek Festival, smiled and said a warm "hello." He introduced me to his wife, and she smiled, but did not understand our conversation. The

gentleman said Dino was a wonderful guy, and I certainly agreed. He said he was glad I could understand his English. I smiled and said it would be a pleasure to have my birthday party within his Festival, and I said I was looking forward to seeing his dancers perform very much, but that I would also like to do my amateur birthday dances. He asked if I did tango. I guess he missed some of what Dino said. I laughed and said: "What would I be doing here four nights a week if I didn't do tango?" He smiled. I asked if he wanted to dance. He said he would loved to, but hadn't brought his tango shoes, since they just came to make arrangements. He said he was embarrassed. I said there's nothing to be embarrassed about. He said we could dance on another night that week, maybe Monday, if I would be there. I said I would like that. Then as I danced down on the ballroom floor with my husband and some friends I wondered if he was watching at all I did want him to see that I could really dance Argentine tango. Later he would complement my performance, but also say how this would generally be totally out of the question to have birthday dances in the midst of his festival performances. But like everyone, he loved Dino, and because Dino asked him as a special favor to allow me to do my birthday performance and birthday dance on the next Saturday night, he had agreed. Because of Dino my party and performance was to blend in beautifully with the Greek Festival festivities and performances. I am most grateful to Dino.

Lessons to Practice for the Birthday Performance

My poor dear husband does not share the enthusiasm for performing tango for others that I do. He particularly doesn't like to have to memorize any choreography, wanting to feel the music and the flow of life in the moment of tango, without any contrived formulas of patterned movements. Nevertheless, every year at the time of my upcoming birthday parties, he consents to join me in some preparation for a performance for our friends and for the other Argentine tango patrons of Lafayette Grill. This year we began taking lessons with Jon Tariq with the express purpose of practicing for the brief one cd tango performance on the night of my birthday party. This performance dance would be followed by the tango men, friends and others, lining up to dance with me for the traditional birthday dance. In the sessions with Jon, my husband and I danced our usual tango connection, with various steps and patterns that my husband led from habit. However, Jon wanted to give us certain more dramatic tango moves and patterns to create more of a show. I, of course, wanted this, but my husband was reluctant when he tried difficult moves and was corrected by Jon repeatedly. However, he came to every lesson I planned and paid for, and as usual his loyalty to me won over his resistance. But it would be touch and go up until the party and performance. The Friday before the

Saturday of the party we had a lesson in which my husband seemed to be forgetting all the possible new patterns we had been practicing. I panicked a little, and was glad that I would be doing the second half of the dance with Jon himself leading me and finishing with a dramatic end. Jon instructed that we come the next day, the day of the party, in the afternoon, for a double lesson. My husband agreed and we came the next day and went over everything from scratch to help my husband remember the moves we had been practicing with Jon. Jon and I were relieved that my husband began connecting again with me, himself, the music, as well as with Jon's suggestions of some more dramatic steps (steps for the stage) that my husband would not have initiated without instruction and practice. All led to suspense, as Jon and I had little time to practice our part since we needed to work intensively with my husband. Jon said the part with me and him would be fine.

The Dress

Lime green neon, flapper era fashion and fringes. It hung on the mannequin in the dress shop attached to a studio that Jon had one of his *milonga*s in. I saw it late at night at a *milonga*, when it was too late to buy anything or try anything on. But I had a partner in crime, who sneakily motioned me to come to the "*nuevo tango*" room where the dress hung on a mannequin, out in the open, where it could be gotten to. The guy who saw it there offered to slip it off the mannequin, behind the closed door of the "*nuevo*" room. Slipping it off the mannequin apparently wasn't that easy. My male friend had to take part of the mannequin apart, and put them back together again, a humpty dumpty feat that had an impish and devilish quality to it. Unscrewing the arms of the mannequin, he managed to lift the delicate fringe cloaked dress, with its short and petite shape, off the mannequin. The dress was delicate and so was the mannequin, but my friend managed to defeat the carefully contrived handiwork of the dress shop keeper who strived to keep the dress on the mannequin. Once he got the dress off the mannequin I was free to run into the bathroom to try it on. I was delighted to see this most exquisite, unique, and glamorous dress fit so sensuously and concisely around my body, and to see how its short length also showed off my legs. I would have worn it there and then, but there was nobody to pay to purchase it, so my male partner in crime slowly and gracefully put the dress back on its wooden personage. I knew I could come back the next day to buy it, the day just before my actual party at Lafayette Grill. I would be there tomorrow, after calling to see that there was a narrow window of opportunity when they would be open and I could come over. Jon came with me, and gave me a cheerful nod of appreciation and attraction to me in this flapper elegant dress. Some others around the

shop remarked how the dress was so incredible and flattering on me. I was definitely taking the lime green fringe flapper dress, which had a neck band in green and green bands to wear on my arms in flapper style. I was definitely taking it! I even wore it out of the shop.

The Birthday Party

I arrived at Lafayette Grill at 8 pm. It was the beginning of dinner time, but early, way before the *milonga* that would begin at 10 pm. Even before my arrival, my 93 year old male tango friend, the famous Alex Turney, arrived, with his friend Joyce. He greeted me with a big hug and kiss. Then other friends began to arrive, including my old friend and colleague, Henry, and his charming artist wife, Linda. When Henry saw me in my lime green fringe flapper dress he went: "Wow! You're slaying me!" He opened his arms wide with the excited enthusiasm of his attraction and offered me a huge hug. Linda kissed me. Then others began to arrive, some bearing gifts although I had asked them not to bring them, and to contribute instead to the institute that I was the Executive Director of. Some brought envelopes with checks for that cause. We began to order dinner from a special menu that Dino had for such big groups as my friends all occupying tables on the balcony. There was always a pasta dish, a fish dish (salmon), and a chicken dish. Everyone found the food delicious! Old friends that hadn't appeared in the tango world for a long time began to come, and I was swept away to dance as soon as the *milonga* began. There were fabulous waltzes with a young thirty something male friend of mine, who had been out of the tango scene since he married a woman who didn't dance tango, and moved to the suburbs. He was eager to get back into the tango music, and he was particularly thrilled to lead me in large sweeping and gliding movements on the dance floor as a whole *tanda* of waltzes played magical symphonic rhythms. I felt the large undulating movements in my body, as the fringes of my dress swayed. I closed my eyes, and enjoyed the close embrace with this young man I had danced with so regularly before his marriage. We were deeply absorbed and guests of mine on the Lafayette Grill balcony watched us, especially those like Henry who loved to dance himself. And the famous 93 year old Alex watched. There were new friends, too, such as an editor of a large New York newspaper, who was also in the world of psychoanalytic institutes.

Lafayette Grill Greek Festival Atmosphere

The evening had a distinct feeling of building up excitement and intensity. More and more people were piling into the Grill, and the dance floor was becoming plentifully stocked with increasing numbers of high

level tango dancers and professional tango teachers and performers. They were all flocking to the Grill because of all the postcards and emails advertising that the international Greek champions were going to perform tonight, in the midst of an overall Greek Festival. On the sides of the dance floor hung designer dresses by a well-known Greek designer, who nobody knew here. The couple that was running the festival, who I had met the night Dino introduced me, asked what I thought of their dresses as they also complemented me on the Green fringe flapper dress that would become neon radiance during my performance. The DJ that night introduced me as the birthday girl, and I waved from the balcony to the crowd now surrounding my party guests, throughout and around the restaurant. I had told the prospective DJ beforehand that I would like to do one performance and two birthday dances. He was skeptical, but I said I did this every year at Lafayette Grill, and that I and Dino had spoken about my doing this. He had withdrawn from any discussion of this by retreating to his DJ position, saying: "Just let me know ahead of time what music I'm supposed to play for your dances." I ignored his silent disapproving judgments, and merely responded to his overt message: "yes. I'll tell Jon to get the music to you by email." Jon did get the music to him and he was prepared for all three of my dances.

I had told Dino that I wanted the cake to be brought to me after I danced my dances, not before. I felt this made much more sense than having everyone sing "Happy Birthday" to me before I had taken flight in dance and won the applause of the crowd. Dino was always extremely generous with those who celebrated their birthdays in his restaurant, especially if they were from the tango community, and even more so if they were regular patrons who brought in tables of guests for their birthday celebration. Every year Dino would ask me which kind of birthday cake I wanted, and he would always offer it as his free gift to me. He did the same for my husband's birthday, or for our anniversary parties. Since I always hired a photographer, and sometimes a filmmaker, for these parties there would always be some pictures of me receiving my chocolate mouse or strawberry cream birthday cakes from Dino. In the old days, when Sondra Catarraso was the hostess, along with Jose hosting every Saturday night, it was Sondra who would bring out the cake, and so she was always in my pictures.

I felt excitement and some pre performance jitters building up in me as the time approached for my performance and birthday dances. So many people had entered the restaurant by then that the bar area, and all the tables on the floor, on the sides of the dance floor, and under the balcony were flooded. The tables were overflowing with people, and even though I had demanded the whole balcony area for my forty or so guests, others had been seated up on the balcony as well. My friend Henry commented: "This

place is really taking off tonight!" My new friend, Michael, exclaimed when I asked him if he had watched me dancing tango with my friends and with my husband, during the *milonga*, "Wow! It's amazing! I am so thrilled by your 'joie de vivre.' You are so passionate about everything you do!" I was feeling like I was glowing, and once out on the dance floor in front of such a large audience I was ready to take off. Someone used the word "scintillating" to describe how I had looked when I did my dances so I must have transformed my jitters into waves of excitement that could flow through me as I began to respond to the elegant and connecting embrace forming between me and my husband. The beginning of the performance dance had been practiced with Jon, who had directed my husband into how to take the initiating lead. My husband slowly walked towards me as I stood ready. He held out his left arm for my right hand and arm gracefully, while he put his left arm around my back and I lifted my arm, and then very lightly lowered my hand and arm behind his head to land lightly resting on his upper back.

My husband remembered to let me come towards him, rather than rushing me, and I leaned slightly towards his chest so there was just enough space between us. Then my husband also remembered to reach his left leg out to the side on the floor, while remaining with his weight on his standing leg, and I did the same, in coordination with him, doing a small ornament, drawing a circle on the floor, as I then stretched my right leg out to the side in coordination with him. Then, and only then, did we move into steps, starting with a basic pattern of me stretching my right leg back to walk with him as he went forward with his right, until I crossed my left leg over my right and the ankle.

The slow elegance, in line with the very classical and famous music of Osvaldo Pugliese's 1950s "Recuerdo," allowed us to look more professional than amateur for this moment. I was so happy that my husband had been able to really feel and carry off the initiation of the dance. Those special first moments on the stage before everyone! So I could relax and let the rest flow, as I intermingled choreography from Jon with the totally "in the moment" spontaneity of tango. Now we are into it! I am doing a *molinete* pattern around my husband, leading into a back *sacada* towards my husband's ankle that didn't totally work because my husband moved, but I nevertheless was feeling the elegance of my legs in my very short dress as I flowed back around him, side, back, forward *molinete* steps, leading into *gancho* kicks under my husband's legs, all of which was following from my husband's lead. Then my husband surprised me by not only remembering steps and patterns we had done with Jon, but also by repeating some powerful leads for me to do *ganchos* under his legs, and *barrida* slides of my foot and leg on the floor, through his upper body movement. As it should be in a good tango performance, the choreography

that we had planned disappeared into the background as it became part of an overall natural and spontaneous flow in the moment of improvisation. All true tango was improvisation! No matter how much you plan a pattern of steps, what really counts is when you feel fully present in the moment with each step, as if it just occurred to you for the first time. Both my husband and I felt it. We felt that "in the moment" feeling, and my husband kept going longer than planned, masterfully feeling his expansiveness and upright posture, going beyond his usual self as we danced before 200 or so people, and all my birthday party friends up on the balcony! We heard their cries of appreciation spurring us on. There was one place in particular when I leaned back on my husband from a side position to do a *planeo*, drawing circles of the floor with my left foot as I moved left with my husband. I also lifted my leg and foot up in the air and continued the circle pattern. At this point, right in the middle of the dance, I heard a few moments of spontaneous applause! Then my husband kept going, while Jon waited for his turn in the dance with me. He then turned me over to Jon, who had less time with me than originally planned, but we were all so happy that my husband, with all his resistance to performing had emerged into the expansiveness of the evening. He emerged with his true talent. He emerged with his musical sensitivity, and with his true capacity for deep connection in tango. Jon took me into some fancier steps, and I did a lot of high boleo kicks and *volcada*s, leaning forward into him and the floor. I did a special spiral ankle turn ornament that Jon had recently taught me, and it came off as I lead from that right into a *gancho*, and then Jon led me into a wrap around his right hip that he navigated into a crescendo turn to end the dance. The applause broke forth at a high level as we bowed to the audience and I gestured for the audience to "give it up" for my husband.

When it was time for my birthday dances with all the guys lining up, my husband started off leading me, and then very quickly a whole line of guys walked up, one after the other, to dance tango and tango waltz with me. Some of the men were friends who were my guests for the evening, but many were other tango guys who were there for the *milonga* and Greek Festival. I couldn't know who would line up and appear before me, cutting in on the last guy, to initiate his moment in the spotlight with me. I felt open with pride and joy, after my performance, so that I genuinely greeted each new male face and body with a welcoming smile and a welcoming acceptance of their offer of the tango embrace. I followed every male partner's unique and distinct lead, so that no turn of the dance with any one guy would appear like the one before or the one after. This was the art of being a follower in tango, whether a man or woman, was in that position. The follower needs to adjust to every man's form of technique, steps, patterns, and most of all to his particular embrace. With some men, the steps and patterns disappeared from consciousness while the sensual feeling

of connection took over, and then I could feel the man's heart in my heart as we resonated to each other through the flow of the music speaking to us through our hearts.

When one CD of birthday dances were over, I got the other CD I had asked for. I was very aware of anyone in the audience that was bored or annoyed. They were usually women, who would talk with each other to snub me, and to express their impatience as they waited for the Greek Festival performers that they had come for. Nevertheless, I felt most people were with me as I continued to dance my last birthday dances. My husband then came in a second time to be my partner within the string of men, and at the end of the second birthday dance, as Dino brought his birthday cake gift to me on the stage, I threw my self around my husband in a big "thank you" hug and kiss. This would prompt a comment from a male friend of one of my male friend guests, one guy to the other saying, "She loves her work. She loves tango. And she loves her husband. What more could one ask." This touched me deeply when my friend told me that his friend had said this. I especially loved the "She loves her husband" part. It felt so good to have such pride in my husband and in our love for each other, and to share it with everyone! One year, my husband surprised me by offering to pay for all my birthday guests, rather than allowing me to do it. He said, "You've paid all these years. I wanted to do it for you this year." I was really surprised. He had already given me a birthday gift. And it did set him back a lot financially. Another year my photographer captured my husband kissing me right after I performed and blew out the birthday cake candles at the Grill. The picture captured such a loving, closed eyes, almost trance like look of love, as if he were melting into me with love and adoration. He was so warm and sweet in his loving and melting into me. What a beautiful picture of our love! It is forever in my mind, as well as in the external photo.

And then I got some exciting reports from Jon Tariq after the evening at the Grill. He said that his girlfriend and tango partner had exclaimed that she couldn't believe how my husband danced in the performance. Jon said that his girlfriend had swooned with amazement: "is that Saul? I can't believe it!" My husband had really risen to the occasion. He had given me the gift of becoming elated in a performance of tango, to be with me in the flights of joy and enthusiasm in performance, whereas he had resisted up until the last rehearsal private lesson with Jon. Jon also said others besides his girlfriend had exclaimed their surprise and ecstatic amazement as they watched my husband's elegant and masterful leading in the tango performance. Jon heard comments around him like, "Who is that guy?" One person asked if he was a professional. He said, "No. She's Susan's husband!" People in the audience looked at my husband as if they had never seen him before.

But even more newsworthy was Jon's report of the Director of the Greek Festival saying to him, "Moi Bien! That was a real show, referring to my birthday dance performances. The Director also told me at the end of the last day of the Festival at Lafayette Grill that he never would normally give permission to anyone to do a birthday dance during one of his Greek Festival company's events. He said it would have been out of the question to allow an ordinary birthday dance before his prime Greek Festival Champion couple performances, but somehow he said it worked. We had done a masterful job of having a real show. But the Director, who Dino had introduced me to, the Argentinian man with a Greek wife, told me separately from his conversation with Jon, that he only made this special concession to allow a birthday dance to please Dino because Dino was such a great guy, and Dino had asked for the personal favor of allowing me to do my birthday dances and performance, since I was such a special patron and guest at his restaurant, along with my husband. The Director then added: "I did it to please Dino, but then you did a great job. It was a real show!" And then he and his company had the real show, the show that everyone else in the restaurant, besides my personal birthday guests, had come for. It was the performances of the Greek Acropolis Festival Champions, a young ballet tango flowing male and a fragile feminine flower of a female follower, coordinated together in all kinds of unique and exquisitely coordinated ways.

The Greek Champions Perform

My birthday party extended into the Greek Tango Championship performance. Some of my birthday guests stayed and some didn't. Mostly, the tango people stayed. They and I got the special treat of watching a young acrobatic Argentine tango couple, who obviously had much ballet training as well as tango practice. Their young bodies performed feats that none of us older folk could. I have two pictures taken by my photographer in which the female follower has her arms and back so intricately wrapped back around her male partner that they appear to be an evocative anomaly of nature. But in my own memory I remember the ongoing organic fluidity of their unexpected acrobatic moves. I also remember their signature piece, a dance in which their most original use of extensive and enlarged *volcadas* are used to heighten the flow and symphonic undulation of tango vals music. The *volcada* is a tango pattern or step in which the woman surrenders her separate axis, and half leans forward into the chest of the man, while she is led by the male leader to sharply extend one of her legs. Then he can lead a *volcada* on the other side with her other leg. Multiple *volcadas* can follow. The male leader guides his female partner's leg, while she is still in the off axis leaning position on his chest. Then he brings the

129

whole extended leg around and towards the other side of his partner's body, so she can cross one leg over the other at her ankles. The *volcada* has become a common modern tango step, and there are many patterns with multiple *volcada*s, but the Greek Champion couple actually did an entire waltz tango with large, huge, sweeping *volcada*s throughout. The effect was riveting, as the female follower showed incredible body flexibility, and the guy orchestrated the aerobic and acrobatic use of his female partner's body, to create the appearance of an undulating stream of water dipping off an ocean tide. The female follower flowed through the heart to heart embrace on the guy's chest, downward towards the floor, again and again, repeatedly undulating the gravity and anti-gravity curve that the man so perfectly conducted, while the female so completely surrendered. And they did it all in such exquisite timing with the music!

This performance was a magnificent crescendo at the end of my last Lafayette Grill tango birthday party. But the party still went on as I had other friends come late, from the tango world, to dance with me, some professional and some amateur. I will savor forever this last party evolution, between the containing walls of the now famous, renowned, and legendary Lafayette Grill.

ESSAY # 19
The CULMINATION of LAFAYETTE GRILL
and NEW YORK TANGO CONTINUES

It was the last day of Lafayette Grill. A sixteen year old legend was about to fade. The unique cultural center, a small restaurant full of spiritual and social life was about to close. The only restaurant that had housed tango *milonga*s for years was on its way out. Since Lafayette Grill began the first Argentine tango *milonga*, the New York Milonga, hosted by Sondra Catarraso, Lafayette Grill had been a central meeting place for the tango community. It was a melting pot of mixed nationalities, religions, races, and cultures. The restaurant was not the only restaurant with such long standing tango patrons, having had *milonga*s for 13 out of 16 years of its existence. But it was also the only home of four tango *milonga*s a week, becoming a second home for some of us.

Yet today was the last day of Lafayette Grill, due to the threat of the Landlady doubling the rent. An exhausted Dino was finally forced to give up the ghost and say "good-bye." He was promising to find another place soon, but we all knew this was a daunting task with New York real estate being what it is. The last week or two of Lafayette Grill, as we had known it, was a mob scene of people from the whole New York community coming to pay their respects by coming to dance their last Argentine tangos on the Lafayette Grill ballroom space. Everyone was dressed up too, in their more formal tango attire. People spoke of these last evenings of *milonga*s at the Grill as a wake or funeral. The staff seemed very sad, and very anxious, especially since Dino hope that some negotiation with the landlady might work till the last minute, and so he didn't tell the staff about the abrupt cut off they were now feeling harshly! Dino had also hoped he could say he had a definite location to move to, hoping to bring the name and spirit of the Lafayette Grill restaurant with him, and with his brother and the staff. When he was called for a standing ovation at the Monday night *milonga*, and came forward to express his gratitude for the showing of support, which extended to cheers and cries of "Dino! Dino! Dino!" he came up to the microphone with a smile and a proclamation, saying: "Thank you all for your support. We've been here sixteen years and we plan to continue. I will let you know soon where we will move to. I'm considering two places, nearby." What a brave smiling face he showed us, and if we wanted to believe his message we did. However, at least some of us and maybe most of us, suspected that without a penny to his name, or so it seemed, from the fears he had shared with us, it was not going to be any simple feat to reconstruct another place to become a restaurant, not only with a bar and kitchen, but with a dance floor as well.

And now on this very last day, even before the last Saturday night *milonga*, which was in fact the last *milonga* of all, I was conducting a conference on the premises. This was the fourth professional conference I was conducting in this place, and I had four years of professional films of the conferences to prove it. As I got up to give my paper, with the other panelists sitting on the long table placed in the center of the ballroom floor for them, I felt the gravity of the day. Before the applause at the end of my paper I cut in, and said a "Farewell" to Dino, his brother Billy, and to the Lafayette Grill staff. The waitresses and waiters were so familiar. Each knew me. They had all stood and watched on the night when I performed at my tango birthday party within the Greek Festival. They were very complementary and shared their enthusiasm for my dancing that night, after I performed.

Now I was doing my last performance at Lafayette Grill, at lunch time, during the conference. I performed with my two professional friends, Sid Grant and Gayle Madeira, a team that had performed at my institute's conferences before. Sid and Gayle had a magic moment, right in the middle of the culminating day at the Grill. They probably never danced better, or more in harmony than in that moment. They did a *milonga* and a *nuevo* tango. I did a waltz tango and a traditional tango with Sid. All the dances were Argentine tango, yet different styles within tango. The dancing was a joy, but the feeling of dancing on ashes started to build in me as the afternoon, after our tango performances at lunch.

As the conference drew to a close, and I had a Board Meeting, Billy, Dino's brother was anxious about the coming evening, the last *milonga*, Saturday night, at Lafayette Grill. So after a whole day of running and speaking, and dancing at the conference, I had to race through the Board Meeting. I was exhausted by the time the last *milonga* began and the tango people streamed in till the place was jam packed. I began giving out copies of a petition I had written, as if Mayor Bloomberg would care, but I wanted to express the sentiments of what a unique New York cultural institution Lafayette Grill and Dino were. To not be with them four nights a week was unthinkable! But now it is five months later and we still have not heard from Dino. Some of us loyal Lafayette Grill patrons whisper our concerns to one another as we meet by chance in other New York *milongas*. I tried emailing Dino but he never checks his email. I get my reports from telephone calls that Jon Tariq makes to Dino. "He's looking, but still nothing definite." Others come up to me, "Any word yet?" I respond, "Dino couldn't put in a whole new kitchen and bar in the place he was looking at. He doesn't have the cash, so I guess he had to let it go." We don't see each other regularly like we used to. I missed out on two farewell parties for a friend of mine I had danced with continuously at Lafayette Grill because the information didn't travel to me as expected by email. Those who knew

132

my relationship with the man who was going back to Argentina fully expected that I would get the invitations they sent by email, and would come to the parties to say "good-bye" with everyone else. He had always come for my birthday parties. But they probably sent the email invitations to an old email address--I missed both Farewell parties. I was shocked when the person who sent the invites asked me why I had not showed at the parties! I was very upset that I had missed out on such an important occasion. I said to my friend who had sent the emails to me, "This would never have happened if Lafayette Grill was still around! I would have seen you there and you would have told me in person what was happening." This was the same woman who ran up to me the week that the Grill was closing, reached out to hug me, and said, "What are we going to do?" She then added that she felt like taking a boom box radio with tango CDs, and camping out on the doorstep of the restaurant that would now be closing its doors to us all. After the auction of furnishings it would all be over, over...

New York Tango Continues, and
So Do Conferences Where I Perform Tango

Six hundred people at the Roosevelt hotel in midtown m Manhattan would be watching us. I had been asked by a colleague (who had joined a monthly psychotherapy supervision group I conduct) to perform two tangos at a psychological conference and to find a male partner. I found Sid Grant, who was very enthusiastic, despite the fact that he was flying back from a workshop he had been doing at a tango festival in Istanbul, just the day before we were to perform. This would be the first time I performed for a psychological conference, separate from the conferences at my own institute, the Object Relations Institute, where I am the Executive Director. It was also the first time I would be paid a fee to perform, so it was symbolic for me of technically being treated as a professional. I was not familiar with the International Emotionally Focused Therapy Association, but obviously they had big conferences. I was told they had closed registration out at 550 people, and had 600 coming all together (with all the organizers, etc.). We would be dancing in the huge Grand Ballroom, where they had the Roosevelt Hotel lay down a large wooden floor in the front of the audience for us to dance on. There were people on the balconies and all through the huge ballroom space below.

Sid and I had just had two practices at his studio, which went beautifully, one before he left for Istanbul and one the day of our performance, the day after he got back. Sid chose the music. We were to perform a classic Argentine tango and a *nuevo* tango. Sid and I danced at his studio beforehand and I felt the clear exactness of his lead—all in close embrace—allowing me to flow freely with all the directives he gave me

133

through his torso in an embrace with my torso. We were heart to heart I had my eyes closed as I concentrated through my body and felt his leads. Sid was very complementary about my dancing, and I was very complementary about his leading and teaching. I could do wide tall movements with embellishments with my feet on the balls of my feet, in my red suede and gold trimmed tango heels. I drew on the floor with the edges of my feet in my tango shoes. And my legs flowed up and around in large ranging movements, with forward *boleos* and wraps, back *boleos* and sweeping movements down and around Sid. I moved around him in side, back, and forward *molinete* patterns. We also did low *volcada* movements, where I leaned forward on his chest and did large leg extensions that were then drawn in to a cross of my legs at the ankle level, all following Sid's lead. Sid did two *volcada*s and then swung my left leg back and forth in his, after the left and right *volcada*s. Then Sid flung my left leg back on the floor, and I landed down on the ball of my feet on that leg and continued to dance in the full range of my upright axis, still in close embrace throughout, with the right side of my face on the left side of his face, my eyes closed. It was a dream of flowing movements for me, and Sid played on each rhythmic turn of the music as he directed my body to follow the music's directives. In the practice, we did many different beautiful tango extensions together at the end of each piece of music, which became the poses we were in at the end. Sid tried many different varieties and shapes of endings, and they all worked, so when the big show came, other endings evolved that worked elegantly, with long body extensions, as well. In fact we ended the second piece of music with our left legs sliding all the way down the floor together. We were in perfect attunement, synchronized together by the music, and by Sid's lead. So it all worked!

I had been terrified that a catastrophe would occur, and Sid would not get in to New York on time from Istanbul. I was so relieved to hear his voice when he did arrive. We had the fluid, elegant, flowing practice I described above. And then it was time to go to the hotel. Just as expected there was a huge audience of extremely excited conference participants who had been told by Sue Johnson, the director of the group, who does tango herself (and uses tango metaphors to describe psychotherapy) that we would be performing tango. We were to be the ordinary man and woman coming together in a dance, so the music began and we danced. The introductions would come after.

All went as planned, except that the guy way up in the music booth in the Grand Ballroom reversed the two CDs, so we did the *nuevo* tango first and the classic tango second. It all worked. Just as in our two practices it all flowed so beautifully. There was so much cheering and applauding that I really did feel like we were stars. Then I and Sid were introduced by my colleague, and the cheering and applauding followed at every line of the

introductions. I was introduced as a Senior Psychoanalyst and Training Analyst, and the Founder and Director of a psychoanalytic institute, and as the author of 5 books and 60 articles, with 11 awards, etc., with themes of writing on surrender in both tango and psychotherapy. Sid, of course, could be introduced as the U.S. tango champion since he won the festival competition the year before with Gayle Madeira. He was also saluted for being named "New York One" on the news for his work with teaching ballroom dancing to New York City school children. Then Sid did a dance with the director of the conference and organization, who thanked us so much for coming. The crowd loved to watch their leader dance with Sid, a sedate tango, which she enjoyed although she had resisted doing it.

After the performance floods of people came up to me to thank me for the performance. I was glad I had hired my own photographer, even if my paying for that, and the prints and CDs of pictures, would far outweigh my performance fee. I wanted some memories to share with others.

That night I went to Sid's Friday night Ukrainian Restaurant *milonga*, "*Milonga* Rosa," named after the late Rosa Collantes who was a shining light of New York tango, before passing away from breast cancer. During his announcements, Sid mentioned our performance for the large audience at the Roosevelt Hotel, and said he was so proud of me. He and I danced some waltzes that night, and I danced with many others, including an Indian man in a turban who had only come to this one *milonga* in New York City. He was a good dancer and complemented my tango with him, saying what a pleasure it was to dance with me. But he might not have asked me to dance if Sid had not announced my great performance success with him that day at the Roosevelt Hotel and had everyone applaud. At the end of the evening, the Indian gentleman wanted to give me his contact info in case I ever came to India and would want to dance tango. So tango goes on, internationally, and very intimately with strangers and friends. Tango is still intimate but not personal, as Carlos Gavito said in his interview with Paul Pellicoro.

Tango in New York Continues

So many of us miss Lafayette Grill tremendously! Many of us wait for the day when Dino will get another place for a restaurant with Argentine tango. But meanwhile, life in the New York City tango community continues. The restaurant with the first *milonga* in New York. City, the New York *milonga*, is closed, at least for now at its original 16 year location. Nevertheless, Argentine Tango in New York City is alive and well! On the same Friday nights when Sid Grant has his *milonga* at the Ukrainian Restaurant on 9th street and 2nd avenue, there are two other major *milongas* in town, both of which I have attended. Jon Tariq has a new

Friday night *milonga* at a fabulous studio at 131 w. 35th street. The floor is huge and brand new, smooth as the skin of a baby, as Jon has said. Jon's new *milonga* has provided a very friendly and spirited atmosphere for Friday evening tango. There is space to glide on the wide, long, beautiful floor where Jorge Torres performed recently at one of Jon's monthly Saturday *milongas*. There is fruit and wine and cookies and pretzels, and plenty of good cheer. Jon always has excellent DJs and a wide variety of tangos, waltz tangos, and peppy *milongas*. Plus, he has raffles and performances (just like the Ukrainian). People come from all over the world, and I have danced with Germans, professionals and amateurs, and a man directly over from France, etc. Also many of Jon's students, friends, and former students attend. The large studio space is a wonderful place to have friendly conversations, as well as to dance. Also, DanceSport has its "Tango Lounge" Friday night *milonga*, where I have enjoyed the dancing and the café, plus performances. Earlier in the evening there is Triangulo, so in just one Friday evening, every Friday night, there are four excellent *milongas* in Manhattan, and now there are *milongas* in the outer boroughs as well.

New York City has it all! We always have the Argentinian and European professionals passing through our great own, giving workshops and private lessons, along with performances. I dance tango in Santa Fe, New Mexico every August, and they have wonderful *milongas* there, and wonderful teachers for classes. But they have much fewer *milongas*, and they do not have the performances we have, on a regular basis, in New York. So we are very lucky here in New York City. Even though I have been twice to Buenos Aires, and have danced tango there in Argentina, New York is such a rich cultural center of Argentine tango dance and cosmopolitan meetings within the dance.

Friday night is only one of seven nights for Argentine tango *milongas*. On Saturday nights we have Sarah La Rocca's "All Night Milonga" and DanceSport's *milongas*, as well as Jon Tariq's monthly Saturday *milonga*, where Jorge Torres this June (2012) and Junior Cervila performed this July. On some Saturday nights there are *milongas* at the Dardo Galletto Studios where the world famous Gabriel Misse—loved by the New York Times—often performs and sometimes teaches workshops on Sundays. The renowned Maestro Facundo Posadas, who is a professor of *milonga*, can often be seen there, as well as at Jon Tariq's *milongas* and at Tioma's Monday night *milonga*. Tioma's and Jose's (Fluk) Monday very special Monday night *milonga*, held at the Ukrainian Restaurant is known for the high quality of advanced and professional dancers. There are no performances here. Only pure social dancing. As can be seen from Tioma's (Artem Maloratsky's) interview herein, the philosophy of tango is alive and well on Monday nights. The Monday night *milonga* only meets now at the

Ukrainian Restaurant because Lafayette Grill closed, which was its former location.

Lafayette Grill also used to house Jon Tariq's former Tuesday night *milonga*, but he converted this *milonga* to Friday night. Since the current loss (hopefully temporary) of Lafayette Grill, Jon Tariq has been using a studio with a brand new beautiful and spacious floor (131 W. 35th Street, not far from DanceSport on 34th street). Now the Dardo Galletto studio is open for a *milonga* on Tuesday nights. Wednesdays used to have Lafayette Grill *milonga*s as well, formerly with Sara La Roca and Magdalena. Now there remains the practice at DanceSport and the Tango Café. Thursday night there continues, one of the oldest *milongas*, with lessons before it, conducted by Coco at La Nacional restaurant, named after a large avenue in Buenos Aires. On Sunday nights we miss Lucille Krasne's Upper East Side *milonga*, which ran for many years, but recently closed. I understand there is an excellent *milonga* in Astoria, Queens on Sunday nights. And on some Saturday nights in New Jersey, Dr. Felix Pacheco and his brother Jose conduct *milongas*. There are others in New Jersey as well.

It should also be emphasized that Gayatri Martin's yearly New York Tango Festival continues each July as bright as ever. There are always world renowned tango teachers and performers at the festival (such as Jorge Torres) and the famous U.S.A. salon and stage tango Championship competitions. Sid Grant and Gayle Madeira won the 2011 Salon Tango championship, but each year there are new winners. Lexa Roséan has won medals year after year for her Salon Tango and Stage performances at the competition. Lexa is known in social *milonga* terrain in New York as the most elegantly skilled female leader. Also, there is the Black and White Ball, which has a multitude of top performances, and the Film Festival, and many other special events. Tango professionals, and tango dancers come from all over the world and all over the U.S. for this special yearly tango festival.

New York Tango goes on, as vibrant as ever, with some mournful and nostalgic remembrance of Lafayette Grill. Also, in New York City women can ask men to dance tango. We can sit and wait to be asked, or we can ask the men. This is "The land of the free and the brave."

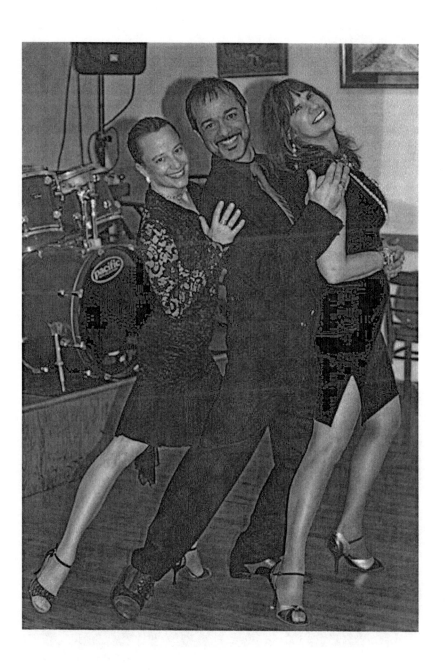

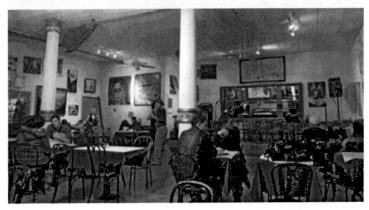

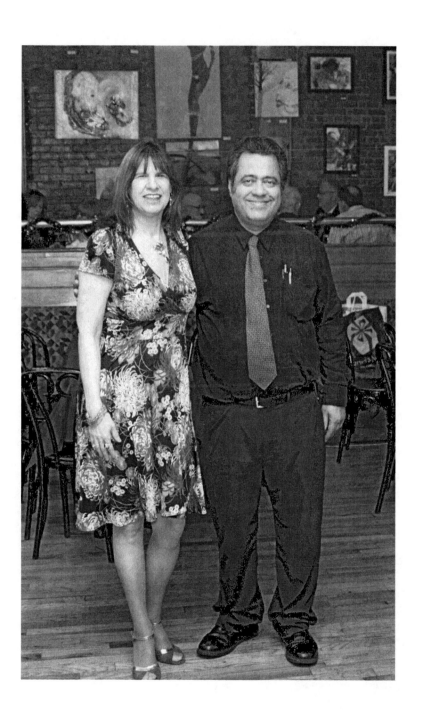

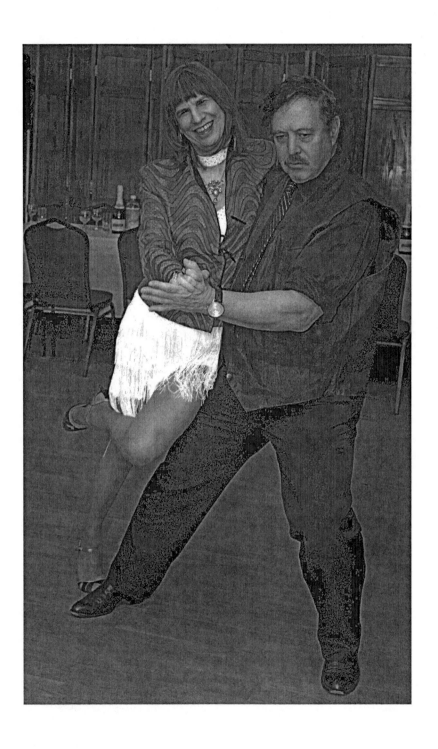

Interviews with New York City's Tangueras and Tangueros

INTERVIEW #1 WITH DINO BAKAKOS, THE OWNER OF LAFAYETTE GRILL

Dr. Susan: Dino, how did you first get involved with Argentine tango and the Argentine tango community?

Dino Bakakos (Dino): Thirteen years ago, in 1998, I was looking for something new for entertainment in my family restaurant, Lafayette Grill. We had always had art exhibits here and different kinds of music- supporting the arts in our restaurant- but I was looking for something different. We had jazz music some nights for guests who dined here or sat at the bar to listen to, but I and my brothers (Billy and then George) wanted to invite guests to dance and develop dance connections with each other, to make friends and connect in a deeper way than just having dinner in a restaurant. This guy named Phillip told me that I could get hosts to conduct a Saturday evening's entertainment with Argentine tango dancing and music.

It was 1998 and Argentine tango was really taking off in New York City, having begun here in 1985, when "Tango Argentino" came to town. There were dance evenings, called "*milongas*" at the dance studios, like DanceSport, but we wanted to offer a new kind of venue for the tango community, a relaxed and friendly restaurant atmosphere, where people weren't looking over your shoulder, judging your dancing like people often do, when they're right there, at the dance studio, studying the dance.

So I hired Marco and Sondra Catarraso, who were my first Saturday night hosts for a restaurant Argentine tango *milonga*. They would come each Saturday night and welcome all the "guests," as we called them, who came to dance at the Lafayette Grill *milonga*. They would welcome everyone, and Sandra was the real organizer who would hire the different Argentine tango dancers to teach and perform each Saturday night. She would also engage bands for live music, and for many years we had the famous bandoneon player, Tito Castro, playing his tango music every Saturday night, along with sophisticated tango musicians accompanying him, the most famous of which was, and continues to be here, Mauricio Najt. We also had the well-known "Los Chantas" tango band, with which I co-produced an Argentine tango CD to encourage people to dance to current tango band music, and to listen to it on their own, so the music would get into their blood to help them move fluidly to the music on Saturday nights here at the Grill.

Marco made all the announcements to the guests when we first began. Sondra later took over this role from him when Jose Fluk came to be the new male host a number of years later, when Marco left to teach tango himself elsewhere. Sondra made everyone feel so warmly greeted. She knew everyone by their names and she would greet them each Saturday

night with hugs and kisses. She met her boyfriend Jimmy here, who was a tango dancer who had taught Argentine tango in his home town, in Washington, D.C.

Dr. Susan: How did you personally connect to Argentine tango as a dance and as a vehicle for social relationships?

Dino: I could feel how beautiful the tango music was, and I watched people doing tango and felt so inspired. I thought it was such a wonderful way for people to experience their bodies, and to connect with others and make friends. I loved to watch the way the arms and legs flowed in circular movements, away from each other and then together again, and always in the elegant tango embrace that contained the whole upper and lower body movements, arms, legs, feet all moving together. I could see that people would feel good through tango and this would cause them to reach out to others and make friends. I learned more and more watching tango. I learned that tango is, probably more than any other dance, about making relationships and being in relationships.

So I started taking some tango lessons myself at the restaurant, along with Mega Flash, who was also just beginning then, and who is currently the Saturday night host at Lafayette Grill, 13 years later. We always had free beginners lessons at the Grill, and then had top professionals from Buenos Aires and from such shows as 'Forever Tango' come to teach and perform here. So it was quite exciting to learn even a little tango. Mega and I studied Argentine tango with the different teachers that came to teach at the restaurant. It was a coincidence that Mega and I also have the same birthday, so each year we each do a birthday dance at the restaurant at the same time.

Dr. Susan: How did you reach out to the tango community, and how did Lafayette Grill expand to four nights a week of *milongas*?"

Dino: We advertised in Reportango magazine and by flyers that were brought to other *milongas* that were on other nights. Later on, of course, we would begin to use email and later Facebook to advertise, just like everyone else. But even with the early kinds of advertising the word got around quickly because people would come here and dance and love it, and we began getting regulars like you and your husband who would spread the word.

Even though dance studios had *milongas*, they weren't usually on Saturday night. DanceSport had a Wednesday night practica and a Sunday night *milonga* back then; and more recently only has a regular *milonga* on Friday night. So our Saturday night 'New York Milonga' was a strong and well attended *milonga*. People loved the relaxed atmosphere to dance here, and they also loved that we had top stars, like Guillermina Quiroga, Junior Cervila, and also local Argentinian teachers like Walter Perez, Carlos de Chey, and Diego Blanco and Ana Padron. Plus, we always have had and

continue to have visiting Argentine guest stars and performers too. We encourage all the talented dance teachers who began to teacher, perform, and choreograph. We encourage both improvisational performances and choreography, and we still do. We always have had Anton Gazenbeek teaching and performing classic tango, and we also have the more current teachers and stars, like Ivan and Sara, who do improvisational shows with *nuevo* tango.

It was a huge step for the Grill when we were able to open up the floor space to a big ballroom space, with a stage for musicians, and columns on the floor. Then we really began to be a popular place for the top Argentinian teachers and performers to come and express themselves, and to teach their unique styles and techniques related to the basic Argentine tango connection. Our Saturday night hosts, from Sondra to Mega, have always been in close communication with the Argentinians who come back and forth from Buenos Aires to New York, and often they travel in Europe too, like El Mundo and his female partners. Viviana Parra has always performed here. We keep in touch with the Argentinians when they are back in Buenos Aires. Teachers in Buenos Aires often call us too, calling to arrange their teaching dates way ahead of time.

Once we were able to rent the space from the building next door we created a large ballroom space. People said it was like a theater or like the *milonga* spaces in Buenos Aires, where you can also see art on the walls, and culture around you. As tango continued to grow and develop in New York, we added three other nights of *milongas* to the Saturday night 'New York Milonga.' For a long time Dardo and Karina had a Wednesday night *milonga* here, after Karina had taught for many years at Lafayette Grill on Saturday nights, often alternating with Carlos De Chey. Dardo and Karina had stars like Natalia Hills come perform, and many other Argentinian performers who had their own big shows in Manhattan.

Tioma (Artem Maloratsky) had also taught at Lafayette Grill on Saturday nights for many years. Then he decided that he wanted to have a Monday night *milonga* here, since he wanted to create a high standard of CD music, with many eras of music, for the *milonga* evening. So he set up a Monday night *milonga* along with Jose Fluk, who also had been teaching the beginner classes on Saturday nights, and had been co-hosting with Sondra Catarraso for years on Saturday nights. Once Tioma set up this Monday night *milonga* at Lafayette Grill on Monday nights, it really took off. Tioma is highly respected both in Buenos Aires and New York by the Argentine tango communities. When he and Jose became the Monday night hosts, with Jose teaching the introductory lesson, and a full evening of dancing to the best orchestras on tango CDs, from all the prime eras of tango music, the best teachers and performers of Argentine tango in New York began to come to the Monday night *milongas* at the Grill. This

Monday night *milonga* has become known as the most popular *milonga* for the tango professionals, those that teach and perform. They come here to socialize, practice, dance with other great dancers, and to network. Then, along with the professionals, there are advanced dancers, like you and your husband, who come regularly to dance at the Monday night *milonga*. Tioma and Jose prefer to reserve the entire evening for pure dancing, so we don't have performances on Monday night, and we don't have birthday dances, except for an occasional few for tango teachers and performers who have their friends here.

So Saturday night had expanded to Monday, and now also to Tuesday with Jon Tariq, and Wednesday nights with Magdalena, and formerly with Lexa Rosean, before Lexa had school courses that conflicted with her hosting the Wednesday night *milonga*. Jon Tariq's *milonga* on Tuesday nights is known for having some of the best musicians perform on a regular basis live music, and also for Jon's own well selected pieces of tango, *milonga*, and waltz tango music. Jon Tariq is also known for his tango lessons, and for his celebrations of birthdays, anniversaries, etc. He loves to make those who attend his *milongas* feel special. Sid Grant often comes on Tuesday night to dance with Bebe Winkley, and sometimes to perform with Gayle, with whom he recently won the U. S. Tango championship at the 2011 Tango Festival. Eduardo and his partners, such as Sandra Buratti, and Cyrena and her Argentinian partners, are also tango champions who perform at Lafayette Grill, both on Saturday and Tuesday nights.

Dr. Susan: Sid Grant has commented on the high quality of the music provided on CDs by Jon Tariq on Tuesday nights, along with the live music that he personally often invests in for his tango guests.

Dino: ... Argentine tango is a beautiful dance. You can get along with another person when dancing tango with them. Tango is a unique experience of being part of a tango couple that can be made up of two strangers or of a husband and wife. It is always fascinating seeing the different kinds of couples in tango.

You can meet dates and sweet hearts at Lafayette Grill, at the tango *milongas* that we have on four nights a week now. We have low cost dinner specials just for the benefit of the tango community. You can have dinner, drinks, entertainment, dancing, and raffles for free wine and free entrances to *milongas* all in one. It is always a festive atmosphere, despite the serious themes in much classic tango music, with singers who may sing of broken hearts. At Lafayette Grill fun and spontaneous events create the festivity of the atmosphere.

A lot of people think of Lafayette Grill as a family place, a family center. We're very friendly here. We have male hosts who welcome female tango dancers, and always ask them to dance. We encourage both the

artistic and the social aspects of tango. We encourage people to dance tango and to gain confidence from doing it. Tango is an experience between two people because tango dancers truly dance out the expression of their feelings.

Tango is a magnificent way to appreciate someone, and we see a lot of relationships begin, develop, and continue to grow here. The rhythm, the music, the feet and the body doing the work enhances the character of the person dancing. There's a whole development that happens psychologically. As you feel the rhythm, the body, hands, and the heart all express the rhythm. Each person's warmth emerges and gives that person a good chance to connect to others. And it is a connection through experiencing what people think and feel through tango. With tango you approach someone you don't know, and ask them to dance. It's a unique experience to dance with someone you don't know. You start to develop dance experience and habits with another that are very unique to both the couple you are forming and to the dance of Argentine tango itself. Lafayette Grill provides the atmosphere for this to happen.

At Lafayette Grill, it is just the right size to see how tango builds relationships. People become more proud in tango, more confident, more aware of their sensuality and aesthetic senses. Guests who come for the first time to see tango at our restaurant hear that Lafayette Grill is the place to do it. When they see tango people dance, and also see the professionals perform, they're amazed and inspired. They see what tango can be even before they start to learn it. Then they want to take their first lessons at Lafayette Grill. We provide free beginner lessons, called 'Introduction to Tango.' People who never knew tango before are launched into the tango world here. They come back again, and keep taking lessons. If you take a date here, you can have a lovely dinner, with appetizers, deserts, wine, and also watching tango dancers. It's a beautiful way to spend an evening! The tango song and Broadway show is called 'Forever Tango,' and tango is forever. It allows for infinite possibilities. Tango teachers even speak of the discovery of new possibilities all the time in proposing steps and figures and making them up, and seeing how the couple transforms the mere steps into actual dance.

Dr. Susan: Some tango teachers who have taught here, like the Argentinian woman, Alicia Cruzado, who was a ballet dancer, and now teaches salon tango, speaks of how learning and practicing good tango technique will allow for the most possibilities to be proposed in the dance of tango. There is always hope for new proposals, new partners, and new possibilities in tango. At a time when economic and political problems can be so disillusioning, tango offers hope and possibility with every moment of dancing and with every evening dancing at Lafayette Grill."

Dino: It's so unique in New York to have a reasonably priced place to have dinner, drinks, entertainment, education, socialization, and in addition to have an exposure to such diverse groups of people from every walk of life, and from all professions, from all jobs, and from all countries, races, and religions. We're a melting pot here! We have infinite fantastic connections. We celebrate birthdays here all the time. We celebrate anniversaries and graduations. We give free cake and free drinks. We have the special Argentine tango birthday dances. For their birthdays ordinary tango dancers can do birthday dances, where they dance with a whole line of partners who line up to dance with them, to celebrate that person's birthday. Ordinary dancers can also get opportunities to perform tango for an audience on their birthdays and anniversaries. We have professionals doing choreographed shows, like the best big tango shows in Argentina. We also have authentic improvisations, and social style dance performance. So people can learn by observing the professionals. They can learn how to dance on the regular dance floor when the performers improvise and do social forms of dance, not just professional choreography.

At Lafayette Grill, we have email connections with top performers in Argentina. There is an endless connection, with all the new teachers, and all the dancers in the New York Argentine tango community. People who dance at Lafayette Grill are fully informed here about the latest workshops, lessons, classes and shows. Professional tango dancers perform at Lafayette Grill and then invite the guests here to sign up for their workshops, classes, tango events, and private lessons. Everyone gets the information here as to "where and when" it's all happening! So Lafayette Grill has become a New York mecca for knowing about opportunities in the tango world Professional dancers look to Lafayette Grill as a place to launch all their passionate projects, and as a place to reach out to social dancers in the tango community. And a great extra is the chance that social dancers get to actually dance with top tango professionals. The top performers will not only perform with their partners, but they will also intermingle with the regular dinner guests. The tango performers will give the social tango dancers the thrill of dancing with them. Top performers and teachers from Buenos Aires will dance with our tango guests. And even while still in Argentina, Maestro teachers and performers will email hosts at Lafayette Grill to set up teaching and performance dates, particularly for Saturday nights, but also for other *milonga* nights (Monday, Tuesday, Wednesday).

Besides hearing top musicians at Lafayette Grill, there is a whole new breed of DJs who specialize in being connoisseurs of tango music. And they will DJ at Lafayette Grill. There are some tango dancers, who have danced here for years, like the Argentinian *milonguero*, Hector Scotti, have developed from exclusively dancing to also DJ-ing, as they create a library of tango songs and music. People like Hector Scotti, who comes

from Argentina, are particularly versed in a large range of tango music. Also Americans, like Eileen from Woodstock, come to specialize in tango music, and also Peter, who is a Greek American from Brooklyn. Peter spent a thousand dollars to buy exquisite music from Argentina!

Often at Lafayette Grill, spontaneous fun breaks out on the dance floor, with social dancers and professionals together suddenly improvising folkloric and tango dancers. Other times the spontaneous fun is around birthday dances. Lafayette Grill is very well known for celebrating birthdays and really making people feel very special on their birthdays. Some non-tango dancers come to the restaurant for the first time on their birthdays. They can give birth also to their new selves at Lafayette Grill, as they risk taking tango lessons, and risk birthday dances. New comers are born into the tango dance and into the tango community right here.

Here at Lafayette Grill we always have paintings on the walls, and new paintings appear after each new art opening at the restaurant. I always have art openings for artists, artists of many kinds, but particularly painter, on Saturday afternoons. People can buy the artists' paintings here too. Sometimes we have fund raisers for social, political and artistic causes, like for Nancy Van Ness's American Creative Dance company. Sometimes we raise funds for countries like Haiti with national disasters. We have belly dancers and flamenco dancers who also perform. Friday night is Mediterranean night, with our prize belly dance associates performing.

And now, for the last four years and still counting, we have psychoanalytic institute conferences here and psychoanalytic institute holiday and anniversary celebrations here through you. We are honored that as the founder and executive director of the psychoanalytic institute, as well as having been in private practice as a psychologist for more than three and a half decades, that you have chosen to have your annual psychoanalytic conferences here at Lafayette Grill. You have chosen us to have your top psychological professional panels lecture and discuss major psychological issues and to have tango performances at lunch with professionals and with yourself.

When I hear you and the other speakers at these conferences I feel like I have an opportunity to get a whole new kind of education. We also welcome your seminars in psychology and Argentine tango, and in psychoanalysis and psychotherapy and Argentine tango.

I have been in the restaurant business during my whole life. I was in the business for 25 years before I had this particular restaurant, Lafayette Grill. But it is here at Lafayette Grill that I have had the chance to make my dream come true of supporting the arts in New York and in the US: dancers, visual artists, poets, singers, and with your books, even writers, and of course the musicians. At Lafayette Grill we are always expanding our range of music, dancing, and art exhibits.

Dr. Susan: Thank you, dear Dino, for your generosity and kindness, and this wonderful and exhilarating interview!

INTERVIEW #2 WITH PAUL PELLICORO

Sitting with Paul Pellicoro, to interview him for my book has been a unique and memorable experience. First of all, I have known Paul Pellicoro since my first years of learning partner dancing with my husband.

It was at Paul's famous dance studio, DanceSport, where it all began. My husband and I had always danced, but my husband wanted us to learn the lead and follow of partner dancing, so I wouldn't be dancing all around him in my own solo improvisations, as I tended to do in the free style of rock dancing (which I did from the day we met in June 1980). When disco came out in New York we didn't have any place to dance until we went away for the summer vacation. We had no introduction to hustle, which could be a creative way of engaging with disco music.

Then in 1997, I passed by a huge sign on the Upper West side of Broadway, illustrating a man dancing with a woman whose head was practically on the ground. Only the lady's legs could be seen. Her leg was way up in a diagonal close to her head, and above the guy's head. Despite the angles of their postures, the man and woman were joined by their hands, and assuming the woman came back up to a standing position, she and her male partner would have been joined by an embrace. I didn't know that the couple in that dramatic pose was doing Argentine tango. I wouldn't know that Argentine tango existed for some time, but I did know that the words on the invitation to study Latin and ballroom dancing were an opportunity that my husband and I had been waiting for.

So it was then that I went inside this several floor dance studio called "DanceSport," and signed up for an intro group of couples dance lessons for myself and my husband. From there, we studied salsa, swing, fox trot, rumba, hustle etc., but it wasn't until my husband and I studied at DanceSport with Helmet Salas, and later with many other teachers there, particularly Ronen Khayat, Cecilia Saia, Santiago Steele, and Viviana Parra, that we found a dance that captured the deepest passions in our hearts and souls. Of course it was Argentine tango. At the center of it all was Paul Pellicoro who was actually the man in the dramatic pose on the big sign on Broadway, along with his dance and studio partner of that time, the elegant Eleny Fotinos. Paul was the studio owner, and one of the first to learn and teach Argentine tango in New York City.

Before my husband and I studied Argentine tango at DanceSport, which led to our many years of dancing at the Lafayette Grill *milonga*s, we were exposed to choreographed "tango fantasia," as well as improvisational social tango, through the performances of Paul Pellicoro and Eleny, and by the other top Argentinian and New York teachers who performed at DanceSport, while in town, or on a permanent basis. Carlos Gavito, one of the stars in "Forever Tango," was one of the most famous; and Cecilia Saia,

who came to teach and perform regularly at DanceSport, had been a top Argentinian young performer. She had been in the cast of "Forever Tango." According to Paul, Cecilia was one of the younger generations' fast tango dancers, as opposed to the slower ones. Like Cecilia Saia, the younger generation performing on stage, had ballet training generally, and were not coming from the social dance floor of the *milongueros* of the 1940s and 1950s. Carlos Gavito was at first one of the fast young dancers. But he later slowed his dancing down to a minimum of highly felt movement with each step. Also doing yearly workshops at DanceSport were world renowned Argentine tango dancers like Pablo Veron, who starred in Sally Potter's famous movie, "Tango Lesson," and who danced in "Forever Tango," and Guillermina Quiroga. Known as the world's top star in Argentine tango, Guillermina is a former ballerina who also starred in "Forever Tango." Guillermina also performed and taught at Lafayette Grill upon occasion, as did, and does, the world famous Junior Cervila, who danced with many partners, but who also joined with Guillermina for a period.

So sitting down to interview Paul Pellicoro for this book had an historic past. Paul generously spent 2 hours and 15 minutes speaking with me, during which time I typed like a fiend. I found that Paul is a gold mine of information on the history of Argentine tango in New York City, and I feel privileged to report some of the interview as I have tried to piece so many facts and names together. Of course, it is not my intention to do a full history of tango in New York, since my focus is on the current New York Argentine tango community and its atmosphere. Also, Paul Pellicoro has already written his own book, called *Paul Pellicoro on Argentine Tango: A Definitive Guide to Argentine Tango* (published in 2002 by Barricade Books).

Paul speaks about the revival of Argentine tango in New York in 1985 when the Broadway show, "Tango Argentino" first came to New York, after having been a hit in Germany. He speaks of tango dying out in Argentina in the 1960s and how this affected tango in New York, and how the revival in 1985 actually got launched. According to Paul, Carlos Copes, the famous tango performer who invented choreography for Argentine tango, and who wished to make Argentine tango a stage performance like Fred Astaire and Ginger Rogers, had performed in New York in the 1960s. Paul added that in the 1950s and 1960s people in New York did not often go to Argentina but there was one tango innovator, Antonio Todaro, who filmed tango in some of the exclusive private clubs in Buenos Aires, creating films that could later be shown to New Yorkers. However, overall tango died in Argentina.

Meanwhile, in New York, tango never got off the stage to the people in social environments. Copes had only been interested in stage

tango performance. American style tango, after the style of Ginger Rogers and Fred Astaire, and the International tango, which was purely for the competitions that began in Britain, were stylized dance forms, mixed in with other ballroom competition styles. These so-called forms of tango never had the organic flow and natural movement, nor the interpersonal intimacy, of Argentine tango as danced either in *milonguero* style or "salon tango" in the 40's and 50's clubs in Buenos Aires.

However, the new revolution of tango for the people, in the Argentine tango tradition exploded in New York out of the Broadway show, "Tango Argentina," which had first taken flight in Germany. Bridgette Winkler came from Germany with the show and would later teach in New York. Carlos Copes was in the show with highly competitive dancers, such as Nelson Avila. Nelson worked with Copes but had come from Argentinian folkloric dance and thought of tango differently than Copes. Also, in "Tango Argentino" were the tango couples who wanted to teach tango and its different eras of historic dance figure origins, Gloria and Eduardo Arquimbau.

When the show "Tango Argentino" set fire to the New York City imagination, Paul Pellicoro immediately began to study with anyone in the show he could. Nelson Avila taught a class at Milford Plaza that related to his folkloric and stage tango origins. Nelson rivaled Copes, and Copes had it in the contracts of the cast members of the Broadway show, "Tango Argentino," that they were prohibited from teaching. So it was a very secret class and group that began to meet in a studio in Queens with Eduardo and Gloria Arquimbau, to learn about club tango, as opposed to stage tango. Paul Pellicoro came there along with Sandra Cameron, since he was working as a ballroom and Latin dance teacher at that time at the Sandra Cameron studio.

Paul and Sandra were the only two professional dancers and teachers who met in the small studio in Queens with the secret group. This was 1985, the year when "Tango Argentino" had first come to town, and taken off. Within the year Paul left the Sandra Cameron studio to start his own studio with the partner, Diane, who he was dancing with then. They formed the New York dance studio, "Stepping Out," which became one of the main New York studios teaching Argentine tango. When Paul and Diane parted ways, Paul Pellicoro started the now most major New York dance studio, DanceSport, where so many top Argentine tango dancers and performers have taught over the years, from the time of the 1980s origins.

Then when Paul and Eleny Fotinos became dancer partners and studio business partners, they established a whole graduated curriculum for studying Argentine tango progressively and in depth. They taught and performed tango themselves and invited many other teachers, who danced Argentine tango, including top Argentinians, to teach on the DanceSport

staff. Some taught regular classes. Others from Argentina, who might be performing all over the world, were invited to teach periodic workshops with their special perspectives on the many forms of Argentine tango, whenever they came to town. Outside of DanceSport, a group with Gustavo (now in Colorado) attempted to break down the elements of Argentine tango to teach it.

Unfortunately, this group made the mistake of bringing in Carlos Copes, because of the man's fame, which required that Gustavo leave, which he graciously agreed to do. Without Gustavo the group never sustained the attempt to break down the tango elements to teach, since Copes was a showman who was not interested in the art of teaching. In Argentina, Petroleo (nickname for Carolos Alberto Estevez) created new moves in tango and attempted to teach these elements. For example, he invented his form of *boleos*, and also *molinete* (grape vine steps of the woman going around the man) that had the woman circling the man to the left rather than to the right. In an on line interview with Petroleo (which means "drinker"), when he was 80 years old, Petroleo says that he would have liked to break down each tango dance into a prologue, central dance, and epilogue.

During the interview with Paul Pellicoro, Paul spouts out a bunch of names of the top tango dancers who contributed to the evolution and re-animation of Argentine tango in Argentina. Most of these I had heard of. Many of these made the trip from Buenos Aires to New York as tango took off in New York City after "Tango Argentino" came to town in 1985 and swept New Yorkers up in a new tango fever. It was one thing to have tango on the stage. It was another thing to have authentic Argentine tango social dancing develop in *milonga*s through the dance studios and restaurants that had tango lessons, practicas, and then the late night *milonga*s that were the formal dances or parties. DanceSport was at the forefront of inviting top stage artists and also top salon and *milongueros* style dancers to teach and perform at the studio. On stage "Tango Argentino" was followed by several other tango shows, some of which are outlined in Paul's book, but the biggest smash hit after "Tango Argentino" with Nelson Avila, and Juan Carlos Copes, was "Forever Tango," starring people who came and taught regularly at DanceSport, such as Cecilia Saia, Carlos Gavito, Guillermina Quiroga, and Pablo Veron. Guillermina also brought famous male partners like Roberto Reis. At one point she danced with Junior Cervila, a time that I remember well, before Junior connected with Natalia Rayo. They performed in many venues in town, including the "La Boca" *milonga* started by Gayatri Martin in the late 1990s at Il Campanello. Lafayette Grill began their *milonga* in the late 1990s and would have top guest stars like Guillermina as well. So I would be able to see several of Guillermina's performances when she was in town.

INTERVIEW: PAUL PELLICORO

Back in the 1980s, after the revival of tango through New York in 1985, Paul Pellicoro went from secret classes in Queens with Eduardo and Gloria Arquimbau, and classes at the Milford Plaza with Nelson Avila, to hosting his own shows and tango *milongas*. Paul was the first to employ Il Campanello restaurant on Thursday nights that featured shows with Artem Maloratsky (Tioma), Viviana Parra, Valeria Solomonoff, Fabian Salas and Helmet Salas. Back at his DanceSport Studio, Paul had both, his developed regular tango staff, and his guest teachers who traveled to DanceSport from Buenos Aires periodically to do workshops. Some of these guest teachers also made tours in Europe since Tango Argentina had ignited people abroad as well as in New York. Paul Pellicoro helped Cecilia Saia create a new partnership with Ronen Khayat, who she trained, after she parted from her "Forever Tango" partner. Ronen was a teacher of mine for many years, and I enjoyed dancing with a man who was leading Cecilia Saia on the stage. Ronen and Cecilia began to teach regularly at DanceSport and to run a Sunday night Milonga that took off around 2002. This more formal dance, the *milonga*, followed Paul's establishment of a Wednesday night practica, where everyone taking lessons could practice their technique right on the dance floor after lessons.

On Saturday nights, Danielle and Maria had *milongas* at DanceSport, and lessons before the *milongas*. Although my husband and I often preferred the informality and social friendliness at Lafayette Grill as its Milongas started in the late 1990s, we also would attend Danielle and Maria's larger *milongas* at DanceSport. Danielle and Maria would encourage the formality of the Buenos Aires *milongas* that had revived the code of dress and conduct that had first developed during the time of the great orchestras in the 1940s and 1950s in Buenos Aires.

As New York took off with tango after "Tango Argentino," Argentine tango culture was re-awakened in Buenos Aires. Consequently, highly attended Milongas sprung up all over, with the most famous of which being the revived Sunderland Milonga. Danielle Trevor and Rebecca Shulman, who first trained at DanceSport, were some of the New York *milongueros* who went down to Argentina to bring the New York passion for tango to Buenos Aires. They then brought the Buenos Aires spirit back to New York. Danielle and Maria tried to simulate the formality of the Buenos Aires *milongas* by asking all who attended their own *milongas* at DanceSport to dress up. During the days of the great orchestras in Argentina all the neighborhood clubs had tango dances, where families and groups of guys and groups of girls gathered. Every neighborhood had their own style of dance, but they were joined together by the "coda" of behavior required for all those dancing tango at clubs and *milongas*. A man must nod to a lady and make eye contact if he wished to dance with her. He could not risk what was seen as a humiliation of asking a woman to dance and being

refused. So he would make eye contact with the lady he chose, and she could respond back with her eyes or a nod to assent to the dance. Or she could turn away to say "no" and the man's fragile macho ego could be saved, as he then would avoid going over to the lady to receive a more overt and direct refusal.

Along with such rules for the interaction of the genders in the tango dance hall were rules about clothing. Back in the 1940s and 1950s, before rock music extinguished the orchestras and therefore the dancing of tango in Buenos Aires – for a whole generation – formal dress was expected by all who danced. Danielle and Maria tried to continue this tradition in New York, according to Paul, by asking men to wear suits, or ties and jackets, and women to dress in evening gowns. It was easier to encourage the women in this direction than the men. Over time, despite the efforts of tango mentors from Argentina, men often began to dress more casually, even in jeans and sneakers. However, women tended to wear dresses, since they enjoyed dressing up. But now it is one American influence on the tango milongas that a full range of dress is permitted. Jackets often make men sweat much too much while dancing. So, all is open now. Lafayette Grill has a full range of dress. Sometimes men are in jeans and their partners are in evening gowns, but it can also be the other way around. One can now wear any level of dress to Milongas in New York, and this has its own form of freedom.

According to Paul many stage dancers, such as those in the top shows of "Tango Argentino," and later "Forever Tango," found it quite challenging to bring the tango from the stage to the social dance environment. They also found it difficult to teach those who wanted to dance in the social dance environment of the milonga. Paul mentions Pablo Veron as one of these dancers, who had to move from stage to teaching social dancing. I had seen Pablo Veron in Sally Potter's movie, "The Tango Lesson," where Pablo danced both on stage, in his own free improvisations on stage, and also in the social dance milonga in Buenos Aires. Once I actually saw him dancing with Sally Potter on the dance floor at DanceSport, and they swept masterfully through a crowded dance floor, until they began to dispute which way to go or dance, just as they had always been in disputes in their movie. There is stage tango, and then there was "Tango Fantasia," which is somewhere in between where large dance figures with kicks under the legs, called *ganchos*, and high and low kicks, called *boleos* could be danced, beyond the sedate grounded floor walking and steps of salon tango. Some mixture in between could also be seen in *milonguero* style in the social *milonga*, but here walking tango elegantly is the most featured part of the dance, and no *boleos* or *ganchos* or *planeos* or *volcadas* (modern tango) are indulged in on a crowded *milonga* dance floor in Buenos Aires. In New York there is more freedom, and mixtures of

"tango fantasia," (where the couple can part and do things separately) and the soft, on the floor tango, as well as the *milonguero* style are seen, with elements of stage tango thrown in.

While tango stars like Nelson Avila, Pablo Veron, Cecilia Saia, Carlos Gavito, Jorge Torres, and Guillermina Quiroga, Anton Gazenbeek, and Junior Cervila stepped off the stage and into the dance studios to teach what became "Argentine Tango" in the social *milongas*, others such as Nito and Elba, from Mar del Plata in Argentina, specialized in on the floor Salon Tango style. Nito and Elba taught on a regular basis at DanceSport, doing workshops and private lessons in their frequent visits to New York. I was in their workshops where they always stressed simplicity, connectedness, collecting the feet in between steps, and most of all elegance. Nito and Elba were a married tango couple who started off in the *milonga*, not on stage. While Susana Miller taught the extreme arduous art of mere walking elegantly in *milonguero* style tango in Buenos Aires, Nito and Elba specialized in the Salon style of tango, with feet always on the floor, that had first evolved through Europe, and which then flourished in the tango club neighborhood dances in Buenos Aires. Nito and Elba taught elegance, and refined ornaments or embellishments in steps for the female tango follower, who must always stay connected to her partner, moving as one.

Nevertheless, salon tango allows the follower to do brief embellishments in between the leader's steps, in between the beats. Paul Pellicoro gave tango dancers in New York a great gift by having Nito and Elba teach here, and others who studied with them taught, not only at DanceSport, and the dance studios, but also on Saturday nights at Lafayette Grill.

When the "Tango Lesson" movie came out in the 1990s, featuring the film director, Sally Potter, and the famous stage Argentine tango performer, Pablo Veron, as the star characters, the evolution from stage to the social dance floor was seen on the movie screen. The male/female conflict and resolution narrative enhanced the telling of this tale. Pablo Veron followed his film performance with regular visits to teach workshops at DanceSport, where he taught the general public stage tango as it was being adopted for the social dance Milonga. In our interview Paul Pellicoro mentions that it was a challenge for Pablo Veron to go from stage to dance floor. But I know that Pablo Veron was part of the trend of teaching stage tango steps that were being adapted to tango and *milonga* dancing in the social dance halls, dance studios, and restaurants, where we held our Milongas, both in New York and in Argentina.

According to Paul, Juan Carlos Copes, who launched his new choreographic style in the world renowned "Tango Argentino," taking New York by storm in 1985, only did parallel style in tango. Copes did not even know about the cross basic tango style taught for social dancing at

167

DanceSport. Copes also had the film, "Tango," which was really about stage tango, and not about the dancing for the public in *milongas* that was featured in Sally Potter's "Tango Lesson."

Meanwhile Hollywood got in on the action, and Paul Pellicoro was part of this modern world development as well. A far cry from Rudolph Valentino dragging a doll-like puppet woman across the dance floor in the 1920s, new movies made genuine attempts at integrating social tango into their creative expressions. Robert Duvall had studied with Paul Pellicoro in the secret Queens class taught during the 1980s, after Eduardo and Gloria broke contract to take the tango of "Tango Argentino" into the dance studios in New York. Robert Duvall had been with Sharon Brophy then, but he later wed a young Argentine tango dancer, built his own huge dance studio to practice tango in, and then featured Argentine tango couples dancing at a *milonga* in his Hollywood film, "Assassination Tango." Many people in the tango world did not like this movie because its plot was contrived and unrelated to tango. Nevertheless, it put Argentine tango and the social *milonga* on the big screen. I know Duvall came in and out of the New York tango scene. I saw him at the Metropolitan club one night at a tango "Gala." As Paul talked, I learned how he and Robert Duvall were both students in one of the first tango classes in New York.

Paul had a more direct interaction with other big screen personalities, the most famous of which were Al Pacino, Robert De Niro, and Richard Geer. Paul was hired by Al Pacino and his female co-star in "Scent of a Woman" to learn enough of the flavor and feeling of Argentine tango to look like they were dancing it in "Scent of a Woman." Paul writes about his experience with Pacino in his own book.

First, there were Thursday nights at Il Campanello in the mid and late 1980s begun by Paul, along with Claudio and Alicia, who were living in the DanceSport studio at the time. At this restaurant venue, Paul himself performed what he was learning and developing in Argentine tango at the Il Campanello restaurant at west 31st street in Manhattan. He performed in shows at the restaurant with top people like Bridgette Winkler form Germany, with Viviana Parra, Rebecca Shulman, Valeria, and Fabian. Some of these women would later form and teach at a rival studio, but Viviana Parra is a top teacher and social Argentine tango dancer who would teach and perform at DanceSport. Mauricio is a top tango musician, a pianist and composer, who started performing live tango music with Paul at Il Campanello. Later he would be a regular guest artist musician performer at Lafayette Grill, where he still performs periodically. Perhaps the most renowned performer at Paul's Thursday night shows was the guest performer Carlos Gavito, who had first been a jazz review dancer, and later starred in "Forever Tango." He slowed his style down considerably as he got older. And by the time Gavito performed in "Forever Tango" with

Marcello Mastroianni, he had evolved his own unique form of intense, passionate, contained, and slow Argentine tango. Gavito is known for inventing the *"carpe,"* or tent-like lean between the male and female tango partners (Pellicoro, 2002). Gavito is also known for small footwork, as well as for the sustained intensity of feeling that he packed into each step.

Carlos Gavito made teaching videos with his "Forever Tango" partner, in which he can be seen illustrating small intricate and subtle motions, motions that totally merge the partners in movement, and which flow out of a close and passionate embrace within the lean between the partners. Gavito would frequently speak about the "intention" of the tango partners, as all body movement needed to flow from this sustained and focused mental "intention," allowing the legs and feet to just follow, as the flow of the music and intention combine. According to Paul, Gavito particularly appealed to older men because he demonstrated that tango was best with minimal, but deeply felt, and deeply passionate, movement. Each single step told an entire story of love, art, and intimacy. He foreswore any acrobatics and even stopped performing any of the stage or tango fantasia *gancho* movements. As in the crowded Buenos Aires *milongas* that would be developing through the 1980s, 1990s, and into the 21st century, Gavito only believed in the grounded tango movements that were all done on the ground, so that *boleos* became "low *boleos*" on the floor. Although Gavito died a few years ago of lung cancer, his legacy remains an important part of the teaching of Argentine tango at DanceSport.

As Paul Pellicoro became engaged in other tango show endeavors, such as "Tango Fest," which he did in collaboration with the "World Music Institute" he turned Il Campanello over to others. Later Gayatri Martin would have a very successful Tuesday night *milonga* at Il Campanello. Gayatri's *milonga* lasted many years, and featured top guest artists, such as Junior Cervila and Guillermina, as well as couples like Armando and Daniella (who had danced together for 16 years before they broke up). Gayatri Martin also took over the yearly July New York Tango Festival from its founder and originator, Lucille Krasne.

Meanwhile other places began to open up that overlapped with the 13 year plus development of the Saturday New York Milonga at Lafayette Grill, and Lafayette Grill's other night *milongas*. In 1996 the "La Belle Epoque" restaurant became an elegant Friday night haven for Argentine tango dancers who wished to really dance at a traditional *milonga*, accompanied by live music. Despite a crowded and small dance floor that had the impeding construction of porcelain floor tiles, La Belle Epoque took off. Many who learned at DanceSport came to dance there when they fell in love with Argentine tango, since at that time Friday night at DanceSport was a night with a collection of many kinds of dances and performances at their Friday dance parties. Later this would change, and

DanceSport would come to host their own Friday night Argentine tango *milonga*, Tango Lounge, in competition with the Ukrainian Restaurant that took over the "La Belle Epoque" *milonga* when "La Belle Epoque" restaurant closed down. Rosa Collantes, who had trained at DanceSport along with Angel Garcia, and who had particularly trained there with Nito and Elba, carried over the "La Belle Epoque" restaurant *milonga* to the Ukrainian restaurant. After Rosa's recent and untimely death from breast cancer, which is mourned continuously by many of us, the Ukrainian restaurant's *milonga* has been re-named "Milonga Rosa," and is now hosted by Sid Grant. Since there are many in the New York tango community, both the Ukrainian restaurant and DanceSport are well attended and often crowded on Friday nights. (In 2012, Jon Tariq began his new Friday night *milonga* in the huge studio space, called "The Ball," nearby DanceSport, so one can go to both the Tango Lounge and Jon's *milonga*.)

But what about the other nights? In 1999, Coco, an Argentinian male dancer, who had first participated in the tango endeavor with Paul by working on the lighting at the Thursday night Il Campanello *milongas*, opened an extremely popular *milonga* on Thursday nights called "La Nacional," a name related to a large avenue in Buenos Aires. Coco still provides lessons and recorded DJ music at La Nacional, and always follows his early evening lessons with a *milonga*, which was the traditional sequence of events at all New York *milongas*. Lafayette Grill always had beginner and intermediate lessons before all their four nights a week *milongas*, going back to the origins of their Saturday night *milongas*. Coco also plays a role in the monthly "All Night Milongas" at Stepping Out studios, the studio first begun by Paul Pellicoro, before he opened DanceSport. Coco's "La Nacional" recently celebrated the 12th anniversary of his *milonga*, which was announced by Tioma (Artem Maloratsky), who now hosted the Lafayette Grill Monday night *milonga*, now moved to the Ukrainian restaurant.

Jon also had his Tuesday night *milongas* at Lafayette Grill. Earlier on, in the beginning of the 21st century, and for many years since Ellen Sowchek had had *milongas* first on Tuesday nights and then on Thursday nights at the Pierre Dulaine dance studio. Ellen was trained by Helmet Salas at DanceSport, as well as by Tioma and others.

At DanceSport itself, *milongas* proliferated. First there was the Wednesday night Practica, where students at the studio, as well as those joining them from the outside, can practice all their recent steps and techniques. This Wednesday night *milonga* has remained through the years.

DanceSport also had an extremely popular Sunday night *milonga*, which was their biggest night before they moved their main *milonga* to Friday night. These Sunday night *milongas* were known for their excellent pre-*milonga* lessons. They were particularly renowned for their many years

170

of intermediate lessons taught by Cecilia Sigh and her partner Ronen Khayat. They also had Santiago Steele teaching the beginner lessons. Carlos Quiroga, the brother of the world famous tango dancer Guillermina Quiroga, and also the editor of New York City's Reportango magazine, would DJ at the Sunday night DanceSport *milonga* parties. In addition, they had launched the tango teaching career of Virginia Kelley, who taught the intermediate classes before Cecilia Sigh (from "Forever Tango"). Virginia Kelley taught a unique approach to Argentine tango, which promoted the initiation of steps and figures by the female follower (generally female, sometimes male in interaction with the lead of the man. This more active and mutually interactive style of tango was certainly a statement about the demise of the totally male dominated macho attitude in tango from pre feminist days.

Viviana Parra also taught at these Sunday night *milongas* when she stayed in New York and taught at DanceSport. Viviana had performed and danced with Tioma (Artem Maloratsky) and many others later, such as Junior Cervila and Ronen Khayat. Nevertheless, Viviana would say she was most dedicated to teaching tango. She was a brilliant teacher, and thus offered a special addition to DanceSport's interest in the education related to the Argentine tango dance connection.

Paul: Men don't have to dance five dances in a set or "*tanda*" of tango every time they want to dance with a woman. Unlike in Buenos Aires, in New York it's ok for the man to dance one of two dances with a woman if he wants to and then say "thank you," and politely go on to others. People should learn a simple open embrace before a closed embrace. In that way they can learn the body technique, and take time to walk and do steps and figures.

I try to discourage people, particularly the men who are learning to lead tango, from focusing on "tricks" and steps. I encourage them to focus on the connection with their partners, the music, and the flow of the dancers in the room of the *milonga*.

[Paul notes that he has trained more men than others in New York, and he is proud of this because he says this is the most difficult part of teaching tango, "getting the men to learn."]

It's more important to fit in with the others on the *milonga* dance floor, and to connect with your partner, than to do any particular steps or tricks or figures in the dance. Musicality is also extremely important. Keeping the men interested is the hardest part.

[Paul prides himself on helping so many men to begin and stay with the learning of the dance, when it is so much harder for men to learn to lead than for women to learn to follow.]

Paul (continues): Men have to have a base. I do this hard nitty-gritty work. Because I focus so intently on this, and value the basic learning, my percentages of keeping men committed are good.

... Most of all, Argentine tango is a sexual experience. People want to be liked and respected by the opposite sex. Men can make less money, and yet win women by being good dancers. Dancing empowers men. Women will always like to dance. If men learn how to dance, the women will be there to join them.

... The tango world still allows people to be a big fish in a small pond. Once can be special within a huge and highly competitive environment in New York City and in the world. Tango is still a little world where you can be special! The world has gotten too fast and too big! Everyone who is the best in any one thing comes to New York. Having the extra encouragement of the tango world gives you what you need.

... You can do a simple *milonguero* style in tango. You don't have to do what the stars do! Everyone can have their own personality in tango. One can do close embrace, and enjoy intimacy, rather than trying to emulate a big star like Junior Cervila, even though nobody can compete with Junior for what he does.

... A lot of men start off doing tango in a too aggressive way. They need to learn how to relax and receive the music and the movement.

... Tango was at first more static. One would stop to do a "sandwich" (man cupping the foot of the woman) or to do a *gancho* (a "hook", or kicking under your partner's legs). Now the flow is the ultimate concern. *Ganchos*, *boleos*, *volcadas*, sandwiches, *colgadas*, *planeos*, etc., are all done while moving in the flow. We have moving *ganchos* now. The new philosophy is about the effortlessness of tango, just relaxing into the body flow and movement, and into the music. If you are "working" you are working too hard. The easier and more natural the movement is - the more organic and authentic the flow is. One need is to follow the new reflex flow that allows intimacy, not just following the historic patterns of tango. Of course we can learn a lot from the historic tango, but tango is ever evolving and we need to allow and follow that evolution."

Paul (having just spent a week learning from Gustavo Naveira in Colorado, goes on to explain): The new (*nuevo*) style that Gustavo started is more dynamic. Tango is always evolving. Gustavo has done all the research on the development of individual steps and figures in tango. He knows how *ganchos* and *boleos* first started. I learned a lot from Gustavo in my visit in Colorado. I can always learn. I have trained top movie stars like Al Pacino, Robert de Niro and Richard Gere, but I am always learning, and growing, and teaching. DanceSport is about teaching, learning, and growing.

172

INTERVIEW #3 WITH SID GRANT

Dr. Susan: How did you get into tango, Sid?

Sid Grant (Dr. Dance): I've been dancing professionally for 22 years. My entire career has been devoted to social dancing. As nice as it is that the competition craze has brought attention to ballroom and Latin dancing, people have lost sight of the fact that partner dancing itself is a wonderful life skill. Nowhere is that more apparent than in Argentine tango.

Argentine tango defines the porteño culture, the essence of the Argentine port city of Buenos Aires. On my very first trip to Buenos Aires, I was amazed to see such respect for a dance and for its social mores, and also for the codes ("*codigos*") of the dance and dance hall, such as the "*cabeceo*," whereby men invite the women to dance with a nod of the head from a distance. It amazed me how a dance defined a culture with such subtlety, poise, and nuance. I knew that it was my destiny to do Argentine tango, because I realized how passionate I was about this kind of partner dance connection. Unlike ballroom dancing, Argentine tango involves learning an improvised physical language. That makes every tango you dance a unique physical conversation. So for me as a dance professional, it's the most artistically acute example of physical listening between partners.

Dr. Susan: Isn't it more than physical?

Dr. Dance: Because of the intensity of the physical listening, it brings the entirety of the person to the tango experience, in its emotional, spiritual, and intellectual aspects. Of course, not everyone who dances tango has that internal access to all those parts of themselves as they dance, for those things to flow through and out of them to their partner. For those that do have that access, however, every single tango dance can approach the sublime. Tango is danced heart-to-heart, "*corazon a corazon.*"

When I had a private lesson in Buenos Aires with Stella Baez and Ernesto Balmaceda, Stella greeted me with a huge smile, her arms outstretched. She instantly put her arms around me in a "gran abrazo" (great big hug) with both hands on my back. She didn't say a word. She just held me in this warm embrace, and we danced in a hug. It was extraordinary because it captured the very essence of the tango experience, the warmth of the embrace, and the spontaneity and intimacy of the tango moment.

Dr. Susan: You had a great introduction to Argentine tango. You are very lucky!

Dr. Dance: I've been blessed by expert tutelage from some of the best tango maestros in Buenos Aires, including Carlos Gavito, Osvaldo Zotto, and Omar Vega. I mention these three men because alas they are no

173

longer with us, and it's humbling to carry their tango spirit forward. It's true that everyone we study with informs our tango. So you take a piece of each by instructional osmosis, and it becomes a part of your physical vocabulary!

I admired Gavito for the deliberate quality of his dancing intention. Working with him changed my tango forever. I admired Osvaldo for his precision and choreographic prowess, and Omar Vega revolutionized my *milonga* by introducing "traspies" form of tango. Omar Vega was such a master!

I would say the person who's had the greatest present influence is Gustavo Naveira, who is now in Colorado. You get your Ph.D. in tango, if you are lucky, by studying with Gustavo. That's Ph.D., as in "Pretty Hot Dancing." Gustavo is a scientist of the dance.

Dr. Susan: How then did their internalized instruction develop within you to define who you uniquely are in Argentine tango?

Dr. Dance: All of this learning starts to manifest more personally. I think tango is similar to other art forms, like painting. The journey of tango is to discover your personal artistry and to be able to share that compassionately and creatively with the partner in your arms; the floor is your canvas, your partner, the brush. Like many journeys it is a lifelong process. I'm at a decade marker in my tango journey, and only now am I beginning to feel the fullness of connection in every tango moment. For me as a dancer, I strive to deepen my dedication to that connectivity.

This new level of insight and inspiration has radically transformed my teaching style. First and foremost, I'm telling every student that I don't teach steps, I teach qualities of movement. If they're ballroom converts, I remind them this is not a syllabus dance. We all know (Sid laughs) that it is not the case in tango at all. It's not a dance with a syllabus of patterns or moves. While it's important to learn certain terminology, like *ocho*, *gancho*, *molinete*, barrida, *baldosa* (six-count basic), *calesita*, *volcada*, *planeo*, *colgada* – these terms are capturing qualities of movement that are combined in an infinitely improvisational way. I'm also a huge believer in the power of the pause in tango, because even in the pause, without any steps, you are in tango.

Dr. Susan: It is a state of mind and body to be in, not a step to be accomplished according to some prescribed recipe of steps.

Dr. Dance: Yes. And it's important for me to say that my instructional realizations are directly proportionate to the evolution of my own tango journey. When I first met Gavito, he joked by calling me "Senor Broadway." I know he did this because I had come from a ballroom background, and I thought at first (like so many other ballroom converts) that tango was about showing off the combinations I learned. So thanks to Gavito, and many others, I recognized that the most profound thing an

174

onlooker can experience is the beauty of the internal experience that the leader and follower are sharing in that kindred tango moment – not contrived choreographic steps, but the quiet beauty of the internal experience that the two dancers are experiencing, as one.

I think Argentine tango is a healing art, and its ability to reconcile and uplift and comfort is unmatched, in my opinion, by any other partner dance on this planet. Consider, for example, the pause we discussed earlier. The power of the pause is best explained if we follow through with the analogy of tango as a physical conversation. If you are beginning a conversation with someone the best thing to do is to speak softly and simply. And take time to breathe. The same is true in the speaking of the body in the dance conversation. The analogy in verbal speech is that if you speak to someone you don't know, and all of a sudden launch into a complicated topic, that would be conversationally jarring. Moreover, as a leader, it's imperative to make the experience as pleasant and pleasing for the partner as possible. The quality of movement should be pleasant, and the appropriate objective for the leader is to make it as enjoyable an experience for the follower as possible.

Argentine tango is communion. Therefore, you need a genuine sense of "the other" in your consciousness to dance it well. If, as a leader, you are preoccupied with a personal agenda of trying out all the steps you know, it undermines the fullness of the connection, because you're distracted by your dancing steps as opposed to the partner's enjoyment. So in as much as following requires surrender, leading requires giving, not controlling. If there is control, it's compassionate control.

Dr. Susan: Could you give an example of compassionate control?

Dr. Dance: Yes. Compassionate control is expressed by leading gently with physical clarity.

Dr. Susan: Are you speaking about intention conveyed physically? I know that Gavito stressed the idea of intention.

Dr. Dance: Yes, compassionate control does involve a kind of physical intention. It also involves awareness that you are transmitting that intention to the follower in every moment. This is the Argentine tango leader's ultimate dance duty. Controlled movement is required, but it's about invitation rather than about examination or manipulation. To tell you the truth, the best tango dancers are those that can set aside their egos and allow for Eros.

Dr. Susan: I was thinking about how my husband and I can dance so well sometimes, sustaining a genuine tango connection in the dance, and this might be just after bickering over some trivial thing a few minutes before we danced.

Dr. Dance: Tango is a physical extension of my teaching methodology. Every time I dance tango it is healing, and it reinforces my

views about teaching dance. Imagine if every person had just a glimmer of what this extraordinary connection. We would be such a peaceful planet…as cliché as that might sound, because it requires that two become one: "*corazon a corazon*."

Of course, I think that one of the things that makes it easier for me is that I have no sexual agenda with women. Since I'm an openly gay man, I can pour 100% of my emotional passion into dancing with women. And since I have no sexual interest, I have totally loved women on the dance floor without question. Also, as someone who enjoys both following and leading, and as someone who can lead and has led both gay and straight men, it's wonderful that I can lead a straight man in tango. It's also phenomenal that something so passionate can end on the dance floor. Of course, I know tango started in the bordellos, so I'm not being so prudish as to suggest that it doesn't relate to sex, but it's liberating to be able to be passionately intimate with both women and men, gay and straight, within the dance itself, which allows for such a large range of passionate connections.

Dr. Susan: It doesn't have to be foreplay?

Dr. Dance: No (laughs), for me it is the "Floorplay!" We play on the floor, and with the floor! In fact, Gavito once said, "We paint with our feet."

Dr. Susan: What is it like to dance at Lafayette Grill? Do you have any thoughts about Lafayette Grill?

Dr. Dance: When I think of Lafayette Grill, I think of how wonderful it is to have a restaurant venue where we can dine and dance, giving those at Lafayette Grill a similar experience to being in the *milongas* in Buenos Aires. I appreciate the fact that the establishment of the restaurant has been supportive of our community, and its atmosphere gives us something special, an authentic Buenos Aires feeling right here in New York.

Other venues have regrettably come and gone, so I was so thrilled that Lafayette Grill not only remained open, but actually expanded their dance floor! I have continued to be thrilled by this, and frequently dance at Lafayette Grill. For me, having traveled to Buenos Aires over a dozen times, it's the closest experience to an authentic *milonga* ambience. The only other venue that feels as authentic is La Nacional, but it's only one night a week. How wonderful to have a restaurant that features multiple nights of tango!

Dr. Susan: Yes. I feel the same way! There is no other place like Lafayette Grill in New York, and Lafayette Grill brings us an exquisite bit of Buenos Aires ambience!

INTERVIEW #4 WITH ARTEM MALORATSKY ("TIOMA")

Dr. Susan: How did you get into Argentine tango?

Artem Maloratsky (who we all call **Tioma**): I came from a technology career oriented family in Russia. So I studied Physics and Math when in school in Russia, but I always felt in my heart and soul that I was an artist and wanted to move towards the arts. I first came to the US to study physics at MIT in Boston as a college undergraduate. I liked Physics and I liked teaching but I knew I hadn't found myself yet when I graduated from MIT in physics and began teaching math and physics to teenagers in high school in Boston and then in Florida.

I like the way I first got into tango. I remember Pablo Veron saying in the movie, "The Tango Lesson," "Tango Chose Me!" That's exactly how it was for me. It all started when my sister wanted a salsa lesson. My first tango lesson was offered along with a salsa lesson I took with my sister. My sister is younger. I was 23 or 24, and we took a class in Florida when I was teaching Math and Physics in high school. Then my sister and I went to San Francisco and saw "Forever Tango" there. I'll never forget that day! My whole body was shaking as I watched "Forever Tango"! I was shaking so hard when I watched the Argentine tango dancing on stage that I was afraid I'd have a heart attack. When there was a break from the dancing for a musical interlude I felt utter relief, because I couldn't stand the intensity of my reaction to the dancing without a break. I was totally taken over. When I walked out of the theater for the "Forever Tango" performance I just knew I had to learn the dance I had seen on stage. I felt like I was being grasped by a "calling." I never felt such a thing before or since.

I had no idea when I began tango lessons that I would end up doing it professionally. I felt possessed and was taking more and more lessons. I had been dancing all my life. I did free style dance in college. I didn't think I had it in me to do professionally. I was still teaching in the public schools. I went to Argentina and there I met Viviana Parra. I stayed with her in a tango and personal partnership for two years in New York. That was actually the height of my professional career in tango. I was performing and teaching. People just began to come to me to learn. It was all natural, and felt inevitable. I had enough work to make a living in tango, so I even gave up the tutoring I had been doing in New York to earn a living.

Then I felt I hit a wall! I had had a calling and an epiphany, but in retrospect, I realize that when I first started tango had been a lifesaving activity for me because I had felt I was starving culturally, starving to have a familiar culture. Before doing tango and joining the New York tango community, I didn't know if there was any cultural glue or cultural containment in the US. Although there was no choice in Soviet Russia,

177

there were shared jokes, shared humor, and shared values that allowed me to feel like part of something, part of a cultural community. Then when in the US and attending MIT, as an undergraduate, I felt good with the college community. But once I was graduated and out in the adult world, people didn't seem to be connecting, and I wasn't connecting with the people around me. The only conversations I heard were about work and one's job. I was craving more of a cultural way to connect that I couldn't find.

Suddenly, I found a cross strata, a cross group cultural milieu in tango. Everyone in the Argentine tango community in New York came together to pursue something more meaningful and beautiful than just their individual selves. People came together in an aesthetic sense of the beauty, sensuality, and emotional meaning of the shared Argentine tango dance.

Meanwhile, in Argentina, a new excitement was brewing as the old generation began consciously passing on the tango culture to the new generation. That felt great to me! I always felt like I was more of an artist than a scientist. I was brought up to do something technical, and for a while I had to do it to be part of my family, but I could feel that art was more in my nature.

Then there was a whole other chapter in my life when I felt like something was off. The old people in tango in Argentina felt out of my reach. Also, limitations in my body seemed to prevent me from going further in tango. I realized that it wasn't just about dance training. I became aware that the older generation of tango dancers in Argentina had not taken ballet, like the young professionals were doing in America. Yet this older generation moved beautifully in Argentine tango. I started studying many body related disciplines to find my energy and flow in tango. I studied bioenergetics, ralphing, and particularly Alexander technique. The study of Alexander technique made a huge difference, but I wanted to work on myself both internally and externally, psychologically and physically, to find the best balance for myself.

The result was that I found a deeper way to pursue tango. My pursuit for personal growth bypassed my aspirations towards a tango career. My first step in personal growth was discovering tango. My second step was finding tango as a spiritual path, and as an evolution towards personal growth. Consequently, I became a lot less interested in tango as a career. The outward appearance and performance became secondary to the internal experience, the experience related to my heart and its connections as I had felt on that first day when I was shaking so much because of the intensity of what I felt in my heart when I watched "Forever Tango"! Increasingly that which I transmitted while either performing or teaching became secondary to my own personal growth. I wanted to become independent of tango financially, which I did by working at a part time job in a software company. This job allows me to teach tango as I experience it,

178

solely as a person, spiritual, and psychological practice, not as the means to the end of earning a living. So now my addiction to tango is healthier. Tango is now for me a spiritual practice, a form of meditation.

Through meditation and martial arts, I have learned that whatever goes through my head effects my dancing. If, for example, I'm thinking judgmentally about my partner, then I naturally and inevitably dance worse than if I suspend judgment and have a loving attitude. I allow myself to have a loving, open, embracing, and accepting attitude. When I do that, my life changes, and my dancing changes.

This change in attitude and in philosophy of life and daily spiritual practice becomes the most challenging and difficult, and also the most significant when engaging with one's own partner, one's tango partner, and of course in life, one's partner in life. For me the two are combined.

I have realized that if I am dancing with my partner, and she regresses in her dancing, it may be related to my effect on her. I try to look at it now as my problem, rather than being reactive to seeing her as inadequate. If I am judgmental of my partner, I am being reactive rather than open and embracing of her as she is. This usually results in her getting worse rather than better as she dances.

Dr. Susan: You seem to be saying that here is a vicious cycle that gets set up in the couple. If you judge your partner, and she feels judged, then she reacts by feeling less confident and comfortable in the flow of her own movement, and consequently she dances worse, and then you increasingly judge her in this and get worse in your dancing. But if you are open and accepting of her movement, she will feel this and be freer to move in her own natural and authentic flow of movement, rather than in reaction to feeling your judgments impinging on her.

Tioma: Performing Argentine Tango has its own problems, and that's why I've chosen to focus more on the social dancing. It's very-very difficult when in the spot light to take the delicate and subtle things that are happening in your body and between you and your partner and turn them outward so that others can see it. Trying to turn things out for the spot light on stage can distract from being fully inside the experience. It can become too much for others viewing you from the outside.

Dr. Susan: I know how distracting it can be from the internal focus of being with your body, the music, and your partner when you become aware that someone is watching you, let alone when the whole audience is watching during a performance.

Tioma: Tango can be a way of showing yourself to the tango and New York community through your self-expression. You are projecting certain energy, and so you affect people with how you dance, like when I was so profoundly affected when watching "Forever Tango." I've trained myself to be less concerned with this, to be less concerned with the people

outside, and particularly less concerned with how I look to them. Still I'm aware of the positive value of affecting other people with my tango energy and expression.

Tango is a functioning community. We express ourselves in a creative way, and we validate each other. It's so lacking in our society as a whole. People outside the tango community don't seem to have that communal source of validation, energy, and creativity that we have within the tango community. I didn't have these benefits of a community in the United States before I began dancing Argentine tango.

Tioma: For me a big part of dancing tango is the physical process. That is something that concerns me quite a bit. People in this culture are generally not physically fit. But people here are willing to work on themselves to change. This is different than with the older generation in Argentina. In the old culture in Argentina, if tango didn't come easily to someone they didn't do it. In the US, and in New York especially, if you love tango you take lessons and learn it even if it's hard to transform your way of moving.

I also do believe in learning tango, even if it doesn't come easy. But I also think there is a limit. I could not get close to dancing like the older tango dancers (*milongueros*) if I didn't change my physical way of functioning. And as we increasingly use machines in modern society it is going to become even more necessary to consciously focus on our physical functioning. Otherwise people could lose touch with their bodies altogether, while they sit and watch a computer screen or a TV screen.

Argentine tango became a great way of working on physical functioning. I believe in tango as a means to this end, as well as being an end in itself in just being in the process of doing it. Tango offers great feedback. The better I am at the physical functioning I need for tango the easier all movement becomes and the easier dancing becomes. The less effort creates the best dancing.

Dr. Susan: It's about being in the natural organic flow, allowing it rather than working at it while dancing.

Tioma: Things get easier naturally with all my tango partners if I work on my body and improve physically. If you just go to yoga class, it's good. But tango gives you a more informative feedback. The physical and psychological aspects of our work come together in tango.

In tango there are artistic and aesthetic goals. It's the spiritual work of purification. The physical and psychological blocks can stand in the way of both my artistic goals and of my spiritual purification. For me tango very much becomes a spiritual discipline. Tango is very much what the Eastern martial arts are about.

I had started with a Western paradigm. Then I moved into Eastern art forms, using tango to work on myself. What happens with tango is a by-

product of psychological and physical change. When I deepen myself spiritually it is a direct result of my work on myself. What happens with Tango is a direct by-product of my psychological and physical change.

Argentine tango allows me to deepen myself, spiritually, mentally, emotionally, and this is always a direct result of my work on myself. Tango is discovering a higher degree of freedom through connectedness. Tango can teach us how freedom and connectedness are two sides of the same coin.

Dr. Susan: This is what we were talking about in Dr. Marcia Rock's documentary movie, "Surrender Tango."

Tioma: Connecting with the ground beneath you becomes an important part of finding that interactive balance between freedom and connectedness. By connecting with the ground in a deeper way through tango you feel both the literal ground and you feel grounded in your own instincts, and grounded in the instinctual nature of your partner as well. Your ability to connect with the other who is your partner in any one dance allows for many other related forms of connectedness, and grounding oneself allows such connection.

... We enhance our general cultural level with the degree with which we connect with the music. To be more connected to tango is to be more connected to a cultural heritage. Tango music has many cultures in it. Rhythmical it is more modern and sophisticated than classical music. The flip side of that connectedness is our individual freedom interacting with communal freedom. When I fly together with a partner I fly with the music as well as with others on the floor. I feel an exhilarating feeling of flight and flow. So with good connection there's more of a flow. When there's a higher connection to all those things you feel there's a deeper experience. When the connection to the partner is more attuned and more in the moment, I and my partner respond to each other. I respond to changes in the movement of the moment with the same person. Every moment becomes a unique connection, different than the last moment, but the connection.

Dr. Susan: I think you are saying that every moment becomes a unique connection that is different or differentiated from the last moment, but the connection between oneself and one's partner, and between oneself and the music, and between oneself and the tango community on the dance floor is sustained throughout the individual differentiated moments.

Tioma: Connection and freedom are two sides of the same coin, and freedom goes with connection with the floor so there is grounding in the literal floor and in the symbolic instincts. When there is a good instinct connection, all effort becomes neutralized. One learns to let the effort go into the ground. That is what gives us freedom. When we connect better to the ground it gives us freedom to do more and to do better. The better

connected you are to both your partner and to the ground, the more freedom you feel to find space together. The more attuned you are to each other in the tango partnership the more space you find in things that had seemed like constraints before. A couple that is less connected has to reconnect after each step.

If we're constantly together then we're not busy trying to find each other. Then there's a constant vibration, both emotionally and psychically. In a good tango connection the woman feels she can take time and the man feels he can go at his own pace. The woman is balanced in her axis and grounded, so she can wait. This allows the man to do things he has never tried before. The female follower gives freedom by connecting more with herself and with her partner, which involves being grounded and with the music.

Dr. Susan: Tell me more about couples, from Argentina to New York.

Tioma: In Argentina, during the late 50s, there were two kinds of venues for tango dancing. There was the neighborhood club, where couples, and families, and children would go, and there were the *milongas* in the center of the city of Buenos Aires. The atmosphere in the neighborhood club was quite different than in the *milonga*. In the club everyone danced in couples. In the city *milongas* single people would come and intermix. There were lots of pickups and switching of partners after each set of dances (*tanda*). So there were two very different cultures of tango starting in the late fifties. Earlier than that, during the 40's and early 50's, when the great orchestras played, there was so much focus was on the music and on following the orchestras wherever they went everyone danced altogether. The tango scene was so much bigger then. There was no huge polarization then, but the later polarization affected the nature of the tango connection and partnership.

In the mid-50s everything in Argentina changed. There was a rapid decline in tango due to the political changes in the country. That's when the division began between tango couples in the neighborhood clubs and singles or couples who switched partners in the inner city *milongas*. Sunderland is the most famous neighborhood club that continues to this day. There everyone dances in couples, either with a spouse, a girlfriend, or with a girlfriend of a friend. This creates a very different kind of a dance than when everyone is constantly switching partners.

The advantage of dancing continuously with your partner is that each partnership develops its own unique style. The couple develops and sustains an organic connection.

However, it may then be difficult for one of the partners to dance with others, to find the flow and connection with another outside the partnership. This situation continues in New York today.

182

But New Yorkers come to tango fresh, without the baggage of the history that affects those in Buenos Aires. There was a time when tango in Buenos Aires and Argentina was not respected, from the time when tango was a dance of the immigrant men who frequented the city brothels. This was however before tango reached Paris and London through young Argentinian men who could afford to go abroad. Once a reverence for tango was developed in Argentina, the *milonga* became a main cultural event, separate from the neighborhood club and the fixed tango couples.

Dr. Susan: Perhaps the transition to *milongas* for singles in Buenos Aires has influenced the transition in New York city from a small number of married tango couples to a massive *milonga* singles scene.

Tioma: In New York City most people switch partners, even married couples. Occasionally some people still stay fixed in dancing only with one partner, perhaps for the female to avoid intimacy with another man other than her partner. However, most couples split up, on and off, and dance with different partners. Sometimes this provokes jealousy. With me and Gayle we dance more with each other than with others, but we always enjoy the richness of dancing with others. That's our way.

From the dance point of view, each couple is unique. With *milongueros*, men who develop their own style and then dance with many women, their dancing is more uniform and less unique. The good dancers in the center of town were more alike. The couples in the clubs in Argentina were more unique. This has continued in New York.

By switching partners you develop the ability to be flexible. I listen and take every partner as a new experience from which I can learn. Switching partners allows for flexibility. I think it's most ideal to have a steady dance partner, and also dance with other people.

Dr. Susan: I agree.

Tioma: As soon as Gayle and I met each other at a *milonga* in New York, we felt a personal resonance with each other. Everyone I have dated is in tango. It would be too difficult to connect with anyone outside the tango community. People feel so much more comfortable in the tango community than in a different kind of social club or dance club or bar. I can be myself in the tango world and have a communal base with all those I meet in the tango world and in the tango *milonga*.

Gayle and I have some critical things in common that brings us together and keep us together. One big thing is that we both take tango seriously as an art form, as well as a form of entertainment. For many others, it is just entertainment. Gayle and I both see Argentine tango as a continuing artistic endeavor. It actually pains me that there aren't so many who see it that way. But there are enough people in the New York tango community who at least have respect for tango having that artistic dimension that Gayle and I greatly prize.

For Gayle and I, a major part of our connection is sharing that outlook of tango being an art form with a whole aesthetic dimension. Both of us are interested in being better artists in whatever way we can. Gayle is amazing! She sings, paints, dances, plays the violin, roller blades, and does yoga. Plus, she has a full time job as a software tester. Up until five years ago Gayle was a professional dancer, in modern dance.

Tioma: In the early days of tango in New York Danielle and Maria had *milongas* in which couples often came, couples such as Alex and Jean Turney, and others who had started together in ballroom and Latin dancing. But as younger people began to study tango at the studios a whole new 'Singles' Scene' developed and is continuously developing in the city. Tango started in New York in the middle and late 1980s and by 1996 the tango community that had been forming was largely dominated by singles.

But I have a few more words to say about tango couples and being in a couple and dancing with other women besides my partner. First of all, there is a very typical dynamic in a tango couple that I have become familiar with in having had various partners. There seems to always be a tension that comes into the dance, and then all hell can break loose. I would be very frustrated with this development, about this disruption. The tension seems to result from each partner increasingly focusing on what the other, their partner, is lacking, at least as they interpret it.

Dr. Susan: I believe that judgmental focus on what the other is lacking comes about because you feel dependent on the partner you are always dancing with, so anything lacking or intruding in their dancing immediately affects you and your degree of freedom, flow, and elegance in the dance.

Tioma: That's it exactly. You feel dependent on you partner, and want to change them, but this is always counterproductive. It just causes tensions and conflicts in the dance and disruptions in the flow of the connection. So I have learned, with much difficulty, over time, to seriously work at keeping my focus on myself and my own style, form, technique, and overall dancing. Actually, once you learn this painful lesson you find a great opportunity to concentrate on yourself, both in your dancing and then consequently in your life as well.

Keeping my focus on myself is much easier when I'm just dancing one or two *tanda*s (sets) with a woman, and not dancing with my ongoing dance partner. I find that as long as I know I'm only with this woman for a few dances, I can relax and be accepting, and only focus on the positive things. However, I know that if I had to dance with the same person for two or more *tanda*s it would be very different.

I've observed that it's very rare for our generation to keep dancing together. It seems to take a lot of emotional maturity to keep enjoying the dance together with the same person.

Dr. Susan: And to work out the conflicts that arise in the dance that may relate to conflicts in your outside life relationship as well. I guess it's different for those who only dance together, like Orlando and Adriana, than for those in an outside intimate relationship, or in a long term marriage, like my husband and myself. When we work out our conflicts in tango we work out our conflicts in our relationship outside, and vice versa. If we work out things outside, we work together in tango and work out tango conflicts.

Tioma: To re-focus on the positive in a couple takes emotional maturity. It's just like the martial arts philosophy I learned. If your attention is on the positive your attention goes to the positive and vice versa. If you focus on the negative in your partner, you will see more and more negative and miss all the positive in their dancing, and in your connection, that can be enjoyed and developed. It's always harder to re-focus on the positive with one's significant other than with others. But when you can do it it's so beautiful!"

Dr. Susan: I know what you mean!

Tioma: Dino, the owner of Lafayette Grill, is a great supporter of the Arts. That's why Lafayette Grill is what it is right now. It's not just a place to eat. The owners and staff at Lafayette Grill are more flexible than at other restaurants. They have agreed to not ask for a minimum at the tables so that people can sit comfortably together at tables in between dances, and to socialize and enjoy the whole atmosphere of the tango *milonga* in its unique form at Lafayette Grill. They offer lower priced dinner specials too for those who wish to enjoy dinner and dance, or those who come in to just eat dinner and watch people in the tango community doing tango, maybe for the first time. At the Monday night *milonga* at the Grill that Jose Fluke and I host, all the tables tend to be filled by advanced tango dancers, but beginners and tourists are always welcome, as they are on Saturday night, and on Tuesday and Wednesday night at the Grill. The quality of the music is so important, and this is what I try to provide on Monday nights.

Lafayette Grill became a great place for many Argentine tango *milongas* when they expanded the ballroom floor. The ballroom floor at Lafayette Grill is just the right size for a *milonga*. It's not too big or too small. There is a Sunday night *milonga* in Manhattan that is so big, with over 200 people, so that you can't see someone across the floor. For me it's just much too big.

Dr. Susan: The feeling of intimacy and community can be lost when a *milonga* space is so big, and the crowd is so big that you can feel lost in the crowd. I agree with you that Lafayette Grill has the perfect size floor for the intimate and communal, and truly social *milonga*.

SATURDAY NIGHTS AT LAFAYETTE GRILL

Tioma: Our Monday night *milonga* at Lafayette Grill is a little different than other *milongas*. It is somewhat more purist, some say a little elitist. We don't have performances and generally no birthday dances either. We stick to straight dancing, so that people can really find themselves in the social dance connection and try many partners during the course of an evening. For me, the quality of the music is the biggest thing, and this concern is what inspired me in the first place to start the Monday night *milonga* at the Grill, which has become such a popular *milonga*, especially for advanced tango dancers and lots of professional dancers, and for the older generation of Argentinian *milongueros* that come to town. If I'm not personally there to DJ for the music, which I generally do, I always take a lot of care to plan a program of music for the alternate DJ. We keep dancing with very few interruptions, although we now have a raffle to give people a chance to win a free entry to another *milonga*, or to win a bottle of wine.

I also believe it's better to have CDs than live band music. There's no constant live music that would provide enough different qualities and flavors of music. And there aren't enough musicians today to provide such variety, especially on an ongoing basis. I provide CDs that have a whole assortment of different eras of tango music, from the 1920s and on. I always play music from the famous orchestras and composers of the 40s and 50s, but I play music from many eras, and I always play waltzes and *milongas*, as well as traditional tango. If you have live musicians, there is the risk of them playing music from tango artists, like Piazzolla, who are more for listening to than for dancing. I make sure that as the DJ for Monday nights at Lafayette Grill that we always have tango music that is primarily for dancing, rather than for performance or for listening to in concerts.

In general, those of us who conduct the Monday night weekly *milonga* at Lafayette Grill make every effort to create a good place to dance, a place where we would want to go.

Jose, and I, and Silvana, and the staff at Lafayette Grill, conduct a *milonga* that we ourselves would always want to attend on a continuing basis.

We create a *milonga* where tango people can just enjoy dancing, a place to be in the moment and in the evening, a place to feel the pleasure of living through the ambience of the dancing and the social connections at the *milonga* where we dance.

It is the rare place where people can just enjoy life through dancing, without the dancing or the social situation being a stepping stone to anything else. That is our aim to help people find that rare location meant for true enjoyment that they can return to week after week, as well as night after night, at the many *milongas* at Lafayette Grill.

INTERVIEW: ARTEM MALORATSKY

Dr. Susan: It is truly rare in this modern time, and in this large metropolis where Wall Street and corporate America live, to find such a precious oasis where one can allow one's spirit to live through dance; to live and to grow, and fully being in the moment and evening of enjoyment.

INTERVIEW # 5 WITH ANTON GAZENBEEK

Dr. Susan: How did you get into Argentine tango?

Anton Gazenbeek: I started at 12 years old, after a vacation in Buenos Aires with my family.

I was walking down the street called 'Florida,' in Buenos Aires, and I heard music blasting from a music store. I didn't know it yet, but it was Argentine tango music. I froze in my tracks. It was totally instinctive. I was just 12 years old. My heart just ripped and tore open when I heard that music! It hit me so powerfully that I ran straight into the music shop. I found out the music came from a CD with Gardel singing. I scribbled down the name "Gardel," and then ran out of the shop again. Literally from the first day I discovered tango through its music and the voice of Gardel, I started being an investigator. I started researching tango music. I found CDs with the music and orchestras of Canaro, Pugliese, and d'Arienzo."

Dr. Susan: It sounds like the act of writing down the name "Gardel" on the first day you heard the tango music in the street was like finding the password to your future life and destiny, and you were only 12 years old.

Anton: When I went back to my family home in San Francisco I kept hearing the music so strongly, the music that had torn my heart open. I discovered that there was so much Argentine tango going on in San Francisco. Since I wasn't a musician or singer, I realized that my body would have to become my instrument to resonate with the tango music.

I found a teacher who taught the old system of tango education. I was 12 years old and yet in a hurry. I wanted to learn everything overnight. This tango teacher helped me to slow down. I was literally like a charging bull. Then I had to realize that I needed slow down. I decided to study ballet at the same time as I studied tango. I was then in these two parallel but very different dance universes.

Suddenly I was on stage with the San Francisco ballet. The world of the ballet was totally different than the world of *milongas* where I danced Argentine tango. I chose tango over ballet and went to Buenos Aires for 8 years to do research on a book on the New York Broadway show, the show that went around the world, and changed the world, "Tango Argentino."

I went to Buenos Aires to make a documentary film on the great show. I began interviewing all the people who had invented the dance of Argentine tango. These people were in their 80s and 90s then; they're not alive now. This all had to happen in Buenos Aires. I stopped ballet, and was performing tango in Buenos Aires. My whole life became tango. There were no days at the beach or the movies. Tango was it! I was 100% totally immersed. I began choreographing for shows too.

189

I had to do research to find the older people who had invented tango at the *milonga*s. I attended *milonga*s six or seven nights of the week. During the days I was rehearsing for shows, and at night I was at the *milonga*s doing research by discovering the old *milonguero*s and *milonguera*s.

When you love what you do it doesn't feel like working. I was at the *milonga*s through the nights, until 5 a.m. In a way this life style totally suited me because I had always had difficulty sleeping. I was brought up in a family where everyone was an author, and they do their most productive work at night. Maybe that's why it was hard for me to sleep at night.

Dr. Susan: Maybe instinctively you wanted to be in on the productivity.

Anton: Well I certainly was used to living with very little sleep. I and my friends from the tango stage and *milonga*s would go around Buenos Aires and see everyone from all the different shows.

I was in on the "practicas," which were all male at that time. When we came into the tango "practicas" we could only dance as 'followers' at first. Only after we did this for some time could we start to dance the lead. Then only later, after being proficient in tango technique and steps could you be allowed to dance with women. To this day, I can do the follower's role expertly, but I always prefer to lead. I feel more comfortable expressing myself as a leader.

In Buenos Aires in those days there were no same sex *milonga*s. There were only traditional *milonga*s where the male professionals were extremely competitive, even vicious. The male tango professionals were cut throat. They had knife fights in the streets if someone thought another guy was stealing a step from him. There were neighborhood gangs that only allowed their own *milonguero*s into the *milonga*s. They couldn't cross over into another neighborhood. In fact, if they did enter a *milonga* in a different neighborhood they'd get thrown out. It was such a violent scene. It was so violent that if someone danced in a way that a group of guys from that neighborhood didn't like they'd throw you out.

I interpret all this as being rooted in how tango people, especially the men in those days, wanted to protect what they were doing on the dance floor, and this didn't want someone doing something very different and getting attention. There was a brutal exclusiveness.

But in spite of this, I as a young American guy, was able to meet such wonderful people in the tango world in Buenos Aires, people who showed me magnificent hospitality. They opened the doors to their homes to me, a guy of 20. It's interesting that with each other they are super competitive, but with a foreigner like myself they were extremely friendly. They wanted to treat me like a part of their families. They acted like they considered themselves my grandparents.

190

In the dance studios, the learning I was exposed to was tremendously exacting. It was exacting to the point of being mathematical. But the *milongueros*, who taught themselves and invented their own steps outside the studios, would practice tango in their apartments. They would invite me to lunch. We would talk as we ate, and after eating. We'd work on some steps together. Then we'd talk some more. A one hour class I was going to take with a *milonguero* in his apartment would turn into a seven hour afternoon. I was really learning about these people's life while I learned tango from them. I learned about their history and about their whole culture and about the way they lived their daily lives. All this came with just asking them for tango lessons.

Every few months I would go to Europe or Asia to perform in tango shows. I met a 20 year old Dutch boy. I learned the old Spanish. In fact, I don't understand the new Spanish, only the old. The old Spanish gave me an understanding of the lyrics of tango because the lyrics are written in the street slang, called *"lunfardo."* These *milongueros* used the street slang to hide their communication from the police. The police couldn't understand *"lunfardo,"* and these guys were always making up new words. The people I met and studied with and socialized with, from the *milongas*, were not educated. They were immigrants often, and hung out on the streets and in brothels. I certainly had never had contact with such people until I entered the tango world in Buenos Aires.

I still cherish my memories of these people. Despite the violence, they were enormously warm-hearted, and they showed this warm-hearted side to me. They would give you the shirt off their backs. This is not something I see today in the tango world.

Dr. Susan: You must miss those people.

Anton: I definitely do. The females would live longer, and I would really get to know them by dancing with them. I miss those people a lot. I knew Carmencita Calderon, who lived to well over 100 years of age. I knew her when she was 102. She danced until her last day of life. She always danced with the same partner, a partner she had after her former partner, the well-known El Cachafaz, died.

The tango couples in those days stayed together. They had such a high level of dance because of their many years of continuing partnerships. Still, to this day, it is the great singer, Carlos Gardel, who made the most profound impression on me. There was nobody like him! In his singing he so perfectly expressed all the feelings in tango. Carlos Gardel was from Leon originally. He moved to Argentina at 12 years old.

Besides Gardel, the person I think of the most, who I knew personally, was Ofelia. Ofelia was the lady who invented the famous Sunderland *milonga*, where the greatest tango personalities come to dance and to perform. This is the most famous *milonga* in Buenos Aires, or in the

world. I danced there with Guillermina Quiroga, who is now considered the top tango performer in the world. I was only 16 years old when I danced with her. She introduced me to El Flaco Dany, which was the guy's nickname. El Flaco then introduced me to Ofelia and Margareta. Margareta was considered to be one of the best tango dancers that ever lived. She would regularly invite me to her table. It was a huge honor and I knew it. In fact, when I moved to Argentina, I was always at her table. When Margareta had an accident, and couldn't dance, resulting in her withdrawing from the *milonga* at Sunderland, I sat instead with Ofelia. Ofelia taught me so much about the woman's part, and she was the gal who had invented Sunderland. I always sat with her at the same table. It was in the front row, and was the best seat in the house. So this shows how when I lived in Argentina I was dancing tango at the *milongas* with these 85 year old women. In the tango shows I was in, by contract, I danced with young women. But let me tell you, nobody in the work could dance like the older women!

The older women were strong like horses. It was amazing! One woman I danced with danced with such ferocity that she wore me out after two dances, and she was 87, while I was somewhere between 16 and 20. She was faster than lightening! I searched for her afterwards. When I ran into her at an old *milonga* it was incredible to find her again! Then her partner died, and she just disappeared. In those days, with that generation, if the male partner died, the woman would never dance again! Tango was something the woman did together with her male, long term, tango partner. It was so different than the singles scene we have in New York tango now.

Tango was one way from 1890 to 1986. In 1986 everything changed! Then tango evolved so quickly into what we call Argentine Tango today. It was, of course, in 1986 that "Tango Argentino" traveled to Broadway. The world then discovered tango and all these people in Buenos Aires started claiming to be "maestros" to get students to teach and earn a living from. Up until that time tango had been just for married couples who always danced together. Now there are people from all over the world in Buenos Aires. It's not like many years ago when everyone went to the same club, with the same table, and the same waiters. Now there are new and different forms of tango all over the world. For me this can lack the depth of the old tango, the tango before 1986. Before there were only married couples doing tango, who danced so much together and for so long that depth always developed. It wasn't so much about novelty. Sometimes, so much new invention can dilute what tango was. Tango is an alphabet, from A to Z. But this was all before the dictatorship. Now they're trying to reconstruct tango from the past, but in my view the reconstruction of tango is only up to F in the alphabet, not yet up to Z.

Tango had to go underground during Perón's dictatorship, which extended from 1954 to 1982. It was awful in Argentina during this time. People would just suddenly disappear. They would get thrown in the river, and we'd never see them again. Everyone in the tango world knew everyone who disappeared. Although Tango in Argentina was never explicitly prohibited, it was banned indirectly since people were prohibited from meeting after 10pm. It became impossible to have open *milonga*s, so tango went underground. Tango events and *milonga*s were no longer publicized, and they took place in the middle of the night.

I actually have films of these very special underground *milonga*s that developed in the 1960s. The people who attended these *milonga*s reached the peak of their creativity. These were people who were risking their lives to dance tango. They absolutely loved tango!

After 1983 the dictatorship was ended. I moved there at eighteen years old, in 2001. I moved there when the dictatorship had ended, but there was a terrible economic crash. It was really horrible! People had no money! All the people were suffering!

I happen to think, despite my love for the people I knew personally there, that the Argentinians as an overall group did have themselves to blame for their suffering. There was a great deal of corruption. The people would do little deceptive things that would multiply and poison things. For example, a shop keeper might not give change back in a shop. This little act of deception would then escalate into an overall corruption. And the whole government is based on corruption.

Still, all that was part of the overall picture of tango developing in this Argentinian culture. All these things somehow evolved into the dance we now love. The corruption is as much a part of the Argentinian culture as is tango. They lie and steal. Cheating is part of their culture. For example, they assassinated the son of the president of the country, and then said that the shooting down of the plane was an accident. Despite all this, I had intended to remain in Argentina, but my fate took a different direction.

I came back to the US to do a tango show for three months. I toured with the cast of the show. Then the last week we took a vacation. I was discovered by a model agency, and I decided to stay in the states. I moved to New York.

For me the main difference between New York and Buenos Aires, in terms of tango, is that people in New York dance tango. But they don't live it. It is not the essence of their lives every day. In Argentina we lived tango in our bodies and in our lives daily. In New York, tango people dance tango extraordinarily well, but it's not the same as living it and breathing it, without any other influences in your life. In some way it might be better now, but it is not what I was used to when I first immersed myself in tango.

Anton: My dancing has totally changed. It was only in 1997 that

the idea of tango as a 'connection' comes about. Looking at tango as a 'connection' is different than the old days in Argentina. I never heard the word 'connection' back then, or even the word 'embrace.' Instead the Argentinians that I knew from the old generation of tango thought of dancing tango as doing a ferocious sport, like soccer. They thought of the dance as a competition. Then those outside of Argentina have dissected the dance a lot, and now they think of the dance quite differently.

Dr. Susan: Was tango a place for the Argentinians to express their aggression?

Anton: Maybe. It was never about romance for them like we talk about it here in New York. It was never soft back then. It was a form of harsh competition. The dance was totally macho in the beginning. It was a dance made by and for men. Men in Argentina used tango to prove their power and dominance. That's why the women were so strong, to deal with these macho men.

In the 1960s the Argentinian dancers believed in interchangeable partners, so there weren't different parts for men and for women. The women were supposed to just fit in with whoever they danced with in shows and demonstrations. But others were in married tango couples. The woman's part was not thought of as a distinctive role then, only as accompanying the man, yet the women became incredible tango personalities. I hate it when teachers say today to women "Don't think. Just follow." They're minimizing the woman's role. For some reason, I tended to dance with women older than myself in Argentina. They came from a generation where they left everything to me as the male leader. Everything was told to them. Now that's changed, so we need to work on enhancing the woman's role. In those old days in Argentina women were used to be controlled, and so they had to be ferociously energetic and talented, to fight the pressure to submit to the man rather than to express themselves.

But in New York today women have other problems in the tango world. I hear women complain about men abandoning them on the dance floor, sometimes leaving them in the middle of the floor after only one dance. We need to revive some of the etiquette the Argentinians had when they would always escort the women back their seats and places at the *milonga*.

Dr. Susan: Psychoanalysts speak about the feminine experience as being one of strength in vulnerability, and of self-expression through receptivity. This is totally contrary to thinking of the female role as passive, as a part of the macho belief system. Would you agree that what I have written about and discussed at tango and psychoanalysis workshops, related to the concept of an active, receptive, self-expressive, and creative

surrender is a helpful way to think of the cultivation of the female experience in tango?

Anton: Yes. I like the idea of receptivity and vulnerability as opposed to passivity. The woman's role should be a very creative and self-expressive one. Perhaps women always do evolve creatively in tango because women seem to live so long doing tango. Why don't men live longer doing tango? And why would women ever give up tango if their partners died? Certainly that wouldn't be true today, and that is a good thing.

Dr. Susan: You said that your dancing is different now in New York than it was in Argentina when you lived there, and you said that tango is so different today in New York than in Argentina, how would you elaborate on such differences?

Anton: The best way I could say it that tango was very dark when I was in Argentina. The atmosphere then in Buenos Aires was like there was a dark cloud ready to open and pour out over everyone. Here in the United States, and in the New York tango scene today, we have more sunshine in our attitudes and in our dancing. Tango is serious here too, but not to the extent it was in Argentina. So, here wouldn't have the depressing atmosphere that there was in Argentina. People here tend to be quite a bit more positive. In Argentina they're clinging to the past. They speak about living in a 'terrible culture,' always remembering the torture during the dictatorship of Perón. Argentinians can sound like eternal victims. They complain continuously about the economy. They are filled with cynicism and despair. At least they were when I was there. I observed how they would bring their heaviness into their dance. Here we don't cling to the past like that. We go on. The people here are quite different.

Anton: I have experienced special warmth at Lafayette Grill that distinguishes it from all other *milonga*s. There's also great food for everyone, and a relaxed feeling. People come there to dance and learn tango, and they don't have to feel judged or observed by those with arrogant attitudes as can happen at other *milonga*s.

Teaching tango at Lafayette Grill is great! There's a mixture of levels of tango dancers in the classes, and the positive side of this is that I always like having new people in the class. Everything about Lafayette Grill is perfect. I feel more relaxed there than teaching elsewhere because it's like home.

Lafayette Grill is a place where you can always have a great evening. I see great people on the dance floor, having fun, truly enjoying the evening and the atmosphere. There's a communal feeling where people at the tables and on the dance floor seem to be having fun together."

Dr. Susan: Do you have any special anecdotes about Lafayette Grill?

195

Anton: Well there are two incidents that I distinctly remember as happening at the Grill. One night, I was doing 'Homage to Argentina,' with a partner wearing the original costume from the show, 'Tango Argentino.' Nelson was there, who had been in the original Broadway show, Nelson Avila. Jose was the DJ for the evening. As my partner and I were just finishing our whole choreographed dance, Jose bumps into the CD player and it skips and begins to play the whole song over. I looked at a friend's face at that moment, and his look said to me, 'I know you have to go through the whole thing again,' and that's exactly what we did. We were led by the music, and to keep up the performance level for the audience we had to dance the whole choreographed routine again because the music played again, and we wanted the mishap to look like a planned event, and not like Jose just bumping into the CD player. So the show must go on, and we kept up the level of the performance by dancing through the choreography to the music again, as the CD replayed. It was a little frustrating at the time, but now I have this memory of this amusing event that took place with the crowd at Lafayette Grill.

The second incident that I remember with amusement and interest is that a few months later, after I performed at Lafayette Grill, a woman came up to me and asked me if I was a ballet dancer, which, of course, I once had been. She said 'You turn exactly like Erik Bruhn.' Now, that was quite a complement because Erik Bruhn was the director of the Royal Danish Ballet. This woman had been in ballet, and was now in tango, having the experience of both dance worlds just like me.

Dr. Susan: It does sound like that was quite a complement and it's nice that you remember receiving it in the warm atmosphere of Lafayette Grill that you have described. Do you have any other comments about the atmosphere of Lafayette Grill?

Anton: Yes. Lafayette Grill is a place where distinct and vivid personalities seem to inhabit the place, returning time and time again, almost like characters in a play or movie. There's a famous French film that you can see on YouTube called "El Bal." It's a fabulous French film, in which certain characters emerge that all end up as unique personalities in a dance in France. This reminds me of Lafayette Grill because at the Grill there are also distinct characters that inhabit the place on an ongoing basis and give an overall character to the place. You and your husband are always at your table on the balcony. George and Betty are at another table on the Lafayette Grill balcony. Vinnie is there. Oscar and his girlfriend are generally there at their table on the lower ballroom floor level of the Grill. Nancy Van Ness and George Lilly are up on the balcony too. All of these Lafayette Grill regulars are characters who have their own unique stories and backgrounds. They all have unique and very different lives, yet they all come together in the place that feels like home to all of them, Lafayette

Grill. I see all these familiar characters greeting each other with kisses and hugs, and a sense of familiarity that makes anyone who comes for the evening feel like they are part of a big tango family. And I know this is definitely not true for all other *milongas* in New York or anywhere else. Lexa Rosean is also a distinct character at Lafayette Grill. And Alex Turney is another well-known tango character who came regularly to Lafayette Grill through his many tango years.

Dr. Susan: Yes, Lexa, as you know, is famous in the New York tango community for her excellent skills as a female who leads other women followers in tango, having won at least three championship medals for her skills at the New York Tango Festival competitions. Lexa is also a spokeswoman for the whole gay tango community in New York. And Alex Turney is our famous 93 year old tango dancer, who starred with his deceased wife Jean, a woman loved by so many, in an award winning movie, called "Tango Octogenarian."

Anton: So my closing words are that Lafayette Grill will always be a special place to me, throughout all my other affiliations in the New York tango community. I am very happy teaching and performing at DanceSport, where I have many performance opportunities. And I am proud to be part of a dance studio with a long tango tradition. But my long history teaching, dancing, and performing at Lafayette Grill makes it a special place for me. The only concern I have about Lafayette Grill is that I would like it to be open to always bringing in new people along with the steady characters who love the restaurant and attend its *milongas* regularly. I don't think it should be a closed club. It needs to remain open to new comers."

Dr. Susan: Well, my husband and I always welcome new people at Lafayette Grill, and I think others do too who come there regularly. Lafayette Grill is a place where people can come to see tango for the first time, and right away take a beginner's lesson and get right into the action. The teachers there, like Jose and Mega, and all the guest artist teachers too, encourage this.

INTERVIEW # 6 WITH ORLANDO REYES

Orlando Reyes is a very popular Argentine tango teacher and performer, working for several years now at Paul Pellicoro's DanceSport Studio in New York City. My husband and I studied for a while with Orlando as a tango couple, after having studied with other DanceSport teachers, both individually and privately, as well as with other tango teachers in New York. We found Orlando to be a very engaging and engaged teacher, with a passion for Argentine tango that has overtaken his early origins as a salsa dancer. He is so popular that it is difficult to get any new lesson times with him. He and his partner Adriana have always been hired for their high level of performance and choreographic skills, but they are devoted teachers of tango as well, as comes across so clearly in this interview with Orlando. This was an open-ended interview, with a few specific questions to guide the interview that took place at DanceSport. The interview heated up and took off as Orlando's passion as a teacher emerged, a passion shown by his intense involvement with the individual development of each of his tango students.

Dr. SKA: How did you get into tango?

Orlando Reyes: I got involved with Argentine tango fourteen years ago in Columbia. I grew up in Columbia, and in Columbia, Argentine tango is very popular. I always listened to tango, during my whole life. My father would go out with friends, get drunk, and then come home and listen to tango music, and sing to my mom. The culture of tango in Columbia was sitting with friends, drinking, and listening to tango music. Then at 20 years old I saw Adrianna dancing tango with someone. I immediately wanted to learn tango then! I had been a salsa dancer. Then I got addicted to tango. I started learning tango with videos. I was inspired by Osvaldo Zotto at first; then later – by Miguel Zotto and Milena Plebs, and Roberto Herrera.

I decided to go to Buenos Aires. I stayed four months, taking lessons every day and going to all the *milonga*s. I would go back and forth then between Columbia and Buenos Aires. I went to dance tango in Aruba and in Dubai. I always went with Adrianna. Adrianna and I worked together in Aruba. We made a lot of connections there with Americans. Then we met a guy who works for Dartmouth University. Through him we started dancing at Dartmouth. It was then that we decided to come to New York because Adrianna had relatives living here. We came to the city and started going to all the *milonga*s. We danced at La National, and a few other *milonga*s. Then we came to DanceSport and met Paul Pellicoro. Paul said he was looking for Argentine Tango teachers. Six months later we were asked by Sondra Catarraso, the hostess then of the Saturday night New York *Milonga* at Lafayette Grill, to teach and perform on a Saturday

night at Lafayette Grill. I remember we were performing at Il Campanello, at La Nacional, at the All Night Milonga, and then at Lafayette Grill. Then we also performed at Corazon and La Turca's Wednesday night *milonga*.

We had a good first impression of Lafayette Grill. We had a great crowd for the lesson. We liked that the Saturday night New York *Milonga* at Lafayette Grill, which had the face of a traditional *milonga* in Buenos Aires in Argentina. The Saturday night *milonga* seemed more traditional than modern. Lafayette Grill had live music. They had the famous bandoneon player, Tito Castro, playing there regularly on Saturday nights at Lafayette. The people were very nice to teach and dance with. I like the Lafayette Grill because it has that old fashioned look. The space and atmosphere is interesting with the columns. I also like that the Grill has two floor heights of tables. The front is very clear on stage, when you perform. It has everything –even a stage for the musicians. People say the food is good there too. People like to go and eat when they dance tango. And along with eating at the tables people have good seating, on two different levels, to watch the tango shows. Lafayette Grill has a rich atmosphere. It's an historical place, unique in New York. Also, so important for the dancers, the floor is very good at Lafayette Grill.

I remember the tiny woman with black curly hair, Betty. She's a lovely woman. I danced with her. She told me of Il Campanello and Gayatri. Lafayette Grill is a familiar, warm family place. Meg, my student likes the place a lot. It's a warm emotional atmosphere. People recognize and greet each other, and have very festive and congenial birthday parties and birthday dances. People connect a lot both in dancing and in socializing, especially Saturday nights...

When you dance Argentine tango you're looking for freedom, but also freedom for your partner. Relaxation is very important in tango. If I am enjoying tango I am feeling free. I feel completely free and connected with the other person. I can lose myself, especially with the follower whom I can connect well with. The leader and follower connect through clear and open communication. It's a feeling of power for both of us, but I feel it as the leader. Everything I do my partner depends on me for, and I then feel I have on impact on her. Also tango is about adapting to many people. I have to change and adapt to many different bodies. I have to change for different people, and for different sizes and shapes.

Dr. Susan: You seem to see it all as an exciting challenge!

Orlando: The tango community has different groups. That's why you need to go to different *milonga*s. You have some *milonga*s that everybody goes there, like the All Night Milonga. You see all the different people and different styles of dancing. You can see the differences between one crowd and another at the All Night Milonga. There are groups within the overall Group. Certain people dance with people they know. Also it's a

place to meet new people to dance with. I could also go there and only dance with girlfriends. Some *milonga*s are cold, with no flavor, no color. Why? It could be the place, the music, or the people.

Dr. Susan: What about the music?

Orlando: Sometimes the place could be warm, but if the music is bad, people don't want to dance. At Lafayette Grill they often have live music. There aren't so many live bands. At Il Campanello they used to have live music.

Dr. Susan: Also different DJs now specialize in playing the music of different classic orchestras or modern bands. What is your preference?

Orlando: When I do performances, I like to dance to Canaro, Osvaldo Fresedo, and Pugliese.

Dr. Susan: What do you like the most about teaching tango?

Orlando: I like the process very much. I'm fascinated by how my students go from being just normal persons to being tangueros and tangueras. My students start changing the ways they dress. The women start wearing sexier dresses. Sometimes, in the beginning, they come with so much clothing you can't see their knees. Then they start showing their knees, their backs, and they get sexier and sexier! They become warmer because of the embrace and the contact. Sometimes they get really sensitive to the different tango music, for example sad versus peppier, etc. This is exciting to watch and experience as a teacher. They start being more relaxed. Some came here and want to dance after dance. Then they become calmer and more comfortable with themselves. Then they get passionate about tango shoes. They start to buy different shoes and want to buy high heels. Salsa people are envious of tango women for their beautiful tango shoes. There is no elegant dress like that in salsa. Then I observe my tango students start to want to go to Buenos Aires, and then they want to go every year.

Dr. Susan: You seem to be saying that it all unfolds as part of a natural process of learning and growth in the tango world.

Orlando: I like seeing Argentine tango students change the way they are as they learn tango. They start becoming happier, more alive. They start to smile and they actually become happier. They start looking forward to the lessons and going to the *milonga*s...

... I believe everybody can dance tango. Anybody in any body shape can do it. But tango is not for everybody, for sure. Some come but don't get hooked. Maybe they like salsa or something else. For tango we have to be willing to connect with the dark and deeper parts of ourselves. Everything is internal and unconscious and we sense the darkness within the unconscious. Salsa, by contrast, is out there, explosive, for show. It's external and noisy. Argentine tango is so active inside!

Dr. Susan: This reminds me of how I have done workshops and seminars on the analogies between psychoanalysis and Argentine tango. Not only are there similarities in the relationship of the psychoanalyst and the patient and the relationship of the follower and leader in Argentine tango, but there are similarities in that both in tango and psychoanalysis (and psychoanalytic psychotherapy) one connects with one's own unconscious and with that of our partner in the process, connecting to deep and primal feelings, like feelings of grief that allows for a developmental evolution through the mourning and creative processes combined.

Orlando: Yes. This is why Argentine tango dancers, especially those who are passionate about tango, are so different from those who prefer salsa dancing. In salsa so much of what you connect to is outside of yourself. You react to the music of salsa, but don't necessarily connect with the internal and deeper parts of one's self and with one's partner. You have to be crazy and obsessive to do tango. But it's a good kind of craziness. I'm very interested in the complexities and subtleties of tango. For me the pleasure and depth of the dance is in being engaged in such an internal focus. Those who don't like tango don't enjoy the closeness and don't like the music. Tango dancers love the music.

Dr. Susan: Yes. I was struck by a comment you made the last time we danced together at Lafayette Grill. You said to me that you could feel how much my heart was connecting with the music. You said that was truly the sign of a tanguera. Your comment touched me, and I carry it with me as a cherished memory of dancing with you. I think that my ability to allow my heart to feel the music so well when dancing with you was also because you were feeling the music deeply as we danced.

Orlando: Yes. Those who don't like the music of Argentine Tango, say that it's too sad and serious. But it's not at all just that. So much is going on inside of people while they dance tango. They can seem sad and serious to those watching, but they are also happy and in a state of pleasure as they sense the tango embrace. One also can have a sad experience while dancing and connecting with the music, and still be happy on the inside. It's very different than ballroom dancing, where the performers can have a false self for the public with fake smiles. This is not true in tango. We may have sad expressions, due to the music, but we are happy inside.

Dr. Susan: You're also saying that in Argentine Tango we feel real, not fake. We are connecting from the heart, from within, not manufacturing a façade or a fake smile. This is true particularly for the social dancing in the *milonga*s. But even in performances, the best tango dancers are the ones who appear to be authentic throughout their body and facial expressions. They often look sad with sad music, but that is because they seem to be genuinely feeling it. They often seem happy in performing the peppier *milonga*s, but this is because the music is not only peppier, but

happier. One professional female Argentine tango dancer said to me after a performance that ended with the heightened play and improvisation in performing *milonga* that for her "*milonga* is sheer joy!"

Orlando: It is true. We feel our true selves, but we also experience different peoples' personalities as we dance with different partners. Sometimes people don't connect that much because they're so into technique. For me, it's about feeling. I feel like I'm melting with my partner, and with the people around, and with the place I'm dancing in. You have to get into that state, something I actually call 'the tango state.' To get there is not easy. It doesn't happen all the time.

Dr. Susan: Some people seem to speak of this as "getting into the zone," as in Marcia Rock's documentary movie on Argentine tango (called after an article of mine, "Anatomy of Surrender," in Reportango magazine, 2002), "Surrender Tango."

Orlando: For me, dancing Argentine tango, is all about what I feel, not what I do.

Dr. Susan: Please tell me more about your interest in your students' development when teaching them Argentine tango. You come across so strongly as a teacher of tango, as well as in your roles of dancer and performer.

Orlando: My students start going out and meeting people at *milonga*s. They get crazy about shoes. They go to Buenos Aires once a year. They become more comfortable with their bodies. They become more sexual.

It's so interesting to see how they go from being regular persons to tangueros. They start losing weight. It just happens. It's great to be there and help them with that. They ask where to go and also do their own research. Meg goes to Lafayette Grill a lot. I told her to go there. My tango students become more outgoing socially, and in general. They start discovering things about their bodies, how they can get into various strong connections. They have to take care of their appearances to get dances and enjoy the dances. Guys start thinking of being clean and wearing new things. Some are more relaxed and like wearing t-shirts.

Example: When this female student first came here she was shy. She was going through separation and divorce. She came in wearing a long black dress. Her posture was closed, like she was protecting herself. She was overweight. She had another teacher. Then she started taking lessons with me. She's a very different person now. She dresses up all the time now and is in shape both physically and emotionally now. She's doing performances. Tango saved her. She's become one of my best students. She blossomed. She said she was saved. She retired and she's spending a lot of time here. She's thinking of taking yoga. Now she's proud of herself. She has that kind of personality for tango, that dark and passionate

personality. Now she's dating, looking for a boyfriend. She looks sexier for guys now.

Orlando: It's all been very good. Adrianna and I understand each other very well, dancing and working together. She had danced tango for a year before me, in Colombia. They had *milonga*s there even before that. So we started with stage tango performances. We decided to go to Buenos Aires and learn to dance their way. We had been salsa dancers. Then tango took over. You really get to know each other dancing together all these years. We're able to talk with each other, as well as dance. Sometimes we had argued over a technique, but now we have the same concepts. Before it was difficult to match; we had arguments. Now it's much easier. It's like being married.

Dr. Susan: You have to accommodate and compromise?

Orlando: Yes. Now we're more relaxed, with less ego...

Dr. Susan: How do you and Adrianna work together?

Orlando: We practice two or three hours five days a week. We do choreography and improvisation. We improvise to develop choreography. We have ten routines we practice, and then create new from improvisation. We believe in each other. We trust each other on the stage when we dance. That's a very important part. We try dancing with others, but it's not the same. It's great when you have that connection and can re-find it. Tango is a very important part in our lives. I totally feel connected together. Trusting, feeling comfortable together.

Another thing I want to mention is how the social dance is very important for the stage dancer. Social dancing is the real tango. Also, tango teaches about living life: My student would say that points of technique relate to real life.

It's good for tango to live in the moment. If you're thinking of the past, you screw up and lose connection with the partner. I have to forget the mistakes of the past, and just keep being in the moment. Things about life occur all the time when you dance tango. You need to take time to allow the process of teaching a male leader to take care of the partner, and to help her to enjoy the dance, and to be there for her. So many things happen in three minutes. It's like the whole life, you pass through. When I'm teaching it strikes me that this is like life. Sometimes I want to translate the freedom I feel when I dance tango to my life. We have moments when we really feel free. Tango teaches you of letting go, and how to trust the other person, and to trust in life as well.

Sometimes the lyrics of the tango are all about pain. But in dancing tango you feel good and feel joy. The sad lyrics can help you develop the dance. You can feel parts of yourself deep inside through the sad music, inward. Sometimes people are just like doing exercise, not doing tango dance, but just steps. The main thing is to enjoy and that brings freedom.

In tango you learn how to let go. If you make a mistake, you learn from a mistake, but then you have to let go; in life too. I have to learn from the experience not to do it again.

INTERVIEW # 7 WITH ALEX TURNEY, 93 YEAR OLD TANGO DANCER

Dr. Susan: How did you get into Argentine tango?

Alex Turney: I started doing Argentine tango in 1985. My wife, Jean, had been a modern dancer, not professionally, but as a hobby. In 1980, we started taking ballroom dance classes together at the Fred Astaire studios. We did waltz, fox trot, cha-cha, merengue, rumba, and American tango at the Fred Astaire studio. We saw international tango, but it looked artificial. We didn't yet know about Argentine tango. There was no heart and soul in international tango. When we saw an announcement that an Argentine tango show was going to be on Broadway, "Tango Argentino," we went to see it. We instantly fell in love with this authentic tango, Argentine tango, which had all the heart and soul we were looking for.

The people in the show were middle aged people. We were in our 60s. The dance done on stage by these middle aged people didn't look beyond our capacities. The next thing we knew we were studying the dance.

In the year of the Broadway show, 1985, we got a call from a friend at a place called "La Milonga." "La Milonga" was a café, an Argentinian restaurant, on 50th street and 9th avenue. There was a man there who was teaching tango on Monday nights, since Monday was a dark night in the theater, and he didn't have to be on stage for the show. His name was Nelson Avila, and he was a star in the cast of "Tango Argentino," teaching on his own on Monday nights at "La Milonga." Nelson was then 44 years old. He kissed and hugged us when we joined his tango class. But then when "Tango Argentina" left New York, Nelson Avila left with the show.

So we persisted and started taking lessons with an American, Eddie Dorfer. Eddie was wonderful to us. We met Eddie in Nelson Avila's class, and we met Paul Pellicoro and his former partner, Diane. We also met Robert Duvall in Nelson's class. We practiced in between classes, and in class Jean danced with Robert Duvall.

After we started taking lessons with Eddie Dorfer, Paul Pellicoro told us he had a lady friend who was a travel agent, who could organize a dance tour for a whole group of couples to go to Argentina to learn more Argentine tango, and we would also stop one week in Brazil for Samba. This was now 1986. We went on the tour, but the other couples were only in their 40s and we were in our 60s. Jean and I thought they wouldn't want us old folks, but the group begged us to go. They didn't have enough people. So we went. We had a mad, fabulous time! There were only eight Americans on the trip. One mature lady in her 60s, a gorgeous actress, was

there with her dance teacher who was in his 20s. We had such a wonderful time learning the tango and Buenos Aires and the Samba in Brazil.

When we got back we were asked to be in a regional competition. The Fred Astaire studio knew we were doing Argentine Tango, which they hadn't taught, somewhere else. So the Fred Astaire studio asked us to enter a completion because they were so impressed with our Argentine tango. Eddie Dorfer choreographed a dance for us. We took first place. It was so uplifting! All of a sudden, Jean and I weren't senior citizens. We felt so very young. We were becoming the darlings of the Argentine tango community in New York City. We had a whole new life!

Jean joked about us, saying "They have shamelessly, and with little or no provocation, performed in night clubs on three different continents." Before we knew it we were going to Paris. In Paris we saw the original "Tango Argentino" show every single night, at the now famous Nelson Avila's invitation. We were so into the tango show biz in Paris that we hardly did other sightseeing. We only went once to the Louvre. We were absolutely too busy with tango. We went everywhere where the "Tango Argentino" company went, along with them, like two geriatric groupies. We actually saw the show 27 times! We couldn't get enough of it! I was 70 when we performed our first dance competition.

Once we found a discarded piano on Broadway. I asked a musician to play it. I asked him to play tangos, and Jean and I danced on the street when he played the tango standard, 'La Cumparsita.' Next, we found a club for Argentine tango people in New York, called 'Agrupacion Amigos del Tango en Nueva York.' Our American teacher told us to join the club because they had a *milonga* once a month. So we joined and became friends with a number of couples. We performed tango for them. We took the two choreographed pieces that Eddie Dorfer had created for us, and we performed. We two old 'gringos' became the entertainment of the club. All this opened a whole new world for us!

Then we went to Germany through the help of an old friend who I had known when I first came to America with my mother and was placed in a Jewish orphanage because my mother had to go and work. I had seen my mother only once a week while she learned a trade. In the orphanage I had met this male friend who now, as I turned 75, made the arrangements for us to go to Berlin at the invitation of the mayor, since my friend and I were Jewish survivors of the Nazis. Once in Berlin, Jean and I went to the dance clubs. We would ask the orchestras if they could play Argentine tango and they would say 'yes.' Suddenly we were performing in Berlin and everyone was applauding. We were old refuges who were invited back to Germany, performing tango now when I was 75, and so when we went to Paris we performed as well. Jean and I would perform in the clubs after the show, 'Tango Argentino,' in Paris. The people in the show encouraged this. They

would actually turn to us and say, 'Now it's your turn!' So we would accept their invitation and perform.

Then we were in Israel, and we met refuges there who were from Argentina. They came to Israel to escape the dictatorship in Argentina. We found 10 Argentine tango restaurants in Israel. So we danced Argentine Tango in the restaurants for the visitors, for the Argentinian refuges and for the other tourists and visitors. People were overwhelmed when we danced and performed.

We found an accordion player in Israel playing to collect change. He put the hat out to collect money, and we asked him to play Argentine tango, which he did. So then we danced in the streets in Israel. The people there screamed with excitement and went 'Wow!' What a trip! We were two old Jewish people dancing on the cobblestones with crippled feet, and people were amazed and thrilled. We couldn't have been enjoying ourselves more!

Then back in New York, in 1992, we joined a drama group that did a play, 'Dear World,' by Jerry Herman. The show is supposed to take place in Paris. We were in New York, on the east side in a drama group called 'The Players!' They put on Broadway shows in a church basement. We had become members even though we and only one other, a kid, were not professionals. The rest of the group consisted of professional singers and dancers. We told Guillermina Quiroga and her husband and partner then, Robert Reis, that we had been asked to be in a show and needed help. Guillermina and Robert had become famous tango performers. Despite their fame they took the time to choreograph a solo number for me and Jean to do in 'The Players' show. We also danced in and out of the Paris Café that was staged. To give the show substance 'The Players' wanted us to do a solo, so we did with Guillermina's and Robert's choreography. Amazingly, there was a consensus that Jean and I were the best part of the show! Here we were with all these trained opera singers and actors, and yet we were seen as the best part of the show. When people saw us they began to fall in love with tango. We were launching Argentine tango in New York. There were only about a couple of hundred people at that time, 1992, who were doing Argentine tango. They were still older couples then, very few young people!

Of all those people, Paul Pellicoro and his partner at that time, Diane, were the youngest. The others were ballroom dancers who had seen Paul Pellicoro do tango and wanted to learn it. They had all seen 'Tango Argentino' and started to take tango lessons with Paul. It was nothing like it is today. Today there can be 100 people in one *milonga*, and there are tons of young single people. In 1992 you couldn't find 100 people doing tango in the whole tri state area.

When in Paris we had been asked to take some dress material to some tango teachers in New York. Milena Plebs asked us to bring dress material to Daniel and Maria, who were teaching and running the first *milonga*s in New York. When we were back in New York we called Daniel and Maria, and they asked if they could come to our apartment to pick up the dress material. We said, "Yes, of course!" But I told Jean, "I don't want to talk about tango lessons with them. My back, body, and feet are killing me."

However, when Daniel and Maria arrived they asked if we would watch a tango video with them. The video tape showed how they danced tango. It wasn't performance style, which we had been used to from following the 'Tango Argentino' troupe around. It was real salon style tango dancing. Even though I had been taking Tylenol with Codeine because everything in my body was hurting from performing tango, and I had at first said to Jean, 'No more tango lessons!,' I couldn't resist wanting to learn to dance the way Daniel and Maria were dancing on their video tape! Again I was hooked!

My wife Jean was quite a comedian, so when we started going to the Daniel and Maria salon tango *milonga*s on Saturday nights we also started performing there, and we did a comic routine. It was a parody on 'Brush up Your Shakespeare,' from the Broadway show, 'Kiss me Kate,' which also had been a parody on Shakespeare's 'Taming of the Shrew.' Jean and I called our new routine, 'Brush up Your Tango.' In this routine Jean says she's hurting all over. Then I come over and say: 'To Buenos Aires we fly!' Jean hugs me and says 'You're my kind of guy.' Then we start doing the tango and singing our lyrics to "Bush Up your Tango!"

... Then this guy, David Licata, wrote this play for Jean and I to do, called "La Camorra." The music is by Oste Piazzolla. In English the title means, "The Quarrel." It was in 2003. People in a health club were asking us to perform tango. Jean said, 'No. I'm tired.' I was 85 years old, and Jean was 79. Jean started becoming ill with breast cancer. Still the show must go on, and we loved tango, so we agreed to do the show at the health club. David Licata came to see us in the show. He saw that people loved us. We did both tango and *milonga* in the show. Also, Jean, who had been a dance teacher, lectured about different Argentine tango styles. David came over to us, and said, 'I love what you did. Would you be interested in auditioning for a tango show I wrote?' Since the audition was only five blocks from our house, at the Alvin Ailey studio, how could I refuse? But I said, 'People of my age don't dance to Oste Piazzolla!' So we danced to a romantic piece, with our own music. David was a 30 or 35 year old man, who was a gorgeous dancer performing at the Alvin Ailey studio. There were other couples who came to audition that day, in 2003. These other couples were young, in their 40s or 50s. I thought: 'David won't take us. He has these

gorgeous younger people,' and that's what I said to Jean. But then after the audition in January, I get a call in May asking jean and I to start rehearsals to be in the show. So we brought our own music and starting to rehearse. David and his crew videotaped every rehearsal so as to see what we were ready to do. Before we knew what was happening, David and his crew had choreographed a piece for me and Jean.

The play was to be a film. In the beginning of the film, which became entitled, 'Tango Octogenario,' Jean and I are seen quarrelling with each other as we walk together in the streets. Then we come to a place with a big dance floor, where the tables of a restaurant are pushed aside, and a man is cleaning up in the after-hours of the restaurant/club. The verbal squabbling and quarrelling is expressed in the dance of tango in the beginning, when the Jean first has the clean-up guy put on the music for us. We fight in dance with gancho kicks, but then the music and connection envelops us, and the tango dance leaves room for both of our self-expressions. This transforms us as a couple into a new romantic connection that breeds peace and harmony, rather than conflict, frustration, and anger. Right there in the middle of the tango romance, Jean and I, as the old married couple, surrender to the music and the tango feeling of connection. Soon we are in love again, and it all happens without words."

Dr. Susan: I've seen the film with my husband. I can see why it took off and was such a success. People are looking for emotional transformation, for romantic and aesthetic transformation; that can sustain a relationship beyond its conflicts, and repair the first intimate connections. This film says that romance never has to die. We all want to be in love, and dancing, in our 70s and 80s. The tango provides the music and the ambience of organic flow and fluid connection for the reparation to take place, and for all the bitter words to dissolve in the beauty of the natural dance movement that can connect us all, and can revitalize our relationships, and particularly our serious relationships, and our marriages.

Alex Turney: Can you imagine that this film was shown all over the world in film festivals? It was a hit in many foreign countries. It was then shown in New York at the New School, along with a German film about ladies and gentlemen over 65 with a similar theme. After the film was shown at the New School, someone in the audience asked, 'How did you get picked for this?' Jean responded, with her usual irony, 'Sir, you have to be very bad to do Argentine tango. We've been doing it for so many years that we finally hit rock bottom. So David Licata picked us.'

Jean was already ill with cancer when this occurred and she was in radiation and chemotherapy. But she was still dancing. In fact, she was still performing! This was now 2004. She was 80, having been born in 1924. She ended up dying at 81. We did the show in 2003. We performed that play that became the film and was taken to all the film festivals. The film

even won some universal Channel Thirteen's contest for the best film, which had originally had 400 submissions. Twenty-nine of the 400 films were chosen to be played for the Channel Thirteen film festival, and then Alex and Jean in "Tango Octogenario" won first place out of all the selected films. It was a living dream for me and Jean. I was in my late 60s when I was re-born through tango and the tango world.

Jean died in 2005, on my birthday. Our anniversary had been that year on October 22nd. I was eight days shy of 30 when I had married her. She saved me from bachelorhood. When I was just 30, this guy I had met at City College asked me to cover over and 'rescue' him at a party, which he reported to have the ugliest girls in New York. When I got there and looked around I thought he was crazy. It was a fabulous party, full of life. It was Farewell Party for Jewish soldiers going over to fight in Palestine. There was a beautiful girl of 24 there. Her name was Jean. I was almost 30. I met also these gorgeous people, drama students, on 112th street and Broadway. I said to jean at the end of the party, 'If you have nothing to do come over!" She shows up at my place and says, 'Here I am!' From this first date we danced our way through life.

In truth, it hasn't always been easy. We adopted three children and our plentiful share of life's difficulties. But we always renewed ourselves through dancing. We danced before and since our marriage in 1948. Jean had been trained as a modern dancer, and had been a member of the Katherine Dunham domestic company. I had already been dancing on my own before they met, having discovered folk dancing in 1942."

Here are some news reports written about us: 'In 1985, the 'Tango Argentino' company burst upon Broadway and the Turneys discovered a new way of life.', and 'to this day, sore feet and all, they continue to dance the Argentine tango. Jean writes, 'It affords a long-time married couple the opportunity to express romantic feelings and also air grievances while still absorbed in the pass of this sensuous dance and all its magical nuances.' 'Tango Octogenario marks jean and Alex's first non-documentary performance in front to of a camera.'

Dr. Susan: I know what you mean about Argentine tango and marriage. My 29 year marriage, with 3 more years together before marriage, was transformed and revitalized when my husband and I entered the Argentine tango world. We both fell passionately in love with tango, after having explored Latin and ballroom dance. Argentine tango brought the connection between me and my husband alive at such a deep heart and soul level, and also offered sensuous play and sensuous feelings, plus the enrichment of dancing with many others, which then and then nurtures our own dance and relationship through the Argentine tango connection with others.

I feel such a kinship with Alex and Jean in this respect, having a long term marriage invigorated and enlivened by a shared love for tango along with a shared love for each other. I have spoken with some people in the tango world who have met their loves in tango. Some have survived, some have married, and some have broken up. But I agree with Alex Turney and his lovely, now deceased wife, Jean Turney, that Argentine tango can be a key to sustained love and intimacy and passion.

Alex Turney: Lafayette Grill was instant simpatico for me and Jean. We loved the music, the tango classes, and the food. And most of all the hospitality was so warm! Sondra Catarraso was the hostess from the first days of the New York Milonga at Lafayette Grill, and she was the hostess for so many years when we danced tango at Lafayette Grill. She was a warm and loving hostess, who made everyone feel at home. Being at Lafayette Grill was like finding a tango family and expanding it. Jean and I found an adopted tango family at the Grill. We felt so proud and privileged to be accepted among the regular people there. By the time we came there regularly there was a whole young crowd actively dancing tango at Lafayette Grill, the tango world in New York having expanded from when there were just a few older couples doing tango. And the presence of you, Dr. Susan, and your amiable husband Saul, didn't hurt either. Being invited to your tango birthday parties at Lafayette Grill as an honored guest didn't hurt my inflated ego either.

The discovery and the passionate involvement in tango, and its hypnotic aura, turned out to be a magnet, a magnet to find a new, joyful, and creative family. At Lafayette Grill we found a creative group of people who felt just as passionate about tango as Jean and I felt. Three or four hours on the dance floor helped us to forget our problems, and to counterbalance the tragedies and sadnesses within our live and family with the joy of life. At Lafayette Grill, where the atmosphere was so filled with warmth and friendliness we felt revitalized. We felt the nurturance of many souls together in the community that shared our tango passion, a community where hearts as well as souls could feel temporarily connected, and could also come back regularly to this family by coming back continuously and connecting at the Lafayette grill *milonga*s, which have now increased to four *milonga*s a week.

Sondra Catarraso was the first hostess at Lafayette Grill. She hosted the Saturday night Lafayette Grill *milonga* for over 12 years. Sondra received all of us with open arms, and always kissed and hugged us with such a loving spirit. Sondra made us feel so at home no matter how many times the outer world would kick us in the shins. Her womanly and maternal presence had made us feel that she was a real member of our family, and that we were real members of the Lafayette Grill tango *milonga* family.

Dr. Susan: Alex, you are a walking Argentine tango encyclopedia! We are so lucky that because of you, your sharp mind and young soul we can connect to the history of this magic!

INTERVIEW # 8 WITH JENNIFER WESNOUSKY

Dr. Susan: Why Argentine tango, Jennifer?

Jennifer Wesnousky: People who get involved in Argentine tango become addicted to it. We put tango above other things. I've always had a love/hate relationship with tango. Now it's just love.

Dr. Susan: Tell me about your journey from love/hate to love of tango.

Jennifer: It was a journey of going from being focused too much on other people's judgments of me to finding myself from within. Because I wanted to be good, and was kind of a perfectionist, I listened too much to other people's judgments about my dancing. I had critical teachers and critical partners, and I think women in general get judged a lot by men they dance tango with at *milongas*, or in classes, even if the men aren't good dancers, or not as good as the women are who they criticize. Because of all this I would let other people's opinions take me over. Then I couldn't be in the moment, which is what tango is all about. This is where the hate came into my tango life, which became my whole life. If you let your tango be judged by tango dancers, you can lose the greatest thing of being in the moment. Some people can be top technicians but not have the amazing connection that others have in tango that comes from the feelings inside of oneself. If you let yourself be taken over by the judgments of such people, you lose the essence of tango, which is being free to be in the moment.

Dr. Susan: So you had to regain your center, your capacity to judge yourself, and give yourself feedback from your own body?

Jennifer: Yes. You fall in love with tango because it feels so great to be in the moment. But then, I wanted to get better and better, so I got caught up in worrying about how I was being perceived from the outside. That's how I lost the natural flow and connection that I once had.

Dr. Susan: It sounds like you're saying that the passion that led you into tango became a painful addiction, as the passion turned into obsession in your mind. I have written about this kind of intrusion of the artist's image of herself upon the experience of being in the moment with the experience of the creative process, as it occurs in well-known historic writers and artists, as well as in artists and writers who I have treated in psychoanalysis and psychotherapy. (I wrote about this in my books, *The Creative Mystique: From Red Shoes Frenzy to Love and Creativity* and *The Compulsion to Create: Women Writers and Their Demon Lovers*).

Jennifer: Yes. Part of it was because I got into performing a lot and being judged on my performances. As I trained myself to be a professional in tango I started losing what all the authentic tango amateurs have, when just dancing freely in the *milongas*. I started losing this, and losing myself, but then I was so incredibly fortunate to finally find a tango

partner who was totally without judgment, and ironically, he was a lot better dancer than many of the other partners I had had. Finally, I found one partner and one teacher who were totally accepting of me and my dancing. They were the people who allowed me to grow, to find myself again, and to find myself in Argentine tango in particular. As I felt accepted I began to accept myself, and in turn I became less judgmental of others I danced with. I became more empathic both to my partners and to myself. For the first time, with one main partner who was nonjudgmental, I began to blossom. I suddenly felt like all the different parts of me could be expressed, and expressed through the dance of tango.

I began to find so many different dimensions in the Argentine tango dance movement, and in my own movement within tango. For the first time I felt what it was like to really give my soul to another person. I felt free to show my partner all the different sides of myself as we danced. I could then merge into the other, my partner, and yet be so much all the parts of me at the same time. Before this I had been too caught up in my own judgments about whether I was good or not, rather than accepting myself and giving myself honest feedback. I had been too caught up in wanting to be good. But when I started flowing without impeding judgments, I could feel infinite experiences of connection. When you really are in the connection and flow that comes in being in the moment, the dynamics of the dance and of yourself in the dance are endless.

Dr. Susan: So you let go of trying to be a perfect image for others, and let go of focusing on technique to create the perfect image.

Jennifer: When you get in that state of flow, you listen and hear differently. You start to always hear new things. You can hear that you and another are hearing the same thing. It's amazing to be on the same page with somebody like that!

Through this resonance with a partner I began to find a balance between being dominating or being in a state of surrender. It meant finding a balance within myself that I could then express in the partnership as it spontaneously happened. I really began to know when to surrender and when to be assertive. I found out that both were parts of my personality. In some moments, this aspect is me, and in other moments, the contrasting aspect is me. I actually began to know how to lead my state of dominance or surrender from a following position. As long as I had a male partner who could go with me as I discovered myself in this way I gained an incredible sense of freedom.

Of course, you have to know when to stop. It takes two to tango and you're not alone. I do believe that you have a particular role as a woman follower that has its boundaries. But at the same time, you have to put your personality into your dancing, and put yourself into your dancing. In some moments you want to take over, but you can't. As in any

conversation, you can't just talk the whole time. A conversation requires you give space for the other and be responsive to the other's part in the conversation. But if I'm really in the moment, I can be in whatever mood I'm in at the moment despite needing to be sensitive to my partner. I can get out anger, sexuality, sensuality, and a million things. I can even cry in the dance.

Dr. Susan: Could you mourn in the dance, the way Suzanne Farrell could in her ballet dancing?

Jennifer: Yes. I could. I like drinking wine when dancing. If I have two glasses of wine at a *milonga* I feel fine, and enjoy letting go in tango.

Dr. Susan: How did you go from learning and dancing tango to being a tango professional?

Jennifer: I think I secretly always wanted to be a professional. People began to ask me to perform. Then I got a job in the same studio I had begun learning tango in, DanceSport. Paul Pellicoro is, as you know, the owner and director of the studio, and he really does give people chances. I'm grateful for that.

When Paul first offered me a job teaching Argentine tango I wasn't good enough. And yet I was a really good teacher, even when I didn't know that much technically. I just tried to convey the feeling of the dance. Now, after ten years of tango, I feel genuinely worthy of sharing the information about tango dancing with students. But the most important thing remains that tango is about the feeling of it.

Performing can be great, but it's less important for me than before. Dancing in the moment in the *milonga* is the essence of tango. But I do like performing when I can do it on a good level. I really like choreographing. I absolutely loved doing the show with Orlando and Adriana, because I got to choreograph with Orlando, as well as dance with my own partner and with him. Now I do truly feel capable of performing. But you really have to test out what you wear for a performance. Otherwise you can fear the outfit will come off or do strange things while you dance...

... One night I danced four hours with someone I dance with, and we didn't break the embrace for the full four hours. Time just went by in a minute, and suddenly it was four hours later. I and my partner of the evening were in such a natural organic flow that we could have effortlessly danced for another four hours. The secret to it all is to dance like nobody's watching you. That is what allows for the organic flow, and for the sense of being immune from time passing. Whether performing or just dancing for your own pleasure, you need to feel in yourself and with your partner, and not be concerned with who's watching.

... Teaching couples to dance tango together is difficult. Each person in the couple tends to get critical of the other. But as a teacher you

217

can help the couple see that they have a great advantage because the repetition of one's dancing with one other person really builds up the level of the dancing. I like teaching older people. I had an 82 year old student who was much better than the younger students I taught. This older man had such great attention to detail and to musicality.

Older men can have such a pure sense of music, and they also can so appreciate their female partners in the moment. There's nothing sexual, but they really open to feeling your soul, and they're amazing!

Dr. Susan: Where was your life going before you found tango as your life?

Jennifer: I was doing concert promotions and doing language translations. When I got a job at DanceSport teaching tango I could quit my other jobs. That was a relief. I felt like I was finding myself.

Dr. Susan: You already spoke Spanish, correct?

Jennifer: Yes. That came in handy to dance and teach tango, since the tango lyrics are all in Spanish.

Dr. Susan: What was your experience like at Lafayette Grill, which has four *milongas* a week now?

Jennifer: I am grateful that I got to perform at Lafayette Grill with many top professional tango dancers. I like performing at Lafayette grill, and have gained much from the opportunities, but I also like going there to just dance, particularly on Monday nights at the *milonga* run by Tioma and Jose.

Dr. Susan: It's been a pleasure interviewing you.

INTERVIEW # 9 WITH MARISA LEMCHE

Dr. Susan: Marisa, how did you first become part of the Argentine tango world?"

Marisa Lemche: I grew up in Buenos Aires, and in school I had a teacher who would ask me to sing tango music in class. At home, when I was a child, there were always TV programs on with tango. Many TV and radio stations were only for tango and tango music. My daddy listened to tangos on radio and T.V. It was something in the air in Buenos Aires when I was growing up. You breathed in tango in Buenos Aires, like you breathed in the air. When my mommy was a little girl she recognized the different tango orchestras, and would say the names to an audience at the local barbershop. The men in the barbershop applauded my mommy for knowing the names of the tang orchestras and for recognizing them as they played on the radio.

When I was little, my daddy would show me tango in the living room This was definitely before I was a teenager because when I became a teenager, I rebelled against tango. I became a 'rock' and 'punk' girl. In fact, I didn't then want to know anything about tango.

When I was 15 I thought I was an adult, and I wanted to come to New York more than anything else. At my 15th birthday I told my father I did not want a party. I wanted a trip to New York. My father sent me to New York and I absolutely loved it. I had always wanted to come to New York. When I saw the crowded New York streets, I was enchanted. Everyone seemed to be enjoying themselves, but at the same time they did not seem to lose respect for other people. This city has always been full of inspiration for me. The architecture is beautiful here. Also, you meet people from all over the world, people of different religions and different cultures. I love that!

Dr. Susan: How has it been coming back to New York as an adult and being into tango?

Marisa: Now, coming back to New York as an adult, and being able to sing tango in New York, is very special! I never imagined that there were so many *milongas* here in New York. Being here now I see that New Yorkers are extremely passionate about tango. All the tango dancers I meet have been to Buenos Aires. I meet so many tango dancers at Lafayette Grill.

I love singing tango music and lyrics. But I also love dancing tango. I also just love watching people dance tango. It's so special, so memorable. I sit and watch the connection between the man and the woman. I love watching and seeing the woman so connected, and yet with her eyes closed. For my own dancing, I'm always eager to learn more tango. Tango is infinite and forever. You can always learn. Also, in tango I

219

always feel complete with the other person, and I see it in others as they dance with each other. Tango is something you can never do on your own. It's like magic!

It's similar with singing tango. It's never complete when I do it at home by myself. I can feel emotion, but when I am on stage it's completely different. I need feedback, and in the dancing I need the embrace. I need the other's hand and arm.

Dr. Susan: What a wonderful way of putting it, about needing the hand of the other! You are sweet, simple in the poetry of your expression, and also to the point.

Marisa: Yes, because you dance with a man that you have never met before. You don't even know his name, but you feel a lot of things, and it pushes you directly into the moment. We're always worrying about the past and the future, but in Argentine tango it's all about the present, the moment! It's so marvelous! And you don't need to talk with the man you're dancing with. You feel who each other through the dance.

Dr. Susan: Do you remember having felt special doing tango with your father before rebelling in your teenage years?

Marisa: Yes. I loved my daddy. It was always special with him.

Dr. Susan: You seem to be saying that it's always about that special feeling, not about steps.

Marisa: Yes. Steps take time to be truly learned so that they can be done with that special feeling. Someone can teach you to do the step, but truly being in the step and learning its full dimensions can take years. It's something we each do over and over, the step, the pattern, connecting with different people as we practice. Each time it gets better and better. The more you practice, the more you do it, the freer you are. In the infinite steps and varieties of tango you're able to truly have your personality as you dance and sing. It's like, at the same time that you're dancing and singing you're growing as a person. Tango improves you as a human being!

Dr. Susan: In what ways?

Marisa: You're always learning to connect better with the other person, and that happens when you connect with yourself. There is the intellectual part that you can think about, but it's the physical contact that makes you feel who you are, and who you are through tango. At the *milongas* it just happens. It's so beautiful.

If you dance with a man who is not gentle, especially if he is rude or violent, you can say, 'No. I won't dance with you.' People often say it is the man who guides the female follower, but this is not true. We feel tango together. We feel the dance and the music together, the man and the woman, leader and follower. The leader proposes the steps, but the follower, usually the woman, responds.

This is the first time I am singing in New York, always singing tango. In my wildest dreams I would never have imagined how much love I would be feeling coming to me from the people here in New York. Things just work easy here!

Dr. Susan: Much more than in Buenos Aires?

Marisa: Yes. For example, I entered into the Metropolitan Hotel. This woman comes up to me and says: "I love your outfit!" She says she's a publicist. Suddenly, the next week, I'm singing at a party she has. It's strange the way it moves here in relationships. I'm here only five months and I'm singing in two restaurants and many *milongas*.

One day here in New York a man comes up to me and asks if I like jazz. Then he asks me on the spot to sing in a jazz group. Now I go there every Sunday to play jazz. Another man comes to see me. We become friendly. The other day he writes to me, "I am Vito Giallo." He then lets me know that he was one of the assistants of Andy Warhol, the painter, the pop artist. I happen to love Andy Warhol.

Dr. Susan: What a coincidence!

Marisa: I can't believe how beautiful people are here in New York! There are always real connections, not stupid hook ups or stupid connections. It's so different than in Buenos Aires. In Buenos Aires when a man wants to talk to you it's always a pick up. Here I have never found it to be about stupid connections. This publicist invites me to three parties, to sing, and is so very nice to me!

Dr. Susan: You find that New Yorkers are very friendly. Is there anything about the tango people in New York in particular?

Marisa: Yes. You say that Lafayette Grill is your second home. This is my home here at Lafayette Grill. When I first arrived in New York, I came and sat alone with my tango shoes in the corner at Lafayette Grill. Then, in a moment, I was dancing. I love Vinnie and Dany. The tango people at Lafayette Grill are so warm, and lovely, and friendly. I have to go back to Buenos Aires to make a CD. I know the *milongas* there in Buenos Aires. But I want to come right back here to Lafayette Grill. I feel that people here love tango singers. Although in Buenos Aires the great tango singer, Carlos Gardel, was also loved. I was sad as a little girl when my daddy told me that Gardel died.

People need live music with the live shows here. There were always live tango bands and orchestras in the 1940s. People would hear that Pugliese was performing and they would go to where he was to dance. But I always loved d'Arienzo.

Dr. Susan: d'Arienzo is truly for the tango dancer, the salon tango dancer as well as the *milonguero* in general.

Marisa: *Milonguero*s love live music. The golden years of tango had huge orchestras and singers. I like to work as a team with musicians as

221

I can with the guitar players who are at Lafayette Grill on Wednesday nights, Joanne and Burley.

I love tango and I love psychoanalysis. I have been on the couch. I find the combination of tango and psychoanalysis that you do so interesting. I loved your big Saturday night birthday party at Lafayette Grill. I loved singing there for you as a birthday gift. There were so many people. You are very popular and have a lot of friends.

I feel more connected to the New York tangueros than to those in Buenos Aires. I met so many people dancing here, at Lafayette Grill. The music I hear here brings our passions together. It's the culmination of a whole circle of connection here in New York tango, and at Lafayette Grill. I love how people will dance while I sing here at Lafayette Grill. I always like having people dancing while I'm singing.

I tell a little about the lyrics of the tangos I am about to sing to everyone at Lafayette Grill. I love this intimate moment that we share as I tell all the dancers here about the lyrics of the songs I am about to sing. I like to tell the drama that's in the lyrics, especially since not everyone understands the lyrics that are in Spanish. It is an extra. I feel that I am authentic when I speak directly to you in the Lafayette Grill audience. I'm telling you my story, the story that I live every day with in my city. The other day I was singing about a neighborhood I love. The experience I had there is more and more strong for me. For me, it's reaffirming what I do and also what I am.

When I came to New York as a teenage I felt like I was being baptized. And this second trip here to New York I feel is my second baptism. Everyone here, especially at Lafayette Grill, is presenting me as 'Marisa de Buenos Aires.' In Buenos Aires, I don't feel I have an identity! My name on my new CD is 'Marisa of Buenos Aires.' I got that name here at Lafayette Grill. It becomes for me more authentic than my last name.

Dr. Susan: You have a special identity here!

Marisa: Yes. I sing on Wednesdays and Saturdays at Lafayette Grill. I feel in love at Lafayette Grill, with the place, with the people, with the Greek guy who is such a beautiful tango dancer. Also the owners, Dino and Billy, are so special to me. The whole staff of Lafayette Grill is so special and friendly: Placido, Inga, Bryant O'Neal.

Imagine how it is for a foreign person like me. I arrive here alone, and put on my tango shoes. Then I feel the tango embrace in a city in which I know nobody. It's not my language here, nor my friends, nor my family. Yet, it all magically happens through the love of the dancing. You don't need the language. It's just love we experience together in the dancing and the music. As a tango follower I can be in silence with my eyes closed, and I can connect with somebody deeply. There's just the music and the dance floor.

Then I got to know you more, as a professional, as a writer. I felt even more intrigued and interested. At *milongas*, there are situations with tango embrace; and it is also for the brains. You can absorb so much through the connection and the embrace, but it first happens in the brains. Then you do the steps and everything. So I was very interested in you not just as a dancer but as an intellectual too. In a way tango is the sudden thinking that you can dance!

Tango also involves sadness. The lyrics are always so different, so sad when you think often. Tango is a philosophy, a lot of things that are profound. By comparison, salsa lyrics are nothing. But the tango lyrics are profound. Tango gives you the possibility. It works like Alchemy. Sometimes you feel terrible because you lost your love in your life. But meanwhile you are singing and dancing. That moment is an alchemic moment. It transforms all that we suffer from into something beautiful!

Dr. Susan: And tango is something to surrender to, rather than to defend ourselves against...

Marisa: Yes, this stuff is different now because it is me and my partner in a moment of movement together, or it is me as a singer together with the audience. When I have a paper before me with the lyrics it is nothing. The lyrics need the singer, but the singer also needs the audience. I feel when singing the suffering of the composer. Then as I sing the composer expresses his poetry. The composer has to find me, the singer, and the musician, to express his tango song. These are small circles that bring us connection, feeling meaning. I become alive with each word and note of musical song. In his way I sing and create a circle with the audience, just as when I dance I create a circle of connection with the man in the embrace, and then there is the circle on the dance floor of all the couples dancing together. There are different kinds of circles of connection all at once.

Dr. Susan: There are different circles of connection interacting on different levels and interweaving in the spirit of tango, and the connection creates emotional meaning that we share.

Marisa: To me it's like a solar system, with all the couples dancing in the line of dance. We are each with the flow of the whole. It's like a beautiful stream!

You have to be careful to be gentle and nice. It's like a sort of celebration. It's very different from football matches, or fights for sports. In the *milongas* we are all on the same team, the tango team.

Lafayette Grill is the place I feel that I am in love with. It's amazing how right here, in a city far from my original home, how I can find my own personality and power as a person. It all happens just by dancing with people at Lafayette Grill.

There's something so special at *milongas* about the way men ask you to dance. In every *milonga* we are together in a mixture. The man looks at the woman in the *cabeceo*, just a look, without saying anything. If he gets a nod back form the woman, he is reassured that he is wanted and asks the woman to dance. Other men come and ask directly if you want to dance. Each man chooses the way, and also the women to dance with. We know how to make a man know if we want to dance with them, and we know how to avoid the eyes of the men when we don't want to dance with them.

There are couples who only dance together and others in couples who dance all together with many exchanges of partners. I find this all so inspiring for me, for my dancing, and for my singing!

I want to tango the lovely guitar player who accompanied me at Lafayette Grill at Magdalena's *milonga* on Wednesday nights. Joanne and Burley are so lovely to work with. I feel so supported by them. And I love supporting them. I am addicted to their music, along with my singing!

Dr. Susan: You enrich the *milonga*, with the musicians and with your special singing.

INTERVIEW #10 WITH JON TARIQ

Dr. Susan: How did you get into Argentine tango?

Jon Tariq: I first got into Argentine tango through the music. My uncle went to Argentina, and brought me back the music to listen to. My uncle didn't know anything about tango. In fact, since he didn't know anything about ganchos in tango, when he saw a woman putting her leg under the guy she partnered with he made a joke that she could kick the guy's balls. Still my uncle thought the dance was amazing, and he brought me back both music and reports of tango performances. I first went to study Argentine tango at the Sandra Cameron dance studios. I started by taking five group classes. But it was discouraging because there were only older people in the classes, and they had a lot of 'attitude' that put me off. There were only older women there doing tango and I was a younger guy. The women didn't want to dance with me, and I didn't realize that five classes didn't teach me anything. I thought I could do the dance after five classes, but I was ignored by the women and I got the message.

I still wasn't really getting into tango. Then one day I was inspired by the great Carlos Gavito, who became famous when the big Broadway show, 'Forever Tango,' came to New York. I was inspired by watching Gavito, but nobody would let me into his classes. You had to be advanced in tango to be allowed entry into his classes, and you couldn't fake it!

Then one day I saw Carlos De Chey and Lorraine dance at some place on Fifth Avenue. So many of the teachers were coming and going, coming into New York from Buenos Aires, and then leaving. When I spoke to Carlos about learning tango he said: "You have to learn from ongoing private work with one teacher that you keep studying with." He said that it's not enough to sometimes feel the music and go to workshops. So I listened to Carlos, and I watched Carlos and Lorraine dance. Then, I wanted to do close embrace tango, and not open embrace.

At that time Carlos worked out of the Fazil's Studio. You remember that place with the ancient furniture and pictures of famous dancers in photos on the walls?

Dr. Susan: Yes I was there once to rehearse choreography with Joe Ramos for a birthday party performance. We were performing to Pugliese's 'Recuerdo' at Lafayette Grill.

Jon: Then Carlos started working out of the Pierre Dulaine dance studio. I started going twice a week to study with him. The guys in his classes were learning to dance lots of pivots. Each time I went to Carlos's classes I learned something new.

Finally, women started accepting my invitations to dance, rather than refusing. The women liked that I came dressed up in jackets, and suits, not just wearing jeans like a lot of the other guys. I had been brought up to

225

dress well since my relatives were in men's clothing businesses. But the women would only dance one dance with me. I thought: "This is tango." But the other guys told me that that's an insult when a woman only dances one dance, and not a *tanda* of dances, which is three or four dances. I was told that if a woman says "thank you" after only one dance it's an insult.

One girl did only a quarter of a dance with me. I then realized that I needed a lot more training to lead in tango. So I ended up actually thinking that it was good that the women had said "Thank you" after one dance, because they gave me the message that I needed a lot more work.

Rather than being discouraged, I was challenged and encouraged. This was true particularly when I would listen to Argentine tango music. It was through listening to the music, and beginning to realize that the connection in tango was all about feeling the music flow through your brain and body that I really started to understand what tango is about. I started thinking about 'musicality,' and began to live with the music in me all the time.

Then Carlos De Chey, who I think is a very loving person, asked me to dinner at his home. We talked. I asked him: "What is tango?" He said, "Tango is the feeling inside of you. You have to feel the music inside of you before you get up to ask a woman to dance." He also said: "You go where the music takes you, not fitting in a gancho or other step to the beat of the music. You have to express your own feeling in the flow of the music. Then, you are doing tango." So Carlos De Chey, Fecundo and Kelly (teaching *milonga*), and Carlos Gavito were my first and main teachers.

Then, there was the confusion of having different teachers. When I went for privates with Gavito, he said to put my left hand all the way up, like the old *milonguero* style. When I went to Garcia he tells me to put my hand much further down. When I went to Carlos De Chey, he said my hand should be at a level under my chin. I would correct myself to comply with one teacher's teachings, and then I would be criticized by the other teachers. But ultimately, I trusted myself, and found a comfortable level for my hand and arm. It's been an ongoing process like this, and now I run many *milongas*, and teach both group and private classes throughout the week. It's always a continuing process of learning and teaching and dancing.

People think that Argentine tango is an old dance, but it is a new dance. The technique and figures and steps are always evolving. The boleo was changed from what it was. Instead of just lifting the leg and turning it around to do a boleo, it changed to doing the all-around with the flow of the body and with the flow of the music. Tango is always changing and taking new shape.

Jon: I like the atmosphere of Lafayette Grill. I also love the set up there. I prefer it so much to other places that look too modern for the traditional ambience of tango.

Also, at Lafayette Grill all the people are mixed from many nationalities and many cultures. We're French, Italian, Greek, Argentinian, American, etc. We adopt each other's ways of eating and also each other's ways of dancing. If I sit back and open to taking in the atmosphere at Lafayette Grill, I can see and feel it all. Sitting at the Grill takes me away from the outside world, and puts me in a dream state, where I feel uplifted. I feel like I'm floating with inspiring thoughts and ideas.

Dr. Susan: My husband and I feel most comfortable at Lafayette Grill.

Jon: There is a warmth and friendliness at Lafayette Grill. The paintings provide an atmosphere, as does the set up at the tables and bar. Everyone is comfortable. Everyone can have their place. Each night at Lafayette Grill is different! Tuesday I feel different than Saturday or Monday or Wednesday. Each night is unique for the *milonga*, and each night of people has a different flavor, along with the different hosts that host the *milongas*. I feel privileged to host the Tuesday night *milonga*. I feel the excitement build as people enter the Grill throughout the evening. Sometimes we have live music and other times I bring all the music I gathered over much time that I store on my IPOD with different CDs.

On other nights, when I am not the host for the *milonga*, I come to the Grill to eat, observe, talk, and dance. I really appreciate the physical set up of Lafayette Grill. The majestic pillars on the ballroom floor add atmosphere. The balcony and the tables above on the balcony offer a special flavor. There are cozy nests of people who can be spectators of performances from above, as well as then descending onto the dance floor to dance. Then these same people can return to their little comfortable nests above on the balcony. The different levels of the restaurant give the place the atmosphere of a theater. Then, the paintings of dancers, and the waves of color and design, give a background for the theater. Descending down from the balcony to dance on the ballroom floor is like going on a stage, even if you're not performing. Even just doing the social dancing in the *milonga* is like entering a stage.

The many people on the balcony, on the restaurant floor, and also those at the bar, will watch and observe, so when dancing, you feel a sense of participation of others, who are eating, talking, and drinking, while also observing, as a bit of an audience.

I'm thinking about the special committed couples who attend the Grill, as well as about the younger single people who hang out and dance at Lafayette Grill. On Saturday night, as you know, since you come with your husband, there are the couples that come to Lafayette Grill regularly and

enthusiastically for years and years. It gives Lafayette Grill a special atmosphere of family and friends. Those who love tango are coming together as a family.

Dr. Susan: Yes we watch each other dance. We dance together in the line of dance circling the floor. We sometimes bump into each other, and then hug each other afterwards because we know and recognize each other. There's John and Milly, the Chinese entrepreneurs who come to Lafayette Grill each time they come back to New York. There're George and Betty; George is retired and focusing on improving tango, to improve his life, and Betty, a school teacher, who is still working, but dancing tango with George – to experience the passion of life. There're George Lilly and Nancy Van Ness, dancing tango together like professionals, with Nancy being a professional dancer; she is the director of her own modern dance company, American Creative Dance. Nancy speaks to me of the magic of George Lilly's spine as he turns to every curve in the flow of the music; she follows with such a look of bliss on her face, and her eyes closed. There's also Oscar and Hortenzia, and other regulars like Terry and Victor, and formerly Dr. Alfredo Astua and his wife Natalia, or Natalie, who are now scarce since they had a baby. Everyone is moving and changing, and yet the one constant is they are in and out of Lafayette Grill.

Since I've found all of your thoughts about Lafayette Grill inspiring, Jon, I'll add some more thoughts of my own. There are also the breaks for salsa dancing, where George and his wife, Betty, do their old ballroom dancing, so we can sit back and enjoy it as we relax in between tangos. Sometimes I do salsa with a guy named Ken, who comes every other week and shows off his ballroom and Latin dance technique as we dance. We each watch our different styles and sometimes switch off partners with each other, as well as with others. There are always new people popping in on Saturday night, to see what the whole New York experience of Argentine tango is all about.

George Lilly and I dance so differently than my husband and I. But it all works! I love the music, and the peppy *milonga* rhythms with George Lilly, and his flowing spine inspires me to return to my husband with new energy for more tangos. Then there is always the joy of dancing with Hector Scotti who now DJs on Saturday night. He is from the old school of tango in Buenos Aires, and walks with elegant *milonguero* style in tango, and is such a pleasure to dance with as his consciousness sinks so deeply into the music as we move. Doing tango with him makes me feel sinuous and feminine in long flowing curves of movement, as he leads and guides me. Doing *milonga* with him makes me feel extremely rhythmic we ingest the beat of the music, as our feet and bodies move so quickly together in the tango embrace. This is an every Saturday night joy at Lafayette Grill.

INTERVIEW #11 WITH JOSE FLUK

Dr. Susan: How did you get into Argentine tango?

Jose Fluk: I grew up in Argentina, in Mar del Plata. When I was seventeen my mother and sister wanted to take tango lessons. They asked me to go along to be a partner for them. I went to the lessons, and after two or three lessons I fell in love with tango. Even though I was about to go to study in Israel, to find myself and get an education, I totally changed my plans when I fell in love with tango. I went to Buenos Aires instead and studied tango exclusively for four years there. I studied Argentine tango in the dance studios four days a week, for 10 to 12 hours each day. As I learned tango in lessons and practicas, and practiced, I went to the *milongas* and danced with women. Then I went to Spain for seven months and continued dancing tango there. I was planning to come back to Europe but I went to New York City because my mother was there. I went to visit my mother, and thought I'd stay two months and do tango in New York.

When I got to New York I called up this woman, an Argentinean young woman, because I thought she could give me information on where the tango *milongas* were in New York. When I called she thought I was calling for a private lesson, but then I asked for the information, and she said she recognized my name. She said that her brother had studied tango with me in Buenos Aires. I recognized the name of her brother. Then she said that I could have a job teaching tango group classes in Brooklyn that she couldn't take then. I agreed to take the job, and then she asked me to be her teaching partner for tango at the Stepping Out studios. She got me these jobs and brought me into the tango community in New York.

Then this same young woman said that she needed a roommate for her apartment, because the roommate she had was moving out. I agreed to move in and pay her rent, and be her roommate. Then the totally unexpected happened. When I moved in to her apartment she and I fell in love. Then, my whole life changed. Instead of going to Europe again, I stayed in New York city and earned money by teaching tango; but for me the social dancing was always the most important thing. I just taught tango out of my love for it, and in that way became a professional who taught tango and sometimes performed. I was 22 years old when this all happened, and I had to go through enormous changes when I fell in love. I had to grow up; and doing tango was my way of learning and growing. But I did this all out of my love for tango, and after six or seven years of doing tango, I fell out of love with tango, at least as a professional dancer and teacher. I began to feel like I was losing my heartfelt love for tango, and this affected everything in my life, including my relationship with my girlfriend.

So, for a while I stopped doing tango professionally and just focused on spiritual practices and spiritual readings to help find myself

again. Meanwhile, I always continued to do the social tango dancing that was the most meaningful thing to me.

My girlfriend and I began to practice both yoga and nei kung, or nei gong, which is a Chinese form of meditation, breathing system, and martial arts, with Tioma. We went every day to Tioma's house and we would do two hours of yoga and two hours of nei kung. I started learning about the natural energy flows in the body, and about the symbols of these energy flows, so that I could understand them. Through this, I felt my body was becoming more perceptive, and more sensitive. I learned that everything is about pushing the floor and moving totally from the center of one's body. To be grounded and centered is everything.

Dr. Susan: You're talking about learning how your whole psychophysical self needs to be grounded to feel fully alive, and to feel fully alive in tango...

Jose: Yes. Thank God, I learned that with Tioma, about the energy flows, through the Chinese martial arts. I understood that I stopped feeling; and if you stop feeling, the yin and yang balance of your mind/body connection is lost. The feminine energy in you won't flow if you lose your body feeling, and just thinking in your head. From the practice of nei kung, I've learned how to always ground my body on the floor, and how to always open up from the core of my body, from my body center. I learned that this is so necessary for both sex and tango.

You can breathe deeper and slower when you are grounded. Yoga relaxes you, but nei kung charges you with energy. Through these spiritual practices, I learned that I could fix thing in my legs that doctors couldn't fix. I like the expression from my feet now very much. I think the feet can be turned in different ways.

I needed to get my love for tango back. When you start losing your love for something dear to your heart, you'll do anything to get it back. I stopped all my professional activities for a while, so I could rediscover my love for tango. The physical work I did began to change my thoughts and beliefs. I never gave up the social tango that was and is the major meaning of tango for me. I always felt love in social tango.

After I studied the nei kung grounding, and had centered my movement with the energy flows, I no longer got panic attacks or fears. I had fears of death when I was a child, and also fears related to thoughts of living forever... When I connected with the ground, and with my center, and through that could connect to my girlfriend and to dance partners and others, I no longer had any of these fears. I realized something that was really important to realize – that we are all part of a whole. Tango makes us a part of the whole dance and the whole community. If I think of being part of a whole, as a human being, I don't think of my individual death or of an endless individual life.

During the time of this spiritual practice and learning I also stayed home and read religious texts every day. I read about Judaism, Taoism, Buddhism, and Hinduism. I wanted to experience religious thinking that focused on the body, not just on the mind. I studied all this in the days when I took a break from professional tango. Then when I returned to professional work in tango it didn't feel like work anymore. I don't feel that I'm working when I work now. The process of life and tango became much easier.

I even became more humble and therefore more loving. We are not only ourselves. I learned and experienced that we are part of a whole thing. When we are part of a whole then everything is more graceful. When you get too caught up in the image of yourself you lose the essence of tango and of life."

Dr. Susan: Yes. One of my published books, *The Creative Mystique...* speaks about this whole issue of how one loses the process of life and of art if you become too caught up in the "mystique," or image of yourself as an artist. I have stories of well-known brilliant artists, some of whom lost their process in the mystique of the art, while others could regain themselves after life's losses by tolerating a mourning process in therapy or in the creative process.

Jose: Yes. I care about the music and the connection in tango, which allows me to connect with my body/mind center and to the ground. Then the energy flows naturally and you lose self-consciousness in the flow, so humility of being part of the process grows and arrogance about your own individual self lessens. When you have your own support, you connect to the music and to your partner. And if your partner is on her feet, and doesn't "take you," she can connect to herself and to you.

Dr. Susan: It's like in a relationship. It's the difference between possessing your partner and connecting to your partner.

Jose: Yes, exactly. If you aren't grounded and connected to yourself you can become like a vampire with your partner, exploiting your partner's energy. In simple terms, if your partner is not balanced on the balls of her feet, then she can be too heavy, and then she takes away your freedom, or vice versa, for a man doing that to a woman.

Dr. Susan: What has it been like hosting the Saturday night New York Milonga at Lafayette Grill, for almost a decade, along with Sondra Catarraso and now with Megan, and in more recent years, hosting the Monday night milonga at Lafayette Grill along with Tioma and Savanna?

Jose: For me personally, it was the first time I was hosting a social dance. It's been a wonderful experience working with Dino Bakakos, the owner of Lafayette Grill. Dino is a particular kind of character. I never had a boss I could work so well for, someone who is more like a friend than a boss, someone who really respects what I do and who I am. Dino never

tries to tell me what to do, or how to do it. He doesn't treat me like an employee. He treats me like a friend and helper. Dino is a very-very special person!

Also, to be hosting a *milonga* at Lafayette Grill is like having a pleasure, and not like work. We don't have that many restaurants in New York with a dance floor. The atmosphere here is unique! It would be such a tremendous loss if we ever lost this place.

Lafayette Grill has been like a school for me. It is a mirror for me here, as I interact with the people. If I don't have enough time alone for myself I can't be with the people. I need seclusion three times a week.

Dr. Susan: That's like having three psychoanalytic psychotherapy sessions a week to go inward into one's dreams and one's internal world and deeper and unconscious thoughts.

Jose: I can't work like a full time professional dancer. I still feel I need to make myself stronger to fight my inner monsters. It's like a mirror for me, at Lafayette Grill, to see if I'm too arrogant as opposed to humble, if I'm empathic to people as opposed to hostile...

I believe the tango community is the whole New York tango community. But those who prefer Lafayette Gill feel that the owner really cares about tango, and about the people who do tango. Since Dino and Billy, the restaurant owners, broke down the wall and made the large ballroom floor, Lafayette Grill became completely different place. This place is fun because we are all crazy in a way, and so we understand each other!

Dr. Susan: How are we all crazy?

Jose: We are all looking for something, not just conforming... We're looking for something romantic and spiritual, for friendship... The most important thing is the respect that we have for each to her. If you don't respect people it will show in the dance. Who you are in your life expresses itself in tango. You can be a technician, but then you're not in the flow and feeling of tango, which involves *loving people.* Tioma reminded me. It's not about the women you dance with. It's about you. If you feel good with yourself you will connect with the woman. Tango is something without definition. It's always a mystery. When you live in the mystery you live for real!

Dr. Susan: The tango world, and Lafayette Grill, is a play space with boundaries.

Jose: It's not something we discover. It's something you have to feel through getting into it, like the rhythm of the music. We have something in common, an understanding we are following and understanding. It's a real art. We show ourselves in a way others can tell. You can see aspects of others and of ourselves that you can't see if you're not dancing. You can see a person's priorities and loving capacities.

232

Jose: To go onto the dance floor is a responsibility. For learning or practice we have lessons and practicas. For dancing we have the *milongas*. We have to be ready for the actual dancing at *milongas* through lessons, practice, and practicas.

Only after six or seven months did I start dancing at *milongas* in Buenos Aires. There are rules; you have to learn about how to treat people at *milongas*. You learn how to ask people to dance, how to lead, and how to follow. This is true for men in tango. For women, they can dance at *milongas* right away. They can sometimes follow right away. For men, it's never like that! We men should go to lessons and practicas before even going to the *milonga*.

Basically, what I feel is if I concentrate on my connection with the ground I can take the best from partners and can leave the bad parts. When we pick up the bad in others it's because we have those bad things in ourselves. For women, even without much training, they can learn to connect. It's about using the loveliest intention we can. If we don't have that open, loving intensity we will make too much effort. Then we will get tired. If we don't have understanding about tango we can't have the right intention. We can see something even if we can't touch it yet. We sense it intuitively. You will grow up as an artist only by doing tango with everybody, but also by having an open, loving, intention in tango. It's never enough to only do tango with one partner. We should be able to dance with everyone. If I dance with a woman who doesn't know how to dance I can still dance with her because of my connection to the ground. However, a woman cannot dance with a man who can't dance tango. For a woman, it is more natural to be graceful on the ground than for a man.

Life is about your whole picture of the world. It's not just about you. I see you dancing with your husband, and it's real. It's not about patterns. It's a real dance. But if you were only to dance with your husband you'd probably, in a few years, end up having a divorce. I know for me, if I don't have love I lose my integrity. If you don't have both feelings and thoughts, feelings and understanding, you can't have a genuine connection.

Dr. Susan: This is psychoanalysis...

Jose: There are seven principles that are one. When I talk about love it's hard to express what I want. After falling in love with my girlfriend I really wanted to discover love for others. I then had much more respect and love for everyone. After falling in love it was a huge existential drama for me. I felt fear and responsibility for the first time. It put me between the sword and the wall. I had to really decide, I had to change myself to be able to love. I wasn't expecting to fall in love. It just happened! To fall in love was the whole transformation of my life. It wasn't easy for me to grow up and become a man. I needed to find peace first, and tango was my salvation! But being fully in love was more than that.

Falling in love is a huge decision. Some people are not ready! We risk everything for real love. It's easy to lose it if you don't work on it forever. If your partner doesn't have his or her own personal process there is nothing to share.

Jose: I dance the social dancing. I dance with who I want while I co-host at Lafayette Grill. I am not a taxi dancer. I dance with whomever I want. Dino doesn't pay me to dance with the women, but rather to teach classes, and to DJ the music. I'm never bored. To dance with different women, and to learn from the woman, is so fantastic! Life gives you what you plant. What you plant is what you get!

Dr. Susan: You seem to be saying that being a host at Saturday and now Monday *milongas* at Lafayette Grill has allowed you to live the essence of what you believe Argentine tango is.

Jose: Yes. I like to say that I was a co-host with Sondra Catarraso at the Saturday night New York Milonga for many years. Sondra would make the announcements and arrange the teachers for the intermediate classes who would perform. I would teach the beginners' classes and do social dancing with the women, and sometimes I would perform with my girlfriend and teach the intermediate class. Now I DJ a lot on Saturday nights, sometimes teach the beginner or intermediate classes, and do social dancing with the women. Since Tioma started the Monday night *milonga*, I co-host with him, and he plans the music and does the DJ job. I then can concentrate on asking women to do social tango, and help everyone to enjoy themselves in that way. I have been offered other jobs performing, but for me that social dancing is always what I live for. The social dancing is where I grow and share in the mystery and enjoyment with others. Lafayette Grill allows me to put my deepest beliefs into practice so I can always continue to grow.

INTERVIEW #12 WITH LUCILLE KRASNE

Dr. Susan: Lucille, you are known in the New York Argentine tango community for being very creative and an early organizer of tango events and popular *milongas*. You have been a big supporter of the tango dances and activities at the Lafayette Grill and Bar. Your tango community contributions include being the first person nationally to create a weekly outdoor *milonga*, initiating the first and only annual New York tango festival in 2001, organizing a tango contingent for the Greenwich Village Halloween Parade with tango singer Isabel de Sebastian, and most recently you have finished a 7-year run of a successful Sunday night *milonga*, Esmeralda's Tango and Tapas. Tell us a bit more about your role in our city's Argentine tango community?"

Lucille: Susan, this is a lovely idea you have to honor the contribution that the Lafayette Grill and its generous owner, Dino, made to our tango world, and also to honor a number of us as well. Yes, I always supported the Grill by creating special parties, including the dinner parties held during our annual festival. And you, Susan, were one of my major "contributions" to the Grill, suggesting (how many years ago?) that you go to the Grill to celebrate both professional and personal special occasions. Hooray! This is the result, your homage to The Grill!!! I organized two tango-themed art shows there as well; one was about 10 years ago. I called it "For the Love of Tango" (around Valentine's Day, of course), and I created fun and unusual items like tango floor cloths (decorative art to walk on!), and shower curtains, along with portraits of local tangueros and tangueras, etc. This is thanks to Dino who loved to have art shows and really enjoyed shows of tango images.

Dr. Susan: Tell us a more about "Hit and Run Tango," your outdoor idea because it really caught on and continues in many forms today.

Lucille: The "Hit and Run Tango" idea came to me back in 1994 after my first year or so in tango when I strolled through Central Park's plaza one morning. The rules for "Hit and Run" being to find a free or cheap, attractive public space with little equipment or red tape, dance sans permits and if the police come, run. It started at Central Park's crowning jewel: Bethesda Fountain and Terrace. One of my cohorts in this was Gerald Wagner who more recently organized a special "Hit and Run" for my birthday, on the last day "The Gates" by Christo and Jeanne-Claude filled the park. There was snow on the ground, we danced up a tango storm, thousands of visitors photographed us; and then the park police came. It was a perfect ending.

Dr. Susan: I remember hearing about another unusual "Hit and Run" event. For history's sake, would you tell about that park event back in 1996, and maybe also something about the tango contingent for the Greenwich Village Halloween Parade?

Lucille: The parade was a wild and wooly idea suggested to me by the great tango singer, Isabel de Sebastian. We organized the first of seven years of participation and appeared in a several page special with photos in *Clarín*, the most important newspaper in Argentina. Trey Parker, the amazing organizer of numerous *milongas*, like the one on the west side barge, continued the contingent with me for 6 more years.

About the "Hit and Run" special event – I organized it for a Friday night in late September 1996, to be held under the 72nd street roadway with its beautiful frescos. Back then, no one would enter the park at night out of rampaging fear about dangers. Everyone warned me no one would show up. I gambled that they would. We had 100 dancers come plus "stars" who magically just showed up like, Rebecca Shulman, Daniel Trenner, Cecilia Gonzalez, Daniela Arcuri, and Armando Orzuza! In today's community, that would be equal to 500 dancers showing up! I had designed a button in case of arrest that said "Free the Tango 50." I thought we would get 50 dancers, if lucky. It was a gorgeous setting, and we put 150 "luminarias" (candles set in brown paper bags) around the fountain and down the 2 staircases. I even found two couples that volunteered to dance in the fountain, even in late September! The women wore fancy tops and boas, men wore tux jackets on the un-submerged parts. I still can't believe I got anyone to do this – and they were beautiful. We made the New York Times and tango lore and celebrated the new star in our community, Brigitta Winkler, who brought to us the "close embrace," the embrace we came to embrace. It was fun. I may try to recreate this! We will see.

The community does grow and does change. We miss Lafayette Grill, and we miss Esmeralda's at Session 73 as well. But new places come along, talented new organizers offering more incredible experiences in this dynamic community, brilliant live music events, and now, Diego Blanco, a great newer talent on the scene is organizing a "tango flash mob" for the now annual Dance Parade. And who knows, maybe another Lafayette Grill will appear somewhere somehow, and another Esmeralda's will pop up as well! Maybe, just maybe.

Dr. Susan: Thanks for these memories and thoughts to add to the fascinating history of our local tango story.

236

INTERVIEW #13 WITH MEGA FLASH

I have known Mega Flash for many years. Both Mega and I have been loyal patrons and dancers at Lafayette Grill. Both of us have danced Argentine tango for approximately 12 years, and have initiated our tango social life at Lafayette Grill. Over the years, we have encountered each other frequently at Lafayette, sometimes dancing together, and sometimes just kissing each other "hello." I have seen his brake dance performances at the Grill, and more recently his tango performances. I only learned recently, during this interview, that Mega has bicycled all the way down from the Bronx to join in the Lafayette Grill ambience.

Although a dancing patron of Lafayette Grill for over 12 years, it is only in the last year that Mega took over the job of Saturday night *milonga* host, giving new life to the Grill. Mega has reached out to the tango community to inform everyone of all the Saturday night tango events, both related to the music and the performances. Consequently, Mega has enlivened the atmosphere with top performing musicians and Argentine tango performance artists.

Mega also hosted a very successful Saturday night *milonga* at Lafayette Grill on the same night (July 23, 2011) as the Black and White Ball at the New York Tango Festival. Despite the competition from the festival, Lafayette Grill was packed. Jon Tariq performed that night with Carolina Jaurena. Of course Lafayette Grill supports the New York Tango Festival, and Gayatri Martin, who runs and coordinates the spectacular festival, is always welcome to make her PR announcements of the festival events at the Grill, including announcements about the Black and White ball. She is personally invited to do so, in public, this year by Mega. Gayle Madeira and Sid Grant, who won the Open Competition at the 2011 New York Tango Festival, performed at the Black and White Ball on Saturday, and then on Tuesday night at Jon Tariq's *milonga* at Lafayette Grill. Sid Grant and Gayle Madeira are also regular patrons and dancers at Lafayette Grill, especially for the Monday and Tuesday night *milongas*. Mega Flash makes everyone feel very welcome at the Saturday night *milongas* at the Grill, and as the following interview shows, Mega is particularly welcoming to all New York tangueras (female tango dancers) who need to find partners to dance with. On Saturday night, he makes it very clear that all women who want to dance – will dance. They will be asked, and they are welcomed to ask men to dance. Mega always announces that he is known for never saying "no" to a woman who asks him to dance. This is New York, the home of the feminist movement and of the rejuvenation of Argentine tango in Buenos Aires and in New York.

Dr. Susan: How did you get into Argentine tango, Mega?

Mega: I've been dancing my whole life. I was a break dancer since 1977. I performed on stage and TV, and had my own company. But what I missed in my life was the more intimate experience of social dancing, of dancing with a woman. You might find this funny, but I couldn't just go to a club and dance with a woman because I'd always end up attracting a crowd around me when I was dancing, and instead of just being in the feeling of dancing to music with a woman I would end up performing. It was like an occupational hazard after doing Breakdance as a performing career for so many years.

I would go to a club, ask a woman to dance, but suddenly the woman couldn't keep up with all my moves, and people would crowd around me and watch me take off in my dancing, just like I was on the stage. This happened time and time again, at many different clubs. I wanted to slow down and dance in a good connection with a woman, so I began to study salsa and ballroom dancing. Somehow neither salsa nor ballroom stuff took off for me. Then one day I discovered tango in Central Park, at Bethesda Fountain. It was 1999. I saw all these gals and guys dancing tango together, and it looked really cool. I hadn't liked the salsa music. I not only thought tango looked hot, but when I listened to the music, I fell in love. So then, I wanted to take tango lessons.

At that time I was working at the Chelsea Piers health club as a rock climbing instructor. The health club decided to teach tango for a month. I took a lesson for free since I was working there, and I was hooked. I studied it for a month at the club. Then those of us studying tango at the health club heard about Lafayette Grill and the tango *milongas* there. I went there with some friends and we all took the beginner and intermediate lessons. Then we stayed and watched the folks dancing tango in the *milonga* that started at 10 pm. Sitting and just watching, I felt intimidated by seeing the really great tango dancers on the floor, and this was even before the bigger ballroom space opened up. I was really impressed by the quality of the dancing, even by the dancing of the more mediocre dancers. It was just the beginning, but I felt an inspiration that made me want to keep returning to Lafayette Grill every Saturday night for their *milongas*.

In those days I spent a lot of time at the Bar, just trying to get my nerve up to ask a woman to dance. But I gained confidence because Lafayette Grill was such a friendly place. I mean the people were really great, really welcoming, and the staff too. I got to know Dino, Billy, and all the staff by name, even the bus boys like Placido. I started coming almost every night of the week, not just when they had tango. In those days they didn't have four *milongas* a week like now. At first they only had the Saturday night *milonga*, which is definitely one of the first *milongas* in New York, maybe the first one outside the dance studios. But because I felt so at home at the Grill, I started coming on the nights when they had jazz,

238

belly dancing, and Flamenco dancing, as well as tango. I'd hang out at the bar and everyone got to know me.

I really worked at my tango then too. I kept coming back week after week, and took all he Intermediate lessons on Saturday nights with all the different tango instructors from Buenos Aires and New York. I sometimes took private lessons with the instructors that I studied with in group classes at the Grill. From 1999, for the first two years, I studied and took all the classes. Then for my 3rd and fourth years of tango I just focused on learning through dancing with partners at Lafayette Grill. It was kind of magical. The timing in my life and with the happenings in New York City had been perfect. I discovered tango in Central Park just when I was discouraged about other partner dances. I had taken a job at Chelsea Piers, and suddenly they were teaching free tango classes to employees. Then I heard of Lafayette Grill at Chelsea Piers and the rest is history!

I thought I should go to other *milongas* for the experience, but I found they were not as friendly as the ones at Lafayette Grill. I had an interesting but disappointing experience at another *milonga*. I asked a woman to dance. We danced one song. She said, "You must be a beginner," and she didn't want to dance anymore. I felt hurt and thought of revenge. I thought that I would get to be better and better at tango, and then I wouldn't dance with her when she wanted to dance with me. She and I did get to know each other, and I told her that she had turned me down to dance when I was more of a beginner. She apologized and said she had been very insecure then because she had just been a beginner herself. Then we did dance a lot together, but I got payback by at first refusing to dance.

Dr. Susan: Yes, but you didn't just retaliate. You communicated with this woman, and told her why you were holding back from dancing with her. You seemed to believe in mutual respect, and maybe that's why you were able to receive the atmosphere at Lafayette Grill and realize how friendly it was. People who were connecting with each other in tango at Lafayette Grill were also talking to each other, and developing social relationships, sometimes real friendships. I know I've experienced that.

Mega: Lafayette Grill was always the friendliest atmosphere. It will always be the home where I first started tango. I really became attached to Lafayette Grill. It became my *milonga*! As I said, I got to the point of knowing everybody at the Grill, including the waiters, bus boys, the owner and his family, the waitresses … everybody. I was at the Grill when they began to rent the big space, from next door, and opened up a fall ballroom for dancing, particularly for dancing tango. They knocked down the walls, and had these great columns that are still so elegant, and they even had a stage just for the tango bands, with special tango music artists and bandoneon players. Also, there are always paintings on the walls. I was told back then that Dino has many artists coming here and having openings

for their different exhibits on Saturday afternoons. The whole place has a cultural and artistic atmosphere.

Dr. Susan: I've heard so many people express gratitude for how much Dino is dedicated to all artists. He supports all the arts. I've heard people who come to Lafayette Grill, and who start to dance tango here, say how this restaurant is like a small palace of culture in the middle of the vast corporate commercialism of New York City. Some people really appreciate how unique this place is. I've also heard people from Buenos Aires comment on how it's the most authentic *milonga* in terms of having the atmosphere of Buenos Aires with the paintings, columns, the stage for musicians, and the comfort of having everyone seated at tables, tables to which they can return to in between dances, having a home at their tables. That's why I began having my yearly object relations psychoanalytic psychotherapy institute conferences here as well as my tango birthday and anniversary parties. Now I have my institute's holiday parties here too. We had our twentieth anniversary celebration here last year.

Mega: I became a regular fixture at Lafayette Grill. I came and socialized with people at the bar all the time. Then I decided I wanted to be a bar tender, and I asked Dino, the owner, if I could bar tend for free to get practice. I bar tended with his brothers, and the female bar tenders for 6 months. I became even more part of the Lafayette Grill family. Dino's brothers, Billy and George, taught me bar tending tricks.

Soon someone from Reportango wrote an interview with me about how I love Lafayette Grill. The interviewer said I rode to Lafayette Grill every day, all the way from the Bronx, on my bicycle. One woman, who read the interview, and was a tango dancer passing through town, a stewardess, wanted to meet me, because she couldn't believe that I was so dedicated to Lafayette Grill that I would ride here every day on my bicycle, all the way from the Bronx, and then ride back. When she met me, she saw I was telling the truth, and that my love for Lafayette Grill was very real.

Mega: During my fifth, sixth, and seventh years of dancing tango I got lazy. I wasn't dancing much. I would still go to the Lafayette Grill *milongas*, but I was hanging out at the bar, drinking and talking, rather than dancing. I loved the atmosphere, but sometimes I wouldn't dance at all. People didn't even know I was a tango dancer anymore. One day I was hanging out at the bar, and I asked a woman to dance. She was surprised, almost shocked, and said "You dance tango?" I was shocked by her surprise. I said, "Yes, of course. I'm a tango dancer!" I certainly still thought of myself as a tango dancer, but I wasn't taking lessons or practicing, or even dancing at the *milongas* anymore.

When I did dance, I started to see that the level of my dancing had really gone down. I became a bad dancer who was pushing women around, which is the opposite of what the organic tango connection is all about.

240

Then one day I couldn't deny how much I had declined as a tango dancer because of the reactions of the women at the tables (not at the bar) at Lafayette Grill. One day I went to a table and asked a woman to dance, and she said "No!" bluntly just like that, "No!" without anything to soften the blow. Then I went down the whole table of women asking each woman to dance, and each and every woman said "No!"

It really hit me hard at that moment. I realized I was no longer a desirable tango dance partner because in the past women always had liked to dance with me. So rather than get depressed, I took this devastating realization as a challenge! I realized I had to work steadily on my technique and also dance a lot. I started taking lessons again. So my dancing got better. Women began to want to dance with me again. And ultimately I got asked to a dance company, so I got into performing as well as social dancing.

Then one Saturday night, at the end of 2010, I wanted to make an announcement at the *milonga* at Lafayette, and so I asked my friend, who was the instructor that night, if I could. Suddenly, the owner, Dino, saw me making announcements, and he also saw that women wanted to dance with me. So it was then that Dino invited me to be the host at Lafayette Grill on Saturday Night, for the New York Milonga.

By this time, there were three other nights of *milongas* at the Grill: Monday night with Tioma and Jose hosting; Tuesday with Jon Tariq; and Wednesday with Magdalena. But the original long term Saturday night *milonga* at the Grill had fallen off from what it had been, "The New York Milonga," the first New York restaurant *milonga* that lasted. So I agreed to become the host. I did it out of my love for the Grill and for tango, and because I really thought I had the energy and intention to build things up again, which is exactly what happened.

Mega: I took over as the Saturday night host of the Lafayette Grill's New York Milonga in December of 2010. The Grill hadn't had a host for several months, and nobody knew what was going on. It was a little chaotic. Attendance at the Saturday night *milonga* had dropped from what it had been, and so I had to do CPR as well as PR, to resuscitate the New York Milonga. I began to organize everything, and to advertise to the New York tango community about how I was lining up top guest tango artists to teach and perform on Saturday nights. I began to hire musicians and excellent DJs as well as great Argentinian and New York tango dancers to teach and perform. By rehabilitating the email list and doing frequent emails and follow up emails people in the tango community felt the outreach and began to respond. They began to feel informed again. I began a whole process of sustained connection with the tango community, and the stability of having a dedicated host again at the Grill, who also knew how to advertise, and do personal outreach began to take effect.

I also did outreach to promote sustained connections on the evening of the *milongas*. Every Saturday night I went around to the people at the tables and made sure everyone was enjoying themselves. I made it clear that the most important thing was that every woman at Lafayette Grill will be dancing, and not just sitting and waiting to dance. Women began to flock back into the Saturday night *milonga* as in the past. When I get up to make announcements I always say, in a joking way, that this guy, Mega Flash, is said to never say "no" to a woman who asks him to dance.

I want everyone who comes to the Grill, and who comes Saturday night, when I host, to feel special. So when it's someone's birthday, I make a big effort to make them the center of attention. Before we ask the birthday person up to do a birthday dance, I sing the birthday song, in a cute way, joking about what a great voice I have, turning "Happy Birthday to You," into "Happy Birthday to J-ou." Then we give the person a cake, have them blow out the candles, and then I ask all the guests to line up to dance with this special person on their birthday. We do the birthday dance separately from the professional performance, although sometimes the professionals of the evening, as well as other professional tango dancers, join in the birthday dances. Sometimes we also allow the person with a birthday to do a performance.

Mega: When it comes to tango I'm old school. I always wear a jacket, and I take the tango etiquette seriously. I learned from the Argentinians that a jacket protects women from men sweating. There's a real respect for women in Argentinian culture. I like to follow the etiquette that displays respect for women. If I see a woman sitting with a guy, I always ask the guy for his permission before I ask the woman with him to dance. I realize that some couples don't want to dance with other people. I also like to keep everything very punctual so that everyone feels at home. They know when to expect the lessons to begin, when to expect the *milonga* dancing to begin, and when to expect the performances to begin. Another thing that I think is very important in terms of the ambience of the *milonga* is that I'm always friendly and polite to the beginner dancers. I was a beginner once too. I encourage beginners to take lessons, to practice dancing, and to stick to tango and not give up.

However, this is New York, and not Buenos Aires, and we do some things different here than in Argentina. We have our own etiquette in terms of accepting, and even encouraging women to ask men to dance. I have been told that Lafayette Grill provides an atmosphere for a *milonga* that is the most like Buenos Aires of all *milongas*. I think the paintings on the walls, the fact that everyone has a table to go to and return to in between sets of tango called *tanda*s, and the fact that we have a beautiful set up for the stage, and for all those at the tables to see the stage, contributes to the atmosphere being like Buenos Aires. But as much as we

create the congenial ambience that resembles Buenos Aires, we do distinguish ourselves as New Yorkers by providing freedom for women to express their own sense of initiative and agency by often being the ones to propose the dance to the guys. Once in the dance they let the guys propose the steps, but this doesn't mean they can't propose the dance to the guy.

Dr. Susan: Yes. This only makes sense, since New York is the home of feminism, and New York *milongas* are filled with professional women in leadership roles of all kinds. Argentine tango was born in a macho culture in Buenos Aires, and here in New York we don't subscribe to the dominance or submission that can go with that for the different genders. We believe much more in mutuality and mutual surrender in the dance of tango and in the social graces that go with it. Professional women love to surrender. It's like a vacation from having to be in control when in leadership roles, but we need to feel the mutuality of leaders and followers alike surrendering to their own internal selves when dancing tango, and also to the music, and to one's partner. I wrote an article on "Anatomy of Surrender" that was published in Reportango magazine in 2002. This was picked up by Dr. Marcia Rock, who is the Director of Broadcast Journalism at NYU. Marcia created her documentary film, "Surrender Tango," in which she interviewed me related to my ideas on surrender versus the sadomasochistic dynamics of dominance and submission.

Both Marcia Rock and myself are in roles as directors of programs and institutions, so we represent a lot of New York women who love to surrender in tango, but who also want the freedom to choose our dance partners, and the freedom that goes with authentic connection in being able to ask friends, strangers, teachers, or our own partners to dance tango. I also am in full time private practice as a clinical psychologist and psychoanalyst for decades, where I am the follower in following the unconscious experience of the patient. I like to lead and follow, and I think this is the way most women feel. When I do tango it is such a pleasure to give up control and be in the following position. But I also like the privilege of asking a man who recently enjoyed dancing with me, or a man who is a tango friend who I regularly dance with, or a stranger, or my own husband, to join me on the dance floor for tango.

Although it is often understood in New York that women are free to choose, free to ask men to dance, it is only at Lafayette Grill that this privilege is made overt and explicit. Only at Lafayette Grill does a host like you Mega, give voice to what is in the heart and soul of every independent woman. Such independence and initiative only enhances the woman's joy in surrendering to the position "of the follower in Argentine tango where she can feel the vibrancy of her femininity."

INTERVIEW #14 WITH GAYLE MADEIRA

Dr. Susan: How did you get into dancing Argentine tango, and then into being a professional tango performer?

Gayle Madeira: I've been a dancer for 37 years, a professional ballet and modern dancer here in NYC since 1992. Tango was always on my to-do list, that list which never seems to quite get done. I had just gone through a divorce and had been sad all the time, but things were starting to get better. I was on my way home after the first day of work at a new job and was feeling positive as I came to a small intersection at 3rd street and 2nd avenue in the East Village in NYC. I didn't have the walk sign to cross and there was a car coming but I knew if I walked quickly I would make it.

A few weeks prior I would have just stood there, in a sad state, without enough motivation to walk faster. Just after I crossed the path of the oncoming car, a police van which had been speeding down 2nd Avenue with its sirens on tore through the intersection, slammed into the car I had just crossed in front of and they both smashed into the pole right where I had been standing seconds before. It was a terrible accident, the car was completely crushed. I knew if I had been standing there I would have died, it happened so quickly.

This was an immensely transformative experience for me in many ways. The following day I signed up for tango. I felt it was necessary to start on my to-do list right away as you never know when you will lose your life. I stayed in beginning tango class for one full year because I knew that I wanted this dance to be the dance form for the next half of my life, so I wanted to get the foundations down very well. It took that full year for tango to really take hold of my heart but after that year I quit all other dance forms and devoted myself to it, and started performing tango after my 2nd year.

Dr. Susan: Being that you were always a professional dancer, and ran a dance company, how do you now compare your passion with Argentine Tango with your love for other forms of dance?

Gayle: Ballet was my first love and I loved it with all of my heart. As I grew older, I went through the transition that many ballet dancers go through, lamenting the increasing loss of jumps and flexibility, feeling the pain of the body as it tries to do what it once did so easily. I wanted to find a dance form that contained the same passion and the same gorgeous music as ballet, and had a level of difficulty that would compel me to be as absorbed in it as I was with ballet. Well, this is a tall order from a dance form! Argentine tango has completely fulfilled this desire for me and much more. The improvisational aspect of it is enthralling and captivating, it has turned out to be so much more interesting than any choreography. The social aspect of tango has been eye opening and wonderful. I grew up on a

farm in Virginia, and in that area people were extremely social, gentle and took their time with each other. You would go visiting quite often, and these visits would last for hours, without any thoughts of rushing off to do things. I missed this and didn't even realize it until I started tango. In the *milonga*s, the phones are left off and in the purses or pockets, the tables are full of people visiting, eating and drinking together. It is a wonderful community and I feel blessed to be a part of it.

Dr. Susan: How do you see Argentine tango as an art form?

Gayle: Compared with an art form such as ballet, Argentine tango is still a youngster! However, it is no ordinary youngster, it is a brilliant youngster; it is a 'Mozart' or 'Picasso' youngster. Upon birth it immediately had a vibrant life force inside it which has only grown more intense and deeper with time. The most amazing thing about Argentine tango isn't even that it is a powerful and transformative art form but that it also has the potential to be a great therapeutic tool. The *milonga*s are microcosms of life. The relationships and dynamics we have in them are the same as in life. If you are aware and consciously seeking out a transformative experience, the tango can put a floodlight onto issues in your life while simultaneously helping you to walk through the issues with the lure of the sweetness of embraces and friendships.

Dr. Susan: What did you find to be particularly special about the *milonga*s and overall atmosphere of Lafayette Grill?

Gayle: I found Lafayette Grill endearing because as New York City became cleaned up in the last twenty years with every restaurant getting fancy, modern renovations, most of the heart was lost from many of those places. Lafayette Grill often felt like the last bastion, the one remnant of old New York. It was a mess, twenty million types of lights, fans, air conditioners that mysteriously didn't quite work though they were plentiful, wires everywhere and some of the worst art I've ever seen! But all of this made it feel like you were in someone's home which lent to a feeling in the *milonga*s that you were with family. You know, in New York city there is so little space and it's very difficult to find a restaurant that will take tango dancers who are notorious for not eating or drinking very much. Lafayette Grill was loyal to the tango community and embraced it, and gave it a home. The space was wonderful to dance in, the floor was great, the size was perfect for an intimate feeling but big enough to do some dance steps and not be on top of other people. The seating layout was unusual and quite nice with the raised stage for half of the area allowing better than average viewing of the dance floor. It was a really sweet place and I'll always think of it fondly.

Dr. Susan: Using your thoughts about mother/infant bonding, how do you think about the connection and the embrace in Argentine Tango?

INTERVIEW: GAYLE MADEIRA

Gayle: Much more information is coming out recently about the healing qualities of the chemical oxytocin which is released only in certain situations: Through breastfeeding (both for the mother and infant), when you are in the beginning stages of romantic love and when you hug which is also the tango embrace! The health benefits of oxytocin currently known include lowering blood pressure and heart rate, stimulating nerve activity, overall improvement of mood, increase of trust and lowering stress levels. Hugging (which is also the tango embrace) also decreases cortico-sterone and other stress hormones and releases dopamine which is a natural "feel good" brain chemical. Basically, the tango embrace gives you nature's version of an anti-anxiety and antidepressant pill!

The other amazing thing about oxytocin is that you don't need larger amounts of it over time to generate the same feelings as you do with other chemicals like nicotine or caffeine. The body becomes sensitive to the chemical so that less is needed to have the same great health benefits. Of course no one has done a study using exclusively tango as the subject but many studies have been done about the power of the hug, and the tango embrace is a hug. One thing to keep in mind is that for the most part, the open embrace found in most *nuevo* tango dancing doesn't generally include a full body hug, so the health benefits may be less, but again, no one has done that study yet.

Dr. Susan: Any other thoughts about Argentine tango in New York, as opposed to elsewhere?

Gayle: I've only danced tango socially in New York and Buenos Aires so I can't speak about other locations. The *milonga*s in New York have similarities to the ones in Buenos Aires but are definitely not the same. I prefer to go to the most traditional *milongas* when in Buenos Aires and in those *milongas*, the host/hostess seat each person in an assigned seat (usually reserved ahead of time) and no one else is allowed to sit in that seat. Single women are seated together in one area, single men in another (usually opposite the single women) and couples seated in a different area.

The *cabeceo* is utilized for leaders to ask followers to dance. The *cabeceo* is a nod of the head used to request a dance. The leader and follower lock eyes and the leader nods their head slightly, then the follower nods their head yes in return and usually smiles. Then the leader walks across the floor to them keeping their eyes on the follower of their choice. The follower should never stand up to dance until the leader arrives right in front of them because the *cabeceo* might have been intended for someone sitting behind the follower.

In New York we don't have any *milongas* with this arrangement. Dancers for the most part walk up to you and ask for a dance verbally. Followers and leaders also ask each other for dances. There are some people who *cabeceo* but it is often done at short distance and if the person

doesn't respond, the leader will often ask verbally after trying visually. In many ways this makes me sad because I love being able to sit out a *tanda* and watch dancers, or eat some food, without anyone asking me to dance. I also love to select the person I want to dance with based on the orchestra that is playing or whether it is a tango, vals or *milonga* set. There are certain people that I don't want to dance Pugliese with, and others who I want to dance *milongas* with most of all. Without the *cabeceo*, it is difficult to do this. When a leader asks you to dance, if you prefer to dance with someone else for that music, you could say "no thank you" and then dance with another person, but often the rejected person will be insulted and never ask you to dance again. So you often find yourself dancing *tandas* with someone while wishing you were dancing with someone else.

I've heard from many people that instituting the method used in Buenos Aires, where the host seats you at an assigned seat, would be impossible in New York or anywhere outside of Buenos Aires. I definitely don't think it would be impossible, but it would take an extremely strong host or hostess and a lot of communication, to let the patrons know what is expected of them, both before and during the *milonga*. However, to be fair, the nice thing about the less rigorous format of New York *milongas* is that you can mingle everywhere whenever you want and talk to anyone you want. It allows for freeform gatherings and re-gatherings of groups as in a cocktail party and this is also extremely enjoyable. I suppose the best balance is what I have right now, to spend some time in New York and some time in Buenos Aires!

INTERVIEW #15 WITH GAYATRI MARTIN

Dr. Susan: How did you get into Argentine tango?

Gayatri Martin: I ended a relationship of 6 years, where we hadn't gone out dancing. I realized I love dancing. So I picked up "Time Out" magazine, and saw an ad for Argentine tango at SOBs (Sounds of Brazil) on Sundays. I went to SOBs, and Tioma and Valeria were teaching a beginners class. I took the class and saw Tioma and Valeria perform later that night. There was live music. An Argentine guy named Miguel danced with me all night, so I had lots of fun! Consequently, I went back every Sunday for four weeks and took the same beginners class.

Then I went to a New Jersey dance weekend with Tioma and Valeria. Paul Pellicoro was there teaching salsa. I met another tango beginner, from SOBS. We ended up becoming partners, and danced seven days and nights a week. We did everything! We did choreography classes. We performed. We went to Buenos Aires in May. We organized a tango workshop at the original Triangulo for Pupi Castello.

Then, my partner and I arranged our own tango tour to Buenos Aires. We were the first to come up with the idea of touring in Buenos Aires with not only classes and *milonga*s, but a tour of the city, a day in the country, yoga, shiatsu, etc.

Dr. Susan: What motivates you to organize and conduct the annual New York City Tango Festival?

Gayatri: Initially, the idea of a New York City Tango Festival was Lucille Krasne's. She asked me and Trey Parker to help put it into action, which we did. It was July right before September 11th of 2001. It was also the year I opened up my many years running *milonga*, La Boca.

When we began, there were about five tango festivals in the world. Now, there are several every weekend. The number of tango festivals changes the world in relation to tango. The tango festival has a different dynamic each year. My relationship to tango and where I am in my life is different every year.

I've just again fallen back in love with Tango, and creating successful events meets my needs to contribute to the community and to bring the audience and performers together. It meets my needs for creativity when I coordinate all these elements.

I love to support the musicians and professional Argentine tango performing artists. The Black and White Ball, for example, has been the home to many historic performances. La Boca, my Tuesday night *milonga* for many years, had been that way too, as featured tango artists had shown off their most unique skills and choreographic ideas there, as well as dress.

We never will forget Omar Vega, the now deceased world famous

milonga teacher, dancing *milonga* in a white tuxedo at break-neck speed, accompanied by the well-known Karina Romero.

This is why I chose always to have live music and performances at La Boca for my Milonga. Now, the New York Tango Festival has expanded to include a Film Festival and the original USA Tango Championship.

Dr. Susan: What do you remember from Lafayette Grill?

Gayatri: I had dinner every Saturday night for many years there and, though I often asked for the menu, I always chose the spinach pie. The Tango Festival would also often include a night at Lafayette Grill. One year, we had the Championship Competition there. Lafayette Grill was one of my home *milongas*. Not only did I eat dinner there for many years, but it was the home to the Saturday part of the New York Tango Festival.

I watched the evolution of Lafayette Grill from the narrower space, sometimes being masterfully navigated by Madalyn and Nelson Avila, to the full flourishing *milonga* and performance space as a full ballroom opened up. We enjoyed it all under the gentle and generous presence of the now deceased Dino, the owner of Lafayette Grill, whom we all cherished!

Dr. Susan: Anything about your philosophy of Argentine tango?

Gayatri: Argentine tango is unique in that it can be anything from a complete way of life, to fulfilling a need for entertainment in that moment, and everything in between. One can fall in and out of love with it endlessly.

Dr. Susan: When you're falling in love with Tango again, in what way is it new for you?

Gayatri: The pleasure of dancing socially is always new because of tango improvisation, and the connection to the music and the community, which is my tango family. The first year I chose not to do a New Years' Eve party for the tango community, I realized I would miss being with my Tango Family, so I chose to DJ and be at the Lafayette Grill party. As my blood family is in Australia, and I can't be near them for such holidays, the places and moments with those in Argentine tango have made it my 'family,' as I imagine it has for many like yourself and Saul.

Dr. Susan: Thank you so much, Gayatri. [hugs and kisses]

250

INTERVIEW #16 WITH SONDRA CATARRASO

Dr. Susan: What brought you into Argentine tango?

Sondra Catarraso: I had seen the movie "Scent of a Woman" and I told my husband, "That was a dance I want to learn." However, my husband wasn't interested in dancing. In that movie, I saw tango performed by Al Pacino, who'd learned it from Paul Pellicoro. Al Pacino moved like a real tango dancer! I was very attracted to this dance. But since my husband didn't dance, I put that idea on the shelf. We were both artists and painters, but not dancers. Then it came about that we divorced, and then, already on my own, I made my list of things to do. I decided: roller blading; martial arts, and then – Tango!

So, I finally got into the dance I learned to love. The first class I took was with Danielle and Maria at Sandra Cameron, and then I started to take classes at Dance Manhattan Studios. This was 1997. I was dancing Argentine tango five nights a week. I was taking classes and workshops, and it became a huge part of my life.

Dr. Susan: How did you go from learning and dancing tango five nights a week to creating the New York Milonga at Lafayette Grill?

Sondra: My friend Elyse introduced me to a friend of hers who knew I was dancing tango. This friend of Elyse knew Dino Bakakos, the owner of Lafayette Grill, and he brought me to that restaurant for their Friday Belly Dancing night, where I did an Argentine tango demonstration. Dino liked it, and so the rest is history. It was 1999.

I was taking many classes, so I knew the tango teachers at Dance Manhattan and at Danielle and Maria's Milongas. I started inviting teachers to teach each Saturday night at Lafayette Grill, and to perform. We began to have very special performances. I had to continually book the teachers who would teach and perform. I organized the program in advance and made the contacts for setting up each Saturday night. I got the best teachers and performers from Argentina. The first one was El Indio and Mariana Dragone, Karina Romero and Walter Perez, and Carlos de Chey. Then other greats came, like Guillermina Quiroga ("Forever Tango"), Fecundo, Armando Orzuza (Daniella and Nuria), Angeles Chanaha, Junior Cervila, Virginia Kelley, Omar Vega, Mariella Franganillo, Sandra Buratti, Cecilia Saia (from "Forever Tango"), Nelson Avila (from "Tango Argentino," 1985), Anton Gazenbeek, Carlos Costes, Juan Carlos Suarez and Alicia, Carolina Jaurena, Valeria Solomonoff, Mariana Galassi, and Annatina – to teach and perform *milonga*. Then, as Argentine tango spread through the whole professional dance community in New York, we also invited New York tango teachers.

We also had live music with the best musicians, such as Tito Castro on bandoneon and Pancho Navarro on guitar. Then many other top

musicians, including the female bandoneon player Laura Vilche, pianist and composer Maurizio Najt, Los Chantas, Juan Jofre, Mario Burgueno, Guillermo Vaisman, and Hector Del Curto.

Dr. Susan: So your life became focused on every Saturday night at Lafayette Grill?

Sondra: Yes. So I tried to get the best of the best of Argentine tango in from Argentina, and then also in New York, on an ongoing basis.

Dr. Susan: What special memories come back to you as you think back on your eleven years at Lafayette Grill?

Sondra: It wasn't easy, because people would start talking to me, and I wanted to listen, but I had to continuously talk to others, and get everything on the program going. I had to get the musicians together and get the dance demonstration going at 11 pm. I was jumping around a lot. We had the very best Argentinian musicians in New York, and later the best in DJs.

Dr. Susan: Obviously you worked 24/7 on these Saturday nights, and everything depended on you! You had some guys who helped you host the evening..?

Sondra: Yes. First, I worked with Marco Leal. Then, for many many years, I had Jose Fluk, who would teach, and perform, and welcome guests with me. However, it was up to me to make all the announcements and introductions for the evening. I even had to teach tango classes there sometimes. When Jose came, it really helped me out, because he could always teach the beginners' class prior to the intermediate and advanced classes with our special guest teachers.

Dr. Susan: Aside from all the hectic and stressful activities of each Saturday *milonga* at the Grill, what particular memories stand out for you that made the whole thing worthwhile?

Sondra: One of the very best memories was seeing Dino do his first birthday dance. Finally, he tried to get up there and dance. We knew he loved the dance and the music, and loved watching others do it, but it was hard for him to try it. He never had time to take classes. He was so continuously busy... But when he tried a few steps in front of everyone we all felt his special place in our tango community, and he felt his connection to all of us.

Dr. Susan: You also made many of us, tango community patrons, feel extremely special; first, by greeting us with such warmth every single Saturday night, and second, by facilitating the birthday dances, and cakes, and celebrations with song and music.

Sondra: It was a wonderful feeling to make everyone so happy! One time someone gave me a card to thank me personally. It was so nice to receive those special thanks.

Dr. Susan: I also know that you came to Lafayette Grill as a single woman, and then your new boyfriend, Jimmy, who was also a tango dancer, began to join you there.

Sondra: Yes. I loved dancing with lots of men, to improve my tango and enjoy tango, and to make the men who came to Lafayette Grill comfortable and happy, but I also had my boyfriend there. He would dance with me and others and discuss classical music with your husband.

Dr. Susan: Is there anything else that you want to add about anecdotes from all the years of Saturday night Milongas at Lafayette Grill.?

Sondra: One thing I'll never forget is the night that a male tango guy got down on his knees and proposed to the tango woman he was involved with, his "love." He was all equipped with a diamond ring and got down on his knees on the dance floor and proposed in front of us all! His girlfriend was shocked, and thrilled, and excited! Everyone felt happy for them and I was so pleased that they had chosen Lafayette Grill for their special night and special moment.

And by the way, I also remember a very special evening that involved you. It was when you and your husband, Saul, had your twenty-fifth wedding anniversary at Lafayette Grill. You both connected so beautifully that night, both in dancing for us and in being together that night.

Dr. Susan: Yes. We had been celebrating all our anniversaries, as well as all our birthdays at Lafayette Grill, partly because we loved to do it with you, and although we came to other weekly *milongas* at Lafayette Grill, we always had our parties Saturday night. Now we're about to celebrate our 30th wedding anniversary, and have been together 33 years, since we met. So many of those years Saul and I were dancing and dining together at Lafayette Grill. We had our special 25th wedding anniversary celebration with you at Lafayette Grill, and as usual Dino so generously offered us a free cake and you and he made time for us to perform, and to do an anniversary dance, with others cutting in. You would buy cakes and also then Dino, for birthdays and anniversaries, and graduations and everything.

Sondra: Actually, now that we're recalling all this, I should have had four arms and hands, because in addition to serving the cake, doing the announcements, telling people to keep to the line of dance in the *milonga*, I was also taking photos of everyone to put in Reportango magazine. I was a photographer for everyone who had a special night to celebrate, and for all their friends. This is what comes back to me, and it was such a major part of my life, those whole eleven years, organizing every Saturday night New York Milonga at Lafayette Grill.

INTERVIEW #17 WITH MARIA V. QUINTANILLA

Dr. Susan: How did you get into Argentine tango and the Argentine tango world in New York City?

Maria V. Quintanilla: I did not learn tango for myself. I learned it because of my job. I took my first lesson with Audrey Martinez and she was my tango mentor. She took me to all the *milongas* in New York City when I had only taken three months of tango lessons. Then she moved away and I didn't continue with any tango after she left.

Thankfully she moved back to New York. She took me to the *milongas* again and I haven't looked back since. Thank you Audrey!

Dr. Susan: How did you become inspired to do a radio show on tango in New York?

Maria: The entire idea is Mario's. I cannot take credit for it. *Recuerdo Radio* is his project, he has a big vision for it and I am happy that his original idea has been welcomed so well in New York City.

Dr. Susan: What memories do you have of Lafayette Grill? Any anecdotes?

Maria: Actually, Mario Cesar and I met at Lafayette Grill. He asked me to dance one night and eventually we became friends. I knew from the first *tanda* we danced together that Mario was a special *milonguero*. There are many special moments at Lafayette Grill. I can tell you that it was such a special place, and it felt like home. We even changed its name from Lafayette Grill, to "The Grill", to "La Parilla" – which means grill in Spanish. Every Monday night, Mario and I would call each other and ask if we were going to "La Parilla." It simply means that Lafayette Grill was more than just a building to us, it was also home.

Dr. Susan: Do you have any particular personal philosophies or theories about Argentine tango as a dance and as a social encounter?

Maria: I do not have any philosophies or theories about Argentine tango. I just love to dance. When I go out to a *milonga* I always have a good time. If I am not dancing, I am talking to my friends, catching up with people I haven't seen for a while, enjoying the music, admiring tango shoes, or watch people dance, which is also amazing.

ACKNOWLEDGMENTS

I would like to thank all those who helped me to create this unique book on Argentine tango. Those whose voices were heard here speak, not only of the dance, but also of the atmosphere, and community of the Argentine tango scene in New York City. They have joined with me, as well, in extending special thanks for the four evening *milonga*s a week, which took place at the Lafayette Grill in downtown Manhattan.

First of all, I wish to express my profound gratitude to all those who shared rich thoughts and emotions related to their experiences and their philosophies (with psychological implications) of the Argentine tango phenomenon.

In order of their interview sequence, I thank our beloved Dino Bakakos, the owner and manager of Lafayette Grill, as well as talented members of Argentine tango community that were an integral part of Lafayette Grill family – Paul Pellicoro, Sid Grant ("Dr. Dance"), Artem Maloratsky ("Tioma"), Anton Gazenbeek, Orlando Reyes, Alex Turney, Jennifer Wesnousky, Marisa Lemche, Jon Tariq, Jose Fluk, Lucille Krasne, Mega Flash, Gayle Madeira, Sondra Catarraso, Gayatri Martin, and Maria V. Quintanilla.

In addition to thanking those who volunteered to actively participate in interviews for this book, there are several others I wish to thank. I want to thank all those anonymous Argentine tango dancers who contributed their thoughts, feelings, and experiences in the NYC Argentine tango world for this book.

I want to thank Jon and Judy, Americans who live in Buenos Aires and teach and perform related to Buenos Aires traditions of Argentine tango – for their permission to write an essay about them in this book. I want to thank important NYC tango personalities and organizers who I did not have any more room in the book to interview, such as Lexa Rosean, a well-known tango instructor, who teaches the unique art of female "leading" in tango. Prior to leaving to further her studies in psychoanalysis, Lexa was hosting the Wednesday evening Lafayette Grill *milonga*, along with Magdalena. Sara La Roca took over her co-hosting with Magdalena, and should be acknowledged here too. Magdalena is another significant contributor to this book, as she was the hostess for the Lafayette Grill Wednesday night *milonga* and worked in many other capacities for Lafayette Grill, arranging various performances and parties.

Also, I would like to mention all people who contributed to the Lafayette Grill's ambience: famous musicians, such as Tito Castro and Mauricio; the guitar players, Joanne and Burley, for their accompaniment of the singer, Marisa Lemche; DJs – Lexa Rosean, Peter, Yesim 'La Turca', Jose Fluk, Hector Scotti, Elaine from Woodstock, Musa (also teacher,

performer, and former Saturday night host at Lafayette Grill), and many others.

I also want to thank the Object Relations Institute for Psycho-therapy and Psychoanalysis (ORI) for being the first psychoanalytic institute to hold yearly conferences at Lafayette Grill, with Argentine tango performances during lunch (by Sid Grant, Gayle Madeira, Artem Maloratsky, Anton Gazenbeek, and myself). These conferences with the tango performances were filmed by Nancy Stevens, a professional film maker and Argentine tango dancer, and they are available on YouTube.

Finally, I wish to thank two people, without whose support this book would never have been written and published. First, is my husband, Saul Adler, who has shared in a mutual passion for Argentine tango with me all these years, being both a prime dance partner of mine, and a kindred soul spirit in a mutual love of Lafayette Grill and of the dance and social Argentine tango *milonga*. He and I have shared lessons, practicas, and *milonga*s together for at least fourteen years. His silent and articulated support for my work and this book is most appreciated.

The other figure of major support is Dr. Inna Rozentsvit, who shared every detail of this work with me. I owe her the most for her dedicated service to all my psychological, educational, literary, and Argentine tango efforts. She is a neurologist and psychoanalysts who teaches courses on neurobiology at ORI, and who is the founder and editor-in-chief of the ORI Academic Press, a publishing venue that promotes cross-pollination between various science disciplines and arts. Inna is fully responsible for moving all this forward.

AFTERWORD

This book was conceived as a tribute to Lafayette Grill and the whole Argentine tango community in New York and beyond. Lafayette Grill had the second oldest Saturday night *milonga*, the "New York Milonga," for 13 years, directed for at least 11 years by Sondra Catarraso. Lafayette Grill also had other newer *milonga*s, such as "Ensueno Milonga," run by Tioma Maloratsky, Jose Fluk, and Gayle Madeira, and Jon Tariq's *milonga*. Lexa Rosean, who is now exploring the vicissitudes of psycho-analysis and Argentine tango, had hosted a *milonga* at Lafayette Grill, along with Sara La Rocha.

Since that time, Lafayette Grill's doors had closed, and our beloved Dino Bakakos passed away. There will never be anyone like Dino, who had opened his generous heart to the New York tango community. With his death, I feel the need to mourn not only the loss of Lafayette Grill and Dino himself, but to mourn the hope that Dino would recreate Lafayette Grill. Dino was planning to do it in another location. We would have missed the unique restaurant with its balconies and theatre-like atmosphere around the ballroom. Nevertheless, Dino had hoped to recreate the Grill's conviviality, the sharing, the caring, the joy of being together to celebrate Argentine tango as a way of being, as a social medium, and as an art form.

Sadly, Dino passed away, and there is no more Lafayette Grill. I share this loss with many I meet today in the New York tango world, who also knew and loved Dino and his (ours) Lafayette Grill. One tango friend, who came to the Saturday night *milonga*s, and with whom I continue to dance, had actually burst out crying when he read one of the essays I wrote for this book. He sobbed, and feeling the grief of loss, he said, "...this essay is all I have left of Lafayette Grill."

After losing lease for the restaurant space, Dino got to revisit his home in Greece, while planning to find another locale to call "Lafayette Grill." Those of us who loved him, were glad that Dino had time to rest in Greece after the tormenting ordeal with the landlady and the auctioning off the furnishings of his restaurant. But nobody could have suspected that Dino would then yield to another fate – of dying from a brain aneurism.

Dino loved to watch people dance. Now, he left us to have our *milonga*s without him. The tango world in New York will live and thrive, and offer us hope for intimate social connections, to counteract the anomie of technological overuse. Yet we miss the feeling of family and community we once shared through our mutual love of Argentine tango at Lafayette Grill. We miss the unique family feeling of the *milonga*s there, and particularly the crowd of friends and strangers who all became a family

together on Saturday nights, as well as Mondays, Tuesdays, and Wednesdays.

Lafayette Grill offered the best of the melting-pot phenomenon of the Argentine tango culture. Amateurs and professionals in tango gathered together from all nationalities, races, and ethnicities. Through sharing our joy in the sublime dance that is all about connection, we created a jewel of artistic and social activity, with art exhibits on the walls of the Lafayette Grill.

The magic of Argentine tango is merely the magic of feeling the fullness of life and human connection, and even love, through one's body feeling experience. This comes about through a dance medium that has steps and patterns, which are secondary to the essence of the "one plus one equal one" connection. This is a dance where the flow is allowed to organically evolve through oneself, in conjunction with an intimate partner, and with the evocative and affect-laden texture of the tango music. The dance can be full of sensuality, anger, romantic love, rage, joy, sadness, and grief.

We grieve and love in tango. We dance heart to heart, *corazon a corazon*. We speak volumes with our bodies. We nurture our souls with the vibration that goes through us from the tango instruments, such as the unique Argentinian bandoneon. Our souls respond, and when the violin and the piano and the bass are added to the bandoneon, we feel the thrill throughout our beings. This is the vibration that flows into a possible containable course, through our natural organic dimensions.

In this book, I have tried to offer glimpses into both the bright and dark sides of tango and of the tango world. In bringing into view some of the dark side, some of the ways that we in this world are not in the moment, or are caught up in conflicts from within and without, I am attempting to give a tapestry of the tango world that is rich and informative, without being idealized. By looking at the foibles and follies of human nature that also happen in the tango world, I am hoping to present a full scope and honest view of this very special world. Since the dark and the light side of everything exist, it would be limited in scope to show only the positive side of things. However, in bringing in the foibles, I in no way intend to minimize the thrill and joy of this infinitely creative and revitalizing dance, nor to underestimate its profound avenue for the human need for social discourse and social community.